JERRY BYWATERS

A LIFE IN ART

AMERICAN STUDIES SERIES

William H. Goetzmann, Editor

D006895

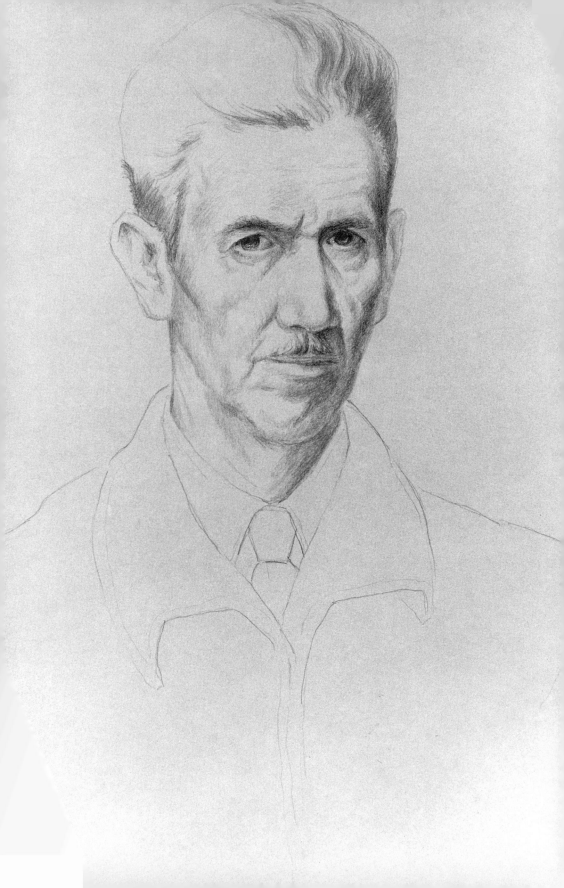

JERRY BYWATERS

A LIFE IN ART

Francine Carraro

UNIVERSITY OF TEXAS PRESS *Austin*

Publication of this book was made possible in part by gifts from the following, whose generosity is gratefully acknowledged:
Jane Christman Albritton
Nona and Richard Barrett
Bob Brousseau
Bill and Mary Cheek
Dr. William H. (Deacon) Crain
David N. Dike
Dr. Gordon Hosford
Irvin L. Levy
Mrs. Eugene McDermott
Stanley Marcus
Frank Ribelin
The Summerlee Foundation

⊗ The paper used in this publication meets the minimum requirements of American National Standard for Information Sciences – Permanence of Paper for Printed Library Materials, ANSI Z39.48-1984.
Library of Congress Cataloging-in-Publication Data

Carraro, Francine,
 Jerry Bywaters : a life in art / by Francine Carraro. – 1st ed.
 p. cm. – (American studies series)
 Includes bibliographical references and index.
 ISBN 0-292-71157-3
 1. Bywaters, Jerry. 2. Painters – Texas – Biography. 3. Art teachers – Texas – Biography. 4. Regionalism in art – Texas. I. Title. II. Series.
ND237.B99C37 1994
709'.2 – dc20 93-39098
[B]

Frontispiece: *Self-Portrait*, 1969.
Collection of Richard Bywaters, Dallas, Texas. Photograph by Reinhard Ziegler.

In memory of my father,
Roy Hansford Ramsey

contents

illustrations

foreword

by Ron Tyler

Texas has not always been – and some would say still isn't – a hospitable place for the fine arts. Few itinerant painters had more than momentary success during the nineteenth century, and native-born artists like Seymour Thomas had to go elsewhere to study and prosper. That situation began to change at the turn of the twentieth century because of pioneer painters and teachers Frank Reaugh in Dallas and Robert Onderdonk and his family in Dallas and San Antonio, who made it possible for Texas-born artists like Jerry Bywaters of Paris to study and practice in their own state.

When I first met Jerry Bywaters in 1971, he was one of the dominant figures in Texas art. He was chairman of the Fine Arts Division at Southern Methodist University, and I was a young curator at the Amon Carter Museum in Fort Worth, in the process of installing a major exhibition of "Texas Painting and Sculpture: The Twentieth Century," which he had organized with Martha Utterback of San Antonio. I did not know of his distinguished career as artist, critic, teacher, and museum administrator, which Francine Carraro so ably documents in this study, and would not have learned it from his quiet and easy-going manner. But Jerry Bywaters and his generation – artists and teachers like Everett Spruce, Alexandre Hogue, Otis Dozier, and Harry Carnohan – grew up with the arts in Texas and forever changed the cultural climate in our state.

As Carraro explains, Bywaters matured with the Regionalist movement, which suggested that the only true American arts were the indigenous creations that sprang from the heart of the country and further encouraged him and his fellow students to focus on their native Southwest. Bywaters contributed greatly to the movement initially as art critic of the *Dallas Morning News*, then as a teacher at the Dallas Art Institute and Southern Methodist University, and, in 1943, as director of the Dallas Museum of Art, a key position he held for more than twenty years.

By the time I met Bywaters again, about two years later, I was aware of his distinguished career because I had tried my hand at an essay on Texas art,

and asked for his critique. My novice effort well deserved its unpublished state, and his gentle and perceptive comments allowed me to set it aside pending a great deal more research on the complex years in which he played so vital a part. Not only was he a member of the group of artists known as the "Dallas Nine," for example, but he reviewed their work regularly. As director of the Dallas Museum of Fine Arts during the tumultuous decade of the 1950s, he and others refused to give in to the conservative attack on modern art. His thorough knowledge of the region and the personalities made him the perfect person to direct the Smithsonian Institution's Archives of American Art project to document art in Texas in 1974.

My final collaboration with Bywaters occurred in 1982 as I gathered paintings to include in a book on the Big Bend region of Texas. Bywaters was one of the first persons I consulted, first to solicit his own work for the book, and second for his recommendation as to who else should be included. The result was *Pecos to Rio Grande: Interpretations of Far West Texas* (College Station: Texas A&M University Press, 1983), which includes the work of eighteen artists. A detail of his *Century Plant – Big Bend*, which graces the cover of the book, evokes the raw character of the Big Bend as well as Jerry Bywaters' love of his native southwest.

acknowledgments

As the course of this study unfolded, I benefited greatly from the generous assistance and support of many individuals and institutions. I would like to acknowledge that my efforts were made pleasurable and productive with the help of a host of professors, colleagues, librarians, curators, editors, and students.

The encouragement, guidance, and vision of Professor William H. Goetzmann were essential not only to this project, but also to my intellectual development. Without his active participation, this study would never have been undertaken, written, or published. His counsel, suggestions, and practical assistance from the inception to the completion of the manuscript on the art and life of Jerry Bywaters were essential and invaluable as his involvement in the project evolved from professor at the University of Texas to editor of the American Studies Series. Dr. Goetzmann was also responsible for introducing my work to the University of Texas Press, where I have had the pleasure of working with the capable members of the editorial and production staff.

Professors Jeffrey Meikle, William Stott, Ron Tyler, and Becky Duval Reese also deserve special recognition for their patient assistance, able direction, and dedication to the subject. Their careful comments and practical suggestions guided my early ventures into this study. I would also like to acknowledge that my initial research for this study was supported by a University of Texas scholarship.

My research was greatly assisted by a number of colleagues who share a sincere interest in relating the story and importance of the work of Jerry Bywaters. They are given proper credit in the notes, but I wish to thank them personally. I would like to express my heartfelt appreciation for the contributions of Marla Redelsperger Ziegler and Reinhardt Ziegler who enriched this study on a number of levels as scholars, as artists, and as friends. In Dallas former friends, students, and associates of Bywaters at Southern Methodist University and at the Dallas Museum of Fine Arts, including Barney Delabano, Patsy Swank, Dan Wingren, Mary Vernon, and John Lunsford, were more than supportive of my work. DeGolyer Library Director Dr. David Far-

mer shared his recent research on Dallas women artists and read my manuscript with a discerning eye for historical accuracy. In Austin, artists Everett Spruce and the late William Lester were always willing to answer questions and to discuss their early Dallas days with Bywaters.

I have relied on the assistance of the staffs of many libraries and museums, but I would like to especially acknowledge the efforts and enthusiasm of Dr. Sam Ratcliffe and Ellen Buie Niewyk of the Jerry Bywaters Collection of Art of the Southwest at Southern Methodist University. They cheerfully met my every request, even on short notice. I would also like to thank the staffs of the Barker Texas History Center and the Fine Arts Library of the University of Texas who made my hours of research a joy.

At Southwest Texas State University, Brian Row, Chair of the Art Department, and my colleagues in the department offered encouragement and genuine interest in the study. Student assistants James Derrick Saunders and Dawn Hollis served the project valiantly with the tedious mechanics of editing and indexing. I also wish to acknowledge my students who challenged me to continue the study by their demanding expectations.

I am deeply grateful to Richard Bywaters and Jerry Bywaters Cochran and other members of the Bywaters family who have been both gracious and helpful in answering my questions and providing information.

Most important, I wish to express my debt of gratitude to Jerry Bywaters and Mary Bywaters. They provided much more than a wealth of invaluable archival material in support of the research. They welcomed me into their home and their lives with graciousness and enthusiasm. Despite their failing health, they endured hours of interviews without complaint. Throughout the completion of this study I encountered former colleagues, associates, students, and friends of Jerry Bywaters from across the state who held him in the highest esteem. They offered testimonials about how Bywaters had unselfishly assisted them in the pursuit of their own careers. I was constantly reminded of the scope of his influence, of his professionalism, of his generosity, and of his unquenchable spirit.

introduction

To present a picture of Jerry Bywaters is to describe a man of Texas-size accomplishments who was a visionary and an artist with a pioneering spirit. His art was a clear statement of his commitment to the region's people and land. Like a Texas hero, he was tall, thin, raw-boned, clear-eyed, and a straight talker. He had an honest, easy manner and a common-sense approach to art and life that was deeply rooted in the Texas landscape.

A likable rebel with a cause, Bywaters instigated and sustained a quiet but energetic revolution in the arts, valiantly taking up the standard of the vanguard in American art. Other Texas artists joined the campaign as Bywaters fought to ensure their place in the forefront of the regional movement in art. His dedication never wavered; for sixty years he worked within established art institutions and developed a variety of means to promote the art and artists of Texas The story of the career of Jerry Bywaters includes the story of the development of art institutions in Dallas and throughout the state of Texas. As an active participant, Bywaters witnessed a fast-paced evolution of the arts in the state. Today Bywaters is acknowledged as the leader of a group of Texas artists who broke out of the limitations of provincialism and attained national recognition beginning in the early 1930s. Bywaters ranks with other great American artist-teachers – such as Robert Henri, Childe Hassam, and John Sloan – who worked consistently to identify and elevate American art.

Bywaters believed art grows from life, not from theories. He believed artists should convey a sense of the locale in their work in order to identify the universal in the particular. Bywaters lived to see his ideas about art come into and go out of fashion, and then become popular again.

In the last years of his life Bywaters enjoyed a wave of adulation and attention, and he received numerous awards and honors. In 1972 he was elected Life Member of the Dallas Art Association; in 1978 he received the Distinguished Alumni Award from Southern Methodist University; and in 1980 the Texas Arts Alliance recognized him for distinguished service to the arts in the state. In 1987 Southern Methodist University acknowledged "our beloved mentor and colleague Jerry Bywaters" with an honorary doctorate. He witnessed a resurgence of interest in the art of the region and new appreciation

for the energy and inventiveness of the artists of the Dallas art community in the 1930s. The patriarch of a prominent art family, Bywaters lived to see a new generation value the art and artists of his region. Until his death on March 7, 1989, at the age of eighty-two, Bywaters lived in Dallas with his wife of 58 years, Mary McLarry Bywaters, in the house on Amherst Street designed by architect O'Neil Ford.

No award, however prestigious, could sufficiently acknowledge the breadth of Jerry Bywaters' extraordinary career in the arts. As art critic for the *Dallas Morning News* from 1933 to 1939, Bywaters wrote hundreds of articles on the art and artists of Texas. He served from 1943 to 1964 as director of the Dallas Museum of Fine Arts (now the Dallas Museum of Art) while teaching art and art history at Southern Methodist University for forty years without interruption. His university duties included chairmanship of the Division of Fine Arts from 1965 to 1967 and directorship of the Pollock Galleries at the Owens Fine Arts Center.

In addition, Bywaters wrote art exhibition catalogues, published an art magazine, and edited art books. His long association with the *Southwest Review* included writing articles on the development of regional art as well as serving as art editor and illustrating articles by other authors. After retirement from Southern Methodist University, he served as regional director of the Texas Project of the Archives of American Art, Smithsonian Institution. Known as "Mr. B," he is appreciated by generations of art students for his indefatigable efforts to promote and encourage their careers. The focus of all his efforts was art education driven by the impulse to demystify art and make it accessible and understandable.

Above and beyond his extensive experience as an art teacher and museum administrator, Bywaters is known for producing a significant body of paintings, prints, and murals. Just as his public efforts were devoted to the arts of the state, the subject of his paintings grew directly out of the region. Bywaters created a new vocabulary of Texas vernacular in painting while transcending the tired stereotypes of the West. Bywaters is renowned for his contributions in the visual arts toward the realization of an indigenous Texas art. He recorded images of the land and people that solidify in our imagination the strengths and foibles of the region. He chose to stay in Texas to pursue his career far from the established art centers of the world. "It takes a different kind of artist," Bywaters once asserted, "to develop in a place like Texas where there is plenty of space and fewer restrictions, where current fashions don't

influence you." Through his art Bywaters sought a universal expression within a regional context.

Bywaters' contributions as an artist were recognized as early as 1933, when *Art Digest* announced that Bywaters had "arrived." His emergence on the Dallas art scene began after he graduated from Southern Methodist University in 1926 with a degree in comparative literature. His abiding interest in literature may account for the emphasis on narrative in his art work. Following graduation, Bywaters began a two-year, self-styled graduate study of art by traveling throughout France, Spain, Mexico, and New England. By the time he returned to Dallas to establish his career in art, he had acquired a new understanding and broad knowledge of art.

In Dallas in the 1930s Bywaters found that his contemporaries had similar interests in expressing their native region in art. Old college friends, including Lon Tinkle, Henry Nash Smith, and John Chapman, were finding literary means to explore and express the life of the Southwest. Architects David Williams and O'Neil Ford were finding inspiration in early Texas architecture and using indigenous forms and materials in their buildings. The hub of the art community was located around the Dallas Art Institute and the Civic Federation on Alice Street, where the atmosphere was charged with discussions about the importance of creating significant art from one's own environment.

As with other cohesive groups of artists (such as the Eight, led by Robert Henri, or the Ten American Painters, led by Childe Hassam), one artist emerged as leader. Because of his ability to write and his connections with the elite society of Highland Park, Bywaters became a central figure and spokesman for a group of young, energetic painters known as the Dallas Nine, which included Alexandre Hogue, Everett Spruce, Otis Dozier, William Lester, and others.

Bywaters and the other artists in the Dallas Nine were individually concerned with developing a personal idiom rather than contributing to a particular movement; however, as their individual styles developed, a body of work emerged that appeared similar in motif and theme. Finding inspiration in the Texas landscape, their work was characterized stylistically by a cohesive concern for strong compositions, clear light, earthy colors, and local subjects. They employed traditional forms of portraiture, still life, and landscape, but used a new stylistic vocabulary. Although they were painting the same Texas landscapes as their provincial art teachers, this group had a new, clear vision

of the West Texas environment. Excited by French modernism, the young Dallas artists rejected the impressionists' use of vague shapes, loose compositions, and pastel colors. In the wake of the Depression, these artists endeavored to record, examine, and interpret familiar subject matter in purely artistic terms. In doing so, they achieved a regional artistic identity and a national significance. Opposed to provincialism, the members of the Dallas Nine represented a spectrum of progressive tendencies in American art of the 1930s.

Neither Bywaters nor any of the Dallas Nine thought of themselves as provincial or isolated from the larger world of art. Contrary to art historians who view the artists of this region and period as isolated, Bywaters and his colleagues saw their art as part of a national movement. Discovering their region as a means to discover America, they saw themselves as avant-garde in the pursuit of identifying a truly American art, and their views were vindicated by the national recognition afforded them early in their careers. Stylistically and thematically their work paralleled the national movement known as the American Scene.

As nationally recognized practitioners of the regionalist aesthetic, Bywaters and the Dallas artists benefited from the art programs of President Franklin Roosevelt's New Deal for the American people. The New Deal government provided unexpected financial relief to artists across the nation as well as a vehicle for artists to participate in what was believed to be a renaissance of American art. Bywaters and other artists of the Southwest competed in the federal mural competitions during the late 1930s and early 1940s. Bywaters readily accepted the opportunity to earn sizable commissions and to bring his work to a large audience. He completed six mural projects across Texas under the federally sponsored program.

The careers of Bywaters and other members of the Dallas Nine advanced as they participated in local, regional, and national exhibitions. Their paintings were added to museum collections throughout the nation. Members of the group became leading figures in art in the Southwest as teachers and administrators. Their individual painting styles evolved, yet remained grounded in the Texas landscape.

Although Bywaters' career was dedicated to elevating the artistic life of the Southwest, neither his art nor his museum efforts suffered from myopic vision. All his efforts included appreciation of art from diverse cultures and styles. Bywaters taught that quality is something independent of period or style or locale and that enduring quality is the most desirable aspect of art.

As director of the Dallas Museum of Fine Arts, Bywaters practically single-handedly brought the Dallas art scene to national attention. Under his direction, the Dallas Museum of Fine Arts operated with the conscious policy of cultivating regionally oriented art, acquiring the best works available from all periods and styles of art, and establishing a rapport between artists and the public. Bywaters recognized the larger educational possibilities of a museum. In a 1945 article in the *Southwest Review* Bywaters asked whether museums should be "repositories or creative centers." The best art of America, Europe, Asia, Africa, and Mesoamerica was introduced to eager Dallas audiences during Bywaters' twenty-year tenure as director with such ambitious and excellent exhibitions as "Religious Art of the Western World" (1958) and "The Arts of Man" (1962), which were produced with a very small staff.

In the mid-1950s Bywaters faced head-on the insidious accusations that the Dallas Museum of Fine Arts was exhibiting works by "Reds" or "pinko" artists. Symptomatic of the McCarthy era, vigilant superpatriots suspected that abstract art was subversive. The discordant chorus of American Legionnaires and right-wing groups was joined by traditional artists and avocational painters who were displeased with the progressive tenor of the Dallas Museum of Fine Arts. City support for the museum was threatened by the agitators, but Bywaters and the Board of Trustees of the Dallas Art Association clung to the standard of freedom of expression and professionalism. As the smoke of the battle cleared, Bywaters emerged as a champion of artistic freedom.

Because of Bywaters' tireless efforts to promote his colleagues and his integral and significant contributions to the development of cultural institutions in the Southwest, the man Jerry Bywaters cannot be separated from his many contributions and accomplishments. The story of this important regional artist parallels the history of the development and professionalization of art institutions in Texas during his lifetime. What unfolds is the development of an artist who chose to interpret his own region and the significance of that development.

This biography traces the influence of Bywaters and follows his developing aesthetic through his writings, his paintings, and his efforts to promote the art of the Southwest. As an art critic, Bywaters left a permanent record of his thoughts on art, and as museum director, he used the opportunity to see his ideas on art at work in a public institution. In private moments in his painting studio Bywaters found the artistic means to express his vision of the region. In order to present Bywaters' well-articulated ideas about the role of art in

American life, this book considers his paintings and writings together to present a comprehensive examination of his art and aesthetic and to spotlight his lifetime of substantive accomplishments.

Although this biographical study includes a comprehensive description, analysis, and evaluation of Bywaters' numerous paintings, drawings, pastels, watercolors, portraits, and murals, it does not constitute a complete catalogue raisonné of the art of Jerry Bywaters. This study does not chronicle the complete history of twentieth-century art in Texas, but follows a central figure in that history. The issues and events that shaped Bywaters' long and important career as an artist, arts administrator, and arts educator characterized the concerns of a generation.

JERRY BYWATERS

A LIFE IN ART

GROWING UP TEXAN

"The little seven year old son of Mr. and Mrs. P. A. Bywaters, who was seriously injured by falling down a ladder and striking his head against the concrete floor of the basement, was reported to be getting along well yesterday and the parents and friends felt highly encouraged over the symptoms." This report appeared in the Paris, Texas, newspaper on September 10, 1913. The child was Williamson Gerald Bywaters, known by all as Jerry. The accident occurred on the day before Jerry was to begin his third year at the

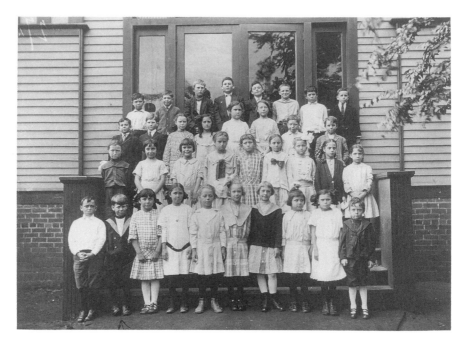

Group school picture, Paris, Texas, 1912. *Jerry Bywaters, age 6, second grade, second from left in first row. The Jerry Bywaters Collection on Art of the Southwest, The Jake and Nancy Hamon Arts Library, Southern Methodist University, Dallas, Texas.*

Fourth Ward Elementary School. The Bywaters were building a new house on Clarksville Street – a sign of their successful wholesale grocery business. The basement had been dug and workmen were installing a heating system. Because the installation of the first mechanized furnace in the neighborhood was of great interest, Jerry tried to climb down the ladder to inspect the work. He missed a step and fell headlong to the floor. He lay there unconscious for a while before he was discovered by a workman. The newspaper reported that "he was moved to the Aikin hospital to undergo an operation." The accident left him blind and paralyzed.[1]

Efforts to relieve a blood clot were successful; his eyesight and mobility soon returned. Jerry was bedridden at home and restrained from any rigorous physical activities for one year. He had a tutor for his school lessons and remained isolated from other children. Wearing a plaster skullcap and bandages to protect his exposed brain, Jerry filled the long days in bed by drawing

pictures. These childhood sketches made with pencil and India ink were important to Jerry's development. Because he was detached from the world beyond his bedroom, the exploration of his inner world grew in significance. For Jerry drawing became more than a way to pass the hours. He discovered art as a means of self-expression. With naive innocence of technique, Jerry learned how to externalize the internal world through art.

The Bywaters family respected art. Hanging in the parlor was a still life of a bouquet of handsomely painted flowers surrounding the Holy Bible opened to a favorite passage. The theorem painting was by Margaret Long Bywaters, Jerry's great-grandmother. Another fine watercolor, completed when she was twelve years old, pictured two doves gracefully sheltering two pink roses. Long after her death in 1892 at the age of sixty-six, Great-grandmother Bywaters' maternal influence on the family remained strong. A survivor, the woman had been determined in will but thin and frail physically. In addition to her duties as a farmer's wife, mother of ten, and tutor, Margaret Bywaters found time to paint watercolors. Her paintings have remained in the family to this day as a reminder that the frontier was tamed by respect for religion, education, and culture. For Jerry his great-grandmother's art represented more than a frivolous pastime.

Most of the Bywaters family were farmers of English descent who had arrived in Texas from Virginia and settled in the northeastern part of the state along the Red River. Sometime after 1847 Jerry's great-grandfather, Alonzo Keys, known as A. K. Bywaters, moved his family to Texas and settled near Roxton in Lamar County. Seven of A. K. and Margaret's children were born in Virginia and three in Texas. The 1860 census lists Bywaters' worth as $2,000.00, which is indicative of his success as a farmer. Roxton was a small town that served as a supply point for farmers in the area long before the Santa Fe Railroad reached the town in 1887.

Their oldest son, Ashburn Hunter Bywaters, was born in 1851 and remained in Roxton as a farmer and proprietor of a dry goods store.[2] He married Alice P. Shelton in Lamar County on October 31, 1872. They had two sons, Porter Ashburn (born 1877) and Karl Hunter (born 1885), and two daughters, Bernie (born 1892) and Myrle (born 1883). Porter Ashburn attended Bingham Military School in Ashville, North Carolina, and later worked at a small grocery store on the square in Honey Grove, located in Fannin County. Honey Grove was an active small town with several churches, schools, hotels, gristmills, and

a weekly newspaper. Porter Ashburn married the grocer's daughter, Hattie Williamson. After learning the grocery business, they moved to the larger town of Paris, located about twenty miles north of Honey Grove. They lived in Paris with their two young sons, Porter Junior and Jerry. The younger son, Jerry, was born May 21, 1906.

Porter began the Paris Wholesale Grocery Company in 1908 with the financial assistance of his grandfather and father. He bought produce from relatives and other local farmers and sold it to grocery stores in the cities of Dallas and Wichita Falls. The Bywaters family was a standard of respectability as upstanding citizens in the Paris community and members of the First Methodist Church. Porter Ashburn Bywaters was a vigorous man who enjoyed the outdoors. Father and sons often went on camping trips to the beach or mountains when Jerry had recovered from the accident. Hattie Bywaters was known for her cooking, and Jerry remembered her as a "good seamstress who wore nice clothes and had a good sense of color."[3]

Because the grocery business was successful, the Bywaters family assumed that the next generation would eventually take over the operations. Porter Junior was expected to help his father with crating and loading boxes of lettuce and apples. Because of the accident, Jerry was protected from strenuous work and encouraged to seek quiet activities like reading or drawing.

Jerry regularly visited relatives in Honey Grove. An unmarried aunt, Effie Williamson, lived with Grandfather Jim Williamson. It was Effie who gave Jerry his first painting lessons. She had attended Kidd-Key College in nearby Sherman, a woman's college that offered art classes to provide a degree of sophistication and polish. Her instruction had consisted of drawing from plaster casts and painting still lifes of flowers or fruit. Jerry discovered his Aunt Effie's art supplies stored in the attic, where she had carefully put them away after her graduation. At Jerry's insistence, Effie began to show him how to use charcoal, watercolor, and oil paints. She set up still lifes for him to paint and gently instructed him on composition and color.

Jerry's ability to recreate a likeness of nature on paper was highly praised by family and friends. With their encouragement and the simple lessons from Aunt Effie, Jerry's watercolor still lifes were considered as fine as the ones by his great-grandmother. Jerry also drew portraits of family members and painted pictures of his house. There was no formal art training available in the small Texas town of Paris in 1916, but Jerry developed sufficient proficiency in drawing to win a prize in a local competition for a World War I

poster. Jerry's only direct connection with the larger world of art occurred when the family took the short train trip to Dallas each year in October to attend the State Fair. At the fair's annual art exhibition in the Public Art Building Jerry and his family delighted in the paintings of the Texas landscape filled with the state flower, the bluebonnet.

In 1917, the year Jerry graduated from the Fourth Ward Elementary School, the family decided to move to Dallas. The move was prompted by growth in the wholesale grocery business. The Paris Wholesale Grocery Company had expanded into a large corporation operating eight branches in Texas and Oklahoma; company headquarters was moved to Dallas and Porter Ashburn served as president. Jerry and Porter Junior initially resisted the move, but their mother convinced them of the advantages of moving to the city. The Bywaters wanted their sons to have access to a better education in order to prepare them for college. They bought a house at 3708 Stratford in Highland Park. This was such a new residential area that Porter planted sweet potatoes on the vacant lot next door. The boys began attending Armstrong Public School, and the family became active in the First Methodist Church. Jerry enjoyed Sunday School and appreciated the special attention given him by his teachers, who believed that his survival from the accident was a miracle.

In 1919 the Bywaters boys transferred to a private high school, Terrell Preparatory School for Boys. Located in the Swiss Avenue district, Terrell was considered the best school for the Dallas elite. Porter and Jerry regarded the experience of a private school to be "tony." Their parents were fulfilling their desire to provide the best education available for their sons. Highland Park High School was nearer their house, but it was new and not yet fully accredited. The boys quickly immersed themselves in Terrell activities; Porter played sports, and Jerry served as art editor for the newspaper and drew illustrations for the school annual. Jerry also took tennis lessons and excelled in the sport. Although he never suffered any long-term effects of his childhood accident, he avoided playing any contact sports. Terrell was academically rigorous, emphasizing literature, mathematics, and natural science.

Porter Junior graduated from Terrell in 1921 and entered the University of Texas in Austin that fall. He became president of Sigma Alpha Epsilon in his senior year. After graduating from Terrell in 1922, Jerry planned on attending the University of Texas as well. However, during his first week in Austin, his arm became badly infected when he was vaccinated for smallpox, and he returned home to Dallas. That fall he entered Southern Methodist Univer-

sity, which was located just a few blocks from his house. He enjoyed fraternity life and, like his brother, became president of the Sigma Alpha Epsilon fraternity. Jerry also became captain of the tennis team and was elected president of the junior class.[4]

Jerry declared comparative literature as his major field of study and successfully managed to combine his interest in writing and art in his extracurricular activities. He wrote a regular column for the campus newspaper titled "Have You Had Your Irony Today?" As editor of the *Rotunda*, the college yearbook, Jerry developed his skills as a manager of a large project and became a stickler for details. He also worked his way up from illustrator to editor of the *Crimson Colt*, a student humor magazine that reflected nationwide trends on college campuses. The *Crimson Colt* was filled with corny jokes about college life, self-conscious spoofs on fraternities, and popular catchwords of the day. As editor, Jerry wrote, "The clean and spontaneous comic . . . has proven to be the best medium through which the peculiar phenomenon of the college mind at work and play may be observed."[5] Through his experience with these student publications, he learned the various aspects of publishing, including writing, copy editing, advertising, layout, graphics, typesetting, and printing. His interest in writing and appreciation of literature expanded to include how the words looked on the page.

Jerry's mentor was the erudite and energetic John H. McGinnis, who taught literature at SMU and edited the *Southwest Review*. The offices of the literary publication were located in the basement of Dallas Hall on the SMU campus. A remarkable teacher, McGinnis would single out his brightest students to participate in the publication of the journal. Jerry Bywaters, along with Lon Tinkle, Henry Nash Smith, and John Chapman, worked on the magazine as students and with McGinnis' encouragement continued their association with the magazine long after graduation from SMU. McGinnis was also editor for the weekly book page of the *Dallas Morning News* and often encouraged his students to publish book reviews and feature articles. With McGinnis' encouragement, Bywaters sought to establish himself as a serious writer and wrote a lengthy article for the March 14, 1926, issue of the *Dallas Morning News*. Entitled "Like Thoreau, Philosopher of Texas Lives 'By Side of the Road, Watching World Go By,'" the article described a local philosopher living in Denton named Robert H. Hoffman. This curious article revealed Bywaters' early interest in literature and writing as well as his

burgeoning interest in the local point of view. The newspaper article was illustrated by a line drawing of Hoffman that was also by Bywaters.

During his senior year Jerry took a painting course as an elective. SMU offered no degree in art, and its few art classes had been offered only since 1916. The art department was directed by Olive Donaldson, a genteel artist of still lifes and pastoral landscapes. In the era of flappers "Miss Donaldson" still wore high-topped shoes and floor-length dark dresses, and kept her hair tied back in a bun. Students respected her stern manner and serious appreciation of art. She was also known for a garden of native Texas plants that she tended on the SMU campus and for her private painting studio, which was located in the cupola of the dome of the main building, Dallas Hall. Her art classes met in the classroom just off the dome, and it was considered very bohemian for the young art students to climb to the top of the main building for painting classes. Later, art classes met in "the Art Shack," a one-story clapboard building with sash windows that was built to train soldiers during World War I. Although Jerry enjoyed drawing and completed some fine illustrations, he never considered art as a possible career, for, as he recalled later, "it still was not thought to be a man's occupation."[6] The last semester of his senior year Jerry studied painting with assistant professor Ralph Rountree. The class was based on the academic tradition of painting from still lifes. For the first time in his college career Jerry began to take art seriously and to see the possibility of becoming a professional artist.

Perhaps Bywaters entertained the idea of living and working as a professional artist from the time he first saw the members of the art colony of Santa Fe. At age seventy Bywaters recalled,

As a youngster the first "real" artists I remember meeting were in Santa Fe, New Mexico, in the lobby of the La Fonda Hotel in the 1920's. My family usually went to either New Mexico or Colorado on vacations and to escape the late summer Dallas heat waves. The La Fonda was the place to stay, a deluxe pueblo style Harvey hostelry with large examples of Indian weaving as rugs, usually with Indian silversmiths or weavers in the patio, and often in the late afternoons members of the local colony of artists or authors would appear as involuntary tourist attractions. Large paintings by Santa Fe and Taos artists hung in the lobby – Indians riding in golden aspen groves (by Cassidy or Phillips); or Indians dancing the green corn dance or

the deer dance (by Berninghaus); or penitentes carrying crosses into the reddish Sangre de Cristo mountains (by Blumenschein). Such paintings inflamed my youthful desire to be a painter[7]

No doubt Bywaters also associated the pleasant patio and congenial company of La Fonda with the life of an artist.

Porter Junior had no interest in artists or art. He graduated from the University of Texas with a major in business administration and immediately returned to Dallas to go to work for his father. His senior paper, "The Organization and Management of the Bywaters Dry Goods Company," described the growth and new direction of the family business.[8] In March 1923 Porter Ashburn and Karl Hunter Bywaters organized the Bywaters Dry Goods Company after buying the assets of a bankrupt dry goods wholesaler. By the time Porter Junior joined the family business in 1925, sales were amounting to over one million dollars a year. Dallas was becoming a market center for the Southwest, and the Bywaters Dry Goods Company offered many exclusive lines in "Notions, Novelties, Holiday and Variety Goods, Fancy Cotton and Silk Piece Goods, Underwear, Furnishings and Hosiery." Their advertising promised, "If it is new – we have it."

Their father had hoped that Jerry would also join the family firm. He was disturbed and disappointed by his younger son's desire to become an artist because he considered art as an occupation to be at best economically perilous and at worst socially unacceptable.

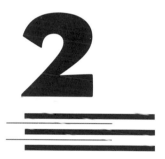

ON BECOMING AN ARTIST

At the age of twenty Jerry Bywaters was tall, thin, amiable, and ambitious. He graduated from Southern Methodist University in December 1926 with an A.B. in comparative literature, and the following spring he carried on an internal debate about whether to become a writer or a painter. He spent time browsing through the art books in the SMU library. There he discovered the *Dial*, a magazine of literary criticism that often included articles about contemporary European art. Through the *Dial* Bywaters was in-

troduced to the revolutionary works of Picasso, Braque, and Matisse in small reproductions. These astonishing works of art were unlike anything Bywaters had seen in Dallas. His library investigations generated enough excitement for the larger world of art that he began to formulate ideas about just how to become an artist. Bywaters accepted the general belief that a trip to Europe was necessary for anyone hoping to be taken seriously as an artist and that an apprenticeship with a practicing artist of high standing was mandatory for an aspiring artist.

In the late 1920s Dallas had several well-established art schools and institutions, and a few entrenched patrons. Art activities in Dallas centered on art classes for beginners and exhibitions of works by established artists. There was only one small art supply store on Elm Street in downtown Dallas, and there was no place for an aspiring young artist such as Bywaters to exhibit his work or view the work of contemporary artists. At a time when Bywaters wished to pursue his interest in modern art, there was no opportunity to study, view, or even discuss European modernism in conservative Dallas.

There were, however, competent art teachers in Dallas as early as 1887, when Richard Lentz immigrated from Germany and began teaching art. One of the first art schools was founded in Dallas in 1912 by Vivian Louise Aunspaugh, a Paris Academy–trained artist. She had attended the New York Art Students' League, where she was a student of Richard Twatchman, and she had studied at the Carlarossi School in Paris. The Aunspaugh School of Art, which consisted of one room with an open gas heater, was the first in the Southwest to use a nude model. Only boys were enrolled in the life drawing classes because Dallas was much too provincial to allow girls to draw a nude male. Girls were partitioned off and allowed to paint china. In her instruction of how to draw the figure, Aunspaugh would point at the model with a long stick. True to the French tradition, she considered the ability to draw the human figure the basis for all art. She not only taught in her own school in Dallas but also conducted outdoor sketching camps in August on the Texas Gulf Coast. Although several of Bywaters' friends studied with Aunspaugh, he did not take advantage of her classes because he believed his training at SMU had propelled him beyond the basics of classical drawing.

The most popular art school in Dallas was the sole proprietorship of Frank Reaugh, who came to Dallas in 1890 and continued to teach and paint for fifty years. Born in Illinois, he moved with his family in 1876 to a ranch near Terrell, Texas. In 1884 he studied at the St. Louis School of Fine Arts and

later at the Academy Julien in Paris. In Dallas Reaugh first opened a studio on the second floor of the Central Bank Building "for painting and the instruction of those interested in the Fine Arts."[1] Then in 1929 he built a studio called El Sibil in Oak Cliff and continued teaching art classes there. Loyal students circulated around Reaugh and formed the Frank Reaugh Art Club. By the 1930s the club included over 125 members who held art exhibitions regularly at the YWCA in Dallas. Although Bywaters never took classes with Frank Reaugh, he long admired the older artist's finely crafted pastels of the Texas landscape.

The most important art institution in Dallas was the Dallas Art Students League, which got its start in 1893 when Robert Onderdonk taught the first formal art classes in the area. In 1900 a special room in the Carnegie Public Library was established as a public art gallery. An art committee of the library presented regularly changing exhibitions. So much interest was generated by the Art Room that in 1903 the Dallas Art Association was founded with eighty charter members committed to promoting art education through exhibitions, lectures, classes, and the regular purchase of works of art. The association's first home was in the Phoenix Building. By 1909 the collection proudly included a painting by Childe Hassam. In March of that year the Dallas Art Association gave the art collection to the City of Dallas in exchange for operating funds of thirty-two dollars per year. Memberships of five dollars per year also contributed to the association's fund. The works were transported from the old Art Room in the library to the new Public Art Gallery on the State Fair grounds. The exhibition space was one large octagonal room that had ample natural light from the skylights in the dome and several small galleries radiating from the central exhibition hall. The Public Art Gallery presented year-round art exhibitions that were free to the public, and it was also the site of the annual State Fair art exhibitions. The Public Art Gallery served as a foundation for the burgeoning art activities in Dallas.

As early as 1886 there were exhibitions of art at the State Fair of Texas each October in Dallas. These exhibitions, arranged by socialite Sallie Griffis Meyer (Mrs. George K. Meyer), were traditionally ambitious undertakings that presented broad surveys of art. Meyer initiated the policy of including Dallas artists in the shows. For over twenty years she assembled exhibitions for the fair and also served as president and acting director of the Dallas Art Association from 1909 to 1926. The Bywaters family never missed the art exhibitions, which grew larger and grander each year.

Meyer was also responsible for organizing and presenting other special art exhibitions for the Dallas elite under the auspices of the Dallas Art Association. The first was held in 1915 at the Adolphus Hotel; because it was so successful, the exhibition became an annual event from 1919 to 1927. The openings for these exhibitions were gala social affairs with elaborate dinner dances in the grand ballrooms of the city's leading hotels, the Adolphus and the Stoneleigh Court. Attendance figures were recorded at over five thousand for these three-day exhibitions of works collected in the art galleries of the East.

In the 1920s there were also such sensational art events as the Texas Wild-Flower Art Exhibition, sponsored by oil man Edgar B. Davis. These annual exhibitions brought national attention to Texas when Davis offered a cash award of five thousand dollars in a national competition for one painting that could depict the "beauty of the Texas flowers."[2] The competitive exhibitions were held in San Antonio at the Witte Museum. Artists all over Texas were keenly aware of the great interest stirred by the exhibitions and lavish prize money. Bywaters was too young and inexperienced to participate in such art events, but their presence in the community was important.

Despite the activities of art societies, schools, and annual exhibitions, there was little opportunity in Dallas to view works of important American or European art. Quality in art was not always clearly defined. Along with occasional exhibitions of minor European masters, there were frequent exhibitions of carved soap sculpture. The Highland Park Society of Arts was founded in 1925 under the leadership of Mrs. A. H. Bailey, who operated an art gallery above the City Hall, located on Turtle Creek in the elite incorporated community of Highland Park. The gallery featured the work of local avocational artists as well as shows of works by artists of regional renown. Without benefit of a professional museum or commercial art galleries, art in Dallas in the early 1920s was the domain of the social elite and amateur artists. Bywaters faced the challenge of entering the world of art in a city where art was reserved as the property and concern of high society. Newspaper articles about art appeared every Sunday in the society section, just after the bridal announcements and the bridge club news. Art patronage was solely the province of wealthy matrons who ventured to New York to purchase works by second-rate European artists.

In 1927 Bywaters decided to go to Europe to see the old masters' work first hand and possibly study with a contemporary artist. He made plans to travel with his SMU painting instructor, Ralph Rountree.[3] An experienced traveler,

Rountree had spent three years painting and traveling in the Orient. His work was highly praised by the local art critic for the *Dallas Morning News*, and he was known not only as an artist but also as a philosopher and poet.[4] Rountree was prominent enough in the art community to rate an announcement in the newspaper that he would "leave early in June for a summer of study and travel in Europe."[5] There was no mention of his younger companion, Jerry Bywaters.

Although Bywaters' father worried that an artist in the family would threaten respectability, he allowed his son to make the necessary trip to Europe to study art. The trip was made possible by a gift from his grandmother, Alice Bywaters, who gave her four grandsons one thousand dollars each upon completion of their college degree. The gift was both a reward and an impetus to seek whatever training or travel might be necessary to make their chosen careers successful. Jerry's anxious but supportive family sent him off by train to New York. On June 4, 1927, Jerry sailed for Europe aboard the *S.S. Pennland* with Ralph Rountree.

While on board, Bywaters filled the time by reading Ernest Hemingway's *The Sun Also Rises* and writing a series of articles for the *Dallas Morning News* based on his own adventures. Bywaters had arranged with the amusements editor to write and illustrate four feature articles for the Sunday edition. This project provided an additional way for Bywaters to finance the trip. "Gay Gotham Welcomes Dallas Lad," published July 24, 1927, the first in the series, described his adventures in New York, including a visit to Chinatown with some unnamed artist friends. The tone of the article is light hearted and the writing style breezy. Bywaters focused on amusing incidents that seem too exaggerated to be factual. The article is accompanied by a cartoon illustration of Bywaters on the dock about to board the ship for Europe; in the confusion of the crowd a fat lady hugs and kisses him instead of her son.

Rountree and Bywaters traveled third class. Their cabin was cramped and the voyage rough. In "Trials of an Amateur Sailor," dated June 6 but published August 4, 1927, Bywaters described in a humorous way his unpleasant ordeal with seasickness. The ship docked in England, but the Texas travel companions immediately set out for Paris. Bywaters later recalled, "Since the Left Bank in Paris was then Mecca for most venturing young American students and since my literary idol Ernest Hemingway might also be visible there, Paris was my first destination." Bywaters' plan was to learn how to be a painter by painting and by adopting the look and demeanor of Parisian artists.

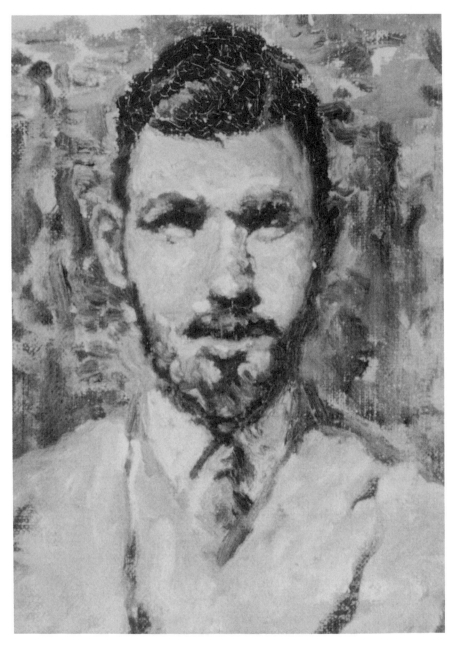

Self-Portrait Sketch with Beard, *Paris, 1927. Oil on canvas. 12 × 9 in.*
Collection of Jerry Bywaters Cochran, Dallas, Texas.

He remembered, "As soon as possible I grew a scraggly beard and walked the streets, night and day, painting some small pictures reflecting influences from Degas through Monet, but giving me some satisfaction."[6] His *Self-Portrait Sketch with Beard*, painted soon after he arrived in Paris, confirmed that Bywaters was becoming the bearded bohemian his father had feared.

This 1927 self-portrait was painted with the light colors and loaded brush of the impressionist style. Bywaters also completed another small painting, *L'Arc de Triomphe, Paris*. The composition is solid, but the forms evaporate with the fluid application of paint and the soft, pastel colors, much like the work of Claude Monet. Thus, Bywaters began by painting in an attenuated form of the impressionist style. In contrast, Rountree employed a tight realism of solid forms and polished surfaces.

Whatever the source of the style, Bywaters felt very avant-garde, painting in *plein air* the sites of Paris that thousands of other artists and tourists had admired. Bywaters professed to prefer a self-paced study of painting rather than attend classes at an academy. The two Texans visited museums, inspecting and discussing the works of the European masters. The treasures of the Louvre opened Bywaters' eyes to the art of Georges de la Tour, Francois Millet, Edouard Manet, Edgar Degas, Paul Cezanne, and others. These experiences were the foundation upon which Bywaters began to formulate ideas about art and about becoming an artist.

Urged on by Hemingway's descriptions of Spain, Bywaters traveled south. His next article, "Seeing Sunny Spain Is Hard on the Feet," appeared in the *Dallas Morning News* on November 13, 1927. It describes the artists' twelve-hour trip by train from Paris to the Spanish border town of Irun. Bywaters wrote, "This is the letter in which I am supposed to arrive in Spain, see one magnificent town after another and openly declare each to be more beautiful than the one before . . . If you want that sort of description, I'm afraid you'll be compelled to send someone else to Spain, because my philosophy is different" Bywaters did not provide any typical travel information nor any description of art or art experiences. In an open and chatty style he described picaresque adventures with himself as the main character. Perhaps he was trying to duplicate both Hemingway's characters and literary style. The article described traveling from Irun to San Sebastian and staying on the beach at Concha; here, Bywaters declared, "you will see two funny looking people asleep in their clothes on the sand. That is Ralph and I." One can only imagine the horror that struck Bywaters' father as he read the account in

L'Arc de Triomphe, *Paris, 1927. Oil on canvas. 9 × 13 in. Collection of Jerry Bywaters Cochran, Dallas, Texas.*

the Sunday paper. Dressed like Spanish peasants and traveling third class, the two artists traveled over the Pyrenees by train to Burgos and by a horse-drawn carriage to the Hotel Norte y Londres. "There," Bywaters wrote dramatically, "we found the world had come to an end."

Arriving during a festival and amid a rainstorm, the foreign travelers found Burgos inhospitable, but they did stay for a while to paint. Bywaters completed *Cathedral in Burgos, Spain.* As is typical of a young artist, Bywaters had not yet developed his own style: he rapidly consumed new techniques and liberally borrowed those that suited his fancy. The small oil painting of the cathedral is painted in a pointillist manner of the postimpressionists.

From Burgos they traveled to Segovia. Because art supplies were difficult to purchase in Spain, the two painters had brought everything they needed from Paris. The train trips in Spain, therefore, were made more difficult by loading several stretched canvases on board along with two suitcases and a trunk. Rountree provided a visual clue about the trip when he produced a painting entitled *Knights of the Open Road.* The painting presents a double portrait of Bywaters and a Spanish man who consented to pose for the artist.

The Spaniard, wearing traditional dress, is in the foreground, leaning on a walking stick and looking straight out. He appears much older and more weathered than the young bearded Bywaters, who is pictured in profile. The figure of Bywaters is the expression of energy and determination to travel the rocky road. The Spanish model must have been a willing subject because Bywaters also painted him wearing the same beret and peasant shirt and clinging to the same stick. A comparison of the two paintings by teacher and student is instructive. The two artists often painted the same subjects but with very different stylistic approaches and results. Rountree included a background of the hills of the Spanish landscape; Bywaters, however, presented the model as though in a studio with the figure projected with harsh light against a plain wall. Both paintings have romantic titles. Rountree's *Knights of the Open Road* may have been how he and Bywaters imagined themselves. The title of Bywaters' portrait of the Spaniard, *Beggar in the Sunlight*, may be a reference to the Baroque paintings of beggars that Bywaters admired in the Spanish museums.

Rountree and Bywaters stayed in Segovia for about a month with a family in a pension, where they set up a temporary studio and painted several portraits of the local characters and many views of the surrounding landscape. Most of this work is now lost or destroyed. In a strong portrait of a ninety-three-year-old woman of Segovia, *Old Spanish Woman*, Bywaters pictured a stern woman who looks much like a mountain with a craggy face and hands of granite. He also painted *Church in Segovia*, which pictured the famous hilltop town in a fine composition that contrasts the geometric architecture of white walls and red tile roofs against a blue sky filled with large white clouds.

Bywaters and Rountree continued on to Cordova, Seville, Granada, and Madrid. After spending the night inside the Alhambra, lounging on the floor like the original fourteenth-century residents and looking up at the scalloped arches and honeycombed ceilings, Bywaters painted an interior court of the Alhambra. The small oil catches all the exquisite light and ornamental pattern of the famous Islamic architecture. Bywaters found little time to write, but while in Madrid he completed the last of his travel articles, "Bullfights Are Fine If You Like Them" published February 16, 1928. He not only saw the bullfights but also engaged in a "lengthy study of the Prado's treasures." The wall-size history paintings of Velazquez, the large tapestry cartoons of Goya, and the realism of Ribera impressed Bywaters.

In early September Rountree returned to Dallas to resume his teaching duties at Southern Methodist University. Bywaters lingered in Spain, where the terrain reminded him of parts of West Texas, and then traveled on to Paris before returning home. The European trip was significant to the careers of both artists. When Rountree returned, he had an exhibition of the works he had produced on the trip. The Highland Park Art Gallery in Dallas showed thirty oils and pastels by Rountree in late April 1928. These works included landscapes, portraits, street scenes, and still lifes painted during the summer in France and Spain.[7] The works that Bywaters completed on the trip brought him his first public recognition as an artist. On January 29, 1928, the *Dallas Times Herald* proclaimed Bywaters as a new discovery in Dallas art circles. Describing some of Bywaters' works, the local art critic wrote, "Another of his experiments was a quick sketch of a little child who lived in the pension where the artists were staying. She had the olive skin of the Latin peoples and he utilized the natural color of the wood with but a thin film of pigment over it, to produce an unique and altogether successful effect."[8] Bywaters' painting *Old Spanish Woman* was highlighted in the article as one of his best works: "The artist has succeeded in giving her skin the dried-apple appearance which it undoubtedly had. The background is descriptive of the life of the town including a glimpse of the aqueduct."

After returning to Dallas, Bywaters immediately enrolled in art classes at the newly founded Dallas Art Institute. In January 1926, the Dallas Art Institute opened on the second and third floors of 1215½ Main Street. The institute was founded by Olin Herman Travis, who had returned to his native state after graduating from the Chicago Art Institute. At the opening of the art school Travis told the *Dallas Morning News*, "The demand for an art school in keeping with the industrial, cultural, and artistic development has grown imperative . . . Dallas is a publishing center and any school organized would be incomplete without being in a position to provide instruction of the highest order in the various branches of illustration and advertising art."[9] At a time when Texas colleges and universities rarely offered art classes, Travis modeled his professional art school after the famous Chicago Art Institute. About thirty full-time students attended morning classes in life drawing and afternoon classes in painting. Travis's teaching methods were based on general instruction and individual criticism. Emphasis was on painting from nature. In the afternoon the students went outside to sketch the landscape around Turtle Creek and then returned to the studio to paint in artificial light. Olin Travis

taught landscape painting, portraiture, composition, and art history. Kathryn Hail Travis taught still-life painting. It is not surprising that Bywaters quickly allied himself with the Dallas Art Institute, which offered the only serious art classes in the city. At that time the institute offered classes in figure drawing, painting, portraiture, landscape, pastel, and still life as well as in fashion, poster, and book-cover design.

The Dallas Art Institute enjoyed a progressive image. The school was praised by Robert Vonnoh, a successful portrait painter who had exhibited at the National Academy. Vonnoh announced to an eager Dallas audience, "In your Dallas Art Institute . . . you have esthetic forcing beds from which will come some of the great artists of tomorrow."[10] This was reason enough to become serious about taking art classes at the institute. It was the institute's ability to offer both fine arts and commercial art that interested Bywaters, who was seeking the best training available in the traditional modes of art and graphic design.

In October 1927 Bywaters was occupied with art classes at the institute and also fulfilling family and social obligations in preparation for his brother's wedding in January. The fact that the bride's full-length picture appeared on the front page of the society section of the *Dallas Morning News* was sufficient proof that the Bywaters name was respected in Highland Park society.[11] It seems that the family's social standing was not diminished by the younger son's desire to be a painter.

That fall Bywaters had time to assimilate what he had learned about art on his trip to Europe and grew anxious to leave the confines of Dallas. While in Spain, he had heard about an astonishing art movement in Mexico, where artists were painting murals with revolutionary themes on public walls. Bywaters wanted to see the magnificent murals by Diego Rivera that he had read about in *Mexican Folkways*. Rivera's fresco murals depicting the history of Mexico in the Education Building in Mexico City were hailed by the magazine as "one of the few excitements in recent times in the international art world."[12] Published in Mexico City and written in both English and Spanish, *Mexican Folkways* focused on the art, architecture, culture, and people of Mexico.[13] Diego Rivera, the art editor of the magazine, used it to promote his art and his revolutionary aesthetic. Bywaters was fascinated by the look and attitude of the magazine, which published photographs by Tina Modotti and focused on the pulse of a region. The urge to see the most avant-garde development in art firsthand was irresistible for this young artist.

In March 1928 Bywaters traveled to Mexico. He later described the trip as an adventure: "I made the long and unpredictable train trip, with carloads of soldiers at the front and rear to make a show of foiling bandits in the mountain passes."[14] After he arrived safely in Mexico City, Bywaters checked into his hotel and immediately set out to meet the artists who were painting on walls of government buildings. The emphasis of his trip was not on his own painting and sketching but on learning what he could about the mural renaissance.

Bywaters later recalled, "When I first met him (Rivera), he was in the first court (of the Secretariat of Public Education, Court of Labor), working with a big crew on very large scaled things and doing an amazing job. Rivera, even then, was a big man physically, and he would work maybe twelve hours at a stretch without coming down from the scaffolding."[15] Within two weeks Bywaters not only met and talked with Diego Rivera but was also introduced to other muralists, including Jean Charlot, Maximo Pacheco, and Fermin Revueltas. He was also thrilled to meet Tina Modotti and the art historian René d'Harnoncourt. Bywaters learned the lessons of the Mexican mural renaissance. The Mexican artists' assertion of their national, cultural, and political identity was a reflection of the Mexican political and social revolution that began in 1910. The band of artists issued a manifesto in 1922 that repudiated easel painting as the product of and for aristocracy and promoted a program of monumental mural works accessible to all levels of society. The mural movement was supported by the Mexican government, which promoted the celebration of the revolution. Grandiose paintings on public walls dramatically expounded nationalistic themes in an expressive but realistic painting style. Bywaters found the ideas and the art exciting.

When Bywaters returned to Dallas, he wrote two articles about Diego Rivera. In the first, for the *Dallas Morning News*, Bywaters outlined the basic philosophy and described the painting technique of Rivera. In this overview of a "revolutionary art movement," Bywaters predicted that "in the next decade or two America will be awakened to the importance of the art trend in Mexico."[16] Bywaters made bold claims for the mural movement. In an effort to bring the message of the muralists to America, Bywaters wrote, "Above all, he [Rivera] believes art should be 'popular' and placed within view of all Mexicans." Bywaters hinted at the political motivation of the murals as he described the substance of a regional point of view: "With flamboyant, almost

Russian, color and ironical insight he has created design and content representative of Mexico."

Whereas the newspaper article briefly described the muralist's technique and style, the article that Bywaters wrote for the July 1928 issue of the *Southwest Review* included a well-developed statement of Bywaters' reaction to this new aesthetic. "Diego Rivera and Mexican Popular Art" summarized what Bywaters had learned from Rivera. Bywaters was impressed by the Mexican's radical proclamation of independence from the art of Europe. Bywaters was aware that Rivera had studied in Paris and worked in a cubist style but credited Rivera for denouncing French modernism and going beyond it to form a revolutionary Mexican art. Rivera promoted and Bywaters readily accepted the denunciation of elitist art and the creation of popular art. Bywaters applied this philosophy to American art, proclaiming, "These assertions, though vitriolic, contain, one must admit, the grain of truth which American artists know yet cannot express in public. For art in America is certainly 'cultural' and not 'popular.'" Bywaters asserted, "Diego Rivera has taught me a lesson I had not learned elsewhere in Europe or America. I know now that art, to be significant, must be a reflection of life; that it must be a part of a people's thought. If I had Rivera's insight, I might have learned my lesson by sitting and studying my dog or by looking at a tree in the backyard."[17] These ideas became a firm foundation upon which Bywaters built his personal aesthetic.

Bywaters did not learn the lessons of regionalism quickly enough in his own backyard in Dallas. Believing that he lacked the technical proficiency necessary to create significant works of art, Bywaters convinced his family that he needed further training in order to achieve the status of a professional artist. Bywaters had demonstrated to his parents through his published articles that he could combine a career of art and writing. They were gradually realizing that their younger son was not going to join the family business, and they agreed to support his endeavor to become an artist.

At this time Bywaters met Robert Vonnoh, who was showing his work at the Highland Park Art Gallery. A well-respected artist with a national reputation, Vonnoh was a sterling example of a successful artist for young Bywaters to emulate. Among the earliest American impressionists, Vonnoh was a noted portrait painter and a former teacher at the Pennsylvania Academy of Fine Arts. He had exhibited at the National Academy of Design, and a por-

trait by Vonnoh was a coveted status symbol in Dallas society. At Vonnoh's suggestion Bywaters decided to travel to the art colony of Old Lyme, Connecticut, for the summer. Dallas artists also had another very close tie with Old Lyme because artist Lucien Abrams, son of a distinguished Dallas family, summered there.

The society pages of the Dallas newspapers were beginning to take note of Bywaters as a young roving artist. On June 10, 1928, the *Dallas Morning News* announced that "Gerald Bywaters and Ralph Rountree are two local painters who plan a summer in the east. The former at the Old Lyme Colony in Connecticut and the latter at the Philadelphia Academy of Art." Bywaters traveled by train to New York and then purchased a used automobile to proceed to Old Lyme. He arrived there alone, but his letter of introduction from Robert Vonnoh ushered him into the artists' fold. Like many other artists since the turn of the century, Bywaters roomed at Florence Griswold's spacious boarding house. The art colony had its beginning in 1903 when painter Childe Hassam began regular summer stays at the Griswold house and other New York artists came to escape urban life. Old Lyme became known as a summer retreat for American impressionist artists and was one of the leading regional art centers. According to the American art historian William Gerdts, "By the beginning of this century Impressionism in one form or another had become the prevailing aesthetic throughout most of America. Regional 'schools' of art arose for the first time, and they were often Impressionist dominated."[18] For Gerdts two principal regional centers in the East were "especially significant for the quality of their work and the importance of their artists: the Boston School and the school in Old Lyme, Connecticut. They are distinct in numerous ways. The Old Lyme painters were primarily landscapists; the dominant trend in Boston was toward the figure" (ibid.). By the time Bywaters arrived in 1928, Old Lyme as an art colony had lost much of its luster. The Lyme Art Association had erected a permanent art gallery in 1921 to display the work of its members, but the leading exponent of American impressionism, Childe Hassam, had discontinued exhibiting with the group in 1912. And, as the number of summer visitors increased, the aesthetic impact of the art colony decreased.

For Bywaters, summer in Connecticut was a welcomed respite from the Texas heat, and the congenial atmosphere did not suggest that the colony was dying in its artistic influence. He was surprised to discover a copy of the July issue of the *Southwest Review* containing his article on Rivera on the parlor

table of the Griswold house. Bywaters' fame as a writer had preceded him. He became friends with several of the regulars there at the colony. Bruce Crane and William S. Robinson often accompanied Bywaters in the used car on tours of the New England countryside. On one occasion they traveled to New York City, where Crane and Robinson treated their young companion to the city's most popular artists' clubs, the Salmugundi and the Lotus Club, just off Fifth Avenue. Ralph Rountree also came to Old Lyme for a week to visit Bywaters and paint. The September 23 *Dallas Morning News* reported that Rountree "was the guest of Gerald Bywaters, Dallas painter, who has maintained a studio there this past summer."

Like every other artist that summer, Bywaters painted the local landscape and scenes in and around the village of Old Lyme. He painted the facade of Griswold's large Georgian house as well as the small cottage that is the subject of *House at Old Lyme.* These small paintings are radiant with the impressionist light and color of Childe Hassam. It is curious that even after assimilating the radical revelations of the Mexican muralists, Bywaters sought the instruction of American impressionists. At the time he did not view the impressionists as importers of a European style, but he would later change his mind about that. The primary lesson of Bywaters' experience at Old Lyme was not in the technical aspects of painting, however, but in the realization that regional expression could achieve national prominence.

As planned, with the approval of his parents, Bywaters stayed in the East the fall of 1928 to attend the Art Students' League in New York City.[19] He settled in to play the part of an aspiring artist in New York by renting a tiny third-floor walk-up apartment on Ninth Avenue near Fifty-Seventh Street. The only window overlooked the elevated. Bywaters tolerated the deafening sound of clanking trains because he liked the inexpensive rent and the view from the fire escape from which he often painted. A work from this period entitled *Night in New York* is a street scene painted with dark, muddy colors. Bywaters' sudden shift in palette from the pastels of Old Lyme to the browns of New York can be attributed not only to his grim surroundings but also to the influence of his teachers and fellow students at the league.

The Art Students' League, located nearby at 215 West 57th, was an unconventional institution that had no set term, no entrance exam, no prescribed curriculum, and issued no diploma. The school was perfect for Bywaters, who had little formal art training and did not seek an academic education. The philosophy of the league was based on the understanding that artists like

Michelangelo and Matisse were not judged by the degrees they held but by their art. Despite the informal organization, the school had a charged atmosphere of competition that generated self-motivation among the students. Bywaters dove into a rigorous routine of day and evening classes. It was customary for the students to work at their own pace, and the instructors would meet with the class twice weekly to give individual critiques.

At the league Bywaters studied life drawing and figure painting. Bywaters' instructor in figure painting was Ivan Gregorovitch Olinsky, a Russian-born artist who was a member of the National Academy of Design. Bywaters' most influential instructor, however, was John Sloan, who taught life drawing. About sixty students in the class drew from two models, one at each end of the room. Sloan taught at the league from 1919 to 1932 and was known for his sharp criticism of students' work, but Bywaters gained much more from Sloan than lessons in draftsmanship. It was Sloan who introduced Bywaters to the work of American artists Robert Henri and William Glackens as well as the European moderns from Cezanne to Picasso. John Sloan's lectures were preserved by Helen Farr Sloan, his student and later his wife. Her class notes of 1927 record this comment of Sloan's: "I assimilated some ideas from the cubists, from Cezanne, Van Gogh, Picasso; but I did not imitate their work. I believe in humanism. Humanism can be applied to drawing people, houses, trees, mountains. It bothers me when I see young artists who have picked up some formulas from study of the moderns, when they draw the age old mountains out in New Mexico with no feeling for the real character of things in nature."[20] Sloan was also responsible for directing Bywaters' attention back to the Southwest.

Sloan made his first trip to Santa Fe in 1919 and returned every summer except 1933 until his death in 1952. He was so taken with the dramatic land that in 1920 he bought a house in Santa Fe. He later wrote, "I like to paint the landscape in the Southwest because of the fine geometrical formations and the handsome color. Study of the desert forms, so severe and clear in that atmosphere, helped me work out principles of plastic design, and low relief concept. I like the colors out there. The ground is not covered with green mold as it is elsewhere. The pinon trees dot the surface of the hills and mesas with exciting textures. Because the air is so clear you feel the reality of the things in the distance" (ibid.).

At the time Bywaters studied at the league, Sloan was painting city views of New York in the winter, and panoramic landscapes of New Mexico and

Indian ceremonies in the summer. Bywaters admired Sloan's unidealized paintings of city life, but above all he was fascinated by Sloan's ability to combine firmness and clarity of structure with breadth and grandeur of concept in the New Mexico paintings such as the 1925 landscape *Chama Running Red*. Bywaters responded to Sloan's keen perception of the dynamic nature of the Southwest landscape and his ability to paint both the specific colors of the region and the dryness of the land.

During the fall of 1928 Bywaters found no time to write. He concentrated on painting and filled his leisure hours with browsing through museums. After three months of dreary New York weather, cramped living quarters, and noisy city life, Bywaters began to think of home. He decided to take Sloan's advice and paint his own region. After he returned to Dallas, Bywaters was quoted in the December 28 issue of the *Dallas Morning News*, saying he felt compelled to return to Texas from New York because of "a developing sense of independence and a desire to work at painting his own way."

A self-portrait from this period reveals a young man anxious to make his mark. Painting with quick, loose brushstrokes and the expressionism and acid color of the Fauves, Bywaters' new self-image is intense and assertive. The routine of art classes and regular critiques had sharpened Bywaters' skills as an artist. He was advancing in technical ability and experimenting with bolder images.

Bywaters' travels – to Spain and France, Mexico, and Connecticut and New York – were essential. From these diverse artistic climates Bywaters absorbed new technical skills, a general knowledge of art history, a respect for tradition, and an appreciation of novelty. Each location offered new insight and new lessons. Bywaters' exposure to a variety of historic and contemporary artistic expressions influenced his own art. From his experience in Left Bank Paris Bywaters tasted the free spirit of a bohemian and began to appreciate modernism. From his travels in Spain he began to grasp the romantic qualities of a specific region and to relish realism and naturalism in painting. From the lessons of the Mexican muralists he understood that rebellion in art is progress and that art is a democratic language. From his association with the American impressionists in Old Lyme Bywaters realized the necessity of respectability and stability and the value of a regional expression. He acquired from his study at the Art Students' League a philosophy of art centered on the reflection of his own experience. From these influences Bywaters forged the belief that in order for art to be significant, it must express the artist's own life,

experiences, environment, and region. He was ready to find his own means of artistic expression.

In a letter dated August 26, 1928, Bywaters lovingly explained to his father his decision to become a painter and carefully justified his desire to become an artist rather than a commercial illustrator. He presented his argument in practical terms to convince his father that he could be successful as an artist:

In regard to the advice in your letters concerning the settlement (to my satisfaction) of the choice between commercial art and 'art' I will sum up some of my findings . . . There is no doubt in my mind that advertising will take an even more pronounced jump in importance and money earning capacity. And I could get as good a job as could be had in that field in N.Y. . . . I substantiated that when I was in N.Y. last week. However that (or any phase of commercial art) would necessitate my staying in N.Y. for at least three or four more years . . . I could make a go for it, but for a good many reasons (all aside from sympathy involved) I can't see my way clear to settling for the greater part of my life up East. Now for 'art' (so called). In this field I've made perhaps more influential friends and from them am about to get to the point where I know all the inside technicalities that can be known (i.e. as regards sale, future, clubs, National Academy, etc.) . . . I can get to work painting (anywhere – and I choose the South) so that by the end of another year I will have enough work to supply some dealer in N.Y. (who I am selecting slowly now as I investigate them all) . . . As to the relative earning of art and commercial art I will admit . . . commercial art will bring a greater immediate income that art at the same time will be evened by the cost of living in the East. And there is no doubt that in five or ten years art will earn for one (if I develop as well as I have confidence I shall) more than commercial art, and as the artist becomes older 'art' continues to outstrip commercial art in its relative earning. That is a fact. I could quote any number of 'artists' who are earning over $60,000 each year. Mr. Crane (who is equally as good as about 50 artists in America) is earning between $40,000 and $70,000 yearly . . . I know they are damn good but in 20 or 30 years I shall be just as good unless I lose my eyesight or have an arm cut off. And the thing which is paramount to me is that in 'art' I will not be 'tied down' as I would be in commercial art. You know as well as I do that I need the out of doors Also, I intend to do a great deal of writing and am gradually getting along in that. And although, art and

writing are about as far from the average layman's understanding as any vocation could be, if they provide happiness and a reasonable income, why not devote your life and talents to them?

In the last analysis, as we've said before, the decision in the whole thing will have to be pretty nearly all mine, and I'm writing all this to attempt to show you I'm taking the decision slowly, without prejudice and with as much sanity as I'm capable of. I hope you can see that I'm duly honoring your advice and am considering not only myself but also my family and whatever girl I see fit to marry.[21]

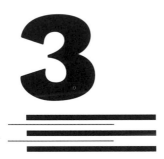

A HOTBED FOR INDIGENOUS ART

The years 1928 and 1929 brought significant developments in the arts in Dallas and were important years for Bywaters. In 1928, in addition to the twenty or more local exhibitions of art presented by the Dallas Woman's Forum, the Dallas Woman's Club, the Frank Reaugh Art Club, and the Oak Cliff Society of Fine Arts, the Dallas Art Association initiated an annual juried art show called the Allied Arts Exhibition, which was limited to the works of Dallas County artists. The Allied Arts show promised to be an

important vehicle for the presentation and promotion of local artists' work. In the spring of 1928 Dallas voters approved $500,000 for the construction of a public art museum. Although several years would pass before the actual building of the museum, the approval of the bond issue was indicative of the optimistic view of the Texas economy and the general support of the fine arts.

The most exciting event in the Dallas art scene of 1928 was the publication of *A History of Texas Artists and Sculptors*. Written by Frances Battaile Fisk of Abilene, this ambitious work was a combination social register and art history book. The work attempted to identify every artist and art institution in every city and region of Texas. Spotlighting the thriving Dallas art community, the dictionary of artists included not only the established artists and art teachers, but also their students, including Jerry Bywaters, Everett Spruce, Alexandre Hogue, Otis Dozier, and Harry Carnohan. This compendium of capsule biographies was dedicated to the encouragement of "our young artists who are to carry on the work in our State, and . . . interpret the spirit and traditions of Texas, thus bring[ing] our State up to the highest standard of culture."[1] At this early stage young Dallas artists were ambitious and wanted to become respected members of the art community. To be listed with all the other Texas artists, past and present, was seen by the young artists as a significant step in the development of their careers.

At the age of twenty-two Bywaters believed he had the ability and determination necessary to be an artist, so he set about establishing himself as a professional. He had completed the essential European tour and had studied with artists of significant stature in order to claim professional status. He was eager to apply his newfound understanding of art and immediately set about demonstrating his serious career intentions. One of Bywaters' paintings was accepted in the State Fair exhibition of 1928 and another was accepted for the Texas Fine Arts Association's statewide exhibition in March 1929. These were indications that his art was being taken seriously. In the *Dallas Morning News* on November 18, 1929, this announcement appeared: "Gerald Bywaters, Dallas artist, has returned and opened his studio after several months sojourn in Lyme, Connecticut, and New York," which amounted to a public announcement that Bywaters was now a professional artist.

That fall Bywaters received as a gift from his father a wooded lot atop a hill in Bluff View Heights, a suburb of Dallas. It was there at 4715 Watauga Road that he built an art studio overlooking Bachman Creek. A newspaper article later described the studio as "a large room, and easy chair, a fireplace deco-

rated with vases, bowls and knickknacks that might be used in still-life de-
signs, high rafters, a balcony, a large easel for exhibiting completed canvases,
an unfinished portrait, and a table strewn with tubes of colors."[2] Such a com-
fortable and chic atelier was a coveted sign of a serious artist. Because of the
financial stability of Bywaters' family and the fact that the devastating effects
of the stock market crash were not yet evident in Dallas, Bywaters was able to
secure his studio. Bywaters considered the studio as an entrée into the art
profession.

The studio was designed and built by O'Neil Ford, a young architect who
had left North Texas State University in Denton to join architect David R.
Williams in attempting to identify and create an indigenous Texas architec-
ture. Bywaters' studio was Ford's first architectural project, and he received
seventy-five dollars for the design. It embodied Ford's formulative ideas about
architectural forms and materials. The simple one-story structure with a steep
pitched roof and wide front porch recalled the earlier architecture of frontier
Texas. The typical dog-run cabin, however, served only as a point of depar-
ture for Ford's design. The walls, fireplace, and chimney were brick while the
loft and roof were wood. Special attention was given to detail not only in the
brickwork but also in the woodwork – the handcrafted columns supporting
the porch, doors, railings, and bookshelves – created by O'Neil's brother
Lynn, a skilled carver and craftsman. The floor of the studio and porch was
of bricks laid into packed sand and cinders, a building technique of early
German immigrants in Texas. A large north window provided light for paint-
ing and a wooden stairway afforded access to the loft. The result was a hand-
some combination of simple form and interesting detail.[3]

About a year later, in 1930, Bywaters decided to add a small house on the
lot. Also designed by O'Neil Ford, the house was situated perpendicular to
the studio. The stone ledge of the bluff served as a foundation for a simple
frame house of three rooms and a sleeping porch, with a garage hidden neatly
beneath the slope of the hill. Recalling the architecture of German Sunday
houses in Fredericksburg, this clapboard structure with shingle roof, rock
chimney, shuttered windows, and dormers was built almost entirely by hand
according to O'Neil's design. The handcrafted architectural details made of
local materials cost less than specially ordered items that were not available
in Dallas. The ceiling of the main room was a handsome herringbone design
of white pine. The house expressed O'Neil Ford's evolving regional aesthetic
and Lynn Ford's ability as a craftsman. The architecture was simple in form

and interesting in its use of the varied textures and natural colors of stone, brick, and wood. The architecture's emphasis was on intrinsic design rather than applied decoration, an idea that pleased Bywaters. The house was built for fifty-five hundred Depression dollars, a sizable sum for an aspiring artist in a collapsing economy.

The house was finished in anticipation of Bywaters' marriage to Mary McLarry. They had met and fallen in love while they were both students at SMU. Born in Leonard, Texas, the daughter of Ethel Hopkins and Denny D. McLarry, Mary moved to Dallas with her family in 1907. Like Bywaters, Mary had an early interest in art and studied painting with Frank Reaugh but concentrated her creative efforts on the piano. She attended Ward-Belmont College, a popular private school for girls in Nashville, Tennessee, where she studied music before entering SMU. In 1928 she graduated with a degree in comparative literature and left for Paris to study privately with Isador Philippe, director of the Paris Conservatory and the American Conservatory at Fontainebleau. Mary returned to Dallas in 1930 and received a second degree in piano with Paul Van Katwijk of SMU.

The Bywaters wedding took place in the Highland Park Methodist Church on the evening of November 3, 1930. The large wedding party included O'Neil Ford and Henry Nash Smith as groomsmen. The petite bride, wearing a fashionable full-length gown and carrying a calla lily, was pictured on the front page of the society section of the November 9 issue of the *Dallas Morning News*. After their honeymoon in New Mexico, Mary moved into the new house on Watauga Road and the couple settled into married life. In the midst of the Depression they lived comfortably. Using the grand piano in the parlor of her mother's home in Highland Park, Mary taught private piano lessons, charging $1.50 per lesson. Teaching piano to the children of Dallas's elite provided a steady and adequate income for the young couple.

Bywaters occupied his time in his painting studio concentrating on portraiture in hopes of securing commissions. Mary often served as his model. Paintings from this period include *Mary at Piano* and *Mary in Yellow Dress*. These works are quiet and contemplative in mood, simple in composition, and limited in tonal range. *Mary in Yellow Dress* pictures Mary sitting on a chair facing front with her arms crossed. The composition is carefully orchestrated to include interesting bits of color and design elements: in addition to the folds of the curtains and a picture of an Indian puppet, the yellow dress is trimmed in black and has a scattering of geometric decorations. Mary also

posed for *Sleeping Girl*, the only nude study Bywaters completed as a finished painting.

Both the informal presentation and the concentration on strong three-dimensional form in these works can be attributed to Bywaters' admiration of contemporary portraits by Andrew Dasburg. No doubt Bywaters saw Dasburg's works firsthand in Taos and also studied reproductions in the *Southwest Review*. Like Dasburg, Bywaters tried for a distinctive Southwest statement in the presentation of a familiar subject in strong light, clear form, and earthy colors. One untitled portrait by Bywaters from this period pictures a dark-skinned little girl who is sitting in a chair and holding a cat. The composition, volumes, and patterning of color of this painting are indebted to the work of Diego Rivera. A strong portrait study that dates from this period is simply titled *Young Negress*. The bust is startling in its three-dimensionality. The handsome features of the head are shaped with a careful brush and the skillful use of light and dark. Bywaters' first commission was for a portrait of Mary's cousin, Helen Hunt. *Portrait of Helen Hunt* was admired at the time for its confident technique and solid composition, which were viewed as an expression of the model's distinctly Texan character.

Bywaters' self-portrait from this period shows a determined face delineated with hard lines and harsh light, a very different self-portrait from the earlier, more colorful, and light-hearted one completed in Paris and the angry, expressionistic self-portrait from his time in New York. In the 1930 portrait a young, intense Jerry Bywaters stares directly at the viewer. Just as the bohemian beard is gone, so is the influence of impressionism. The forms are rock-solid and the palette is limited to the muted colors of stone. This strong portrait is of a self-assured artist who intends to identify and produce his own unique artistic expression.

Bywaters' new interest in volumetric form in portraiture can be traced to the influence of the teachings and example of Thomas M. Stell, Jr. A student at Rice Institute and the New York Art Students League, Tom Stell was hired by Olin Travis in 1929 to teach life drawing at the Dallas Art Institute. Born in Cuervo, Texas, in 1898, Stell was a vibrant character, a demanding teacher, and an accomplished draftsman. He introduced his students to the painters of the early Italian Renaissance, whom he considered superb draftsmen and compositionalists. Stell became known for his portraits of contemporary Texans painted in the tight, detailed manner of the Quattrocento Florentines. Stell painted sculptural figures, as though carved in stone and harshly pro-

jected in light. Definition, organization, and solidarity of form were of major concern for Stell as an artist and a teacher. Bywaters had studied with Stell at the Dallas Art Institute and admired his abilities as a painter and teacher.

Even after establishing his own studio, Bywaters continued to take classes at the Dallas Art Institute. There he met other students who had similar interests in becoming professional artists. The institute served as a central meeting point for artists and a focal point for developing new ideas in art. Not only did Bywaters take classes from Tom Stell and Olin Travis, but he also made friends with a number of other young artists who would figure significantly in his career, including Everett Spruce, Otis Dozier, William Lester, and Alexandre Hogue. The teachings of Stell and Travis at the Dallas Art Institute greatly influenced young Dallas artists and provided the platform for the emergence of a regional point of view and a Dallas school of painting.

Bywaters and other students at the institute found Stell's strictness was balanced by Olin Travis's good humor and indulgence of antics in the classroom. Travis's own painting was impressionistic. His landscape paintings were noted for pale, pastel colors and fluid brush strokes and were praised for their "sylvan beauty." His most important contribution to art, however, came as a teacher who focused on the elements and principles of art. He wisely did not teach a particular style but demanded well-composed and well-painted works from his students.

The Dallas Art Institute grew in popularity when Olin Travis and his wife Kathryn purchased and renovated an abandoned sawmill on Mulberry Creek near Cass, Arkansas. Amid pine trees and dogwoods the rustic cabins and lodge served as the Ozark Summer Art School for instruction in landscape painting, portraiture, and still life. Bywaters participated in several annual summer sketching trips, which afforded the opportunity not only for drawing and painting from nature but also companionship.[4]

On one such trip in 1925 Travis persuaded Everett Spruce, an eighteen-year-old country boy from Arkansas who showed promising artistic talent, to come to Dallas and study at the institute. Travis had an eye for talent; he brought Spruce back to Dallas to study and work at the school for room and board. Spruce studied there for three years – his only formal art training. Spruce recalls, "Travis was very sympathetic; impressed upon me the importance of being a real artist."[5] By that statement Spruce meant a professional artist, not a Sunday painter or bohemian. Travis shared his knowledge of art history and introduced his students to the greater world of art.

Two other important figures to join the small circle of artists were Otis Dozier and William Lester. Born in 1904 in Lawson, Texas, Dozier was raised on a farm near Forney. As a child, he drew the animals on his father's farm. At the age of sixteen he traveled by wagon into Dallas each Saturday morning to study drawing with Vivian Aunspaugh. When the price of cotton plummeted in 1921, Dozier's father, like many other farmers, moved to Dallas to seek a job. Dozier continued art classes at Forest Avenue High School and after graduation studied at the Dallas Art Institute.

William Lester, born in Graham, Texas, in 1910, also developed an interest in art at an early age; he was frustrated with the limitations of crayons by the time he was five. But art classes were not available to Lester in that small town. As the only boy in a family of eight girls, he never had the opportunity to study art until he moved to Dallas, attended Woodrow Wilson High School, and went to Saturday-morning classes at the Dallas Art Institute. Lester spent two summers painting at the Ozark Summer Art School. Lester studied with Travis, Stell, and Hogue even after he graduated from high school in 1929 and began working as a draftsman for the Dallas Power and Light Company. From 1928 Lester continued his intensive study of landscape painting with Alexandre Hogue, who held summer workshops at Glen Rose, Texas.

Alexandre Hogue, a key figure in the circle of artists in Dallas, was known for being outspoken, energetic, and political. In 1929 Hogue was recognized by James Chillman, director of the Museum of Fine Arts of Houston, as "one of the leaders among the artists of Texas."[6] Born in Memphis, Missouri, in 1898, the son of a Presbyterian minister, Alexandre Hogue grew up in Denton, Texas. Seeking a career in commercial art, he studied at the Minneapolis College of Art and Design. In 1919 Hogue returned to Texas and worked in illustration and advertising until 1921, when he moved to New York. He worked in the city as a commercial artist for four years while taking advantage of the numerous art museums and galleries. He often returned to Dallas in the summers to join Frank Reaugh on sketching trips to paint the West Texas landscape. Hogue returned to Dallas in 1925 and, like Bywaters, became a regular at the Dallas Art Institute soon after it was established.

As Hogue's interest in landscape painting grew, he began to travel to Taos to paint. He became friends with the artists of the area, including Ernest Blumenschein, Herbert Dunton, and Emil Bisttram. One painting Hogue completed in New Mexico was *Liver Basket* (1929), which depicts the inspec-

tion of a fresh calf liver as a sacred Indian ritual for divining the future. Hogue's choice of subject matter is an indication of his search for an indigenous American subject, which is at the root of regional expression. Although Hogue's stylistic debt to the Taos school is obvious in the work, Bywaters wrote at the time, "I dislike his being forever compared to Blumenschein, Dunton and the others. Hogue is becoming himself. Let us permit him."[7]

Bywaters' comments point to a connection that developed between the artists of Dallas and Taos. Hogue was not the first Texan to venture to New Mexico to paint. Dallas artists E. G. Eisenlohr and Frank Reaugh often traveled to New Mexico and were friends with the artists in Taos. There were regular exhibitions of works by Taos artists at the Highland Park Art Gallery, and Dallas patrons avidly collected their work. Both Hogue and Bywaters often traveled to New Mexico and were enamored with the vastness and color of the land and the rich cultural heritage of the region. They enjoyed camping and fishing and took numerous sketching trips there. Both Hogue and Bywaters wrote favorable articles about the art and artists of the area. In a review of an exhibition of eleven artists at a Taos gallery in 1929, Hogue wrote, "The group represents varying degrees of modern tendencies."[8] The Taos Society of Artists proved to Dallas artists that artists outside New York could have successful careers. Bywaters and Hogue admired the Taos artists for their attempts to identify indigenous American subjects. As the circle of Dallas artists grew in number and as their ideas about the viability of a regional expression evolved, a subtle schism between the two art communities emerged. Writer Henry Nash Smith was first to identify the diverging aesthetic:

> Finally, there is at Taos and Santa Fe a widely known group of painters. But almost without exception the painters are Eastern Americans or Europeans who have come to New Mexico looking for seclusion, a stimulating climate, and the appeal which the primitive sometimes has for the highly sophisticated. They are not native, and they only begin to become known to the Southwestern public. In other words, however excellent their painting . . . they do not represent an inner working of the past in the group mind; they do not speak for the Southwest or to the Southwest[9]

Dallas artists viewed the Taos artists as painters who adopted American subjects in a European-born painting style. The transplanted eastern artists

were viewed as outsiders, tourists painting the exotic local color. Bywaters and the other Dallas artists were seeking a native expression, an art derived from experience instead of mere observation. For the young regionalists of Texas only an indigenous art could be considered within the mainstream of modern American art.

Bywaters, Hogue, and others wanted to speak for the Southwest and to the Southwest. As their desire to find a truly American expression grew, they began to employ a painting style that was also uniquely American. The Dallas artists became vocal and coherent in developing the idea of creating a regional expression and formulating an appropriate painting style. And, as art historian Matthew Baigell explains, the Dallas artists "were the first serious artists of the Southwest to concern themselves with the land itself. Its visual character and those aspects of it that might resonate in the minds of its inhabitants and affect their emotional and psychological character. That is, they were concerned not only with genre and scenes of local color, but with the look and feel of the landscape."[10] Bywaters, Hogue, Dozier, Lester, Spruce, and others were seeking a stylistic vocabulary to express the uniqueness of the region. As sons and grandsons of Texas farmers, their values and attitudes were shaped by their connection with nature and the landscape. Not only were these artists interested in presenting the visual reality of the subject; they also wanted to present the myth of the land as only a native of the region could. As Dozier explained years later, "Any craftsman can make a copy of nature, but the good artist finds a way to interpret what he sees."[11]

This new regional aesthetic can also be defined by what the artists were reacting against: impressionism. The impressionistic method of painting, the target of their youthful rebellion, was widely known and taught by European-trained teachers. Students of Aunspaugh, Eisenlohr, Reaugh, and Travis learned the brushstroke, palette, and light-suffused quality of impressionist painting and then quickly abandoned it. Many Texas painters employed an attenuated form of impressionism in interpreting the Texas landscape. Amateurs and semiprofessional artists alike painted the misty blue fields of bluebonnets in varying degrees of competency. The young Dallas artists objected to the impressionists' use of vague shapes, loose compositions, and pastel colors. In 1929 Bywaters' disdain for impressionism was clear when he wrote, "We shall learn some day that beautiful color alone in painting is pointless."[12] Bywaters thought that impressionist works by contemporary artists were sen-

timental and foreign in origin. He objected to innocuous paintings that were soft, uninspiring, and old-fashioned.

Bywaters' youthful declaration of independence from the stylistic constraints of impressionism included the destruction of many of his paintings completed in Europe. He considered these early attempts merely student work and later explained: "Once I got back here and began to get interested in myself, then I realized that those paintings had nothing to do with me, but were the paintings of a tourist who was just picking up the pictorial things – the picturesque side of travel in a foreign country . . . they were really not original works of art."[13]

In an effort to distinguish themselves as artists, Bywaters and others abandoned any vestige of pretty colors and broken surfaces in their art. Impressionism, an innocuous, unexciting painting style, was abandoned. After identifying the painting style they would rebel against, Bywaters, Hogue, and others adopted the polished surface and somber realism taught by Tom Stell. The young artists also decided to portray local subjects.

Just as the stylistic framework and aesthetic parameters of a regional artistic expression were being formulated by painters Bywaters, Hogue, and Stell, the intellectual foundations of regionalism were first enunciated by writers and historians. Bywaters' former college friends Lon Tinkle, Henry Nash Smith, and John Chapman were finding literary means of exploring and expressing the life of the Southwest. One of the leading exponents of the idea of a distinctive regional expression was John H. McGinnis, founder and editor of the *Southwest Review*. This important literary magazine was known for excellent writing and for openness to new ideas.

One of Bywaters' closest friends was Henry Nash Smith; they had worked on the journal together as students at SMU. Smith served as associate editor of the *Southwest Review* for ten years and was the first to identify and promote the regionalist movement with a momentous article titled "Culture" in the January 1928 issue. Smith's writings amounted to a manifesto for the young Dallas artists. He urged artists to create from the "inevitable flowering of fresh experience" that reflected their own environment. His new definition of culture was "the ability of Texans to relate themselves to their specific environment."[14] Smith called for the rise of a localized American culture to be demonstrated in the art that comprehended a specific region. He advised artists that a Texas culture could be recognized only if artists had an "understanding

of their own times and places" (ibid.). Smith also called for the public to recognize the achievement of the young Dallas artists. Smith's efforts to promote the work of Dallas artists included a speech to the Dallas Women's Club entitled "Our Indigenous Arts."

The substance of Smith's discussion in "Culture" was the identification of a predicament that profoundly troubled the younger generation of artists in Texas: the pursuit of "culture" on a frontier is of necessity a "spare time" activity. The chronic consequence of this predicament is that art and artists suffer from lack of interest and support. Smith also lamented the encroaching urbanization of Texas and predicted increased uniformity in American culture. He believed that with increased communication and technology comes increased difficulty of identifying the distinguishing characteristics of a particular region. It was clear to Smith that artists and writers were chosen spokesmen to identify and preserve the region in their art. These were issues that Bywaters and Smith discussed at length around a campfire in the Chisos Mountains of the Big Bend.

The probing of this philosophical basis for regional expression also brought to light two key concerns; first, the overriding issue of regionalism versus provincialism; and, second, the specific problem of identifying what is regional or indigenous. The *Southwest Review* became a platform for the discussion of issues and current topics in regional art. This periodical provided a forum for aesthetic and philosophical discussions for both literary and visual artists within the Southwest. In contrast, the Taos artists had no such vehicle for the clarification and promotion of their views. The *Southwest Review* proved to be a springboard for discussions among Dallas artists. The July 1929 issue included a forum of opinion entitled "Points of View: A Symposium on Southwest Culture." The discussion of a wide range of topics crystallized in a consensus that a regional point of view is not to be confused with or confined to provincialism. The dangerous state of being perceived as a limited provincial was to be avoided by all who sought to identify and explore the region in art.

The need to identify what is a true indigenous expression became a major concern. Across its pages the *Southwest Review* traced the development of the regionalist aesthetic in a continuous flow of discussion. The search for the individuality of the region and the typically Texan occupied artists and writers. "An Indigenous Architecture," written by David Williams and illustrated by O'Neil Ford, hailed "houses . . . designed in the Texas manner, using the

early Texas work as a source of inspiration . . . [and excluding] any foreign forms or details."[15] Another article, "Is the Southwest Musical?" by David W. Guion, identified the Southwest as "the very center of American native music. The Negro, the cowboy, the Indian, the pioneer are the sources of our folk-music: and we have them all, as no other section of our country has . . ."[16]

The *Southwest Review* chronicled the development of the new regionalism in the visual arts. This changing direction of thought emerged as early as July 1926 in an article entitled "Art of the Southwest," in which author Marion Murry searches for a viable artistic expression in Texas: "Even Julian Onderdonk's painting of bluebonnets – the state flower – seem[s] to lack the background that makes our section individual – the traces of an ancient Indian civilization, the lazy Spanish traditions. So far as embodying the spirit of the Southwest is concerned his bluebonnets might as well be lilacs. Some of Onderdonk's other work – his paintings of dusty Texas roads, for instance – are more typical."[17]

Beginning in 1928 both Hogue and Bywaters wrote feature stories and reviews on art exhibitions for the *Southwest Review*, which Olin Travis praised in a letter to the editor in 1929 as "very excellent articles." The artists' assessments of art revealed their own developing aesthetic. Hogue called an exhibition of works by Rockwell Kent at the Highland Park Gallery "the most important exhibition brought to Dallas in some time" and observed that "Rockwell Kent is American through and through – by birth, training, education, and viewpoint. He has recognized no art creed and acknowledged no passing school, but has blazed his own trail to a native expression and a consistent viewpoint."[18] In the same issue Bywaters wrote about a group exhibition of paintings by Olin Travis, Kathryn Travis, Alexandre Hogue, E. G. Eisenlohr, Frank Klepper, and Reveau Bassett at the Sartor Galleries on Knox Street in Dallas. Bywaters predicted that "Southwesterners who have had only a second-hand acquaintance with what is being done hereabouts will be astonished by the wealth of paintings on constant display."[19] Bywaters observed that Hogue's "New Mexico period seems now to be passing as he becomes more and more interested in Texas . . . Mr. Hogue has been unusually fortunate in rendering the clarity of Texas sunlight." The young Dallas artists were proclaiming their stylistic independence and their legitimacy as spokesmen for the region.

During this period Bywaters also completed several illustrations for the *Southwest Review*, including a series of frontispieces on frontier naturalists.

The portrait sketches of Gideon Lincecum, Ferdinand Jacob Lindheimer, Charles Wright, Thomas Drummond, and Edmund Montgomery accompanied lengthy profiles of the naturalists by various scholars. Bywaters also continued to earn a small income by publishing a few articles as a free-lance writer. While at the Ozark Summer Art School in the summer of 1929, Bywaters met and interviewed a local celebrity who was actively looking for lost Spanish gold in the Arkansas hills. Bywaters told the humorous story of the hillbilly eccentric and buried treasure in a feature article in the *Dallas Morning News*.[20]

Bywaters traveled to Mexico on an assignment for *Holland's, the Magazine of the South* in December 1929. Written and illustrated by Bywaters, the article described four Mexico City churches, Guadalupe, Santo Domingo, San Juan Bautista, and La Iglesia de la Profesa. "For my sketches," Bywaters wrote, "I selected four iglesias of different architectural design and varied interest."[21] The text describes little about the actual sketching of the sites but dwells on the Spanish history of the churches. Regarding the drawing of the San Juan church, Bywaters wrote, "After completing one of the towers and the puestas de velas – candle stalls – below it, I gave up the effort of drawing and recording the events mentally." Bywaters apologized for "the rather shaky sentiment of my sketch" (ibid.). The drawings are small but well-executed pen and ink sketches that give a good sense of scale and the position of the building on the street.

There were great expectations for 1929 among artists and art enthusiasts. In May the Dallas Public Art Gallery moved from the small octagonal building in Fair Park to the spacious second floor of the Majestic Theatre in downtown Dallas. Jurors for the Second Annual Allied Arts Exhibition included Sallie Griffis Meyer, Gutzon Borglum, Robert Vonnoh, David Williams, and Frank Klepper, all of whom were members of the established art community. The exhibitors in the show included Bywaters and his contemporaries, who were viewed as young, emerging artists. As the *Dallas Morning News* reported, "Unquestionably it is from the ranks of the present amateurs that Dallas County's future artists and craftsmen will come. Such an exhibit is to encourage embryo artists to develop their creative impulse and improve their technique through observation and study."[22]

The fall season opened in 1929 as usual with the forty-fourth annual State Fair art exhibition, and the new director of the Dallas Public Art Gallery arrived from Missouri. The cultured, gentlemanly, well-educated John S. An-

keney was hailed as the first professional director of the gallery. After teaching art and art history at the University of Missouri, Ankeney wrote and spoke about art with a kind of exclusive language reserved for those in authority. Ankeney outlined his ambitions for the future direction of the museum: "There is a marked renaissance in the modus operandi of public art museums all over the country . . . today they are becoming centers humming with activity, through the establishment of classes instructing 'the public' and its children in the various mediums of art expression and art appreciation."[23] Ankeney had studied painting in France and Italy and at the Art Students' League in New York. He had also studied art and art history at Harvard and was one of the organizers of the College Art Association of America. Ankeney revealed the direction the Dallas Public Art Gallery would take during his tenure: "I am thoroughly in rapport with the present movement in America to make museums more intimate and less formal. The right kind of a museum develops local talent, in helping it to get an audience."[24] Of course, Bywaters and the circle of Dallas artists welcomed this kind of support. Ankeney quickly established himself as a spokesman for the development of a regional expression in art.

Ankeney and his wife were introduced to the art community and Dallas society at a Sunday-afternoon tea party at a Swiss Avenue mansion. The December 1 *Dallas Morning News* article, entitled "Mrs. Archie N. Rogers Hostess to 50 Gifted Dallasites," listed the members of the art colony who were invited to the occasion; they included Jerry and Mary Bywaters, Alexandre Hogue, O'Neil Ford, Lynn Ford, John Douglass, Ruby Stone, Lloyd Goff, Allie Tennant, Vivian Aunspaugh, Joseph Sartor, Arthur Kramer, and others.

Ankeney arrived in Dallas in time to assist the members of the Dallas Art Association in their preparations for the annual Beaux Arts Ball, held every February to raise funds for the organization. The costume ball was announced as the event where "society will mingle with the arts and vie with genius in the creative splendor and distinction of costume."[25] Art works by young aspiring artists were exhibited and offered for sale at the ball. Olin Travis was chairman of the February 26, 1930, event, which had as its theme "An Algerian City." Plans were made for six hundred costumed guests. Twelve Dallas artists worked "at one time in the creation of one great canvas to be placed on a gigantic easel in one end of the ballroom."[26] Bywaters not only attended the ball with Mary but also exhibited some of his paintings. Dallas artists were well represented at the affair; the February 2 *Dallas Morn-*

ing News reported that the Beaux Arts Ball brought the "spotlight of publicity [to] aspiring young artists who are making their bids for fame" Dallas artists also became infamous for what was later referred to as the "Boozearts Brawl" when the newspaper reported an incident involving two artists in Arab costume, an undercover policeman, and the violation of the prohibition law at that august event.[27]

Soon after Ankeney arrived, he began a series of Monday-evening gallery talks at the Civic Federation titled "The Story of Art." His lectures on the history of art were well attended by an appreciative audience. The public was distressed, however, when the first exhibition of modern art arrived in Dallas. The art reporter for the *Dallas Morning News*, Maureen Osborn, reviewed the Dallas Public Art Association's troublesome exhibition of works by French contemporary artists that included paintings by Redon, Dufy, Roualt, Ozenfant, and Picasso. Expressing the views of most Dallasites, Osborn wrote, "They have succeeded in portraying ugliness in its most hideous forms, figures floating around in space, nudity in all its shapes both natural and grotesque and scenes worked out in colors so deadening that the picture must be studied intensely to discover if there's anything represented except the splotches of paint."[28] Concluding her assessment of the exhibition, Osborn added that the work by Picasso "will afford some amusement."

In an article that appeared two weeks later in the same newspaper, Ankeney tried to offer a more sympathetic explanation of modern artists' work. He viewed the exhibition's value as chiefly educational and regretted that the works by Derain and Picasso were "unimportant examples."[29] He condemned the negative criticism of the exhibition as "the natural viewpoints of those ignorant of the real basis of art in life and also to those who have practiced one method of seeing and thinking of art to the exclusion of all other ways." The explanations which Ankeney offered revealed a clear understanding of the intentions and approaches of modern artists. Ankeney described cubism as the "effect of rendering form as we see it in motion." He revealed his keen insight as he explained that "men like Matisse . . . wanted to paint like children – that is, get the fresh inspiration of the five or seven year old. *The Regatta* by Dufy . . . [is] a good example of putting down things as a child would."

After the shock of the French exhibition the 1930 Allied Arts Exhibition was only mildly controversial. Art critic Maureen Osborn did warn potential visitors to the show that they "may as well become modernistic minded to

begin with."[30] The third Allied Arts Exhibition had both a juried section and a nonjuried section and a generous thirty-nine awards were given for various categories of art. It was clear from the number and quality of works by the young artists of Dallas in the show that the group was becoming visible in the community.

There were several good exhibitions that spring featuring the work of younger artists. Bywaters was a regular exhibitor. A review of a March exhibition of eighteen Dallas artists at the University Club included this assessment: "Gerald Bywaters divides his canvases equally between landscapes and portraits, successfully portraying the presence of a mirrored reflection in the 'Self-Portrait.'"[31] In April the Graphic Arts Society held an invitational exhibition in the studio of Margaret Scruggs Carruth at 3715 Turtle Creek, which included works by Jerry Bywaters, Alexandre Hogue, Olin Travis, O'Neil Ford, Lynn Ford, Dave Williams, Frank Klepper, Allie Tennant, E. G. Eisenlohr, Reveau Bassett, and Margaret Carruth.[32] The foundations of a new aesthetic had been laid in the arguments of the *Southwest Review*, and the artists were now demonstrating their realizations and abilities in paint. Bywaters and his colleagues were not yet mature artists; yet they were trying to realize in their art the full import of the regionalist aesthetic.

These artists searched for new and innovative ways to exhibit their work. In October 1930 the Dallas Women's Club initiated a series of exhibitions by Dallas artists. The list of exhibitors included Bywaters, Charles Bowling, John Douglas, J. B. Martin, and others.[33] The young artists were encouraged by this evidence of unprecedented interest by the Dallas elite. Bywaters surveyed the fall openings for 1930 and wrote, "In a period of financial depression the art organizations of Dallas began their year in October with marked confidence."[34] It is ironic that just as the art community began to feel a quickening sense of activity, the chilling effects of the Depression began to numb the business activity of Dallas.

4

THE FIGHT FOR ACCEPTANCE

By the winter of 1931 the economic effects of the Depression were evident in Dallas. Artists began to feel the pinch as the wealthy of Dallas began to tighten their belts. Yet it was in the midst of the Depression that Bywaters as well as his colleagues found the expressive means to create significant works of art. Hard times served as subject and substance of their art. Despite a lack of patrons and public interest for their art, the young artists struggled for acceptance.

Bywaters emerged as a spokesman for the band of young Dallas artists. His ability to write and his connections with Highland Park society facilitated his role as arbiter and promoter. In an effort to promote the local art scene, Bywaters wrote the *Southwest Review* editors, "Perhaps your magazine's 'indigenous and regional' fling has blown back in your faces: nevertheless it has created a much needed reaction in preparing the public audience for uninhibited reception of the local artists' interpretation of the local scene, and has encouraged the artists to come out in the open with their fight for acceptance of a logical sort."[1] Fighting for acceptance became a battle cry for this group of young Dallas artists, who were anxious to prove their worth and determined to be recognized as professional artists. Through deft diplomacy, rather than agitation, Bywaters promoted a stylistic revolution in art that he expected established art institutions to support. The enemy was apathy. For Bywaters the "logical sort" of acceptance included patronage and exhibitions.

Bywaters saw the first steps toward recognition in two spring exhibitions. The Fourth Annual Allied Arts Exhibition, a major art event for 1931, was praised by the *Dallas Morning News* with a review entitled "Fourth Annual Allied Show Overshadows Past Exhibits."[2] In March one hundred and fifty Texas artists were invited by a jury of art dignitaries from New York and Paris to show at the clubhouse of the Dallas Women's Forum at 4607 Ross Avenue Bywaters' work was included in the show.[3]

His progress toward recognition continued to advance throughout the year. He completed two cover illustrations for *Holland's* magazine. The cover of the August issue depicted "two Spanish fishing boats, tilting along before the breeze under full sail, the sea reflecting in darker tones the clear blue of the cloud flecked sky," according to an article in his hometown newspaper that announced, "Former Paris Boy Becomes Widely Known as Artist and Illustrator."[4] Joseph Sartor Galleries in Dallas became Bywaters' exclusive agent. Henry Nash Smith described the Sartor Galleries as a "modernistic" space with white walls and skylights designed by Alexandre Hogue. Because Sartor dared to show the work of young local artists and did not cater to the popular demand for paintings of fields of bluebonnets, Dallas artists considered the gallery the most advanced in the city.[5]

Bywaters' first one-man show, in 1931, was sponsored by the Joseph Sartor Galleries and held in the lobby of the Dallas Little Theatre. The *Dallas Morning News* of October 25 mentioned the show of fifty canvases, including portraits, figure studies, and still lifes. Another critic commented about the

show: "Gerald Bywaters whose paintings are hanging at the Dallas Little Theatre also, continues to experiment in white."[6] *Still Life with Spanish Shawl* and *Still Life with White Pitcher* were limited in color and may have been those "experiments in white." The exhibition included several portraits of Mary, portraits of A. W. Sommerville and Helen Hunt, and a portrait of Martha Wolcott entitled *Girl with Apples*. There were two figure studies entitled *Reverie (Musing Girl)* and *Sleeping Girl*. Only one landscape, *Near Taos*, was included in the exhibition, which was an important opportunity for Bywaters to present his strong portraits and figure studies to the public.

Bywaters also exhibited in an October 1931 show of local artists' works at the Dallas Women's Club. Critic Maureen Osborn reviewed the exhibition of works by sixty artists and stated flatly that "confusion and eccentricities of modernism are no longer the vogue of the Dallas Art Colony . . . flamboyant expressionism is subordinate to the more conservative aspirations of color, harmony, balance, and draftsmanship" (ibid.). The review avoided substantive description and analysis of the paintings in the exhibition, but implied that the young Dallas artists were individually concerned with developing a personal idiom. Their paintings from this period were the works of emerging artists who had not yet developed individual, mature styles. Each artist was searching for his or her own expression and was not particularly concerned with contributing to a particular movement.

There were changes taking place that promised a new era in the arts in Dallas. In 1931 the Dallas Art Institute moved from its original location at 1215½ Main Street to Alice Street, a short, unpaved street between Maple Avenue and Cedar Springs in the downtown area. The *Dallas Morning News* headline reported: "Art Institute Will Operate in 'The Barn.' Civic Federation Backs Enterprise as Non-Profit Venture. Unity of Forces. Artists Cooperating to Help Make Success of School."[7] The Dallas Art Institute's new location was in a temporary building on the grounds of the Civic Federation, the city's center for literary and philosophical discussions. With the move to the large space, the institute added several new teachers to its staff to accommodate the growing number of art students.

Bywaters became a member of the expanded staff at the Dallas Art Institute. In the fall of 1932 he began teaching classes in painting and graphic representation.[8] Other teachers at the school included Allie Tennant for classes in sculpture, Reveau Bassett for outdoor sketching and etching, Alexandre Hogue for painting, and Forrest Kirkland for watercolor. Olin Travis

taught painting and composition, and Kathryn Travis gave instruction in still-life painting. Thomas Stell left the institute and began teaching private art lessons at his studio at 2012 North Harwood.

The close proximity of two Dallas cultural institutions, the Dallas Art Institute and the Civic Federation, created the hub of the art community. The Alice Street atmosphere was charged with discussions centered on the importance of creating significant art from one's own experience and environment. The tempo of the art scene quickened as native artists returned from travel and study abroad with new and controversial ideas. Bywaters told of his experiences in Mexico and New York and his unfolding art theories. When Harry Carnohan returned from studying with cubist André Lhote and Harry Lawrence returned from excursions to Chicago and Paris, there was animated discussion of new possibilities in art. Artists banded together in Dallas not only to discuss art but also for support and inspiration.

Art students and young professionals began to live in the area. A house called the Studio, located at 2411 North Pearl Street, was considered the center of the Dallas art community. Referring to the Studio, the *Dallas Times Herald* announced that "Dallas is to have a salon des artistes at last"[9] Architect David Williams lived on the first floor with his library of fine antiquarian and modern books. The walls were lined with tapestries, etchings, and paintings. The brothers O'Neil and Lynn Ford lived there. O'Neil joined Williams as a draftsman and became his right-hand man, and Lynn was a wood carver and craftsman who helped to fabricate their designs. O'Neil Ford later recalled, "We occupied a three-story, most unusual 'modern' stucco building that looked like an early Lescaze or Corbusier effort."[10] The Studio served as office, workshop, and home for the architects. Historian Muriel McCarthy writes, "In many ways the Pearl Street location was very like a craft compound, since furniture, lighting fixtures, fabrics, and hand carved details such as newel posts and mantels were designed and made on the premises for the homes taking shape on the drafting boards" (ibid., p. 31). During the Depression there were, however, few architecture jobs available. Ford remembered, "The idea of regular salaries had disappeared, and Dave just collected when he could and divided the money" (ibid.). As the economic pressure of the Depression increased, the tenants began referring to the Studio as "Tortilla Flats" because of frequent disputes with the electric and water companies, resulting in the use of candles for light. Often water had to be hauled by bucket from the neighbors.

The Studio remained a bohemian compound until 1932. O'Neil was an excellent draftsman; the etching press that David Williams had bought him was at one end of a large living room balanced by a Steinway concert grand piano at the other end. Harrison Stevens, a painter-musician and the director of the music department at Hockaday School, lived on the second floor of the Studio. In the cramped quarters of the third floor lived writer Horace McCoy, who worked for the *Dallas Journal* as a sports reporter and also wrote novels. McCoy was an amateur actor in the Dallas Little Theatre and had an occasional short story published in *Black Mask Magazine*, but fame as a writer came much later when he wrote and published in 1935 the tense drama of a pair of Texas misfits at a grueling dance marathon entitled *They Shoot Horses Don't They?* McCoy had a green Hudson Speedster that he allowed his friends to borrow. The tenants of "Tortilla Flats" were friends of Bywaters and well known in Dallas art circles. O'Neil recalled, "Dave saw to it that I became associated with the cultured bohemian set, and bold talk and brave discussions were our principal occupations (girls filled in the empty places)" (ibid.).

The small community of artists, craftsmen, and writers also congregated at the Whyches' boarding house at 2212 Alice Street. There for twenty-five cents they could buy a home-cooked meal and potent homemade beer at a nickel a glass. Bywaters remembers Cecil Whyche as a "misfit who dabbled in astronomy."[11] May Whyche was the enterprising one who turned their living room into a public restaurant and the upstairs into quarters for boarders. William Lester was one of the young artists who boarded for a while with the Whyches.

After a filling dinner of pinto beans and cornbread, the large dining table was cleared and the discussions began. The group called itself the Alice Street Coffee Club. Debates about the latest art theories lasted into the night. Everyone was reading the *Dial* magazine and examining its reproductions of works by contemporary European artists. Avant-garde works by Picasso, Braque, and Matisse provoked animated discussions about the validity and substance of abstract art. Prompted by the articles that Bywaters and Hogue wrote for the *Southwest Review,* the discussions often turned to the concepts and issues of developing a regional expression in art. The animated discussions about art at the Whyches' dinner table were informal, but as the number of participants grew, the group of artists decided to organize and have regular meetings. They called themselves the Dallas Artists League, elected

officers, and met regularly on Tuesday evenings at eight o'clock. The first official meeting was held May 21, 1932. Dues were set at twenty-five cents per year, and among the original members were Jerry Bywaters, Everett Spruce, Otis Dozier, E. G. Eisenlohr, William Lester, John Douglass, Perry Nichols, Nina Peeples, Forrest Kirkland, Alexandre Hogue, Ruby Stone, Ruth Glascow, David R. Williams, Velma Davis, Margaret Exline, and the Whyches. The league quickly grew to include not only painters but also patrons, writers, architects, and art teachers.

Tuesday nights for the next three years at the Dallas Artists League were important events in the development of a cohesive art community. The discussions continued, and guest lecturers were scheduled. SMU professor C. L. Lundell spoke on his recent archaeological discoveries in Mexico; merchant Stanley Marcus, an organizer of the Book Club of Texas, spoke on contemporary book making; John Rosenfield, *Dallas Morning News* arts editor, discussed art criticism; David Williams spoke on early architecture by European immigrants in Texas; Talbot Pearson praised the Little Theatre movement; O'Neil Ford analyzed modern architecture. Thomas Stell, Jr., titled his talk on September 6, 1932, "The Art and Craft of Drawing." Later that month Olin Travis spoke on interpretive painting versus creative painting. Artists Harry Carnohan and Harry Lawrence discussed the School of Paris artists. John Douglass, a former student of Boardman Robinson and Thomas Hart Benton, discussed the importance of painting the American scene. Henry Clausen, the artists' model and a wrestler, titled his talk "Is There Progress in Art?" Writers John McGinnis and Henry Nash Smith constantly urged members of the league to consider a local viewpoint to express universal values.[12] What emerged from the discussions was a growing sense that the most progressive art is based on local subjects and local themes. Dallas artists and craftsmen used these meetings as a forum to discuss controversial art theories and aesthetics.

A nagging topic of discussion among the members of the league was the financial uncertainty of the Depression. Economic conditions aggravated the proverbial problem of lack of patronage, which was also recognized by the *Dallas Morning News*: ". . . art conscious citizens are proud [of Dallas artists], even though they do not always show their pride by patronizing the home artists."[13] Spruce commented years later that the wealthy Dallas patrons often donated prize money for exhibitions, but they continued to purchase art of questionable quality from New York galleries for their Swiss Ave-

nue mansions.[14] Wealthy Dallasites did not look to the resources of their own city for high culture but rather elsewhere.

In November 1931 Ankeney curated a show of works from the homes of seventy-eight Dallas collectors. Included in the exhibition were paintings from the homes of Arthur Kramer, Herbert Marcus, Stanley Marcus, S. I. Munger, and other Dallas notables. Works by Julian Onderdonk, Herbert Dunton, Walter Ufer, Frederick Waugh, Ivan Olinski, Gardner Symons, Currier and Ives, Thomas Moran, Marie Laurencin, Thomas H. Benton, and Victor Higgins were included in the exhibition, but none of the young Dallas artists were represented.[15] The exhibition proved that there were sophisticated collectors in the city, and members of the Dallas art colony realized the need for a campaign focused on local patronage. They saw the conservative but well-accepted artists of the Taos colony as their main competition.

Because there were few patrons and limited means to exhibit and sell their work, the artists of the league began to discuss and plan new ways to promote and sell their work. Only one month after their first meeting the Dallas Artists League presented an open-air art exhibition and sale.[16] The emphasis was on creating an inviting and entertaining atmosphere to lure an audience. Inspired by the successes of the Washington Square Outdoor Show (founded by John Sloan in 1932) and the Greenwich art carnivals, Bywaters directed the first Alice Street Carnival on June 29 and 30, 1932. It was a major undertaking and a success. The unpaved Alice Street became an art gallery and a fiesta complete with mariachis and Captain Lucey's Colored Band. In an article titled "Artists Go Arty and Dear Public Goes to See Them," the *Dallas Morning News* described the event:

> Sixty-five artists parked their paintings, etchings, drawings, and other art work on each side of Alice Street . . . Almost as many donned berets and costumes to create a Bohemian atmosphere that seldom pervades a studio in which the artist is engaged in composing a painting . . . It was all staged for the first art fiesta . . . an occasion that drew a crowd of more than 3,000 people. Pictures were displayed in baby buggies, on sides of houses, on front porches, in poster-like signs along the street, on picket fences and in specially made stalls. Olin Travis with drooping beret that reached his shoulder, was kept busy from early evening until midnight sketching caricatures of visitors for the price of fifty cents . . . Harriet Grandstaff spent most of the evening cutting silhouettes, each of which brought the sum of

twenty-five cents. Lynn and O'Neil Ford conducted a soda water stand in connection with their exhibit of etchings and drawings. Ruby Stone made quick sketches.[17]

The amount of total sales, about five hundred dollars, was large in terms of Depression dollars, and the artists were heartened by the attendance and publicity. Bywaters recorded the attendance for the three nights at seven thousand. The Alice Street Carnival served its purpose of building a public following for the group's art. The fact that the league chose the carnival to introduce and sell their work to the public is significant. Although there were a few art galleries in Dallas that had ventured showing works by some of the younger artists, they certainly had not sold very much. Most of the people who attended the art carnival had never been in an art gallery or an art museum. The carnival – a Texas-style spoof of Bohemia – presented a nonthreatening environment for Dallasites to view and purchase art and meet real artists. Paintings were sold at bargain prices or bartered for goods and services (Ruby Stone traded a watercolor for a permanent wave). Members of the league were thrilled with the success of the first carnival and believed it was a key factor in developing new audiences for their work in their continuous struggle for acceptance and patronage.

League members also agreed that twenty-six-year-old Jerry Bywaters had a good idea for promoting their work: an art magazine focusing on the art of the Southwest that would rival the slick art magazines of the East. Bywaters had seen the great impact of the *Dial* in spreading new ideas, and he understood the important connection between a cohesive art community and an organ for expounding ideas and promoting work. Bywaters' model became *Mexican Folkways*, although it had stopped publication in 1929.

Funding for such an ambitious venture was secured when Bywaters approached Mrs. A. H. Bailey, a wealthy Dallas matron, with the idea. She was known for her support and promotion of the arts through the Highland Park Public Library and Art Galleries and the Fine Arts Department of the Texas Federation of Women's Clubs. She was also active in state arts organizations, including the Texas Fine Arts Association and the Southern States Art League. Bailey not only funded the new publication but also provided office space for the project in the Highland Park Art Gallery. Bywaters arranged for some young printers who were new in business and eager to produce quality work at low prices to print the magazine. He designed the typeface and mast-

head and wrote and edited most of the copy. He solicited articles from Tom Stell and Vernon Hunter. The result was a well-designed and handsomely produced publication about the arts and artists of the region.[18] The first issue was published in August 1932 with the title *Southwestern Art*; subsequent issues were titled *Contemporary Art of the South and Southwest.*

Although the major contributors to the magazine were the young artists of Dallas seeking a platform for their work, several leading art figures from southern museums and universities lent their names to the publication's list of advisors and contributors in an effort to legitimize and broaden its influence. One thousand copies of the magazine were produced quarterly. Subscriptions sold for one dollar per year, and copies were distributed to regional and national museums and art galleries. This publication was not the work of amateurs or students, but rather a statement of a self-conscious group of young professionals who were producing new and significant work and seeking recognition. The credo of the magazine appeared in the premier issue: "South-Western Arts will attach itself to no 'ism' in the arts. It will sanction sincere work and bring before its readers those unknown, but deserving, who lack only the finding. It will assist in coordinating the immense amount of creative activity in these states into logical significance. It will mold its policies to be of the greatest service possible to the development of Southern and Southwestern arts."[19] The effort to produce an art magazine of quality was based on a belief that "creative art is coming of age in these states but has lacked a medium to assist it in taking place along with the important regional developments in the country" (ibid.). The artists of Dallas saw themselves not as a small, provincial colony but rather as part of a large movement in American art on a par with the regionalists of Iowa, the social realists of New York, and the progressive artists of Taos. The magazine served as a mouthpiece to disseminate information about the vibrant art activity of the region.

The magazine reflected Bywaters' interest in highlighting all of the arts and crafts produced by contemporary artists of the region. Members of the Dallas art community were ambitious and competitive. Bywaters called on his friends, young enthusiastic artists and writers throughout the region, to write articles and provide art work. The first issue included articles on stagecraft, modern bookplates, the decorative arts, book reviews, and listings of exhibitions and theater performances. In reviewing a Texas Fine Arts Association exhibition, Stell mentioned many of his colleagues and former art students, including Everett Spruce, William Lester, Perry Nichols, Otis Dozier,

Alexandre Hogue, and Charles Bowling. Stell wrote, "To one who has observed the progress in Texas over a period of ten years the Texas Fine Arts Exhibition shows gratifying tendencies. Sentimentality, melodrama, and anecdote have long since ceased to dominate southwest painting, picturesque and interest in atmospheric phenomena are on the wane and particularly in the work of the younger artists, we find an increasing interest in the more profound aesthetic problems of line, volume and rhythm."[20] Stell's message was clearly that impressionist paintings of Texas bluebonnets were out of vogue and a new generation of artists was emerging.

Only four issues of *Contemporary Art of the South and Southwest* were produced. The magazine was expensive to publish, but it served its purpose as issues were sent to museum directors and gallery owners. Bywaters knew that to have names of artists and their work reproduced was very important in the promotion of their individual careers. The publication also created greater cohesiveness among Dallas artists. The editor and writers of the magazine considered Dallas the center and circumference of Southwestern art; *Contemporary Art of the South and Southwest* served as a means to explain the aesthetic of regionalism and as a showcase of art by members of the Dallas Artists League. Artist Vernon Hunter echoed the theme of innovation in his assessment of the art of the region:

> In the west of the South some sort of emergence is obvious. The art of the region is like a baby kicking to find its strength . . . I can glance back through a teaching experience of the past decade which enables me to observe and compare the creative skill of art students from almost every region of the nation; and in the course of that time I seem to recognize that the students native to the southwest have shown the most solidly marked ability among the regional groups. It is not ability with unique personal flare, but a direct and compelling way of interpreting their native experiences, usually without hesitation of statement, and with less influence from superficial tradition than students from other regions show.[21]

Members of the Dallas Artists League found other opportunities to educate the local public about their art and promote an image of respectability. In 1932 the Dallas Women's Club initiated a series of lectures on art. On the first Tuesday of each month different speakers were invited to enlighten the group concerning art. Vernon Hunter's talk was entitled "Presenting Art – Past and Present." Sculptor Allie Tennant discussed her own work. When Bywaters

lectured on December 6, 1932, he boldly expressed his view to the women of Dallas society that "there is nothing highbrow or mysterious, about this business called art. An artist may be both highbrow and mysterious, but what he eats, how he lives, when he sleeps, has nothing whatsoever to do with art. No, the only mystery lies in the curious attitude of the laymen that art should be clear to him without any effort on his part."[22] While Bywaters lectured, Olin Travis demonstrated on a canvas the principles of painting. Bywaters also made reference to the paintings on exhibition at the Dallas Women's Club to illustrate his points.

The Dallas Women's Club continued to have exhibitions of works by Dallas artists. The exhibition in the autumn of 1932 included 150 works by sixty Dallas artists. Bywaters exhibited an oil on canvas and two lithographs in that show. *Lunch Table* presented a traditional still life of fruit and wine but in a cubist style. The table is tilted dangerously, and the composition includes a cat that is responsible for the chaos of the scene. Bywaters was a timid cubist, however, who allowed the scene to be grounded in realism. The newspaper review of the exhibition was very sympathetic to the efforts of the young Dallas artists: "This group is relatively small, but the work they are doing is of the creative type that goes to make lasting art"[23]

Artists of the Dallas Artists League began to receive recognition through such exhibitions as "Dallas Younger Artists," in Denton, Texas, as well as "Exhibition of Young Dallas Painters, All under Thirty," at the Dallas Public Art Gallery. These exhibitions included works by Bywaters, Carnohan, Douglass, Dozier, Hogue, Lester, Nichols, Spruce, and Stell, who were identified as leaders of the Dallas school. Their careers were bolstered substantially by a favorable review in *Art Digest*, a national art magazine. According to the writer of the review, the Dallas exhibition presented "an indication of the aliveness of artistic creation in the Texas city, . . . the artists concerned themselves more with experimentation and ideas rather than illustration . . ."[24] The energetic young Dallas artists were distinguishing themselves as innovators. Their experimentation centered on a realistic style and regional subjects.

Such articles in the national art press combined with the local interest created by the league's art carnivals to focus national, regional, and local attention on the group. For Bywaters and the other Dallas artists 1932 was a watershed year. Bywaters continued to concentrate on portraiture and still

lifes, and his work was being noticed. Bywaters "created a good deal of talk" when he exhibited *Sleeping Girl*, described by one art critic as "a painting of reclining half-nude girl interesting for its color harmonies and reproduction of the body lines," at the Dallas Public Art Gallery in February 1932.[25]

The Fifth Annual Allied Arts Exhibition in April was a showcase of the young Dallas artists' work. With 330 works on display, the 1932 show was the largest of the Allied Arts shows. In the April 10 issue of the *Dallas Morning News* Maureen Osborn gave this glowing assessment of the show: "One will be struck immediately by the evidence of assurance, freshness, invention, originality, spontaneity, and best of all versatility."[26] *Art Digest* published a reproduction of the purchase prize winner, Dozier's *On the Lot*, with a review and complete list of the prize winners, including Bywaters, Hogue, and Lester.[27] The *Southwest Review* praised the group show: "The public in general will do well to study the work of the younger artists in this group. Otis Dozier, the winner of the purchase award for "On the Lot," William Lester, Perry Nichols, John Douglass, Everett Spruce, Jerry Bywaters, Lloyd Goff, John Fisher, and Dorothy Austin, whose names come to mind at once, are to be congratulated for their achievements."[28] Reviewer Mary Marshall singled out Bywaters for special recognition: "The versatile Jerry Bywaters, who displays a high degree of excellence in many types of expression, easily might have been the winner of the purchase award. He brings intellect and spirit to bear on his subjects. His 'Zerilda' is a marvelous piece of painting, and his 'Girl with Apples,' though the painting of the lower area of the canvas, including the hands, is not so fine as that of the remainder of the picture, has an inner significance that places it a little above 'Zerilda.' 'The Sleeping Girl' is another meritorious canvas" (ibid.). *Zerilda*, a portrait of Zerilda Ross, was a strong portrait of an attractive woman with dark hair and eyes. Like many of Bywaters' portraits, the woman is pictured with arms crossed and unsmiling, staring directly out at the viewer. She wears a dark, simple dress and occupies an uncluttered space with an open book and a louvered window. The crisp realism and pronounced three-dimensional form of the painting was a distinctive characteristic of Bywaters' painting style.

Bywaters' painting *Girl with Apples* was also shown in New York City that fall at the Geragie Galleries under the auspices of the College Art Association. Bywaters was one of forty artists chosen from five hundred entries of works by "younger artists of the country."[29] The *Dallas Morning News* art

reviewer quoted the *New York Herald Tribune*'s pronouncement that "among the salient works on view is the efficiently realized *Girl with Apples* by Jerry Bywaters of Dallas, Texas" (ibid.).

Reviews of the young artists' work were not always favorable. An editorial in the *Dallas Morning News* on May 29, 1932, condemned the work of artist Vernon Hunter: "Take the trouble to step up to the Dallas Public Art Gallery if you would have something to snort over." The critic was baffled by "a tin ware exhibition up there with pigmentation inserted by the tinsmith to enhance the arty flavor of the effort." Although no record exists that describes Hunter's work, it is possible that he was experimenting with a painted and cut-out tin frame for a painting of a regional subject. Whatever the image, the public reaction to Hunter's experimental work is best judged by comparison with the biggest art news story for 1932 in Dallas. James Owen Mahoney, a former SMU student and a senior at the Yale School of Art, won the coveted Prix de Rome with his classically perfect painting *Sunday Afternoon*.[30] For Dallas patrons the success and stylistic conservatism of Mahoney was commendable, whereas the experimentation and modernism of Hunter's work was not appreciated.

During the summer of 1932 several events raised the expectations of young Dallas artists. The Dallas Public Art Gallery moved again from the Majestic Theatre to the ninth floor of the Dallas Power and Light Company Building and took the name Dallas Museum of Fine Arts.[31] Six galleries provided more room for the growing permanent collection of eighty-seven works and for traveling shows. The most important development, however, was the fact that the museum had dedicated one gallery especially for the exhibition of works by Dallas artists.

Early in the summer of 1932, with work on the first issue of the magazine nearing completion, Bywaters traveled to Taos for a ten-day visit to research material for future articles for *Contemporary Art of the South and Southwest*. While there, he wrote an article for the September 18 issue of the *Dallas Morning News*. The newspaper article was disjointed and had a general tone of disappointment. Bywaters lamented that the Taos art colony had changed just as the town was changed by the tragic loss of the north side of the plaza by fire. "Arriving in Taos in the capacity of art editor on the trail of articles, paintings for reproduction, and underworld gossip," Bywaters wrote, "is to blandly pass by the studios of the squatting Indian painters Sharp and Phillips and travel down to the younger more active artists."[32] Bywaters found Emil

Bisttram, a recent addition to the colony, to be the most interesting because he had studied fresco painting in Mexico. For Bywaters and others the end of the dominance of the Taos school provided an opportunity for the emergence of the Dallas school.

Encouraged by the prospect that Dallas could replace Taos, by the sales and attendance at the Alice Street Carnival, by the success of the 1932 Allied Arts show, and by the increased recognition of art and artists by the newspapers, Bywaters wrote a letter to the editor of *Southwest Review* that arrogantly challenged the public to support art and artists. Bywaters wrote, "The artist as unbent, is willing to be a human worker and not a luxury-vendor. It now remains for us to see how far sincere public indulgence will support the strong localized development – to see whether all this excellent art agitation and noisiness show the Southwest to be merely art-loving or actually art-owning."[33]

After delivering that challenge, Bywaters returned to the active art scene in Dallas in time for the 1932 State Fair. Art critic Frederic McFadden categorized the State Fair exhibition as "charming, cheerful, pleasant."[34] He noted, however, that the show was "responsive to the newer trends of thought and expression which come under the general classification of modernism. Alexandre Hogue, Jerry Bywaters, Otis Dozier, three Dallas artists contribute examples of their work in interesting canvases . . . *West Texas Town* by Jerry Bywaters is a rhythmical study in design in which clouds, roads, and grain elevators are employed to form the pattern" (ibid.). The critic's assessment of the Dallas artists as modernists was predicated upon their use of contemporary subjects: penetrating portraits of contemporary Texans, candid views of Texas cities, and sympathetic scenes of rural Texas.

By 1932 the effects of the Depression were visible in Dallas, and sensitive artists saw human misery that needed to be addressed in art. The State Fair exhibition included Forrest Kirkland's watercolor *Hoover City Mansion*, which presented a grim scene of shacks, tents, and movable houses erected near Union Terminal in downtown Dallas. Other Dallas artists were monitoring the changing social and economic conditions of their region and recording them in their art. The artists of the Dallas Artists League were receiving local and regional attention as the leading artists in the South and Southwest.

THE TEXAS SCENE IS THE AMERICAN SCENE

Bywaters' year was 1933. On May 21 the *Dallas Morning News* proclaimed, "Bywaters is entitled to the highest commendation . . . Mr. Bywaters has been before the public this year more than any other Dallas artist." [1] At the age of twenty-seven he had emerged as a multifaceted individual with an active career in the arts. His efforts were highly visible: his paintings won top awards, he taught at the Dallas Art Institute, he continued to write articles for the *Southwest Review,* and he assumed the important position

of art critic for the *Dallas Morning News.* Bywaters was recognized nationally for his leadership in the Dallas art community. *Art Digest* proclaimed, "Bywaters isn't a 'comer' in Dallas, – he has 'arrived.'"[2]

In his painting Bywaters concentrated on portraits and figure studies, and he began to paint landscapes. His fascination with the forms and subjects of Rivera's art continued to inform his paintings, and his major works of 1933 included *Mexican Man, Mexican Mother and Children, Mexican Women.* As the portrait market diminished during the Depression, Bywaters began to paint more figure types than specific portraits. *Mexican Women* presents a scene of women washing clothes at the edge of a river. The composition combines simple shapes and kaleidoscopic colors. Bywaters' experiments with reducing forms of figures and landscape to geometric volumes resulted in a style that recalls the modernism of Leger and the second-generation cubists. Although this painting was considered innovative by his contemporaries, Bywaters was not completely satisfied with his stylistic approach. In his own criticism of the work Bywaters wrote that it "essays a genre subject with doubtful authority, bending the figures and forms to fit in a preconceived design."[3]

The work by Bywaters that received the most attention in 1933 was a portrait of Dallas architect David R. Williams. Titled simply *David*, the work claimed the coveted Keist purchase prize of the Sixth Annual Allied Arts Exhibition at the Dallas Museum of Fine Arts. *David* was described as "one of the finest pieces of work Bywaters has yet produced and gives evidence of the unusual development this young artist has made during the short period of a year. It is a strong composition, splendidly executed and rich in coloring."[4] Although the influences of Stell and Rivera are evident in this work, *David* established Bywaters as a consummate professional with the technical proficiency to create a penetrating portrait of substance and character. The bust portrait is painted in a manner reminiscent of the Quattrocento Florentines with the conventions of contemporary dress, closed space, and an attribute of a book to denote that the subject is a learned man. David Williams was known for his collection of rare books on art and architecture, which included some volumes from the sixteenth century, and he was one of the founders of the Book Club of Texas. Stylistically the portrait also recalls the works of the early Italians with its limited palette, hard lines, emphasis on volume, and sharp definition of forms. The composition of the painting owes much to early Renaissance portraiture with the subject shown as a bust facing slightly left and placed in the corner of a fenestrated room. To further em-

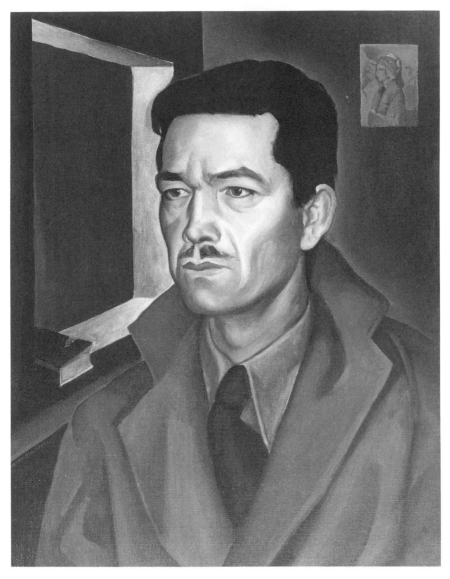

David **(David R. Williams, also called** ***Portrait of an Architect*** **),** *1933. Oil on canvas. 26⅛ × 20 in. Dallas Museum of Art, Kiest Memorial Fund Purchase Prize, Sixth Annual Allied Arts Exhibition of Dallas County, 1933.*

phasize the stylistic connection with early Italian Renaissance art, Bywaters included a prominent visual clue in the right background: a portrait of Petrarch, the Quattrocento poet and humanist.

David was most admired for the solidly constructed and volumetric figure, the accurate likeness of the portrait, and, above all, its solid, serious, and undeniable masculinity. The *Dallas Morning News* reviewer saw *David* as "more purposeful and more intent" than the artist's other portraits. *Art Digest* published a reproduction of the painting and called it "hard and troubled." Independence and strength were identified in the likeness of a man who was known for his quest to locate the truly Texan in architecture.

A reproduction of the portrait also appeared as the frontispiece of the spring 1933 issue of the *Southwest Review,* for which Bywaters wrote an article on regional architecture focused on the work of David Williams and O'Neil Ford. In "More about Southwestern Architecture" Bywaters revealed what he believed to be important in both architecture and the architect: the qualities of "sincerity, integrity, and common honesty." Bywaters affirmed that "a building must tell the truth about its construction and materials; ornament should be of the surface – not on it. Nothing save original, indigenous, 'pure' design should enter into a building." [5] When the article was written, Williams had just completed what was to be his last private-residence design. Built for the mayor of Highland Park, Elbert Williams, the house brought Williams his greatest recognition and was perhaps the most characteristic of his attempts to identify and create an indigenous style. The house was a clear articulation of a rambling urban ranch house, and the furnishings and fixtures were custom designed and executed on the premises to ensure the cohesiveness of design and concept. Williams also commissioned Bywaters and Stell to paint a living-room mural depicting the history of the Spanish missions in Texas. Painted directly on the salmon-colored brick of the fireplace, the narrative is arranged in a tri-level frieze of schematic figures. Bywaters summarized the work of David R. Williams and O'Neil Ford with the highest praise, stating that it "represents a preliminary effort toward the discovery or development of a general American style – or, more accurately, of the Southwestern variant of a general American style" (ibid.). Bywaters believed the architects were successful in obtaining the goal he had established for the visual arts of the region.

Other paintings exhibited by Bywaters in the 1933 Allied Arts show included a portrait of Margaret Exline entitled *Margaret*. Described as "vivid,"

the colors are more vibrant and the presentation less formal than those of the portrait of David Williams.[6] Bywaters was also awarded second prize for his landscape *Taos Mountains* and an honorable mention for his drawing *Yellow House*. According to the *Dallas Morning News*, over seven hundred people attended the opening of the show at the museum. Ankeney wrote this about the exhibition in the *Dallas Times Herald*: "There is much fine work in the current show, which displays the improvement that is being made in Dallas and shows the consistent progress that is taking place from one year to the next . . . The young men are making investigations and are showing marked progress in their undertakings. The people of Dallas should demand of them as well as of the traditional artists that their work be done well."[7]

Ankeney's use of the term "traditional" is important because it had become synonymous with the work of older Dallas artists. A newspaper article appeared a few weeks later under this headline: "Youth Serves Itself: Are Dallas' Older Artists Neglected?" Referring to the elders of Dallas art – Frank Reaugh, E. G. Eisenlohr, Olin Travis, Frank Klepper, and Reveau Bassett – the article stated, "The charge has been made throughout the year that the press of Dallas has given its attention more to the younger artists of the city than to the men whose names go to make up the older group."[8] The imbalance was explained flatly in this way: "They are not exhibiting with the embattled persistence of the fledglings. In short they are not making news."

Indeed, the younger generation of Dallas artists were making news. The group that included Bywaters, Hogue, Spruce, Lester, Dozier, Carnohan, Austin, and others were referred to as the "artists of the rebellion" and "exponents of the new freedom," while the recent Allied Arts show was hailed as "victory for the rebellion." These artists worked within the traditional media of oil, pastel, and watercolor, and they employed the traditional conventions of portraiture, landscape, and still life; yet they were offering a startling array of new subjects and a distinctively new stylistic vocabulary. These young painters were concerned with strong compositions, clear light, earthy colors, and local subjects. They were rebellious because they dared to depict the real world. People were presented in portraits that were as rock-hard as reality. Bywaters' portrait of the dashing David Williams was captivating in its intensity, and Stell's portrait *Sophia* appeared carved rather than drawn.

In the midst of the Depression the young Dallas artists presented an unidealized vision of their world. In the Allied Arts Exhibition there were several paintings that presented the industrial side streets of Dallas, including *Indus-*

trial Landscape by Otis Dozier, *Deserted* by William Lester, and *Back Door* by Lloyd Sargent. These artists also dared to picture the Dallas that the socially elite discounted. Charles Bowling's oil painting entitled *Mexican Quarters, Winter* made no attempt to disguise the poverty and misery that existed a few blocks from the department stores and office buildings of downtown Dallas. Bowling presented the unemployed loitering on the dirty streets lined with dilapidated shotgun houses. Otis Dozier's powerful painting *Deep Elm* presented a glimpse of the dignity and beauty of a black couple at a time when blacks were not allowed in the Dallas Museum of Fine Arts. Because Dozier's work incorporated vibrant color, broad flat shapes, and everyday subject matter, he was identified most closely with modernism. An art critic was prompted to write, "The modern dominates the traditional so strongly that the effect is startling."[9]

The Allied Arts Exhibition was an important forum for Dallas artists, and they took advantage of the opportunity to exhibit their work to large audiences. Each artist could submit up to eight works in twenty-nine separate categories. Jurors for the 1933 exhibition included Emil Bisttram, Cora Stafford, and Don Brown; they accepted 234 of the 525 entries and awarded prizes in various categories. The first award in sculpture went to Dorothy Austin's *Noggin'*, a head carved of white pine that entered the permanent collection of the Dallas Museum of Fine Arts. Austin, a member of one of Dallas's wealthiest families, had studied at the Art Students League in New York and developed her own bold style in direct carving. Alexandre Hogue's watercolor *Drought* also received special recognition from the jurors. The work was one of a series of studies focusing on the drought-stricken area of West Texas for which he soon gained international attention. In recording the stark emptiness of the West Texas landscape, Hogue pictured the devastating drought that dried the land and the wind that swept away the topsoil that had been overplowed by desperate farmers. Far removed from the misty lushness of an impressionist landscape, Hogue's paintings presented the dry desolation of the Dust Bowl.

The art critic for the *Dallas Times Herald*, John William Rogers, recommended the Allied Arts Exhibition to Dallasites and praised the work of the young Texas regionalists. "To those of us who call Dallas home," he wrote, "this exhibition has a significance that a collection of the finest masters in the Louvre would not have, because here we find the living art . . . born of our own lives and our own environment."[10] John Ankeney echoed the regional-

ists' rhetoric, arguing that the sooner local artists are accepted, "just so much faster will be our real growth toward getting beauty into the daily life of everyone."[11]

Another significant event held at the Dallas Museum of Fine Arts in 1933 was an exhibition of fifty works on loan from the famous Samuel H. Kress Collection of early Italian painting. The predominantly fourteenth-century works were viewed by record-breaking crowds and studied intensely by every artist in Dallas. Thomas Stell had long admonished his students and colleagues to examine and emulate the work of the early Italians. This exhibition presented a great opportunity to view original works firsthand. The exhibition's importance for the stylistic development of regional art was recognized at the time by Harry Carnohan and Jerry Bywaters, who each registered their reactions in print. Both artist-writers came to the conclusion that the development of the early Italian Renaissance was parallel to that of the emergence of a contemporary regionalist expression in Texas. In separate articles they urged local artists to study the subjects, style, and content of the works in the Kress Collection. Carnohan commended the "broad pattern and simple tone" of the works and praised their "charming, rhythmic, distorted-abstractionist" qualities.[12] Bywaters saw the works of the Italian masters as revolutionary, arguing that "Cimabue, Giotto, Masaccio, Uccello, Castagno and other great primitives had brought new information to the problems of form, design, and color, in fresco and tempera painting . . ."[13] It was the clarity of atmosphere, fineness of detail, and structural integrity of the works that the young Dallas artists admired. They associated Mantegna's harsh light and rocky landscapes with the Texas light and land. Spruce later explained, "I thought certain painters from Northern Italy – Mantegna, Bellini, Carpaccio – their landscapes looked like this country here in West Texas. I made that connection."[14]

The general admiration and emulation of stylistic characteristics of the work of early Italians was not only a unifying factor in the stylistic development of the Texas regionalists but also an abiding interest in the work of other artists of the American Scene. Records of John Sloan's teaching notes include this discussion: "I feel I must continue digging into this problem of drawing, the separation of form and color – the concept of the thing in its integrity, the realization of plastic existence. These problems which the artists of the Renaissance solved with such dignity."[15] Sloan's biographer, David Scott, cites the art of Carpaccio, Mantegna, Giovanni Bellini, and Piero Della Francesca

as Sloan's principal sources of inspiration."[16] As Sloan's student, Bywaters may have heard this discussion; at any rate, he certainly agreed with the favorable assessment of the art of the early Italians that Bywaters called the "true Renaissance."

Other events in 1933 served to unite and promote the circle of Dallas artists. Locally the Joseph Sartor Galleries presented "All American," an exhibition featuring the works of Dallas artists Hogue, Bywaters, Bassett, Eisenlohr, and Lucy Wells, along with works by George Inness, Childe Hassam, Julian Weir, Ernest Blumenschein, and others with national reputations.[17] In the summer of 1933 the Second Annual Alice Street Carnival was as successful as the first, bringing a large number of Dallasites in contact with art and artists.[18]

The catalyst that most visibly coalesced the art community, however, was the naming of Jerry Bywaters as art critic for the *Dallas Morning News*. In his weekly reviews of art exhibitions and essays on art and aesthetics, Bywaters assumed the role of spokesman and advocate for the art and artists of his own region. Bywaters' first assignment as art critic for Dallas's largest newspaper was to write a series of articles on the art exhibitions at the Century of Progress Exposition in 1933 in Chicago. Traveling by train from Dallas to Chicago, Bywaters arrived to record the highlights of the large collection of historic and modern masterpieces. After scanning 1,227 art objects valued at $75 million, Bywaters asserted, "Probably the most important gathering of paintings ever made in America, the exhibition is equally important in that it is being looked over and discussed by hundreds of thousands who will not again soon have a like opportunity of seeing the world's art from the 13th century up to the present so adequately illustrated."[19]

Bywaters' review digressed into a condensed art history course as he attempted to reconstruct the grandeur of the exhibit for Dallas readers. There were obvious gaps in his knowledge of art history, as evidenced by this curious observation: "It is not surprising to find in the exhibit's oldest entry the institute's thirteenth century Etruscan 'Madonna,' a definite similarity to the paintings of twentieth century Modigliani" Despite the historical inaccuracies, Bywaters demonstrated his good eye for the abstract qualities of art in his comparison of the simplified form of a painting by modernist Modigliani with a primitive form of an ancient figure. His four-part series of articles marched through art history in progressive fashion, describing the exhibition of nineteenth- and twentieth-century European and American art.

In the August 18 article Bywaters observed, "Between the rooms of modern

French masters and international 'istics' are the contemporary American paintings – fittingly placed, we believe, not only in the museum, but in art as well. Modern American painters show an amazing versatility and a corresponding amazing lack of direction."[20] For Bywaters the lack of direction constituted the lack of a cohesive contemporary American style, and he despaired that "few Americans . . . have kept their distance from Paris." Urging American artists to declare their artistic and stylistic independence from the School of Paris, Bywaters singled out such works as Grant Wood's *American Gothic,* John Steuart Curry's *Baptism in Kansas,* and paintings by Charles Burchfield, Walt Kuhn, Charles Sheeler, Reginald Marsh, and Edward Hopper as examples of "a promising freedom in approach and technique" In summation of his critique, Bywaters presented this challenge to American artists: "Perhaps Americans will yet find a niche for art in this mechanized civilization . . . It remains only for the American artist to dig in more seriously, with his mind more on the times than the stars" (ibid.).

Bywaters' final article from the Chicago World's Fair reported that he found the fair's "most outstanding example" of art not in the Chicago Art Institute's vast historic exhibition but in the Indiana State Building, which housed a mural by Thomas Hart Benton. Bywaters wrote, "The work 250 feet long and twelve feet high depicts the history of the Hoosier State from the days of the Indian mound builders up to the present"[21] Bywaters gave a capsule biography of Benton and was careful to point out that the artist "decided to forget Europe and the arty atmosphere of easel painting and confine himself to preliminary studies for mural decoration." It is clear from the complimentary tone of the article that Bywaters saw Benton as an artist he wanted to emulate. Because of his enthusiasm for the work, Bywaters overstated its importance, asserting that "Benton's mural is the first great work produced by a son of the Middle West and inspired by its native culture." Bywaters used the article as an opportunity to add this challenge: "The satisfying culmination of the job should suggest the necessity of a similar accouterment for the pending Texas Centennial" (ibid.).

The trip to Chicago with an assignment to complete four substantive articles in a week's time was ostensibly a test by the newspaper to see how Bywaters could handle the job as art critic. The quality of the articles was sufficient to land him a permanent position as art critic for the *Dallas Morning News.* For the next six years Bywaters wrote a weekly column on the changing art scene in Dallas, receiving five dollars per article. The trip to Chicago was

also important because Bywaters saw a vast array of international art that influenced his ideas about art and informed his painting.

When Bywaters returned to Dallas, the first articles that he completed were features on Dallas artists J. B. Martin and Lloyd Goff as well as a survey of local craftsmen that highlighted the versatile Lynn Ford. Bywaters called Martin a "natural painter" and praised his "pure unaffected style."[22] Martin was a self-taught primitive artist who painted nostalgic scenes of longhorns and was well known in the Dallas art community as the first caretaker of the Public Art Gallery in Fair Park. Bywaters described Martin's work as "the culmination of definite and sympathetic interest in nature so directly recorded that there is an entire lack of the mellifluous attributes in high favor with Sunday afternoon esthetes who think art a form of inspired and involuntary action." Painter Lloyd Goff received the critic's attention because he had just returned from assisting artist Leo Katz with a large mural for the Johns-Manville Building at the Century of Progress Exposition.[23] In an article that touched on the man-versus-machine theme, Bywaters introduced the handmade crafts of Lynn Ford and described him as "a self taught craftsman with a natural talent for fine design in a large range of decorative and utilitarian articles."[24]

In a September 3, 1933, article that served as a prelude to the fall 1933 art season, Bywaters challenged Dallas artists: "Our art can be reactivated if painters will cease to play in the role of sensitive outcasts and recover the classic role of making things more tangible, not more intangible. A relevant art is needed and it will not be shown entirely by the relation of an eggplant to a guitar."[25] The message is clear that the formal problems of art were not sufficient to claim the attention of an artist. Bywaters used his new weekly platform to exhort artists to be concerned with more than constructing well-organized compositions. Bywaters took the responsibility of instructing artists to produce art that was relevant.

In an editorial titled "Art's Theory of Relativity. The Muses and Their Historians; A Critical Agenda,"[26] Bywaters aired his views on what an art critic should and should not do. He affirmed that a critic should not serve as a mouthpiece for art dealers to publicize their wares. Regarding writing styles, Bywaters expressed dislike for both "flowery gush" and "straight forward damnations." He maintained a personal style of writing that tried to be straightforward and persuasive, although his language was sometimes cumbersome, often earthy, and always colorful. He stated emphatically that an art critic

"should have technical knowledge, a sensitivity toward art expression, a power of logical analysis." Bywaters continued, "He should be able not only to react, but to judge his own reactions for their importance in presentation." Presumably Bywaters believed he possessed these requisite qualities as an art critic. The critic's principal "stock in trade," Bywaters continued, "should be a standard, neither traditional nor particular, broad enough to realize the equal significance in the wall carvings of Assyria, Japanese prints, Chinese ceramics, Aztec sculpture, paintings from Giotto through Cezanne to today." It is clear that Bywaters did not claim to be an authority in all periods and styles of art, but he believed that it was necessary to appreciate all artistic expression. Without elaborating, Bywaters concluded that his role as art critic was to "scrape the mold off the mind of art" (ibid.).

Bywaters' review of an exhibition of the works of Frank Klepper at the Joseph Sartor Galleries is an example of art criticism in its mold-scraping mode. Bywaters took Klepper's new work to task for reverting to subject matter that is "idyllic or pastoral" in the form of "impressionistic landscapes."[27] Urging Klepper to return to a previous direction in his art, Bywaters wrote, "We remember one of Klepper's paintings a few years back – negroes returning from fishing along a levee. A story picture, but one with splendid possibilities. It seems to us that this painter would do well to tap again the qualities of that piece and enlarge on them." Bywaters used the review not so much to criticize Klepper's new direction as to condemn impressionism as an outdated style. Bywaters added, "Monet, old man, did you have any idea what you were letting us in for when you broke up color so you could scatter it over a canvas? What a shame you got so interested in pretty color that you sold your talent for a mess of chromatism." Bywaters judged impressionism not only as old-fashioned, as merely colorful, and as a denial of structural compositions, but also as a stylistic detour from the main currents of art. In his final appraisal of impressionism he wrote, "It is amazing to think that impressionism, such a scandal at its inception many years ago, has been so completely adopted by America and wallowed in that by now, when most painters have learned it, and left it, it remains as the distinguishing timber of student work, academic exhibitions and dealers' dead stock . . . Many years will pass before we will be able to get back to the high road of art from which impressionism has led us" (ibid.).

The Forty-eighth Annual Art Show at the State Fair of Texas provided a

major art event in Dallas for Bywaters to critique. Tens of thousands of visitors strolled through the galleries to view European and American masterpieces. Director John Ankeney curated the extensive exhibition, which was long anticipated by Texas artists and art enthusiasts. Bywaters' column covered several aspects of the State Fair art exhibition, but the most important article, dated October 5, 1933, focused on the art and life of Thomas Eakins, whose *Portrait of Letitia Beacon* hung in the exhibition. Dubbing Eakins "America's Rembrandt," Bywaters viewed his art as a "possible basis of a 'tradition' for the future of American painting."[28] It was important for Bywaters to locate an American master to serve as the father of an indigenous American art. Bywaters asserted that Eakins "did not paint to show how pictures were being made in France, but to show what people were like in Philadelphia." Bywaters used Eakins' art to voice an argument against the sweet lyricism of impressionism and to promote realism in style. "It is because of this uncompromising truthfulness and lack of saccharinity that Eakins has been somewhat neglected," Bywaters affirmed. Eakins was above all a model for Bywaters as an artist and a mentor for the regionalist movement: "Uncourted by officialdom, Eakins let fashion go its way while he proceeded with his own development into a master of economic utterance in paint and thought" (ibid.).

Bywaters devoted a special article to the works in the Texas Room of the State Fair exhibit and praised Ankeney for an "orderly sequence of paintings illustrated by remarkably good works."[29] It was important to Bywaters that the Texas artists' work show favorably among the works of well-known European and American artists. He found Stell's *Della* to be "equalled only by the Renoir, Hunt and Eakins." Bywaters then described the emerging style of his Dallas colleagues: "Carnohan is . . . finding a personal outlet for his intense theories and practices – his West Texas landscape achieves a confounding sense of space; Spruce will surely become more legible through his introversive landscapes; Dozier is bringing a classic meaning to humble natural forms." Bywaters also wrote about his own work and reserved the harshest criticism for his painting *Mexican Women*: "Effective enough in color at close hand, the painting is vitiated by this color when seen from the center of the gallery." In his overall assessment of the exhibition of the works of twelve Texas painters and one sculptor, Bywaters concluded that "they stand up well in the formidable company." The State Fair exhibition served as further proof for Bywaters of the dominance of regionalism, and he predicted greater ac-

complishments for his Dallas colleagues: "Carnohan, Spruce, and Dozier (Lester also) have a great deal to say that is disquieting and not quite definite – an ideology common to the best of creative artists" (ibid.).

Shortly after the close of the State Fair, Texas artists had an opportunity to see how their art measured up to the works of contemporary American masters. The Dallas Museum of Fine Arts hosted a traveling exhibition of twenty-five paintings from the permanent collection of the Whitney Museum of American Art, the first museum dedicated exclusively to American art. The Whitney Museum was then only two years old, but it owned an impressive collection, including works by Raphael Soyer, Charles Sheeler, Alexander Brook, Stuart Davis, Robert Henri, Arthur B. Davies, and many more. In his review of the exhibition Bywaters praised the efforts of the museum's founder, Gertrude Vanderbilt Whitney, to promote and collect the works of American artists. Bywaters viewed the circuit show as a means to acquaint "a large public with what is being done by the best American contemporary artists who are rich in native soil substance, even though they may be plagued with a faint perfume of Europe."[30] It is interesting to note that Bywaters found the work of American Scene great John Steuart Curry shallow and too illustrative. Despite his disappointment in Curry's work, he welcomed the opportunity to examine the work of leading contemporary American artists.

A competing newspaper, the *Dallas Times Herald*, published a full page of reactions by local artists to the Whitney exhibition.[31] Following a brief introduction by art critic John Rogers and a public-relations statement about the exhibition by Juliana Force, the director of the Whitney Museum, was a collection of short articles by artists Alexandre Hogue, Harry Carnohan, Otis Dozier, Margaret Ann Scruggs, Frank Reaugh, and Maggie Joe Watson. The essays were less about the quality of the Whitney show and more about the artists' individual concerns.

John Rogers introduced Frank Reaugh as "the dean of Texas artists" and "perhaps the most indigenous of all our artists." Reaugh was certainly well known among Dallas artists for painting the cattle and the landscape of the region. His viewpoint was valued by the younger artists, but it is clear that his comments delineated a different aesthetic from that of the younger generation. Reaugh's assessment of the traveling Whitney show was brief: "The show is interesting; and some of it I like; but I prefer pleasing subjects." With a professorial tone, Reaugh continued his evaluation by warning, "I have seen many 'isms' in art rise and pass in my time, and some of them did much

good. Modernism may at least encourage independence. But that is a thing opposed to civilization. Let's don't have too much of either." Alexandre Hogue praised the Whitney exhibition for its overdue recognition of the decentralization of art: "At last the Whitney . . . has decided that, to live up to its 'American' label, it must 'find' America which, as everyone knows, except Gotham folk, is not to be found in New York" (ibid.).

"The Whitney Show, now at the Dallas Museum of Fine Arts, is a little disappointing," wrote Otis Dozier, "for the men represented are some of our best painters, yet the examples shown do not put them on an equal to the best of European painters." Dozier, who was gaining a reputation as a painter of local subject matter, voiced a clear and careful warning against the limitations of regionalism: "The present wave for indigenous painting must have something more potent than John Steuart Curry's 'Ne'er Do Well' to be a lasting movement. He is riding the wave of American subject matter" (ibid.).

Harry Carnohan also expressed concerns about the current stylistic trends: "The timid and sometimes cross exploitation of the so-called "American Scene" is a perfect revelation of which way the wind blows in this country. In an examination of the great epochs of art, we find that in some ways this spirit points to a greater art than the last 100 years of really fine individualistic art." For Carnohan "the Whitney show only adds to our conviction that the great period is ahead of us rather than behind us" (ibid.). This prediction of a golden age in American art in the near future was a recurring theme. Bywaters restated this prediction in his summation of the value of the Whitney exhibition: "Of all the many forges at work during the past decade to bring about a renaissance in American art the founding of the Whitney Museum can be taken as the professional move that made a reality out of what was otherwise a mental yearning rather than an actual fact."[32]

Bywaters, Hogue, and Carnohan each expressed a popular idea of the time. The concept of an American Renaissance and a golden age of American art dawning across the country was current in the thought of artists and critics. The concept emerged as early as 1928 when R. L. Duffus wrote *The American Renaissance*. Duffus affirmed, "There can be no doubt that America, having expressed herself politically, mechanically and administratively, is on the point of attempting to express herself aesthetically."[33] By 1930 there were many who thought the golden age was in sight. *Creative Art* magazine devoted its entire November 1931 issue to the subject of American art and the emergence of an American Renaissance. The special issue examined early

examples of American folk art, discussed the role of art dealers and art museums in collecting American art, highlighted the work of American graphic artists, applauded the efforts of American industrial designers, and praised the achievements of American painters. In an essay on American painting, Edward Alden Jewell, art critic for the *New York Times*, found evidence to support the findings of "an American 'renaissance' now being advanced with increasing confidence. Some of these painters we may feel are yet in process of attaining the fuller native stride with which we are at the moment concerned"[34]

Jewell was not alone in advocating that American artists portray American themes. Dorothy Grafly, a Philadelphia critic, joined the affirmative chorus along with Juliana Force, director of the Whitney Museum. Peyton Boswell, editor of *Art Digest*, was a major supporter of the American Scene movement. The interest in American art and artists prompted the Whitney Museum to sponsor a debate in 1932 entitled "Nationalism in Art – Is It an Advantage?" The affirmative position prevailed. The argument focused on American versus European art, not modernism versus realism. The debate about the nature, substance, and subjects of American art would continue throughout the decade, along with speculation about the American Renaissance.

This renaissance was generally thought to bring not only an increase of artistic activity but also to signal an uplift in American morality and spirituality. It was understood that this renaissance would take place in a democratic manner. Artists would produce more and better art. Citizens would appreciate this art and somehow learn good taste. Americans were expected to purchase this art; everyone was a potential patron, not just the wealthy elite. By the same token, no one single artist was to represent all of American art. All artists were equal in the sense that no extreme individualism would be acceptable. Taken to its logical conclusion, the elitist concept of the masterpiece would be eliminated and the catering to the artist's ego ignored. The concept of an American Renaissance also included the theory that this movement would be national in scope and decentralized, occurring in every city, town, and hamlet across the country. New York was no longer the center and source of American art. This view opened the possibility that Dallas artists could produce significant American art.

By 1933 there was ample evidence for those monitoring the progress of the impending renaissance to support their claims. According to American art historian Matthew Baigell, "It seemed as if the arts were flourishing in all

areas of the country, a delightful idea which fueled the fantasies of those predicting the imminent arrival of an American Renaissance."[35] There were obvious advancements in the decentralization of the art world. Touring exhibitions such as the Whitney show brought works by leading American artists to the heartland. Dallas artists no longer felt isolated from the larger world of art. There was a conscious effort on the part of leading art institutions to promote and exhibit the work of regional artists throughout the nation. "*Creative Art* is not alone in consecrating considerable space to the 'renaissance,'" wrote Henry McBride. "There is to be much ink spilled this winter on the subject . . . The opening exhibitions of the season largely reflect the patriotic tone and the word 'American' is in big type"[36]

In addition to the Whitney's important annual survey of American art, in December 1933 the Museum of Modern Art in New York sponsored an invitational survey of works by artists from sixteen cities across America. The foreword of the catalogue to the exhibition stated, "Most of the currents which flow from Europe to America pass through New York and radiate from there throughout the country. This traffic has been too often a one-way affair. We feel that an effort should be made to restate a more even balance of trade. To do this in a concrete way we are proposing that instead of our sending you an exhibition you should send us one."[37] The fact that the works of six Dallas artists were sent to the Museum of Modern Art in New York was further evidence that American art was experiencing a renaissance – a rebirth of interest in American subjects and renewed interest in developing an art born on American soil. The exhibition, "Painting and Sculpture from Sixteen American Cities," included works by Dallas artists Carnohan, Dozier, Eisenlohr, Hogue, Travis, and Austin. A catalogue included a biography of each of the 119 artists from across the nation and a black and white reproduction of each of the works in the exhibition. Represented in the show were such nationally acclaimed artists as Ivan Albright, Grant Wood, Joe Jones, and Victor Higgins. John Ankeney selected works by Dallas artists for the exhibition. "These works offer adequate summary," Bywaters wrote in his column, "of the work being done in this region and show the stimulation of a wide variety of subject material in the southwest."[38]

The occasion of the Museum of Modern Art exhibition also prompted Bywaters to discuss his views of American art in a special commentary entitled "Making a National Art." Bywaters wrote, "This week the Museum of Modern Art, New York, reenters the race with the Whitney Museum of

American Art, the College Art Association and other national organizations, to see who can present the most inclusive 'picture' of present-day American art."[39] Bywaters saw this activity as evidence that the art world was moving "toward the realization of a national art." This article is worth examining in depth because it summarizes the issues and concerns of a regionalist artist. Bywaters found "some amusing and some serious angles" to the "mounting numbers of these advocates for provincialism in art." While he was grateful for the attention that New York art museums gave heartland art, Bywaters found it curious that "art created in Maine and California, North Dakota and Texas does not become American art until the examples are dragged from their home towns, assembled under one roof and made ready for the critical puzzle solvers." He was suspicious that this new interest in art from the various regions of the nation was only a temporary diversion for New York literati who were suffering from the effects of the Depression. "Now we are finding time to enthuse over our own painting," Bywaters explained, "because the dealer's market is sluggish, the strangeness has departed from modern art, and personal budgets permit travel only from county to county where it was once from country to country."

Bywaters promoted further study and exhibition of American art as a means to identify what was truly American: "There is no denying that the time is propitious for devoting our attention to American art, particularly after we have enjoyed the engrafting to our family tree of many good qualities of modern European painting. Surely our native vision would be the poorer if the European conflagration had not lighted up certain dark spots in our native scenes." Bywaters recognized the influence of European modernism on contemporary American art but yearned to see a uniquely American expression.

Bywaters' editorial included a warning that may at first seem out of character for an artist who sought to paint his own region and an art critic who promoted the work of "indigenous" artists. His concern for an art of substance and longevity was revealed in this statement: "The dangers are in trying to find the American scene and, once found (which is improbable enough), in setting it up as the best art because it is American. For, according to whether we are cosmopolite or provincial, nationalism can be a name for the philosophical defect of our art or it can sum up the virility of our regionally created art." For Bywaters the subject of an art work should be neither provincialism

nor chauvinism. The possibility of an art based solely on a jingoistic platform was repugnant to Bywaters, who believed in the individualism of the artist.

Bywaters assumed the role as the Southwest spokesman for and explicator of the American Renaissance. He was persuasive in the argument that the national resurgence of the arts was fueled by the vitality of Dallas art, which he called "the local hotbed of indigenous thought and action."[40] Everyone in Dallas understood that the Texas scene was the American Scene and the American Scene was the mainstream of art.

Baigell confirms that by 1933 the American Scene "had become firmly established as the most popular movement in American art."[41] In his history of the American Scene movement, Baigell discusses its forms, foundations, and intellectual framework. "The American Scene was a movement of hope and optimism, of self-recognition and self-glorification – a movement that looked to the future as well as to the past," Baigell writes. "Complex and contradictory, it represented the fervent wish that America had artistically come of age and that it would now create an art expressive of its own traditions and aspirations" (ibid., p. 18). Baigell sees the American Scene movement not as an interruption or postponement of the progress and aesthetic of American modern art but as a continuation of a general American propensity for realism and a manifestation of popular thought.

Americans in the 1930s were generally searching for a usable past and a promising future. In the midst of a Depression that shook the very foundation of American values, artists began looking closely at American subject matter to find their own identity. It was clear to Bywaters and others that local subject matter was a means to identify what is intrinsically American. There was such enthusiasm in 1933 for the discovery of a uniquely American expression that Robert Harshe wrote, "It is quite probable therefore that the naissance of American art – not its rebirth – will be dated from this decade by future art historians."[42] As evidenced by the works in the Whitney and Museum of Modern Art exhibitions, 1933 was a time in which American culture was discovered, lauded, and sometimes criticized by artists throughout the country. American artists were concerned with depicting scenes of local and regional history, landscape, portraiture, and folklore in a manner that rewove local strands into the larger American fabric. In general terms artists consciously recorded and commented on the American scene. This national propensity was evidence of a culture becoming aware of itself.

Accompanying this growing consciousness of America as a unique culture was an attempt by artists to develop a democratic art easily accessible to the ordinary person by means of commonly recognizable images. This insistence that art be accessible and understandable to the public was voiced in Bywaters' plea that art be "relevant." Painters of the American Scene insisted that their art be readable and relevant. Artists in the 1930s were propelled by an urge to provide an appropriate style for the forging of an American art. The diversity of America was accounted for in the assimilation of the frontier spirit with modern technology, the fusion of the individual with the machine. In the rediscovering of America, artists sought an art that would accommodate complex social phenomena with individual expression. Artists were in search of a way to express the past and present realities as well as American values.

Also implicit in the American Scene movement was the acceptance of environmentalist theories to explain and justify art. Bywaters and his colleagues understood environment to be the social, intellectual, psychological, physical, economic, and political currents in human society. A profound concern for the American environment lay at the heart of the American Scene movement. This concern arose along with a new sense of nationalism. The local interpretation of the environment found in paintings of regional subject matter satisfied this nationalism. Art of the American Scene became a vehicle for the encoding and the decoding of a national identity.

In 1933 Dallas artists demonstrated their abilities and participated actively in formulating a regional expression, making Dallas one of the leading art centers in the nation in the midst of the Depression. They were ready to prove themselves in a national forum. In the last days of the cold winter of 1933 an astonishing announcement came from Washington, D.C., of a nationwide program to support art and artists. The advent of a national art program was a definite confirmation of their belief that America was standing at the portal of an unprecedented renaissance in art. Bywaters and all the other Dallas artists were poised and ready to enter this promised land.

A NEW DEAL FOR ART

On December 13, 1933, Dallas newspapers began a series of star-
tling announcements. Headlines in the *Times Herald* read "Texas
Creative Artists Will Be Employed at Wages for Craftsmen –
Paintings, Murals and Statuary to Decorate Public Buildings at
Government Expense" and "Artists Plan Decoration. City Hall
and Schools to Be Adorned by Jobless Painters." The *Dallas
Morning News* announced, "Artists to Redecorate Municipal
Buildings as Government Pays Wage," with an editorial entitled

"Emergency Use of Arts." These articles outlined a simple yet unprecedented project: the federal government would pay visual artists to make art which would then become government property. According to one article, the art work would "include the decoration and embellishment of public schools, prisons, State structures and . . . may be mural decorations, paintings, sculpture and similar undertakings of an esthetic nature."[1]

Without elaborate explanation, the newspapers urged artists to begin work at once and to submit proposals for large-scale projects. The articles were not specific about who could apply for this unusual work, but one reported that twenty-seven Dallas artists had registered for projects that were to be completed by February 15, 1934. Most important, the articles did not begin to answer the larger questions concerning individual expression and public patronage. However skeletal, the message was clear: artists in Texas and across the nation in need of work had an opportunity to produce works of art for government wages. Bywaters read the announcements with great enthusiasm. He clipped the newspaper articles and anticipated receiving a government commission for an art work.

The early months of the New Deal were charged with urgency and excitement as new bureaucracies sprang into existence. In the election campaign of 1932 Franklin Roosevelt had promised a New Deal in which government would take immediate and decisive action to solve the pressing economic and social problems of a country staggering from four years of economic depression. By the winter of 1933–1934 work relief programs for the fifteen million unemployed were a well-established part of the New Deal. The Public Works Administration (PWA), the Civilian Conservation Corps (CCC), the Farm Credit Administration (FCA), the Tennessee Valley Authority (TVA), the Agricultural Adjustment Administration (AAA), and the National Recovery Administration (NRA) were created between March 9 and June 16, 1933. Two of the New Deal agencies, the Federal Emergency Relief Administration (FERA) and the Civil Works Administration (CWA), both directed by Harry Hopkins, provided relief assistance for unemployed artists. But, as the Dallas newspapers announced in December, there was a new federal program designed directly to employ the nation's ten thousand unemployed artists.

The plan to provide emergency aid to needy artists was devised on December 8, 1933, when U.S. Treasury official Edward Bruce invited several of his associates, eight of the nation's leading art museum directors (including Ankeney of the Dallas Museum of Fine Arts), and special guest Eleanor Roose-

velt to discuss the plight of thousands of artists and to convince the group of the efficacy of his plan for a government-supported art project.[2] Over lunch a new federal agency was founded – the Public Works of Art Project, or the PWAP. The Civil Works Administration allocated $1,039,000 to fund the project, and the Treasury Department, which had experience with large architectural commissions, was designated to administer the program. The PWAP was the first formal agency in the United States for government support of the arts. The plan was based on the understanding that art paid for by public dollars would remain in the public domain. Art produced by PWAP-funded artists would be displayed in tax-supported buildings such as courthouses, schools, and post offices. Theoretically the opportunity for government commissions existed in every state for every unemployed artist throughout the nation. Based on the structure of the Civil Works Administration, the nation was divided into sixteen regions. The art museum directors present were appointed chairmen of the regional divisions with responsibility to appoint local committees who would hire artists and administer the projects.[3]

Artists were eligible for a PWAP commission if "first . . . they were actually in need of the employment, and second, . . . they were qualified as artists to produce work which would be an embellishment to public property."[4] While the primary objective of the PWAP was relief, the founders also wanted the best art work possible in public buildings for the education, delight, and enlightenment of the American people. The issue of government support of professional artists versus needy artists, or aesthetics versus relief, remained largely unresolved through the life of the PWAP and the successive generations of related New Deal art-supporting agencies.

The director of the Dallas Museum of Fine Arts, John Ankeney, was appointed director of Region 12 of the PWAP. No record exists of the conversation at that historic meeting, but no doubt Ankeney's contribution was significant. He came to Washington as a kind of ambassador from one of the nation's vibrant centers of artistic activity. Dallas artists were spotlighted in the art press as major exponents of regionalism. Ideas expressed at the meeting about the emergence of a national art made up of regional schools were not new to Ankeney nor to the Dallas artists. Plans for the PWAP were based solidly on the values and aesthetics of the American Scene movement in that the new federal agency was to operate on the premise that art should be accessible and meaningful to all Americans regardless of locality and that art is necessary and of vital interest to the nation. These ideas were very dear to the

Dallas artists. Returning to Dallas as director of the PWAP in Texas and Oklahoma, Ankeney immediately formed a committee of museum professionals and university professors from across the region. He chose architects George Dahl and Arthur Kramer to serve from Dallas. He then established a publicity campaign to inform artists of the new opportunities for government commissions and to persuade the doubting public of the importance of government-supported art in public places.

One week after Ankeney's initial announcement Jerry Bywaters recorded his reaction to the news in an article for a Sunday art column that was titled "Walls and Wages for Artists. Recognizably a New Deal in American Crafts." His enthusiasm for the project was tempered by some reservations. He wrote:

> The plan of recognition proposed by the American civil works administration obtains a wary combination of both the medieval and industrial attitudes towards the artist. The first news given out was of walls, wages, and free materials – powerful inducements for the artist in such lean times to become a public-spirited organism while retaining his trade. On waking Tuesday the American artist must have felt the millennium at hand and may have even vowed that he, whether still life painter, window dresser or miniaturist, would lay aside his personal designs and favor public walls with his conception of government and history. After the initial surprise, local brows have become knitted for several reasons . . . work must be of a nature that will appeal to the public as worth while and preliminary sketches must be approved before the work can begin . . . But the principal worry of the artists who have never read Cennino Cennini is that a twenty-foot wall offers a challenge not suggested by a twenty-inch canvas."[5]

Despite these concerns, Bywaters proclaimed the PWAP an "amazing opportunity" and "another step in the 'American Renaissance.'"

Ankeney also believed the PWAP was an important step toward reaching a golden age in American art. Seeking public support for this new governmental project, Ankeney published a newspaper article that relied heavily on historical justification for official government art patronage and mural painting, evoking the memory of the Italian Renaissance. Ankeney insisted that painting is a necessary and vital force "to help us keep our national consciousness alive."[6] Bywaters joined Ankeney's public relations campaign and pronounced the PWAP "something of a unique answer for those who have insisted that America has neither a national art nor a national art spirit."[7] In an

article entitled "On the Public's Wall" Bywaters traced the history of mural painting from Egyptian tombs to Mayan walls and from Italian frescos to Mexican murals. Drawing on his understanding and admiration for Rivera's techniques and compositions, Bywaters offered some technical advice about how to paint a mural: "Because a mural 'belongs to the wall' it can not be designed on paper, but must rather be conceived in monumental form on the wall, being plastic or bendable to architectural interruptions. Perspective as used in easel painting must be omitted to retain the integrity of the upright wall and a vertical perspective substituted. Composition can leap the bonds of factual reality, indulging in 'montage' by bringing widely separate elements together in one panel. The drawing of the figure assumes an unwonted simplicity and flat areas of color perform wonders."[8] Bywaters provided these lessons in art history and mural technique because he sincerely wanted the PWAP to be a success. He wrote, "The reaction of the public will be of no small importance in computing the success of the venture."[9]

The one aesthetic demand made on artists who participated in the PWAP, that their work express the American Scene, was open to broad interpretation. As Ankeney observed, art work produced by PWAP artists "must come up to a high standard of excellence . . . and must be of regional or topical nature."[10] The founders of the project believed that public art must be understandable and accessible to the public and urged artists to depict scenes of local history or folklore with themes supportive of American ideals. Bywaters understood that because the murals were commissioned by the government for the public, "a lack of controversial political subject matter is certain. Ideas will derive either from history or from the peculiarities of present day life."[11] Expressing the ideology of the American Scene movement, Ankeney wrote, "The Texas artists today are offered the chance to recreate salient and socially significant events and conditions taken from our actual existence and environment. It is in their power to help us relive the bravery and hardihood of our pioneer forefathers – to rethink their ambition of a country offering a livelihood to all energetic men and to help us take a step beyond them in conquering and using for the common good the vast power developed by the machine."[12] That densely packed paragraph by Ankeney summarized the thought of an era that reconstructed colonial Williamsburg, built Rockefeller Center, and presented two world's fairs that focused on technology as the hope of the future.

The Dallas art community readily accepted Ankeney's challenge. Bywa-

ters, Dozier, Lester, Hogue, Stell, and other artists were confident and ready for a vehicle to present their work to a larger audience. These artists considered the federal art projects as a means to broaden, not restrict, their artistic careers. Bywaters, like the founders of the PWAP, believed it to be a grander and even more promising impetus for the arts than the Mexican mural project of a decade earlier. It was in the Mexican mural renaissance that American artists found confirmation of the idea of a mural renaissance for a national art. The peak of the Mexican mural activity came in 1925, when the Mexican government subsidized murals by Diego Rivera, Jose Clemente Orozco, and David Alfaro Siqueiros. Their art reflected the political and social revolution in self-affirming terms. The popularity of Mexican murals reached its height in the United States in 1932. From 1930 to 1934 the three giants of Mexican mural painting received numerous private mural commissions in the United States.

The New Deal art program was based on the success of the Mexican mural project. In retrospect this was a curious proposal because the Mexican murals, with their Mexican folk art and modernist expression, were forged from a Marxist ideology. Painting public walls became the means for Mexican artists to convey their messages of social revolution. Rivera's strong, dynamic history paintings presented a bold, readable lesson intended to be accessible to the masses. The Marxist ideology notwithstanding, American artists found the Mexican experiment a viable resource as a model for a government-supported art program.

The presence of major works by leading Mexican artists promoted the idea of mural painting in the United States, but their presence was not without controversy. In May 1933 one of Rivera's murals, *Man at the Crossroads*, was covered and then removed from public view. The infamous battle of Rockefeller Center ensued when John D. Rockefeller objected to Rivera's blatant condemnation of capitalism and the inclusion of Lenin in the mural commissioned for the new center. The scandal focused for Americans the larger questions revolving around the issue of an American mural renaissance.[13] Questions that circulated in American thought included "What would American murals by American artists express?" and "Is it American to have freedom of expression in art or controlled expression?"

In general, American artists and patrons, both public and private, wanted an art that was pleasing to everybody and offensive to none. This policy would

uphold traditional values and satisfy the Depression maxim that everyone should work together. Traditionally American art did not have a propensity for heavy-handedness and was viewed by most as a nonpolitical medium. What Americans of the Depression era most feared about a government-sponsored art project was the possibility that it could become a voice of a monolithic government. Artists were wary of a project that could possibly force a stylistic straitjacket on them. They shuddered at the term "official art" as the examples of propaganda of Fascist Italy, Nazi Germany, and Communist Russia became visible.

Bywaters and other Dallas artists welcomed the opportunity to earn a PWAP paycheck by placing a permanent mural in a public place; however, they were aware of the arguments circulating about the pros and cons of an official art. They continued to paint local subjects in the style that they had used to obtain recognition from the art world. They welcomed the opportunity to promote their artistic careers with government commissions. They saw their art as part of a national movement, a positive force that would further both the acceptance and availability of art in America but also uplift the morale of a depressed nation.

Ankeney assigned projects to artists of his region as soon as he could secure permissions for the use of public spaces. Preliminary sketches were required of the artists, and the commissions were approved at the district level. Just two weeks after the PWAP was announced, nearly every artist associated with the Dallas art community who did not have a full-time job received a PWAP commission.[14] At the Forest Avenue High School in Dallas Otis Dozier completed two 6-by-14-foot murals depicting scenes of agriculture, horticulture, and mining. Tom Stell went to work on two easel paintings for the same school, glorifying the heroics of the Alamo and the surrender of Santa Anna. Paintings by Harry Carnohan, John Douglass, William Lester, Perry Nichols, Kathryn Travis, Ruby Stone, Frank Klepper, and Olin Travis appeared on the walls of the area's high schools, hospitals, and county courthouses. Dallas artists were so busy with commissions for public works of art that the *Dallas Morning News* of January 18, 1934, announced, "The weekly meetings of the Artists League are being temporarily discontinued due to the fact that so many of the artists are occupied with work on projects that must be done at night."[15] In January the Dallas Art Institute presented an exhibition of sketches for murals by twenty Dallas artists who were executing government commissions.[16] The annual Allied Arts Exhibition for 1934 was also canceled

because artists were working on commissions for public murals. There was so much interest in solving the technical problems of murals and obtaining a readable image that Bywaters began teaching a studio class devoted exclusively to mural painting at the Dallas Art Institute.[17]

Bywaters and Hogue completed the largest PWAP commission in Dallas County, a series of panels at Old City Hall. The two young artists were ready to prove themselves with a large commission. Bywaters later attributed his good fortune in obtaining the commission to his knowledge of mural painting: "It was from the Mexico trip, when I saw Orozco and Rivera and the rest of them, that I remembered a lot about what a good mural painting could be – how to simplify things; how to arbitrarily make them hold up for great distances; how to make strong compositions."[18] Charged with the task of presenting the history of Dallas from the building of the first log cabin to a city of skyscrapers, Hogue and Bywaters collaborated on the narrative scenes with the technical assistance of Russell Bailey. Included in the mural series were scenes of a frontier trade day, the arrival of the railroad, the changing skyline, and the building of the viaduct bridge on the Trinity River. The artists were commissioned and paid for work on four panels, but with energetic zeal they finished twelve panels that filled the second-floor lobby. The artists could not work on the murals during business hours, so the large project was completed at night. The panels presented a complicated, yet readable, chronology of the development of industry, architecture, and culture in Dallas.

Bywaters and Hogue studied the history of the early development of Dallas County to achieve an accurate depiction of historic detail. The first panel depicted two Tonkawa Indians watching from a hiding place as John Neely Bryan built his cabin. The next panels incorporated the early settlers crossing the Trinity River and a frontier trading scene of French immigrants who came to settle old La Reunion colony. The mural chronology included the coming of the Texas Central Railroad and the building of a modern city.[19] The artists' efforts did not always satisfy their audience. "On some occasions," Bywaters recalled, "we would paint a little bit later in the early morning, people would come in and we would have to put up with their comments about what we had done in the last few days. They would have corrections to make about the way some house was built or if we were doing something that had to do with mechanics, they'd tell us about how the early trains looked."[20]

Despite the insignificant mistakes in details, simplified figures, and awkward compositions of the murals, the efforts of the artists were praised by

PWAP chief Edward Bruce and Thomas Hart Benton. When the venerable regionalist Benton arrived in January 1935 to lecture to the members of the Dallas Museum of Fine Arts, he inspected the new murals in City Hall and reportedly said, "I've seen enough art in my time to be sick of most of it and yet I found your Dallas City Hall job interesting. If you want any art to grow through the efforts of such men as Bywaters and Hogue. In spite of all cultivated whoopings to the contrary art cannot be imported. It has to grow. Keep your plant and water it." [21]

Benton's positive assessment of Bywaters and Hogue's efforts was tantamount to a benediction. Benton's face had appeared on the cover of *Time*, and his trip to Dallas made even the skeptical take notice of the advanced state of the art of the region. Benton's presence in Dallas and approval of his work crystallized Bywaters' ideas on the renaissance of art and the role of Dallas artists in that renaissance. Bywaters used his newspaper column as a forum to discuss regionalism and claim Dallas artists as leading practitioners of regionalism.

Months before Benton's visit to Dallas, Bywaters had completed a PWAP mural commission in his hometown, Paris, for a new public library. "Engaged again by PWAP," Bywaters wrote in the *Paris News*, "I requested the regional director to place me for work in the library at Paris since that agency was eligible to receive such work without cost to it. This was agreeable with the Board of the Library and I met with them to decide on where the paintings should be placed and what subjects should be chosen." [22] Four 3-by-6-foot panels were commissioned. Two panels located in the children's section of the library pictured the Texas heroes Davy Crockett and John Chisum, both of whom had historic roots in Paris. For the adults' reading room Bywaters chose subjects related to "the fire of March 21, 1916, an event that changed the development of Paris." For example, he portrayed a family saving their possessions from the fire and other dramatic scenes that were met with approval from the townfolk. For each of the panels Bywaters carefully researched period costumes and town buildings in order to make the murals as accurate as possible. The Paris murals were stylistically indebted to the work of Diego Rivera in the use of broad, flat shapes, shallow space, and colors limited to earth tones.

Dallas artists completed PWAP commissions throughout the state with a high degree of technical competency and creative fervor. Otis Dozier received a PWAP commission for two 10-by-7-foot panels entitled *Applied Bi-*

ology and Pure Science for the library at Texas A&M University. Vernon Hunter received a commission for a series of murals on frontier life for the new courthouse in Fort Sumner, New Mexico. Ankeney also secured PWAP funds for a decorative stage curtain for the auditorium at Fair Park. A husband-and-wife team of artists, Maurine Chanty and William Anderson, painted the allegorical scene *Modern Texas* on the 65-by-37-foot curtain. This commission was one of the largest PWAP projects in the United States.[23]

The PWAP created a whirl of activity across the nation that lasted only seven months. Artists chosen by the regional committee were given two months to complete their work at $26.50 to $42.50 per week, a pay scale based on the Civil Works Administration's wage scale for skilled labor. In that short time in Texas 44 artists received much-needed paychecks, many as early as February 1934. Across the nation 3,749 artists were supported by the government at a price of $1,312,000, of which 90.3 percent went directly to the artists for 15,633 works of art.[24] The PWAP was first of all a government agency to provide needed relief for unemployed artists, and the committee for Region 12 was mindful of its mission, which accounts for the uneven quality of PWAP art works across the state and across the nation. Both professional and student artists vied for the same commissions. It became evident to many that mural painting, like any artistic form, is redeemed or condemned by the ability of the painter. Bywaters voiced his concern that "the better artists" and not "hack painters" be given the commissions.[25]

The PWAP, hastily formed by officials who were unaware of its historic significance, was never intended to be permanent, but it was assumed that the works of art resulting from the PWAP would remain in the public domain. The project's major failing was in the lack of provisions for maintaining the government-owned art. In its time the PWAP was deemed a success, and it served as a kind of dress rehearsal for the subsequent and more permanent art programs sponsored by the federal government. "It is true," Bywaters wrote a few years later, "that there [were] probably more pictorial faux pas than profound manifestations uncovered by the P.W.A.P. but this project gave despairing artists new courage, showed the public that art might have some interest for them and definitely proved that Gotham's art dictatorship was undeserved and false – New York was not America."[26]

In October 1934 a new federal agency was formed that picked up where the PWAP had left off and attempted to solve the problem of obtaining consistent excellence in art work. The Section of Painting and Sculpture of the

Treasury Department was administered by the same officials in Washington – Edward Bruce, Forbes Watson, and Edward Rowan – but the agency had a new focus and structure. The agency was established to secure art of the best quality for new public buildings through open anonymous competition for commissions. Another program, called the Treasury Relief Art Project (TRAP), was set up in July 1935 to be administered by the Section of Painting and Sculpture for the decoration of existing public buildings. A new funding arrangement for the Section ensured that artists who won the nationwide competitions would receive fair, even generous, payment for their work. Art works under Section rules were financed by 1 percent of the money allocated for construction of new or remodeled public buildings. The Section underwent several name changes from 1934 to 1943, finally operating as the Section of Fine Arts, and despite bureaucratic rivalries and occasional artistic disagreements, the business of obtaining original painting and sculpture for the public domain continued. In numerical terms the Section was impressive, returning to taxpayers over 2,500 murals, 17,000 sculptures, 108,000 easel paintings, and 11,000 designs nationwide. In Texas most of the 75 mural commissions granted from competitions were completed between 1939 and 1943.[27]

Bywaters and other Dallas artists regularly entered the competitions and received several major commissions for murals during the life of the New Deal art projects. They were convinced by their experience with the PWAP that the U.S. government was sympathetic to the needs of artists and supportive of their efforts. For Dallas artists, their decade of participation in the New Deal for art was confirmation of their importance in the American Scene movement.

THE TEXAS RENAISSANCE

In 1935 Jerry Bywaters painted a self-portrait that is remarkably revealing. The portrait is a statement of Bywaters' growing ability as an artist in the handling of subtle color, convincing form, and expressive content. The candid and arresting self-portrait presents an artist of confidence and directness. Bywaters may have been thinking of this self-portrait when he wrote in his weekly newspaper column, "Where photographs or self-portraits of artists recently revealed bearded American Matisses wearing initialed

lounging robes or berets, there has been a sudden change into sunburned sons of the soil in blue duckins with corn-cob pipes and plugs of star navy much in evidence."[1] In this presentation of his own self-image, all of the evidence of his brush with bohemianism is gone. Bywaters presented himself as a sun-tanned Texan, a new and true American artist who was neither effete nor an aesthete. Bywaters saw the same momentous changes in art and artists across the nation, and he readily participated in the strategy to make art an everyday necessity that included seeing artists as everyday people. The self-portrait is evidence that, at the age of twenty-nine, Bywaters was secure in the knowledge that his work was part of the mainstream of American art and full recognition of this fact was within reach.

While the New Deal PWAP dominated the Dallas art community through-out 1934, the activity of the art scene was as vibrant as ever. The years 1934 through 1936 were a time of debate and change. Leading art magazines pro-moted the discussion, and exhibitions at major museums across the nation provided the forum. Bywaters actively participated in the American art re-naissance as the art critic for the *Dallas Morning News*. During this time Bywaters solidified his ideas about regionalism, which he promoted in his writings and demonstrated in his art.

There were momentous changes in the Dallas art scene. The directorship of the Dallas Museum of Fine Arts changed three times within a twelve-month period as plans escalated for the completion of a permanent art build-ing in Fair Park. Dallas was chosen to host the historic celebration of the state's centennial. With an infusion of New Deal funds, the pace of the entire state quickened in preparations for the 1936 Texas Centennial. Dallas was becoming an art capital as Dallas artists continued to receive national atten-tion for their contributions to developing a regionalist expression. The entire June 1, 1936, issue of *Art Digest* was devoted to the Texas Centennial Exhibi-tion and Texas artists. An important dictionary of Texas art and artists, written by Waco journalist Esse Forrester O'Brien and edited by Bywaters, was begun in 1934 and published in 1935.[2]

During this time the discussion of regionalism in American art reached a crescendo. The December 24, 1934, issue of *Time*, which pictured Thomas Hart Benton on the cover, reported a change in U.S. sales of contemporary art: "This year the French schools seem to be slipping in popular favor while a U.S. school, bent on portraying the U.S. scene, is coming to the fore."[3] In the article John Curry and Grant Wood, pictured smoking pipes and wearing

farmer's overalls, were described as "a small group of native painters [who] began to offer direct representation in place of introspective abstractions. To them what could be seen in their own land – streets, fields, shipwards, factories, and those who people such places – became more important than what could be felt about far off places" (ibid.).

It was generally recognized at the time that regionalism in painting accompanied a growing feeling of nationalism in the United States. During the Depression there was little money for travel or study abroad; therefore, as artists became isolated, they painted the subjects and themes of their area. Nationwide the Depression was a period of introspection for the American people. It was also a time of discovery and celebration of the vastness, vitality, and variety of America. New Deal politics brought renewed confidence. The federal art projects made possible a healthy decentralization of art production.[4] The national survey exhibitions of art in the 1930s revealed the great vitality with which the American scene was being painted by artists across the country. Regionalism was thought to reveal a national identity in art. The active debate about regionalism in art generally encompassed the enthusiastic discovery of American art history and the active search for vital contemporary American art.

In February 1934 NBC Radio began broadcasting a series of sixteen lecture programs on art in America from 1600 to 1865. Ranging from colonial architecture and the art of Benjamin West to the Hudson River painters, the "Art in America" radio series culminated in a guide on collecting and a lecture entitled "Art and the Public Taste." *Art Digest* reported, "These programs are designed to appeal not only to the museum-minded and art-wise but to the people in their homes who long to know something of the art of their country."[5] The program was predicated upon the belief that the average American wants "authentic background for his artistic life without critical hair-splitting and 'arty' technicalities" (ibid.). René D'Harnoncourt directed the program under the auspices of the American Federation of Art. "Art in America" is only one example of the programming from this period that was developed to educate the American people about their own culture.

The debate also included the search to find the true and important contemporary American art. Virgil Barker, former director of the Kansas City Art Institute, wrote an article for the February 27, 1934, issue of the *American Magazine of Art* which speculated on the foundation and elements of a general American style. He concluded that the truly American in art fused "he-

redity and environment." This he found required a "significant vision" to combine technique and content resulting in an "authentic Realism." He admonished artists that "this is no exhortation to painters to go out and 'paint America.' There have already been too many instances of American painters becoming muscle-bound in self-conscious patriotism."[6]

The discussion of the day focused on the nature of regionalism. Was a regionalist artist myopic, self-conscious, and provincial, or was a regionalist artist an authentic visionary? Regionalism was generally accepted as the examination and interpretation of local and regional subject matter. Regionalism became a poorly understood and much maligned term in American art after the advent of abstract expressionism in the 1940s. In its broader sense, the regionalism of the 1930s was an honest effort to record, examine, and interpret familiar subject matter in purely artistic terms and to achieve a national artistic identity by those means. Ironically, the term was often used as an indictment, despite the efforts of painters of the American Scene to locate an American rather than a regional artistic vocabulary. Nevertheless, the term "regionalism," according to Matthew Baigell, "unfortunately stuck," and "in the eyes of both critics and the public it became identified with three Middle Western painters – Benton, Grant Wood and John Steuart Curry . . . because of this linkage, Regionalist painting came to stand for an art of rural and country views, apolitical in content, often nostalgic in spirit, and usually unmindful of the effects of the Depression."[7] Although the term did not adequately describe the Dallas artists who painted local subjects, they were nevertheless identified as regionalists. The Dallas artists succeeded in finding a truly regional painting style that dealt with contemporary themes without nostalgia or chauvinism.

In its narrowest sense regionalism describes a movement initiated by the painters Thomas Hart Benton, Grant Wood, and John Steuart Curry and championed by their spokesman, Thomas Craven. There were many native sons like Joe Jones and others who joined in the regionalist parade. The blatant nativistic iconography of their paintings and jingoism of their rhetoric attempted to isolate a purely American art uncontaminated by any European influence. In their self-consciousness the artists launched a feverish campaign against European modernism and East Coast art dealers. The negative connotations of the term "regionalism" stem from the mistaken idea that regionalism is totally chauvinistic. Bywaters and the Dallas artists did not subscribe to this narrow definition, however.

Carey McWilliams was certainly referring to the aesthetic of Dallas artists and the best of regionalism when he wrote in the July 1934 issue of the *Southwest Review*, "The Regionalist of today believes that the relationship of the artist to his immediate environment is much closer and more intimate than the artist will generally admit."[8] For McWilliams the artist must look deep into his own experience in order to create lasting and significant work, and the development of culture is ultimately dependent on "the extent to which this relationship is understood."

Bywaters agreed with McWilliams's assessment of regionalism. In his review of an exhibition of fifteen paintings by Everett Spruce at the Dallas Museum of Fine Arts, Bywaters admired Spruce's ability to identify an iconography that was specific to the region. Bywaters wrote, "Not often is there to be encountered original idiom more personal than Spruce's blasted and burnt trees, houses and barns, rocky gulches, mountains, and trailing cloud forms."[9] Bywaters carefully pointed out that Spruce's "complete treatment of native matter places Spruce's work well above that of the average indigenous painter, who depicts only the picturesque quality of his particular backwoods without attempt at interpretation." Bywaters emphasized that the regionalist aesthetic is not merely of surface and subject and pointed to Spruce's ability "to handle complex masses."

In a review of a one-man show of works by Harry Carnohan at the Sartor Galleries, Bywaters commented on the realism of Carnohan's paintings of the desolate West Texas landscape: "We find he has actually achieved West Texas in an art form while most other painters seem to be bringing us only the incidental complexion of a landscape."[10] Realism for Bywaters was defined as extracting the essence of the subject and not merely presenting a picturesque or representational or impressionistic scene.

At the close of each year Bywaters wrote a newspaper article that was a review and summation of the year's art activities. He characterized the 1934 art scene as "a desnoberizing trend which has aroused national enthusiasm."[11] He described "a tendency for artists to turn their attention to social comment, to dig into their native tradition, however unsophisticated" There is a strong current of disdain in Bywaters' writings for what he terms "art artists." He reported that "art artists and their esthetic retchings [are] decreasing much to our pleasure." For Bywaters "art artists" do not have a social conscience. Art for art's sake or art that expressed a solely emotional and egotistical perspective was unacceptable in an era of Adlerian psychology

that measured success in terms of how well one "fits in." Bywaters shared the general belief of the time that, in order for art to be significant, it must not be an impenetrable, personal introspection. Bywaters wrote, ". . . individualism as a doctrine has been losing ground. This may be a sign of creative disintegration but it is more probably a cooperative attitude that will materially assist general art appreciation." Bywaters was encouraged by a "quickening of the idea that the arts may have an essential place in normal human life" (ibid.).

When a notable art collector moved to Dallas, Bywaters saw this as a positive sign. He reported in his newspaper column that Mrs. A. E. Zonne had arrived in Dallas from Minneapolis with a substantial collection of over three hundred original prints. Artists represented in her collection included Piranesi, Rembrandt, Canaletto, Daumier, Picasso, Matisse, Laurencin, Pennell, Kent, Rivera, Bellows, Sloan, Marin, Bacon, and others. Bywaters realized that the presence of a serious collector of prints in the area was of great benefit to Dallas artists. He wrote, "If the presence of one print collector in Dallas can lead to the development of the interest among others, that collector is apt to be Mrs. A. E. Zonne." [12]

In the same article he recounted the burgeoning interest in printmaking in Dallas. That fall the 1934 State Fair included a touring exhibition titled "50 Prints of the Year." The Dallas Museum of Fine Arts was presenting a show of prints on loan from a private collector from California, and the Highland Park Galleries occasionally had print shows from the Southern States Art League. Despite these signs of interest, Bywaters complained, "Dallas has not yet shown itself overly receptive to the idea of producing and collecting prints," and he emphasized to his audience that "the print is the most inexpensive means of collecting art" (ibid.).

Bywaters was encouraged by the tempo of advances in the Dallas art community. In the November 25, 1934, issue of the *Dallas Morning News* was a photograph of a group of men and women in their twenties, dressed in their Sunday best, and appearing very serious about their careers. Pictured were eleven men and eighteen women of the Dallas Artists League. [13] The respectable appearance of the group belies the fact that they considered themselves practitioners of avant-garde art. The photograph and article marked the occasion of the arrival of a new director of the Dallas Museum of Fine Arts. Due to ill health and the pressures of his position as regional director of the PWAP, John Ankeney had resigned as director of the museum. A new direc-

tor, Lloyd Howard Rollins, took charge in the fall of 1934. Rollins arrived in Dallas at an opportune moment, and he took full advantage of his position in a museum on the rise. A museum professional, Rollins had studied at Harvard's Fogg Art Museum and served as director of the California Palace of the Legion of Honor and as director of the M. H. deYoung Museum in San Francisco. Prior to his arrival in Dallas, Rollins had been the director of the PWAP for New York City. He understood the general trend in art to be the American Scene movement and supported the efforts of artists who were practitioners of the regionalist aesthetic. He announced to the local press upon arrival that he was determined to raise the Dallas Museum of Fine Arts to a new level of visibility, centering on the issues of support for local artists, art education, public involvement in the arts, and the encouragement of private patronage.

In the fall of 1934 the Dallas Museum of Fine Arts presented a series of exhibitions that significantly affected the work of the young Dallas artists. In November the museum opened an exhibition of seventy-five works by contemporary Mexican artists. Bywaters' review of the exhibition gave him an opportunity to reiterate his view that "the aim of the Mexican artist is always to recreate his own connection with the things about him. It is not a camera snapshot for his scrapbook but a nervy physical reaction."[14] John W. Rogers, who reviewed the show for the *Dallas Times Herald,* expressed admiration for the strong combination of primitivism and modernism in the work of the Mexican artists and admitted that seeing such work gave him new insight into and appreciation for the work of the Texas regionalists.[15] The review noted that Otis Dozier recognized the synthesis of European modernism with pre-Columbian abstraction and Mexican folk expression in the work of the contemporary Mexican artists. And Harry Carnohan was impressed by the active rhythms and enlivened forms in the Mexican art. The exhibition served to generate discussion among Dallas artists about the validity of developing an expression of one's own particular region and experience.

Within a month after his arrival, Rollins curated an impressive exhibition of printmaking in America that also stimulated the interest of Dallas artists. Bywaters suggested in his review of the exhibition that local artists had lobbied the new director for an exhibition on printmaking. An exhibition of over two hundred lithographs by leading American artists opened on December 9, 1934, to an enthusiastic audience and press. "American Lithography from 1830" included works from the 1830s to the 1930s with a special focus on contemporary printmakers.[16] Prints from the Currier and Ives company

were spotlighted as examples of a uniquely American expression. Contemporary artists represented in the exhibition included George Bellows, Yasuo Kuniyoshi, John Sloan, Thomas Hart Benton, Reginald Marsh, John Steuart Curry, Stuart Davis, Max Weber, Peggy Bacon, Mabel Dwight, Alexander Brook, and Rockwell Kent, all of whom used the medium of lithography. Also included in the exhibition were prints by young Dallas artists like Alexandre Hogue, whose 1934 transfer lithograph entitled *Moonlight* pictured Rancho de Taos in dark, rich tones. Rollins was thus the first in Dallas to present an exhibition in recognition of the art form of printmaking, which was enjoying a resurgence of interest among American artists.

This exhibition not only presented excellent examples of prints for the Dallas artists to study, but it also served to intensify discussion about their own presentation of the local scene. Bywaters praised the exhibition in his newspaper column and used the opportunity to deliver a lesson on printmaking techniques and printmakers. "Many of the ablest contemporary painters of this country who have done important work in lithography," Bywaters asserted, "bring to this art something of the largest spirit of painting, better craftsmanship, emphasis on design and an originality of concept" (ibid.). He concluded that lithography is a truly American art form and advised collectors seriously to consider purchasing original prints because they were comparable in price to "a pair of shoes or a supper and dance." Harry Carnohan in the *Dallas Journal* examined the exhibition and found in it a positive influence on local artists. Writing from a perspective of years of experience in Paris, Carnohan urged artists to come back to their "promised land" of America for artistic fulfillment. He lauded the prints for their "definitive muscular structure and real human appeal."[17] In February 1935, a few months after the exhibition closed at the museum, a group of artists formed the Dallas Print and Drawing Society, which was dedicated to the production, promotion, and distribution of original prints.

The Dallas Museum of Fine Arts under Rollins's direction had a full calendar of events for the spring of 1935. Rollins presented a lecture series on art and occasionally wrote weighty art-history articles for the *Dallas Morning News*. In an effort to be progressive, the museum initiated a series of "Negro nights" which opened the city-funded museum for the first time to the city's black population. A newspaper announcement about this new service proclaimed, "It is to be understood that these occasions are purely experimental, and if the interest shown does not warrant them, they will be discontinued."[18]

The theme of experimentation continued as the museum hosted a lecture by Gertrude Stein on March 20, 1935. Bywaters found the famous poet and art critic to be wise, witty, and perfectly intelligible. "On hearing her Wednesday night," Bywaters wrote, "the large local audience elected to be more captivated than not by Miss Stein's streamlined thoughts. Behind a homey and frank delivery she explained pictures in a way at once as simple and as complex as any explanation of pictures ever can be."[19] Shortly after Stein appeared at the museum, Bywaters completed a cartoon in watercolor commemorating the event. Marla Redelsperger has aptly described the work: "The painting shows Bywaters to be a caricaturist in the best sense of the word. He has overstuffed the truth, comically exaggerating Stein's already manly face and ponderous body. The writer is presented as a masculine dwarf incongruously clad in a matron's dress and baby-doll shoes."[20] Bywaters presented an absurdly humorous picture of Stein engrossed in her own words ("If a painting is a painting and it *is* a painting can it be *anything?*") while two baffled members of the audience strain to resist boredom and seize lucidity. His caricature of Stein commented on the local audience's reaction to the spokesperson for modernism. For Bywaters there was no contradiction between his public praise for Stein and his private joke about the local reaction to her speech.

One of the most important events at the Dallas Museum of Fine Arts in the spring of 1935 was the Seventh Annual Allied Arts Exhibition. Because the previous year's exhibition had been canceled due to the pressing activities of the PWAP, the 1935 show took on greater importance. Competition was more stringent; only Dallas County artists could participate, and they were limited to five entries each in the areas of painting, drawing, sculpture, and prints. A panel of seven jurors chose 158 works from a field of 383.[21] Seventy-two artists were represented in the show. The overall quality of the work was immediately recognized. "The two-year lapse since the last Allied show may not have been a bad thing," proclaimed John Rogers in the *Times Herald*; he went on to praise the "vital quality" and "unexpected and provocative comment" of the works.[22]

The winner of the Kiest Purchase Prize for 1935 was a carved bust in black Belgian marble by Allie Tennant entitled *Negro*. The work was praised for its strength of form, powerful characterization, exquisite carving, and contemporary subject matter. Other prize winners included Otis Dozier's *Still-life with Gourd*, Harry Carnohan's *West Texas Landscape*, and Everett Spruce's

Swollen Stream. The newly established Dallas Print and Drawing Collector's Prize was shared by Jerry Bywaters and Charles Bowling. When the *Dallas Morning News* invited Alexandre Hogue to critique Bywaters' prize-winning print, *Gargantua,* he used the opportunity to humble his friend and colleague. Hogue wrote, "As for the visual qualities I would say Bywaters' values are poorly organized and spotty." Hogue's disapproval of Bywaters' technique was tempered, however, by appreciation of the artist's "ability to draw human traits into inanimate things."[23]

There were three other works by Bywaters in the 1935 Allied Arts Exhibition: an oil, *In the Chair Car*; a watercolor, *Village on San Cristobal Canal*; and a drawing, *Mrs. Bush's Place.* Carnohan saw the exhibition as a clear pronouncement of the artist's interest in "his own particular locality" and favorably compared the efforts of Dallas artists to other artists of the nation.[24] Bywaters proclaimed that the Allied Arts show was "one of the most interesting exhibitions ever to be housed by the Dallas Museum of Fine Arts."[25] In reviews for both the *Dallas Morning News* and the *Southwest Review,* Bywaters found the exhibition to be further proof of the importance of a regional viewpoint in art and confirmation that Dallas was among the leading "sectional movements toward a logical American art." Bywaters lauded the artists for discovering and painting their own backyards, but he was quick to point out that the works "are by no means merely resuscitated American genre paintings, but are interpretations of familiar and factual things through painting adequately handled as a creative medium."[26]

Amid signs of success and vibrant activity, Bywaters expressed his frustrations with what he called "Victorian notions about art."[27] He complained that "although Dallas is an art center with one of the strongest groups of producing painters in America, the number of paintings sold by these artists could be counted on a hand with the thumb and maybe a little finger missing." As art critic for the *Dallas Morning News,* Bywaters had an effective vehicle to influence public opinion and educate an art audience. In the summer of 1935, when there were few exhibitions to review, Bywaters wrote a series of potent articles on aesthetics. An editor's note prefaced the series as "articles to establish the condition of today's painters and sculptors. Prophesied is a return to the concepts of the Renaissance when artists were not merely busy journeymen, but art was at its greatest."[28] In four articles Bywaters presented the conditions that he believed must exist in order for the much-heralded and long-anticipated renaissance in American art to appear.

Bywaters began the series with "New Relations for Esthetics and Business," in which he gave his own explanation of the mistaken prejudices held among business leaders and artists. He admonished artists to leave the position "that no self-respecting painter would do art work for advertising; that the public has unfailingly bad taste; that businessmen are unimaginative and uncreative."[29] He urged business leaders to change their belief that artists are all "shiftless, undependable misfits who rather live in a garret on bread and water than accept the natural changes of progress" He blamed the Industrial Revolution for the rift between the business world and the art world. This reconciliation of views was important to Bywaters in his understanding of a new dispensation in which art would be an integral part of life. He insisted that artists must get out of the "sanctuaries such as the Left Bank, Greenwich Village, and Provincetown," and in doing so he foresaw a new relationship between aesthetics and business in a modern renaissance that would "infuse beauty into utilitarian devices." Typical of his generation, Bywaters had a sincere faith in progress and technology. He wrote, "Control of the machine and design for it is this decade's accomplished solution of the past century's frightening mechanistic problem." Implicit in his argument was appreciation of the new breed of industrial designers. He saw them as ushering in the age of thoughtful integration of art and business.

When Thomas Craven, the art critic and spokesman for a regional aesthetic in art, lectured in Dallas in 1936, Bywaters seized the opportunity to make a substantive argument for regionalism. Craven was known for his anti-intellectual and isolationist views, voiced with a chauvinistic tone that made his ideas clear.[30] Bywaters reviewed Craven's history of modern art, entitled *Modern Art: The Men, the Movements, the Meaning,* and commented on Craven's "hymn of hate toward most modern painters."[31] Bywaters attributed the popularity of Craven's ideas to "the backwash of a growing boredom for European art fandangos." In another article Bywaters made this guarded comment: "Thomas Craven of Missouri wrote an entirely diverting book called 'Modern Art,' which convinced us that one should not paint in Paris although living there is very, very exciting."[32] On the whole, Bywaters was cautiously supportive of Craven's robust enthusiasm for American art.

Bywaters certainly admired the work of the three leading regionalists in America – Benton, Wood, and Curry. Bywaters referred to Benton as a "mural painter and social observer" and praised Benton's murals for the New School of Social Research in New York. "To arty artists who forget that Ben-

ton has been through their mill," Bywaters included this advice: "Benton can be of great assistance to these art wanderers as an example of organizing in paint factors which have an intelligible meaning."[33] Bywaters' report of Benton's talk at the Dallas Museum of Fine Arts presented an interpretation of Benton's philosophy. Bywaters did not see Benton as anti-European. Whatever Benton said during his stay in Dallas, it was interpreted by Bywaters to mean "the world's art tradition must be absorbed up through the latest modern trick and then put to work setting up the happenings of the painter's home town or region."[34]

Bywaters referred often in his writings to the dawn of a revolutionary era in art, and he gave a prescription for that occurrence: "The best art is produced from acknowledging our own world rather than rebelling against it and from troubling to find out about our own environment rather than chasing around the world looking for one already set up, then it would seem that the millennium has arrived; great things can evidently be expected from the new kind of contemporary American artist. . . ."[35] He saw the American Scene movement as momentous, "the most important change in American art since the upsetting elixir called modern French art was distributed at the Armory show in 1913." His evaluation that the American Scene movement was as important as the Armory Show was not a denouncement of European modernism but a recognition of a tendency in American art toward realism and away from abstraction.

Above all, Bywaters viewed the leading regionalists as exemplars, and he instructed his fellow artists to follow in their footsteps: "The leaders like Wood, Benton, Marsh and more have known all the tricks of modernism, but were unsatisfied. They decided that the good craft of the Italians applied to ideas with social importance would lead closer to a great American art and . . . they are now finding out what is socially significant in America. They are also showing the East that there is a territory west of the Alleghenies which deserves after so long a time to be included in the American art nation" (ibid.). For Bywaters the largest contribution of Benton, Wood, and Curry was the discovery and mining of uniquely American images in art. The pioneer work accomplished by those three artists opened the way for others to continue the exploration of American subjects.

Bywaters was impressed by John Steuart Curry's depiction of "tornadoes, the circus, State fairs and tank baptisms." The examination of the ordinary, informal, and everyday seemed timely and daring. "Thomas Hart Benton

of Missouri," Bywaters wrote, "has painted large scale hillbillies, stevedores, politicians, main streets, cotton gins, oil wells and power plants." That Reginald Marsh ventured beyond the acceptable limits of genteel art and painted "burlesque show girls, subways and East side false fronts" was commended by Bywaters. Referring to Grant Wood's painting *Dinner for Threshers*, Bywaters wrote that it "depicts everything American including the kitchen stove" (ibid.). To identify the uniquely American was of great importance to Bywaters.

During this period his own art work began to explore more vigorously the subjects that identified his own region. Bywaters painted Victorian gingerbread houses, false-front main streets, abandoned railroad stations, pretentious courthouses, common weeds, and Mexican funeral processions. A 1935 watercolor by Bywaters entitled *Boneyard* is emblematic of the artist's views of the region and the Depression era. An abandoned farmhouse is surrounded by a broken windmill, a blasted tree, and a useless fence. Three broken-down Model A's are reminiscent of better times. The rural theme continued to interest Bywaters, and he produced a drawing and later a lithograph of the same subject and composition.

The clearest statement of Bywaters' views on regionalism was published in the *Southwest Review* in April 1936. Titled "The New Texas Painters," the article explained just how contemporary Texas artists fit into the national movement of art. One-third of the lengthy article is devoted to the contributions of Benton, Wood, and Curry toward the development of a vernacular vocabulary of art that is "interested only in America, its history, people, habits, and troubles."[36] Bywaters also recounted the history of art in Texas and credited early pioneers in art. Bywaters commended the older Texas artists for their use of regional subjects but condemned their use of impressionism because it "involved the sacrifice of the innate character of a place, object, or person to a ready-made method of painting" (ibid., p. 334). He found contemporary regionalists in Texas "united in their enthusiasm for the development of a regional art which shall coordinate the best efforts of previous European, American, and Texas artists in a living art of today" (ibid., p. 335). The new Texas painters to whom Bywaters referred were not eccentric modernists or reactionaries but part of a mainstream of American art interested in American life and land. Bywaters admitted that the American vocabulary was "modified under the impact of new experiences in the particular environment of Texas and the Southwest" (ibid., p. 336). Most important to Bywaters

was "the realization that in Texas, and in many other parts of America, artists have at last gained confidence in themselves and their native environments" (ibid., p. 342). Bywaters recognized that the art of his region was in step with the larger national trend of painting the American scene. Several years later Bywaters wrote about a new American school, stating, "If Benton represents the purpose, energy and objectivity of the American Scene in art, Charles Burchfield is its pioneer, Grant Wood its chief philosopher, John Sloan and Reginald Marsh its New York representatives and John Steuart Curry and Alexandre Hogue its most effective regional exponents."[37]

While Bywaters' writings convinced Texas artists that they were an integral part of the American art renaissance, the state's 1936 Centennial Exposition focused the nation's attention on Texas and spotlighted the work of Texas artists. Just as the state was becoming aware of its own unique history and character, Texas artists were celebrating it. As Bywaters observed, "Texas was a territory unlike any other, with its own peculiar destiny. Likewise, in the state's past and present there were enough individual traits to warrant the undivided attention of the creative artist."[38]

Dallas had fought hard to become the official site of the 1936 Texas Centennial Exposition. The spectacular celebration reached a total cost of $25 million. To secure the coveted position as host to the event, Dallas promised and delivered six new permanent museum buildings on the State Fair grounds. The $500,000 Ulrickson bond issue, which had passed in 1927, was finally utilized to build a permanent, modern facility for the Dallas Museum of Fine Arts. The six new museums gave Dallas a cultural cachet that aroused Fort Worth's sense of rivalry. The two cities competed for tourist dollars; as Dallas prepared for a fair of exhibitions of historic, cultural, and technological interest, Fort Worth opened a glittering array of nightclubs and dance halls. The watchword of the day was "Go to Dallas for education, then come to Fort Worth for entertainment."[39]

Dallas artists anticipated that the centennial celebration would be a glorious opportunity to showcase their work. As ardent interpreters of the Texas experience, they pressed early in the planning stage for their art work to have a large presence at the exposition. As the 185 acres of Fair Park were transformed by architect George Dahl into the Art Deco "Magic City," the opportunities for architects, designers, painters, sculptors, and muralists were irresistible. Many of the Dallas artists had completed murals for the PWAP, and they were ready to prove their abilities with important commissions for

the halls and walls of the twenty-six new exposition buildings that would become part of the Fair Park complex.

Every detail of design and construction of the exposition was controlled by architects George Dahl and Donald Nelson. To the disbelief and great disappointment of Texas artists, the architects chose foreign-born artists to execute murals, sgraffito, and bas-reliefs throughout the exposition complex. Painter Carlo Ciampaglia and sculptor Pierre Bourdelle were brought to Texas along with artists Raoul Josset, Jose Martin, Julian Garnsey, Eugene Gilboe, and Juan Larringa. Despite their weighty resumes, which impressed Dahl and Nelson, these artists, artisans, and illustrators were not well known in the larger world of art. Bywaters graciously credited them as "designers for exposition buildings" (ibid., p. 180).

Some fifty local artists were hired to assist the imported artists. Despite the economic windfall, Dallas artists were dissatisfied with the lack of artistic freedom in their roles as executors of other artists' designs. The largest disappointment for Dallas artists came, however, with the loss of the major commission for the murals for the Hall of State. The great public hall was designed to include a panoramic mural of the state's one-hundred-year history – the focal point for the entire 1936 Texas Centennial Exposition. The group of Dallas artists envisioned a mural cycle of Texas history on a grand scale.

Bywaters and a group of nine other Dallas artists embarked on a campaign to convince the exposition authorities of their artistic ability to handle the coveted $30,000 mural commission. Unsolicited, the artists completed extensive historic research and produced designs for a comprehensive mural interpretation of Texas history. Bywaters' contribution was a composite view of the arrival of the Spanish conquistadores and priests. Stylistically the design was modeled after the murals of Diego Rivera in which a sequence of events and a variety of characters are stacked onto a flattened composition. But in September 1935 Bywaters confided in a letter to Thomas Hart Benton that the prospects for a commission were not promising: "The Texas Centennial mural prospects are jammed up in politics and meager funds. Even so a group of nine of us local painters (the youngsters) have worked all summer as a group on designs and we haven't gotten a smell of a contract yet."[40] Despite repeated attempts on Bywaters' part to present the designs to the members of the exposition's Board of Control, the plans were never considered.

New York artist Eugene Savage was commissioned to complete the Hall of State murals, despite rigorous arguments by Bywaters, Hogue, and others.

Dallas artists were indignant that an "outsider" was recruited to do a job that Texas artists could do better. Savage was a competent artist, but he was unfamiliar with Texas history and had a stylistic bent toward classicism. Bywaters characterized Savage's finished murals as "adopted from the past, and in a weaker strain . . . They completely lacked individualism. They had a kind of fantasy about them which goes along with the exposition as being something unreal"[41]

Bywaters tried to solicit Benton's help in convincing the architects that they had chosen the wrong artist for the Hall of State commission. Benton was empathetic but candid about his reasons for not publicly voicing a protest. In a letter to Bywaters, Benton wrote:

> I know your work and believe you are fully capable of doing a better and more interesting job than Savage or anybody else unfamiliar with the State of Texas. I am strong for the development of regional abilities and am convinced that the major part of the Centennial work should go to you. But I am also convinced that some fair portion of the work should come to me because of my own connections with Texas and because I made the first bid for the job in 1933 . . . I cannot start jumping on a competitor whose work pleased the Centennial authorities better than mine. In addition – In Savage's own state of Indiana I did exactly w[h]at Savage is now doing in your state. I went into Indiana, on a state call and took the Indiana job out of the hands of the Indiana artists . . . if I start yelling in defense of Texas artists I am sure to get the Indiana story thrown in my face.[42]

The new Dallas Museum of Fine Arts building on the fairgrounds was completed June 1, 1936, just in time to open an impressive art exhibition specially selected to give proud Texans a large overview of the history of art and a comprehensive view of the art of their state. Bywaters had long anticipated the building of the museum and believed that it was a necessary element in the establishment of Dallas as a center for art activity. A permanent facility would not only provide stability but also act as a magnet for the art community. Bywaters supported enthusiastically "this modern educational and pleasure center."[43] Architects for the art museum, Roscoe DeWitt, Herbert M. Greene, LaRoche & Dahl, Ralph Bryan, and H. C. Knight, studied major museums in the nation. The city also sought the advice of Philadelphia architect Paul Cret and a committee from the Dallas Art Association. Bywaters served on the committee, which "compiled an elaborate list of plan-

ning requirements." It was Bywaters' hope that the Dallas museum would become "one of the most effective living museums in America" (ibid.).

Another important change at the Dallas Museum of Fine Arts was the hiring of a new director. In December 1935 Richard Foster Howard arrived in Dallas, committed to winning national attention for Texas regional art. A graduate of Harvard with a specialty in museum management and with experience at the Philadelphia Museum of Fine Art, Howard was qualified to oversee the building of the new facility, direct the activities of the museum, and promote the artists of the region.

The art exhibition at the Texas Centennial was an ambitious effort to present a comprehensive survey of the history of art. Paintings, sculpture, and prints by artists from the Renaissance through the present were on display, with special galleries devoted to American Scene painters, Southwest artists, and Texas artists. To ensure the success of the exhibition, Howard consulted with Robert Harshe, director of the Chicago Art Institute and curator for the impressive art exhibition for the 1933 Century of Progress Exposition. Texas was not to be outdone, and an astonishing collection of paintings and sculptures worth $10 million was assembled for the exhibition.

Bywaters wrote extensively about the art exhibition in his newspaper column throughout the summer of 1936 in a kind of serial art history course. He urged viewers that the art exhibition had to be "frequented several times . . . to be seen for all it is worth."[44] He praised the Italian primitives for their good design qualities and called the artists of the Italian Renaissance "the greatest of all moderns or rebels or progressives." Bywaters termed French modernism as a "Little Renaissance."[45] Bywaters' delight in recounting the history of American art is evident in his review of the exhibition of historic works and the large survey of contemporary American art. A special gallery of Southwest art included the works of Frederic Remington, Alexandre Hogue, and various Taos artists. Bywaters also reviewed an exhibition of art in the Hall of Negro Life and highlighted the murals of Aaron Douglass, which he characterized as depictions of "the historical, social, and industrial experiences of the Negro race in America. Executed in boldly patterned colors"[46]

Regarding the 184 works in the Texas gallery, Bywaters went on to proclaim the exhibition "a milestone in the evaluation of our region's art" (ibid.). Howard had appointed Hogue to recommend artists to be represented in the Texas gallery and then named Hogue a juror, along with James Chillman, director of Houston's Museum of Fine Arts, and Elsworth Woodward, presi-

dent of the Southern States Art League. Hogue was adamant that the Texas gallery represent the best work of the region. Hogue wrote to Taos artist Emil Bisttram, "The paintings shown in the Texas Section of the Museum of Fine Arts exhibition during the Texas Centennial will prove conclusively the worth of these men and others here."[47] According to art historian Richard Stewart, "From the beginning, the Texas regionalists were determined to make their work the dominant element in the exhibition."[48] Seventy-three Dallas artists were represented in an impressive display, while only thirty-eight artists from the rest of the state were included. Works by Dallas artists included Tom Stell's portrait *Miss Dale Heard*, Harry Carnohan's surrealistic *West Texas Landscape*, Lester's primitive *Oklahoma Landscape*, and Spruce's expressionistic *Suburban Landscape*. *Drouth Stricken Area* by Hogue, *In the Chair Car* by Bywaters, and *Annual Move* by Dozier were key works in the exhibition.

Subjects of the work in the Texas gallery mirrored the hard times of the Depression and the Dust Bowl. Hogue's crisp painting style was particularly adept in depicting the wind-carved banks of sand which choked the Southwest's farmland in a devastating four-year drought. *Drouth Stricken Area*, an eloquent commentary on dangerous and neglectful farming practices, was painted four years before Dorothea Lange's photodocumentary of the Dust Bowl for the Farm Security Administration. *Annual Move* by Dozier revealed the plight of the sharecropper during those difficult times. The scene is of a tenant farmer and his family packing all their possessions into a Model T for their seasonal migration to yet another contract farm. The work mirrored the hard times with empathy. Dozier remembered that, like the farmers of the 1930s, his family had been forced to leave their farm when the price of cotton plummeted in 1921. Dozier's painting could have easily illustrated John Steinbeck's later novel, *The Grapes of Wrath*.

The exhibition brought the art of the region to the attention of thousands of Texans, but the national spotlight was cast on the work when the June 1, 1936, issue of *Art Digest* was devoted exclusively to coverage of the exhibition. Peyton Boswell, the editor, announced, "This is the largest number of the *Art Digest* that has ever been printed in nearly ten years of its life and maybe most interesting to the American People."[49] The laudatory tone of the publication in describing the work of the Texas artists was confirmation that the Dallas artists were a vital part of a national movement. Boswell wrote, "America is now in the midst of one of the most expressive and glorious periods of art that

any nation has ever experienced. Some of the artists who in the future will be recognized as leaders of this renaissance are burning their candles under baskets, but not through any fault of their own. It is time that the baskets were snatched off by the boasted metropolis." Boswell concluded his editorial with an astonishing salute: "Artists of the West, if you deserve it, the nation is yours!"

Throughout the entire issue the bright light of the Texas regionalists shone. The magazine reproduced numerous works in the exhibition, including Dozier's *Annual Move*, Bywaters' *In the Chair Car*, Hogue's *Drouth Stricken Area*, Spruce's *Suburban Landscape*, and Lester's *Oklahoma Rocks*. Articles by Jerry Bywaters, Alexandre Hogue, John Rogers, and Foster Howard actively participated in the "basket snatching." In an essay titled "Art of Texas Presents an Epitome of Aesthetics of Modern Age," Howard contrasted the regionalism of the past and present in Texas. He acknowledged that "even the older men painted the local scene," but he found in the younger artists a "strong, conscious and alert rebellion against the academic." [50]

In a somewhat testy article entitled "Progressive Texas," Alexandre Hogue proclaimed that the speed of Texas' progress in art is in proportion to the amount and quality of local newspaper coverage. Hogue scolded Texas cities for their lack of progress, citing Houston as belonging to the South and clinging to impressionism. He cited progressive artists in Fort Worth but judged them "retarded by biased support from the newspapers." [51] He found San Antonio suffering from a "bluebonnet complex" and Austin closed-minded. Hogue credited the *Dallas Morning News* with being "chief among contributing factors in accounting for the great progress made by many Dallas artists as compared with other cities." He also speculated that Dallas artists were ahead in the race because "we rebelled earlier." Finally, Hogue praised the Dallas artists for their "robust color and linear pattern . . . devoid of false charm, empty prettiness and sentimentality" (ibid.).

Bywaters used this opportunity to write an article for *Art Digest* offering a history of the development of art in Texas and presenting an explanation of how contemporary Texas art fit into the mainstream of American art. [52] In an article entitled "Opportunity," John William Rogers wrote about the history of art institutions in Dallas as a foundation for the outstanding Centennial exhibition. In his view, the significance of the exhibition would "prove a sort of a yard stick for years in the Southwest . . . against which to measure

the lesser exhibitions, the creations of our own artists and the parade of dealers."[53]

In addition to extensive coverage of the exhibitions of painting and sculpture, the magazine covered the print exhibitions, stating that "America has seen in the last decade a revival of lithography as a graphic medium suited to the American temper."[54] Works by prominent lithographers were on display, and a large gallery was devoted to a collection of works by Texas artists Peter Hurd, Bertha Landers, Blanche McVeigh, and E. M. Schiwetz. There was great anticipation that Dallas was becoming an art capital as Dallas artists continued to receive national attention for their contributions to a regionalist expression.

This special issue of *Art Digest* celebrated more than the 1936 Texas Centennial Exhibition. Each article presented an analysis of a group of artists unified in their dedication to their region and each practicing an individual style. Their new vision of the Texas environment produced direct and penetrating statements about the harsh economic conditions and social consequences of the Depression. Their work went beyond realism to expressionism in an effort to identify the harshness of the era. For many of the artists who had come from a rural environment, nature remained a constant source of inspiration. Their observations of nature, however, did not become sentimental. Far from the misty lushness of impressionist landscapes, the artists presented the dry desolation of the Dust Bowl. Significantly, the Dallas artists were examining the plight of the farmer as subjects of their paintings at least five years before the Farm Security Administration was initiated by the New Deal to photodocument the American farmer's condition.[55]

In conjunction with the Centennial celebration in 1936 the Lawrence Art Galleries presented an exhibition simply called "Thirteen Dallas Artists" which featured one work by each of the leading young Dallas artists – Everett Spruce, Perry Nichols, Thomas Stell, Dorothy Austin, Allie Tennant, Alexandre Hogue, Otis Dozier, Charles Bowling, Jerry Bywaters, Harry Carnohan, William Lester, John Douglass, and Arthur Niendorff. Much of the work also appeared in the Centennial art exhibition. In the foreword of the small gallery exhibition catalogue Richard Howard wrote that "the eleven painters and two sculptors in this group from Dallas represent one of the most significant yet natural regional developments in contemporary painting."[56] United in their interpretation of the subjects of the Southwest, they shared character-

istic thematic material, and as a rule their forms were sharply defined in strong, clear light and their colors were borrowed from the Texas landscape. Dallas artists successfully combined realism and social content. They developed an iconography of abandoned farmhouses, empty rural towns, and people packing up and leaving to look for jobs elsewhere.

Lester and Spruce were represented in the gallery exhibition by landscapes typical of their work from that time. *Oklahoma Rocks* was painted near Fort Sill, Oklahoma, where Lester had worked briefly at a Civilian Conservation Corps camp in 1935. As official artist of the camp, Lester was assigned the task of depicting the activities and grounds of the camp. He chose, however, to paint the surrounding landscape, with its massive rocks jutting from the ground and isolated trees scattered about the scene. The interesting shapes of the landscape are presented in a vast, airless space. In contrast is Spruce's *Suburban Landscape*, seen close up in an abruptly receding perspective. The line of the stone fence sweeps into the background with an energetic force. In the distance the trees and houses are disproportionate in size. A large tree and a rushing river are painted as though they had the structural solidity of rock.

Jackrabbits by Dozier relies on crisp lines and well-defined forms to present a jackrabbit as tall as prickly-pear cactus. Anthropomorphic jackrabbits dominate the foreground of the barren landscape. Dozier accurately captured the animals' odd anatomy without being taxidermic. The color of the painting is a study of contrasts and harmonies, demonstrating the artist's ability to combine the colors of warm orange-red earth of the region with the cool grey-white fur of the jackrabbits while limiting the palette to a narrow range of values and intensities of those colors.

Charles Bowling's painting *Church at the Crossroads* pictures a typical peopleless country town which consists of a railroad crossing, church, and store. Bowling has the ability to create a vast expanse of space within a small picture. Harry Carnohan's *West Texas Landscape* displays a surrealistic world of refuse which humans have abandoned. The scene is desolate, arid, disturbing, a severe depiction of the rural Texas landscape. Both of these works suggest that the only enduring element is the land.

In the Chair Car by Bywaters was also included in the Lawrence exhibition. The subject of the painting is taken from Bywaters' childhood memories. Bywaters recalled seeing nuns traveling by train from their small convent

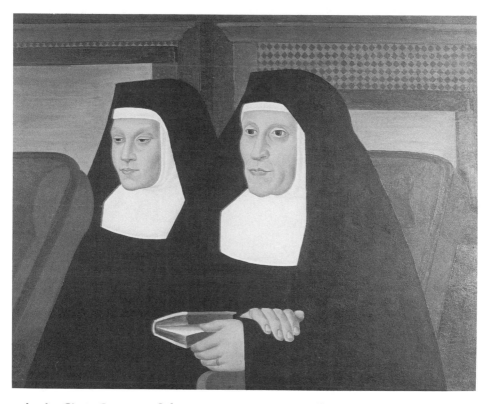

In the Chair Car, *1934. Oil on canvas. 24 × 30 in. Collection of Jerry Bywaters Cochran, Dallas, Texas. Photograph by Reinhard Ziegler.*

in Paris, Texas, to the diocese in Dallas. Bywaters painted his memory with startling modernity. The pattern of the stark black and white habits contrasts with the active patterns of the seatcovers and window shades. Throughout the unified composition is a sense of balance of color, texture, and form. The broad, flat shapes and shallow depth of the work can be attributed to Bywaters' interest in mural painting at this time.

One of the most important paintings of the time was Bywaters' *Share-cropper.* Exemplifying a popular convention of art in the 1930s, the work is not a portrait of a specific person but rather a symbol of Everyman. Symptomatic of an era with a social conscience, the painting depicts the plight of the American farmer. Bywaters used himself as the model but altered the nose and eyes to create an intense but anonymous face. The sharecropper stares coolly and directly at the viewer as a grasshopper attached to a stalk eats the

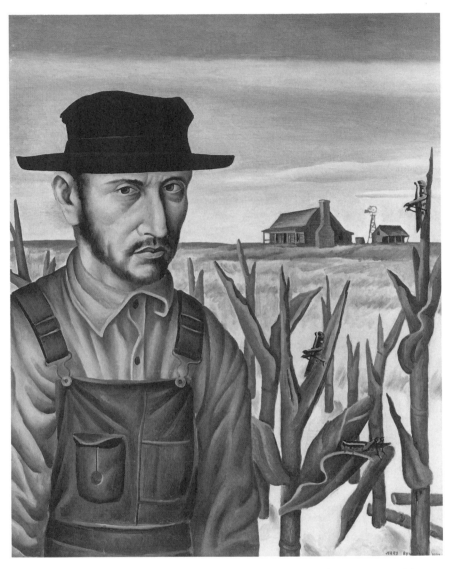

Sharecropper, *1937. Oil on masonite. 29¼ × 23½ in. Dallas Museum of Art,
Allied Arts Civic Purchase Prize, Eighth Annual Dallas Allied Arts Exhibition,
1937.*

meager corn crop. The subject was easily understood by Bywaters' contem-
poraries because it referred not only to the devastating effects of drought but
also to the unfortunate natural phenomena that accompany drought condi-
tions. Swarms of grasshoppers were known to wipe out a field of crops in a
day's time. The painting's appeal is immediate, yet the work solicits neither

sympathy nor pity. There is dignity and steadiness about the figure. A contemporary review commended the painting as a timely symbol of a man "discouraged, dogged, but undefeated."[57] The work remains emblematic of American virtues without sentimentality.

The criteria for significant art for the Texas regionalists consisted of these parameters: the work must reflect the region in subject and spirit; the artist must present a personal interpretation of the subject; beyond an exercise of mere technical proficiency, the work must demonstrate the artist's ability to handle composition, color, and structure; and the work must successfully unite significant content with readable, substantial form. If those critical elements were embodied in the art work, the result would be a timeless, placeless expression that speaks to humanity. Bywaters summarized the aesthetic this way: "There is first the discovery of a situation or character peculiar to the region, seen through the medium of the artist's individuality; next, an understanding of the subject from within rather than an inspection of it from the distance of an ivory tower; and finally, abundant evidence that the special character of place or person has been uppermost in the evolution of the work."[58] This idea was so clearly understood by the young Dallas artists that decades later Otis Dozier was still convinced of its truth. In an interview concerning the nature of good art, Dozier said simply, "You've got to start from where you are and hope to get to the universal."[59]

BYWATERS PAINTS AMERICA

It was no surprise to anyone in the Dallas art community that Bywaters' painting *Sharecropper* was the purchase prize winner for the 1937 Allied Arts Exhibition. The painting embodied the regionalist aesthetic; it spoke of national issues in local terms. The painting was daringly political and bluntly contemporary. Above all, the work identified Bywaters as an accomplished artist. *Art Digest* reproduced the work, calling it a "forcible characterization of a Share-Cropper" and an important work "in the style that

seems to have become peculiarly Texas' own"[1] At this time Bywaters and the young Dallas artists were receiving national recognition that they were indeed creating a unique regional style, and they were anxious for this recognition to continue. The memory of the fame engendered by the art exhibition at the Texas Centennial was not enough. They wanted Dallas to continue to grow as a regional art center.

Always an ambassador for Texas' small circle of regionalist artists, Bywaters wrote an article for *Art and Artists of Today* listing the Dallas artists who, according to Bywaters, "have never forgotten their natural background and . . . returned to Texas to use their talent and training in expressing reactions to their own native environment."[2] Bywaters' writings of the day as art critic for the *Dallas Morning News*, art editor for the *Southwest Review*, and a free-lance writer for art periodicals amply document his views on aesthetics and his promotion of the art of his own region.

From 1937 through 1942 Bywaters grew in confidence and ability as an artist. Most of his important paintings and murals were created during this brief period. He continued his commitment to examining the subjects of his own region. A contemporary critic wrote that Bywaters was "one of the staunchest believers in the regional art of Texas, he not only develops it in his writings, but in his teaching tries to get his pupils to see the importance of their own environment and in his own painting seeks to present the symbols of this region whether they be landscape, people or the interesting old houses and county courthouses for which he has a fondness."[3] Bywaters' prints, paintings, and murals from this period are strong and indicative of a mature artist. When he was at the peak of his artistic expression, his art in subject and style most closely fit his ideas of a regionalist aesthetic. Bywaters wrote, "This most recent trend in our art, variously called popular art, the American Scene, and the American Renaissance has been in reality nothing more than a desire on the part of the American artist to paint what he knows best, his own surroundings and the doings of his own people."[4] Bywaters identified in his art what he knew best – the land and the people of the Southwest.

In 1937 Bywaters resigned from teaching classes in art at the Dallas Art Institute and took a position at Southern Methodist University as instructor of painting, drawing, graphic design, and commercial art. The small art department at SMU included classes in interior design by Mrs. D. C. Walmsley and art history lectures by Richard Foster Howard. Bywaters' commercial art students designed fashion booklets, travel folders, posters, package designs,

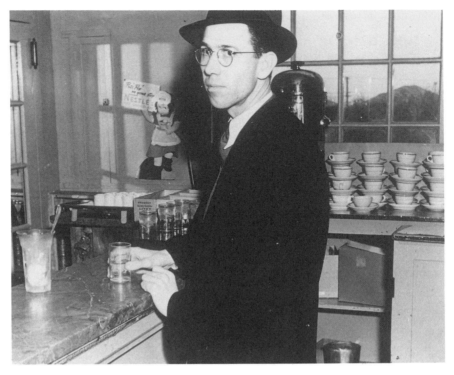

Jerry Bywaters in fedora at soda fountain at Southern Methodist University, ca. 1938. *The Jerry Bywaters Collection on Art of the Southwest, The Jake and Nancy Hamon Arts Library, Southern Methodist University, Dallas, Texas.*

fashion, wrapping paper, and other items. By the summer of 1940 the art classes had been moved to the third floor of Dallas Hall, where there were two classrooms, an art library and reading room, and a large lecture hall for art history classes.[5] Teaching had many benefits for Bywaters. The rigor of explaining and demonstrating the technical elements and aesthetic principles of art on a daily basis strengthened his own art. And his small but steady salary from SMU was welcomed as the Bywaters family grew: a daughter, Jerry, was born on June 11, 1936, and a son, Richard, was born on September 2, 1939.

As his art and teaching career and family life became more complicated, Bywaters continued to monitor the activities of the Dallas Museum of Fine Arts and to measure its relative progress in the promotion and presentation of regional art. Bywaters urged the new museum at Fair Park to use what funds

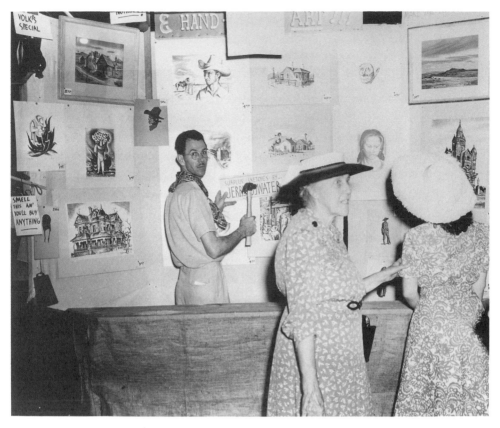

Jerry Bywaters at Alice Street Art Fair with prints, 1941. *The Jerry Bywaters Collection on Art of the Southwest, The Jake and Nancy Hamon Arts Library, Southern Methodist University, Dallas, Texas.*

it had to develop a collection of works by local artists. He believed that the Eighth Annual Allied Arts Exhibition presented an opportunity for the museum to establish a collection of works by Dallas artists. He wrote, "The Allied Arts exhibition has saliently made the point that perhaps its best field of endeavor now and in the future might well be the building of a good regional collection rather than exhausting limited funds and natural inclination in a vain attempt to rival the great and wealthy metropolitan institutions."[6] As the new museum faced the year with diminished city funding and meager private contributions, it was obvious to Bywaters and others who shared the dream of an active art scene that without significant support from both the public and private sectors little progress would be possible. To substantiate his argument

he wrote an article titled "Art Comes Back Home" for the October 1937 issue of the *Southwest Review* in which he promoted the establishment of regional art centers. "The admitted success of the many new regional exhibitions," Bywaters asserted, "has uncovered the fact that the public is more interested in the original art of the provinces than in provincial imitations of New York or European art."[7] It was Bywaters' ambition for the Dallas Museum of Fine Arts to break the dominance of Eastern metropolitan art centers by becoming a strong center of regional art.

After the closing of the 1937 Allied Arts Exhibition the museum presented an exhibition of one hundred original prints from Associated American Artists. Bywaters' review of the show heralded "a revolutionary departure for the distribution of original art in America in that these examples are the work of some of the leading American artists and are sold at a price no greater than that of a good book, a theatre or concert ticket."[8] Bywaters viewed original prints as a viable means to present art of quality to a broad public at low cost. Like others in the 1930s, Bywaters understood prints to be a direct means for the public to have access to affordable and understandable art.[9]

During the print exhibition Samuel Golden, president of Associated American Artists in New York, came to Dallas to view the prints of local artists for possible inclusion in a new series of reproductions to be published. Associated American Artists promoted the production of high-quality prints at affordable prices. Golden was impressed by the quality and diversity of the printmaking efforts of Dallas artists and announced that Dallas was "one of the major sectional developments of American art."[10] Dallas artists were also featured in the June 1936 issue of *Prints Magazine*, which published the results of a survey of printmaking activity across the country. The magazine credited local print clubs such as the Dallas Print Society with stimulating interest in printmaking throughout the nation. This praise was sufficient to prompt Dallas artists to make a larger commitment to the medium of printmaking.

By November 1937 the Dallas Print Society had opened a commercial gallery called the Print Center, adjoining the John Douglass frame shop on Cedar Springs Road. Alexandre Hogue designed the modern space and supervised the operations of the gallery. The sales gallery carried a large stock of historic and contemporary prints, but its primary purpose was to promote the sale of works by local artists. Although the gallery survived only one year, it

became the center of printmaking activity among Dallas artists and helped to establish an audience for original prints.

Hogue and Bywaters led the way in Dallas by entering prints of fine aesthetic and technical ability in local competitive exhibitions. Soon Dozier was using printmaking effectively. Charles Bowling quickly mastered the technique and developed an ability to create sharp, evenly toned surfaces. As a medium, lithography was a perfect vehicle for artists to enter the field of printmaking. Novices with little technical expertise could satisfactorily employ the medium while more accomplished printmakers could exploit its complexities. For a simple black and white lithograph, the inexperienced artist merely had to draw on transfer paper and then locate a competent printer to complete the printing process and produce an edition of prints. Artists like Bywaters became more familiar with the medium and began to draw directly on the lithographic stone with excellent results. The relatively simple and inexpensive medium of lithography was tailor-made for the needs of both artists and art collectors in the wake of the Depression.

As the number of printmakers in the region increased, a group of "the more adventurous Dallas artists" banded together in May 1938 to form an organization modeled after Associated American Artists.[11] They called themselves the Lone Star Printmakers. This group of men produced and published editions of their own prints and circulated touring exhibitions of the original prints for four years. Founding members of the Lone Star Printmakers included Jerry Bywaters, Alexandre Hogue, Charles Bowling, Tom Stell, Otis Dozier, E. G. Eisenlohr, Olin Travis, William Lester, Perry Nichols, Everett Spruce, Harry Carnohan, Mike Owen, H. O. Robertson, John Douglass, Reveau Bassett, and Merritt Mauzey. By its third year the group also included Ward Lockwood, Don Brown, Edmund Kinzinger, and William Elliott. The artists used printmaking to express their distinctive, individual styles. Later in 1939 a separate group of women printmakers formed a group known as the Printmakers Guild because they felt excluded from joining the Lone Star Printmakers.[12]

Bywaters praised the project for restoring the print "to its popular and historical place alongside the printed book."[13] In an effort to distribute their art to a wider audience, the group discovered that an exhibition of original prints on paper is less expensive and less cumbersome to ship and exhibit than a show of paintings. Bywaters explained in a review of the Lone Star Printmak-

ers' first exhibition that "a first exhibit of thirty unframed black and white prints was offered to any regional museum, college, or study group willing to purchase one print and pay the small express charge necessary to secure the exhibit from the previous exhibitor."[14] The project was well received; the first folio of prints by fifteen artists was exhibited in 1938 at twenty-three locations throughout Texas, Colorado, Oklahoma, and Louisiana. From the first tour 184 prints were sold, with Jerry Bywaters and Reveau Bassett topping the list of individual sales. Prices for the original prints ranged from five dollars to eight dollars, and editions were usually limited to fifty. The circuit exhibitions served to expand the audience for printmaking in Texas.

The Lone Star Printmakers caught the attention of Carl Zigrosser, a New York print dealer known nationally for advocating printmaking as a democratic medium for distributing high-quality art to the public. Zigrosser managed the Weyhe Gallery and sold prints from the Lone Star Printmakers portfolios on consignment. He demanded high standards in print quality and content. An author of several books on the history of printmaking, Zigrosser visited Dallas in 1939 when he was making a survey of printmakers in the United States on a Guggenheim fellowship. Zigrosser interviewed Bywaters and in 1940 wrote a lengthy article for the *Southwest Review* on contemporary printmaking in Texas. After describing the peculiarities of life in Texas, Zigrosser stated, "It is against some such complex background that the Texas artists strive to realize themselves."[15] He found the Dallas artists the strongest "because they are articulate and banded together, and because they have had understanding and sympathetic advocates in the press" (ibid.). Zigrosser highlighted Bywaters' prints in the article and proclaimed, "Bywaters has passed through the experimental stage and has arrived at a sound and effective conception of graphic art" (ibid., p. 58).

Gargantua, Bywaters' first attempt at printmaking, had won the prize for prints in the 1935 Allied Arts Exhibition. Bywaters simply drew the image on a piece of transfer paper and contracted a local printer to produce a lithograph of the image. Perhaps it was the combination of inexpensive paper and poor technique that prompted Zigrosser to comment that "his early prints, largely transfer lithographs, do not plumb the textural possibilities of the medium" (ibid.). Prints allowed Bywaters a degree of humor or satire, which were often off limits for the more serious medium of painting. *Gargantua*, a caricature of an overstuffed Victorian house, effectively used exaggeration to make a point. Bywaters found humor in the curious mix of architectural styles

that dotted the Texas landscape and small towns. "No greater paradox has ever been seen on the Texas plains," he claimed, "than Gothic Cathedrals serving as courthouses, or wives of ex-cowhands speaking French in the Chinese drawing rooms of Romanesque mansions."[16]

Bywaters also poked fun at stuffy high culture in a lithograph titled *Opera at Popular Prices*. This 1936 work is a cartoon about a traveling opera company's performance in Dallas. The scene is drawn from the distant vantage point of the cheap seats, where the melodramatic action on stage is barely visible through a screen of bobbing heads, ceiling fans, and light fixtures. Bywaters pictured his friend Otis Dozier sitting in the upper gallery of the audience. This gentle spoof is Bywaters' commentary on the coming of high culture to the former frontier town. *Opera at Popular Prices*, produced in an edition of thirty, was sold for three dollars at the Alice Street carnivals.

Through Zigrosser, Bywaters was introduced to a professional printer and excellent craftsman, Theodore Cuno, who helped him produce fine-quality prints in traditional crayon lithography. Cuno was a respected printer who worked with a number of the nation's best artists from the basement of his modest row house in Philadelphia. His careful attention to detail and technical ability resulted in prints of excellent quality on fine paper. The long-distance printing process was arduous. Cuno shipped grained stones to Bywaters in specially constructed boxes. After Bywaters completed his drawings, he mailed the stones back to the printer with written instructions. Proofs were sent to Bywaters for his approval, and finally the editions were printed. The delay was considerable, but the results were worth the effort. Bywaters later worked with Laurence Barrett of Colorado Springs using a similar procedure. These prints sometimes have the initials *J B* in the lower right corner and are always signed, numbered, and titled in pencil. Some but not all of Bywaters' lithographs have a printer's mark.

Bywaters found printmaking a fitting vehicle for his regional themes and an accessible means of reaching the public. The informality of prints was perfect for art that dealt with everyday aspects of the local environment. *Election Day in West Texas*, a 1938 lithograph in an edition of fifty, is reminiscent of the best genre scenes of George Caleb Bingham as Bywaters documents the important activity of democracy on the steps of the general store in Balmorhea, Texas. Bywaters' prints are narratives with the leaven of humor and insight into the character of the region.

Bywaters' strong portrait of western life entitled *Ranch Hand and Pony* was

Election Day in West Texas (also called **Election Day in Balmorhea, Texas**), *1938. Lithograph, ed. 50. Image 11 × 15¾ in. Dallas Museum of Art, gift of Violet Hayden Dowell.*

exhibited at the 1938 Venice Biennial Exposition of American Graphic Art. A close-up portrait of a stern cowboy and his saddled horse is pictured against a vast fenced prairie. Zigrosser wrote Bywaters that he liked the piece.[17] Some of Bywaters' best images from this period include *Country Store, Hye, Tex.,* which presents a sympathetic document of country life. This lithograph pictures an elaborate false-front main street with a store, a post office, a telephone pole, and a windmill. The country store at Hye remains today exactly as Bywaters depicted it in 1942.

One of Bywaters' most popular prints was *Texas Courthouse,* which presented an elongated composite of the courthouses of Wise and Denton counties. This synthesis of forms composed a telling statement about the elaborate buildings that preside on the squares of small Texas towns. "I had always been interested in architecture," Bywaters later wrote, "both early and contemporary, as the tangible reflection of peoples and times. So it was logical for me to record old buildings graphically, but I 'adjusted' their character – making

Texas Courthouse, 1938. Lithograph, ed. 50. Image 20 × 14⅛ in. Dallas
Museum of Art, Dr. Sam Driver Purchase Prize, Ninth Annual Dallas Allied Arts
Exhibition, 1938.

courthouses taller because they dominated the little towns on the flat farm-lands . . . In the lithograph 'Texas Courthouse' I attempted a sympathetic synthesis of all such intriguing structures."[18] The 1938 lithograph endures as a strong image which speaks of ambitious cultural aspirations.

Bywaters may have sketched the courthouses and the country store on one of his many trips throughout Texas and the Southwest. He was fascinated by the "vast area extending from Marathon and Alpine south for some seventy miles to the bend in the Rio Grande River . . ." (ibid., p. 28). He often traveled to the Big Bend area on sketching trips with Dozier and Hogue. Bywaters used lithography as a means to depict the dramatic landscape of this area of Texas in works such as *Adobe House and Ovens* (1939), which pictured the buildings of molded adobe blending harmoniously with the surrounding landscape. The shapes of the distant mountain range are repeated in the adobe houses and outdoor bread ovens. Other lithographs that explored the vast West Texas landscape were *In the Big Bend* (1934), *In the Mountains* (1942), *Ranch in the Big Bend, Chisos Mountains* (1941), and *Rain in the Mountains* (1941), which presents a dramatic shaft of rain in the distant mountains across an expansive prairie – a scene that Bywaters would return to in pastel and watercolor.

He looked for images that characterized the region. In 1937 Bywaters pro-duced a small watercolor called *Mexican Cemetery, Terlingua*, also called *Terlingua Graveyard*. Bywaters recognized the adobe tombstones, wooden crosses, and handmade shrines as folk art of importance. Bywaters' work ac-knowledged the unique cultural expression as well as an appreciation of the cemetery's sculptural forms. Two years later Bywaters reworked the image into a lithograph called *Mexican Graveyard* in an edition of twenty-two. Stew-art regards the 1939 print as a "more sophisticated arrangement of forms and shadows" than Bywaters' other prints of the same period.[19]

The second annual portfolio of prints produced by the Lone Star Print-makers was composed of thirty lithographs. The *Dallas Morning News* re-ported that "securely entrenched in the frontline of printmakers is Jerry By-waters whose four lithographs in this series continue to heighten his artistic stature. A magnificent sense of space is achieved in the background of plains and mountains of *House in Taos*, adobe structure with its little patch of corn in the foreground. Well articulated is *False Fronts – Colorado* imposing fa-cades on dinky little shacks, while *Mexican Graveyard* is distinguished for its

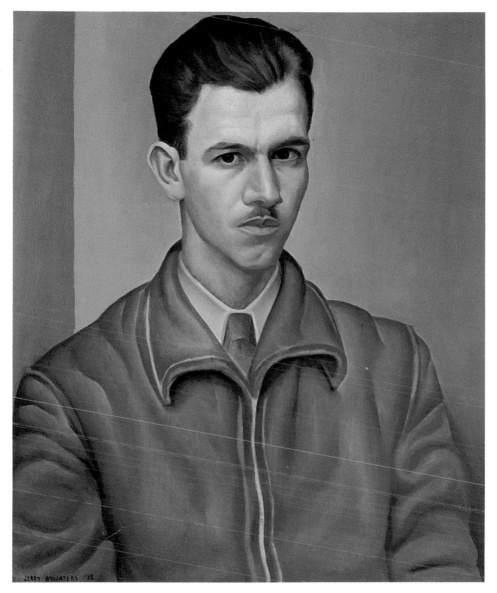

Self-Portrait, 1935. *Oil on plywood.* 19⅞ × 23⅝ *in.*
Dallas Museum of Art, Dallas, Texas, gift of Mr. and Mrs.
Duncan E. Boeckman in honor of Mrs. Eugene McDermott.

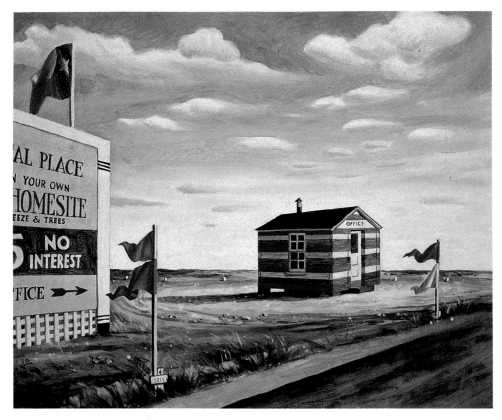

Texas Subdivision, *1938. Oil on masonite. 20 × 24 in.*
Collection of Jason Schoen, New Orleans, Louisiana.
Photograph by Reinhard Ziegler.

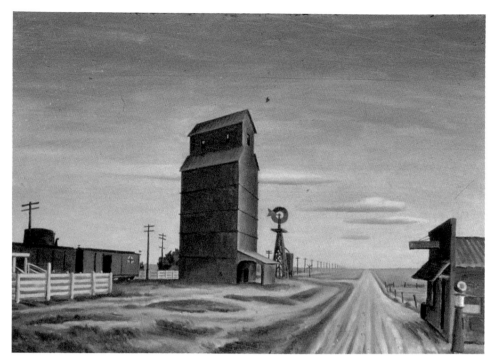

West Texas Town, Adrian, 1938. Oil on canvas. 18 × 24 in.
Collection of Henry M. Halff, Arlington, Virginia.

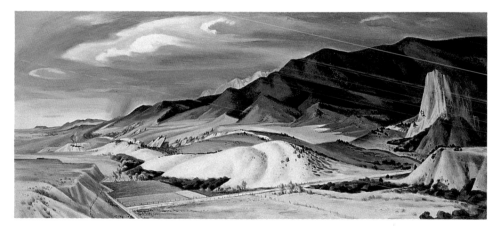

Where the Mountains Meet the Plains, 1939. Oil on masonite. 18 × 40 in.
Gift of the 1939 Senior Class, University Art Collection, Southern Methodist
University, Dallas, Texas.

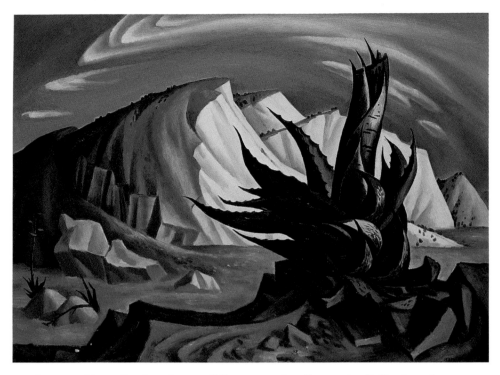

Century Plant, Big Bend, 1939. *Oil on masonite. 18 × 24 in. Collection of Henry B. Stowers, long term loan to the University Art Collection, Southern Methodist University, Dallas, Texas.*

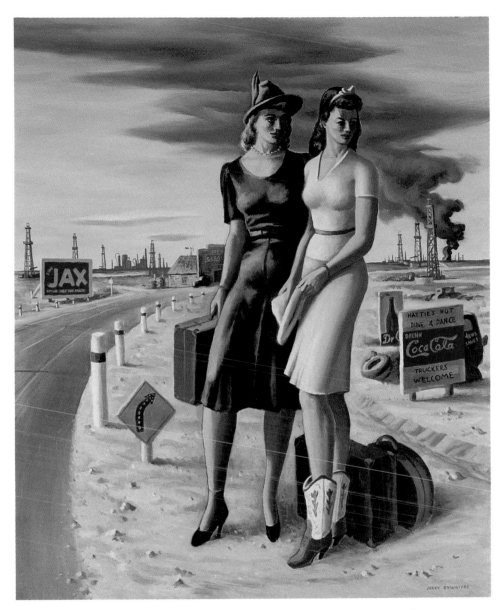

Oil Field Girls, 1940. Oil on board. 30 × 25 in. Archer M. Huntington Art Gallery, The University of Texas at Austin, Michener Collection Acquisition Fund, 1984. Photograph by George Holmes.

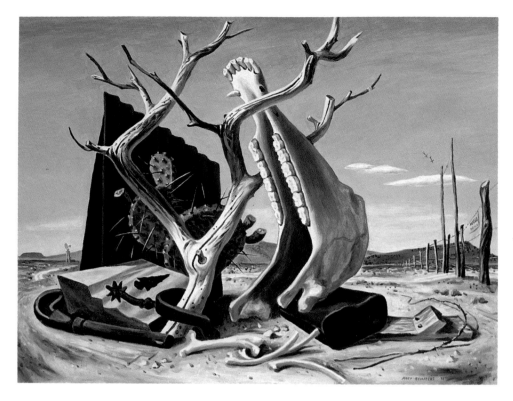

On the Ranch, 1941. *Oil and tempera on masonite. 19⅞ × 25⅞ in. Dallas Museum of Art, Dealey Prize, Thirteenth Annual Dallas Allied Arts Exhibition, 1942.*

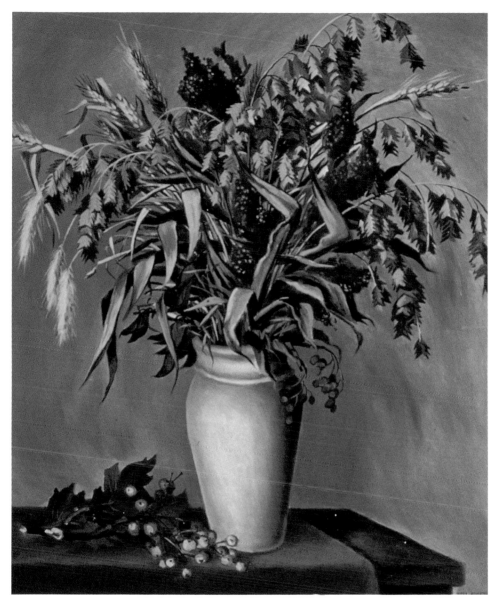

Autumn Still Life, 1942. *Oil and tempera on masonite.* 24 × 20 *in.*
Collection of Katie Bywaters Cummings, Arlington, Virginia.

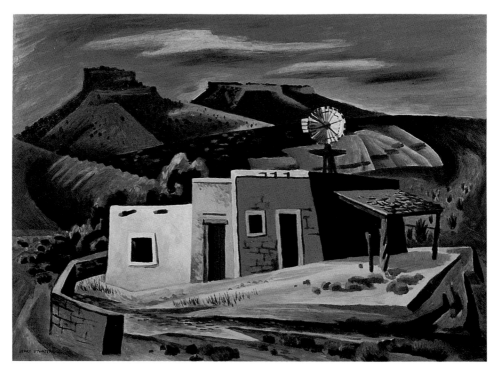

Houses in West Texas, Big Bend, 1942. *Oil on masonite. 18 × 24 in.*
Collection of Richard Bywaters, Dallas, Texas.

Autumn Cotton Fields, 1973. *Oil on canvas. 24 × 36 in.*
Collection of Richard Bywaters, Dallas, Texas.

pattern of crosses wreathed or draped. There is finally the portrait study of a *Negro Girl.*"[20]

Bywaters' travels to New Mexico and Colorado are reflected in such prints as *House in Taos* (1940) and *Left Behind* (1940). He searched for the American vernacular and found an artistic vocabulary in views of small-town main streets. *False Fronts, Colorado* (1939), in an edition of twenty-two, received a prize from the Dallas Print Society in 1941 at its first statewide juried competition. Later in the 1940s Bywaters completed oil paintings of similar themes. He also produced identical images in lithography and watercolor of Divide, Colorado, a mountain town.

Prints from this period also included figure studies. *Man and Maguey* (1938), *Mexican Mother and Children* (1936), and *Lily Vendor* (1938) are stylistically related to the work of Diego Rivera, but Bywaters demonstrates his own unique ability to capture solid form with a few well-placed lines. These works are simple statements of character types that identify for Bywaters the essence of the region.

On one of Bywaters' sketching trips to the Big Bend with Otis Dozier, the two artists discovered a new medium to record the landscape. In a later interview Bywaters recalled, "It was so hot, often 110 degrees, that watercolor was not good. So we began to work in the medium of pastel. Pastel was particularly good because the colors themselves have a kind of chalky quality and they are dry."[21] As much as they appreciated the texture afforded by pastels, Bywaters and Dozier were disappointed by the commercial colors. Unable to achieve the gradations of browns, greys, siennas, and umbers of the southwestern landscape, the two artists began to make their own pastel colors. They had learned from Frank Reaugh how to blend dry pigment with glue and mold it into usable sticks. Bywaters made small pastel drawings that satisfied his desire to record composition, color, light, and texture of the southwestern landscape. It was also during this period that Bywaters began to take his Kodak camera on trips west. He photographed not only his travel companions in candid and posed portraits but also the landscape, the highway, small towns along the way, cactus, and ranch gates. He used the camera as a kind of sketchbook. His numerous scrapbooks filled with photographs were a source of material and visual clues to the light and images of the landscape.

In November 1937 Bywaters had a solo exhibition at the Lawrence Galleries in Dallas that was praised by art critic Frances Folsom in the *Dallas Morn-*

ing News for catching "the spirit . . . of the locality."[22] The works in the exhibition documented his excursions to Colorado, Montana, and New Mexico as well as the Big Bend and Panhandle areas of Texas. A 1937 series of pastel landscapes, including *Study Near Butte*, *Christmas Mountains*, and *Chisos Mountains*, demonstrated Bywaters' ability to create monumental form in a small format. His pastel palette grew from the earthen colors of the landscape. Like many of Bywaters' small pastel paintings, *Top of the Chisos Mountains* presents a simple but strong composition. A sculptural yucca in bloom in the foreground is silhouetted against a mesa in the background. Watercolors in the exhibition included *Butte Mine Study*, *Farmer's Branch*, *Fort Davis Ranch House*, and *Captain Dilly's Mansion*. Art reviewer Frances Folsom wrote, "A careful survey of the works displayed reveals the fact that Mr. Bywaters' strongest characteristics are a feeling for composition, an excellent sense of humor and an understanding of form." The only weakness in Bywaters' work, according to Folsom, was a "failure to impart movement to his objects" (ibid.).

A year later Bywaters had a solo exhibition at the Hockaday School in Dallas, where Alexandre Hogue was the director of the art department. There were twenty-eight works in the exhibition, including ten pastels, ten prints, five watercolors, and three oils. The *Dallas Morning News* reported that the pastels possessed the "purplish haze characteristic of the atmospheric conditions in parts of the Southwest. A ranch gate, a house in Ranchos de Taos, a New Mexican valley, a New Mexico ranch and others in Alpine, Palo Duro Canyon and the Chisos mountains have all furnished subject material for Mr. Bywaters' crayon. Simple in design and strong in color, they are eminently satisfying expressions of a large talent."[23] The extent of Bywaters' artistic talent and expertise was evidenced by the fact that he also designed, typeset, and printed the catalogue for the Hockaday show.

While watercolors and pastels served as quick memory sketches of the character and color of the landscape, Bywaters' oil paintings were more fully developed artistic statements. In oil on canvas he continued to explore his interest in the landscape and people of the Southwest.

As Bywaters witnessed the urbanization of Texas he stepped up his search to identify the character and spirit of Texas. Awaking from the effects of the Depression, the city of Dallas prepared for a future of growth. Bywaters found some gentle ironies in the promotion of land sales as he documented the burgeoning suburbs. The 1938 oil *Texas Subdivision* pictures the flat, treeless

land surrounding Dallas that was being offered to those hopeful of a better life near the city. A large, colorful billboard, numerous flags, and a tiny makeshift office stand like totems of a new religion. They symbolize the grand hopes, big deals, speculative ventures, and expansive dreams that were typically Texan. Bywaters exhibited this strikingly contemporary view of Dallas in the Ninth Allied Arts Exhibition in March 1938 at the Dallas Museum of Fine Arts.

Increasingly Bywaters pictured the landscape as a vast, indomitable place. Although he rarely pictured human figures, he suggested man's ubiquitous mark upon the land. *Ranch Gate* is an oil painting typical of Bywaters' quest to characterize the region. The painting was composed after a pastel sketch of a vast landscape that is measured and organized in human scale. In straightforward terms the painting presents the entrance to a West Texas ranch with its simple cedar-post gate, barbed-wire fence, and dirt road leading to an unseen, distant house. The broad horizon and deep recession into the picture plane suggests that this ranch is measured in sections, not acres. His painting *West Texas Town, Adrian* characterizes towns along the highway throughout West Texas. In a flat land the only signs of human life are a small general store, a towering grain elevator, and a windmill. The three parallel lines of the railroad tracks, the telephone poles, and the dirt highway rush through the town without deviating from their straight course.

Bywaters was a prolific painter during this period, but not all his Texas landscapes met with approval. Regarding the State Fair exhibition in 1938, the art writer for the *Dallas Morning News* commented that "in quality and quantity, the Dallas group easily leads the rest of Texas," but she expressed disappointment in Bywaters' *Texas Farm*, noting, "This usually careful artist has tried too hard for a tricky composition, losing his proportions on the way."[24]

For Bywaters the Big Bend area offered the artist "an endless variety of plant and earth forms."[25] His 1939 painting *Century Plant, Big Bend* was a carefully composed interpretation of the region, a synopsis of the lessons he had learned from close observation of the landscape. According to art historian Becky Duval Reese, "In *Century Plant: Big Bend*, the desert plant (which is said to blossom once every hundred years) and the desert landscape are made up of harsh, angular shapes and dry, brown colors which suggest the reality of the Big Bend area."[26] Within the discipline of a solid construction, the painting is an expression of freedom. The muted colors of the desert

are harmoniously balanced. The sculptural form of the century plant virtually dances with the repetition of shapes and the rhythm of lines. The painting states emphatically that nature is not static but dynamic. The bold shapes and Southwest imagery are reminiscent of the choreography of Martha Graham in *Primitive Mysteries*. The way the objects are magnified to fill the canvas and the connection with natural forces are similar to Graham's theatrical dance. Oliver Larkin was referring to this painting in his 1949 survey of American art when he wrote, "Perhaps Orozco suggested to Jerry Bywaters how the shapes of cactus could be made to writhe against Texas cliffs"[27] Bywaters reworked the popular image in a lithograph that, although simple in line, has the strength of the painting.

An important landscape that encompasses Bywaters' aesthetic is the 1939 oil *Where the Mountains Meet the Plains*.[28] Like other artists of the period, Bywaters set out to paint the great American landscape. This painting recalls John Sloan's *Rio Grand Country* (1925), which Bywaters might have seen as a student at the Art Students' League. The two works are similar in concept, and both adopt an aerial view to present the vast panorama of the Southwest landscape. Bywaters recorded his interpretation of *Where the Mountains Meet the Plains* in the catalogue of his 1976 retrospective exhibition: "Moving to the west from the east Texas woodlands, the grassy prairie takes over near Fort Worth and continues to the high plains near the Caprock before meeting the first mesa and finally the mountains. On many vacation trips to New Mexico and Colorado, this gradual transition has always fascinated me. The return trip reverses the progression, moving from the tumultuous forms of the mountains through a series of adjustments until things quiet down to become the flatness of the cattle country."[29] Bywaters conceived of this work as an epic vision of a great sweep of landscape.

Where the Mountains Meet the Plains, which received critical acclaim and was widely exhibited, was first exhibited at the 1939 State Fair exhibition, an invitational show at the Dallas Museum of Fine Arts. It also won a one-hundred-dollar prize at the 1940 Texas General Exhibition, which traveled to Houston's Museum of Fine Arts and the Witte Museum in San Antonio. A contemporary critic wrote, "Without doubt the most impressive painting is Jerry Bywaters' West Texas landscape, *Where the Mountains Meet the Plains*. There are many larger but none so dramatic in interest, so right in realization. The vast stretches of hills and valley, Farm land, pasture, rocky terrain, and sharp slopes are strangely exciting."[30] The October 28, 1939, issue of *Art News*

reproduced the painting with the caption "Expansive landscape interpreted by a Texan."[31] The painting was purchased by Southern Methodist University and was studied by numerous art students, including artist Dan Wingren. The work demonstrated, above all, Bywaters' ability to paint the colors of the Texas landscape, which Wingren paid tribute to years later: "Today I envy more than ever his ability to make the colors of the Texas soil – the siennas, umbers, ochers and blue-greys – sing and sparkle, and I envy his ability to seize the revealing glare of Texas light with those colors."[32]

A small watercolor of 1940, *Dawn Near Tucumcari*, is a quick sketch of an expansive landscape with a low horizon filled with the pinks and golds of a dramatic Western sky. Thirty-five years after painting this work, Bywaters re-marked, "With a small set of watercolors and working very quickly, you can really put down enough material to encompass a big scale landscape . . . You can also get local color which has great variety and which is very difficult for you to remember."[33] He also completed a series of pastels in 1940 that docu-mented his vision of the West, including *Cattle Country, New Mexico; Grey Day on the Plains*; and *Navajo Country*. Two works, *Rain on the Mountains* and *Rainstorm, South Park*, picture storm clouds and diagonal shafts of rain in the desert, a subject which fascinated Bywaters. A 1941 landscape in pastel, *Near Tucumcari*, demonstrates Bywaters' ability to create a monumental con-cept in a very small format.

In 1941 Bywaters completed a study, a print, and a painting of a composi-tion that summarized his vision of ranch life in Texas. *Study for On the Ranch* in conte crayon and white tempera on brown paper located the subject and identified the essential mood of the final painting. The black and white litho-graph in an edition of twenty demonstrated how strong the composition was without the support of color. A painting of the same subject received a $250 purchase prize in the 1942 Allied Arts Exhibition. The oil and tempera paint-ing *On the Ranch* pictures a carefully arranged still life of ranch parapher-nalia against a vast West Texas landscape. A newspaper article reported, "Ac-cording to Mr. Bywaters, he has interpreted in his work 'those things which the cow punchers on the ranch are always picking up.'"[34] The article com-mended the work "not only for its accuracy but for its sparkle and imaginative grouping." Bywaters had selected objects from his own collection of "visible totems" of ranch life, including barbed-wire fences, scraps of corrugated tin, an Indian arrowhead, a discarded cow bell, and an old rusted gun. The natu-ral objects presented in the composition are equally lifeless and hard; a dry

horse skull, a dead mesquite, and a thorny prickly pear. Bywaters chose a harmonious, but startling, palette: the distant mountains are mauve and lavender, the flat sky is grey-blue, and the sculptural cactus is decisively blue. Bywaters later wrote, "I painted *On the Ranch* to symbolize the ranching country and the vast spaces always in sight."[35] In this icon of the West the general is stated in the specific. The polished surface of the painting reinforces the feeling of the dry atmosphere of the region. The formal presentation and the subject matter are inseparable.

It is interesting to note that *On the Ranch* was painted by Bywaters the same year that Georgia O'Keeffe painted *Red Hills with Bones*. Bywaters assembled a collection of incongruous objects but protested that the realistic work was not in any way related to or influenced by the controversial style of surrealism.[36] For Bywaters this painting was not a subconscious vision, but a rendition of a real landscape. Although both artists tell the story of the landscape with bones, there is a fundamental difference in approach. Whereas O'Keeffe allowed a hip bone to levitate above the landscape, Bywaters' view of the land could never accommodate such an irrational occurrence. His artful arrangement of jaw bone and ranch articles was grounded firmly in the landscape. Like O'Keeffe, however, Bywaters found monumental sculptural form in the contours of the land. Bywaters' 1941 oil *Mesa near Terlingua* isolated the abstract form of the West Texas landscape. He simplified the mesa without losing its essential form and specific presence, rendering the colors of the sandstone in smooth modulations of continuous shadings of tone.

Bywaters described West Texas as "one of the few remaining sanctuaries in the country where you can live for days without encountering another human being."[37] Houses became a symbol for Bywaters of the stalwart types who inhabited the lonely land. In a 1941 oil painting, *West Texas Ranch House*, he pictured a frame house standing bravely in an isolated, inhospitable place. The only defense from the surrounding sand is a lean cedar fence. *Yellow House with Oak Trees*, a 1942 watercolor, presents a refined cottage hugging three wind-swept oak trees. About this watercolor Bywaters wrote, "In traveling the territory I searched constantly for examples of varied styles in architecture – echoes of Greek revival, Romanesque, 'carpenter' gothic, Victorian or simple structures in the country striving for some distinction with accents of jig-saw and scroll-saw decoration as in 'Yellow House with Oak Trees'" (ibid., p. 20).

The painting *Houses in West Texas, Big Bend* (1942) was a clear artistic

statement of the abstract shapes of the mesas and plains that Bywaters found echoed in the geometric adobe houses of the region. The houses and the landscape are similar in color and form. The repetition of shapes and earth tones, the careful construction, and the ordering of planes create a harmonious composition. Dallas art critic Patricia Peck described the work this way: "With a bright blue door, the eye is led straight into the center of the picture; with skilled use of color values and line, it is carried back to the angular hills beyond, but never does it get far from the brilliant light of the mountain valley and the shadows on the squat houses."[38] This painting was a successful artistic expression for Bywaters for two reasons. First, it embodied his idea of abstraction. Bywaters consistently identified abstraction with form. As Redelsperger explains, "Whether natural or otherwise, the more order, sequence, and geometry found in the form, the more abstract it becomes to Bywaters. Abstraction is not something he invents, but something he sees."[39] *Houses in West Texas, Big Bend* is also a subject that is undeniably American, which is of utmost importance to Bywaters. The landscape cannot be mistaken for any other area of the world, and the adobe architecture is identified with the region. In an effort to offer the image to a wider audience, Bywaters completed a lithograph of the same subject in 1943 in an edition of fifteen.

While landscape remained an abiding interest for Bywaters, he also painted still lifes that embody the essence of the region. *The Provider* (1941), essentially a view of a wheat field with a still life in the foreground, is an allegory in which barnyard animals assume human qualities. The title refers to the rooster in the picture, which is standing on a shock of wheat tossing down bits of grain to several hens on the ground. The idea for the painting occurred to Bywaters as he made preparatory studies for a mural project. The careful depiction of the rooster, hens, and wheat attests to Bywaters' keen observation of nature. Bywaters recalled, "In this painting I combined egg tempera and oil glazes to secure the involved details and textures. It was a medium I came to like and use often."[40] One of Bywaters' most successful paintings in oil and tempera was the 1942 still life entitled *Autumn Still Life*. The composition is traditional, but the subject is surprisingly contemporary and undeniably regional. A bushy bouquet of native Texas grasses and weeds fills a stylish ceramic vase. The palette is derived from the dusty, dry colors of Texas autumn. The grey-green of parched leaves and the bone white of wheat are accented by the brown-magenta of sumac. In color and character the still life defined the region.

After the success of *Sharecropper* Bywaters attempted to paint the share-cropper's wife. The painting was first exhibited at the Pan American Exhibition at the Dallas Museum of Fine Arts in the summer of 1937. The work, however, lacked emotional and psychological appeal. Whereas the male figure identified a cause, the female figure was weak and uncertain. Perhaps Grant Wood's famous *American Gothic* (1930) was Bywaters' inspiration for this husband-and-wife pair, but the plight of the farmer's wife was not a strong enough issue to rally around.

There were other more successful works, both portraits of individuals and paintings of character types, that reinstated Bywaters as a painter of people of the region. Bywaters excelled in portraiture. His oil portrait entitled *Elizabeth* received a one-hundred-dollar prize at the 1939 Allied Arts Exhibition at the Dallas Museum of Fine Arts.[41] The stunning portrait of Elizabeth Williams Rucker was praised for "commanding attention for its quality of repose, its subtle palette and its finesse of execution"[42] and as "one of the best pieces" of Bywaters' career.[43] The painting certainly rivaled any of Tom Stell's portraits of the period. The figure of a slender woman wearing a white head scarf and a pink sweater was painted with precision and convincing form.

On the strength of *Elizabeth*, Bywaters received a coveted commission in 1940 from Trinity University in Waxahachie, Texas, for a portrait of Dr. Samuel L. Hornbeck, a much-loved professor emeritus of the university. Louise Long, art critic for the *Dallas Morning News*, praised the Hornbeck portrait as a success in "translating onto canvas a moment in the life of the man which seems to sum up the whole of his personality . . . It is an articulate and provocative study of a distinguished man."[44]

Bywaters not only portrayed Texas notables but also Texas common folk. *On the Beach at Galveston* (1940) is a humorous description of a couple of honeymooners on the Texas Gulf Coast. Bywaters sketched this couple while on a holiday in Galveston. The cowboy and his charming, rotund mate are West Texas types who are not used to beachcombing. In these unfamiliar surroundings the cowboy refuses to take off his hat or boots. He is a modern cowboy who is no longer corralling cattle but is hunted and shot by a commercial photographer. This is an anecdotal work, typical of Bywaters' humor. The cowboy's bowed legs are exaggerated in a manner similar to the figures of Thomas Hart Benton. Perhaps Bywaters was thinking of the Benton figures that had been shown at the Dallas Museum of Fine Arts in a large exhibition of Benton's work in January 1940.

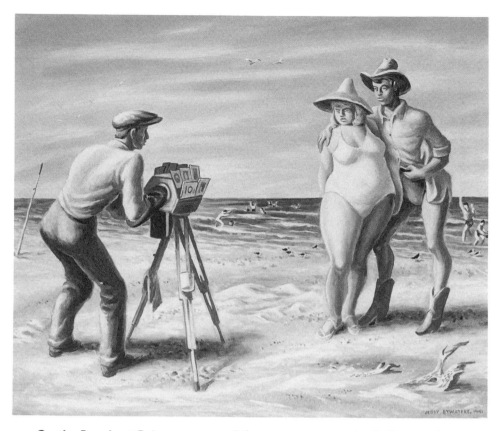

On the Beach at Galveston, *1940. Oil on canvas. 21 × 25 in. Collection of Richard Bywaters, Dallas, Texas. Photograph by Reinhard Ziegler.*

In contrast with the humor of *On the Beach at Galveston* is the monumentality of *Navajo Man, Shiprock*. This work, remarkable for its succinct characterization of a southwestern type and its three-dimensionality, was shown at the Texas State Fair art exhibit in 1940. The art critic for the *Dallas Times Herald* praised the work for its "strong compositions, . . . splendid colors, . . . mastery of paint" and for the artist's success in "injecting the third dimensional illusion to give solidity to his figures and space to his landscapes."[45] Bywaters later completed a lithograph in an edition of twenty-five of the same subject, and *Navajo Man* was as strong as the oil painting. For Bywaters the portrait of a native American was a clear expression of his desire to locate indigenous subject matter. The use of realism was central to his understanding of American art.

Just as Mody Boatright recorded tales from the oil fields and John Lomas

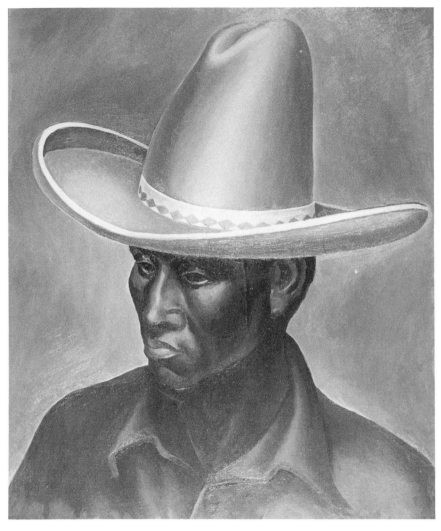

Navajo Man, Shiprock, 1940. *Oil on masonite.* 22 × 18 *in. Collection of Robert Chapman Cochran, Dallas, Texas. Photograph by Reinhard Ziegler.*

rescued western folk songs from oblivion, Bywaters identified and preserved the character of Texans by depicting emblematic figures in his art. *Oil Rig Workers* (1940), a painting praised for its accuracy and action, pictures strong men working together with massive, modern equipment. The image confirmed the American work ethic and the Depression dictum to pull together to accomplish a common goal. The status of men who work in the oil fields was elevated from roughneck to worker in this painting.[46] Bywaters also en-

dowed cowboys with the nobility of dedicated and trustworthy workers in a painting called *Testing His Stirrups* (1940). A contemporary review complained, however, that "the peculiar pungent flavor characteristic of Bywaters' work is missing here."[47]

One of Bywaters' best works, *Oil Field Girls* (1940), was acquired in 1983 by the Michener Collection at the University of Texas at Austin. *Oil Field Girls* is a painting that embraces both myth and reality while creating an unmistakably Texan image. Two young women, tall as oil derricks, are waiting at some unmarked bus stop beside a West Texas highway with suitcases in hand. An oil fire burns out of control in the background, and the landscape is a cluttered wasteland of rigs, billboards, and abandoned tires. The clear, strong light of the region and the subtle, yet distinctive, colors of the soil are successfully translated into paint. The only living things in this barren world are two curvacious young women with impossibly long legs. Bywaters ignores the traditional rules of perspective to make the figures loom large in the foreground. Billboards appear small in their presence and the vast Texas landscape becomes a vacant lot. There is a tension of exaggeration and subtlety in the painting. Both women have made a special effort to appear well dressed, wearing hats and a bit too much makeup. The blond, who seems a little older and more traveled, is overdressed in her basic black and rhinestones. She also wears an identifiable emblem of independence and immorality – the delicate but daring ankle bracelet. A neat yellow ribbon holds the brunette's pageboy in place; she wears a tight-fitting sweater and skirt and a brand new pair of red and white cowgirl boots.[48]

Despite all the feminine finery, these are sturdy, self-assured girls. They may be "working girls," but their eyes are set on some distant place, a place better suited to their taste. The signs cluttering the roadside describe the life from which they expect to escape. A contemporary art critic called this work "reportorial and graphic."[49] It is interesting to note that where Alexandre Hogue portrayed the Dust Bowl as the rape of Mother Earth, Bywaters equated the profit and pollution of the oil business with prostitution. With this combination of raw realism and gentle humor, Bywaters is able to embrace simultaneously both the myth of the Texas independent spirit and the reality of everyday life.

Oil Field Girls traveled to the Golden Gate Exhibition at the San Francisco World's Fair the summer and early fall of 1940. In December 1940 Bywaters had a one-man retrospective at the Dallas Museum of Fine Arts that

consisted of thirteen oils, nine pastels, six mural studies, one watercolor, fifteen prints, and two drawings.[50] One of the new works in the exhibition was a portrait of Bywaters' daughter, Jerry, titled *Miss Priss*. According to art critic Louise Long, "The solemn, elfin face, the finely modeled head, the deep warm colors combine to make this work one of the most distinguished in the collection."[51]

In his easel paintings Bywaters developed an individual artistic voice. A contemporary art critic summed up his work this way: "His paintings are marked by a mobile, restless spirit – a spirit that leads him time and again into experimentation. They are strong and realistic, punctuated with hearty humor and a kind of crude vitality. They present an emotional impact which takes slight cognizance of polite society. Artistically the paintings are of first quality. Mr. Bywaters is one of the finest draughtsmen in the region, a fact which curiously, is frequently overlooked."[52] At the time, Bywaters realized that oil paintings were the works by which he would ultimately be judged as a serious and professional artist. Paintings, however, are one of a kind and not accessible to the public unless on display in a museum. Bywaters' populist leanings prompted him to work in media that would be accessible to the public. In addition to the production of prints and book illustrations, which allowed wide distribution of his art, Bywaters also continued to produce murals until 1942: this work was completed under the auspices of the Treasury Section of Painting and Sculpture. Bywaters saw murals as a counterpart to prints, both in the celebration of American life and in commentary on American conditions.

Bywaters continued to be an ardent supporter of the New Deal art projects and argued that "if America is to have an art Renaissance it is making headway toward it now and largely as a result of the impetus of the three art projects instituted by Uncle Sam."[53] He viewed the patronage of the federal government as an unprecedented opportunity for local artists. Bywaters praised the New Deal program: "No better or more salty glimpse of the real America can be found than in the easel paintings executed under this project."[54] Bywaters and Dallas audiences viewed the work of WPA artists first hand at an exhibition at the Dallas Museum of Fine Arts called "New Horizons in American Art." Circulated by the Museum of Modern Art in New York, the exhibition was curated by Holger Cahill and Constance Rourke.

Bywaters submitted several designs to the competitions for mural commissions for the Treasury Section of Painting and Sculpture. Artists entering

competitions were required to submit a completely designed color sketch for the mural in the scale of one inch equalling one foot "to give as clear an idea as possible how the proposed mural decorations will look when completed."[55] Also required from the artist was a "full size detail of an important part of the mural scheme" of two feet square. After the local judges made their selection, the anonymous designs were sent to Washington, D.C., for final approval. Once the decision was made, the identity of the artist was revealed to the judges and announced to the public.

In 1937 Bywaters submitted both the required drawing and a four-foot-square full-scale detail of a completely worked out mural for a competition for a mural in the San Antonio post office. Bywaters produced a color sketch titled *Padre and Spanish Soldiers.* Although artist Howard Cook won the competition, Bywaters received recognition for his effort, and he developed new techniques in the experience. Bywaters employed a time-honored technique to transfer an image from a small sketch to a full-scale painting by using a grid. Like other entrants in the competition, Bywaters considered it worth the trouble to enter the federal government's competitions. At stake were important commissions of large-scale works that would be permanently installed in a public place. And payment for the work was good. All new tax-supported buildings, including post offices, courthouses, schools, and hospitals, were required to spend one percent of the total building cost on mural or sculpture decoration. The prospects for a major commission and a sizable check from Uncle Sam prompted Bywaters to submit work to each competition that he was eligible to enter.

Bywaters' support for the New Deal art programs was predicated upon his belief that the local artists would have their rightful opportunities to paint significant works of art for local public walls. When the Treasury Section of Painting and Sculpture in September 1937 commissioned two artists from California to paint murals for the new Dallas Federal Parcel Post Building, Bywaters and eleven other Dallas artists protested vehemently and urged that local artists be considered for the project. Bywaters, Hogue, Dozier, Lester, Spruce, Bowling, Stell, Douglass, Carnohan, Travis, and Bassett signed a petition and complained to their representatives in Congress. Hogue wrote a convincing letter to the Section administration explaining that the Dallas artists were experienced and known for their art of "distinct Texas flavor." Edward Rowan, director of the Treasury Section, reversed the decision and announced an open competition for the large Dallas commission.[56]

From 1937 to 1942 Bywaters was awarded four mural commissions by the Section of Painting and Sculpture. All in Texas, the commissions included one mural each in the post offices of Trinity, Quanah, and Farmersville, and three murals in the Parcel Post Building of Houston. Bywaters, like other artists commissioned by the federal government, was charged not only to paint an attractive work of art, but also to complete a permanent and accurate record of the individual character of the community. For each commission Bywaters researched the area's history, topography, economy, and culture. He was well aware that hometown folks looked for accuracy of detail in these mural records of their history and achievements.

In the summer of 1937 Bywaters was invited by the Section of Painting and Sculpture to submit sketches for a mural painting for the new post office in Quanah, Texas. The letter to Bywaters from Superintendent Edward Rowan explained that the commission was based on "the merit of the design submitted by you in Competition. The submission of design for this building is not competitive. Upon the approval of the new designs by the Director of Procurement, a contract for the execution of the painting will be prepared for your signature."[57] Bywaters answered by return mail that he welcomed the opportunity, found the sum of $690 for the mural satisfactory, and planned a trip to Quanah to discuss the project with the postmaster and collect historic material for the mural.[58] The design for the mural at the Quanah Post Office was approved in December 1937 and installed in the spring of 1939. Entitled *The Naming of Quanah*, the mural is not one of Bywaters' successful works. Bywaters tried to unite past and present events and figures in a pyramidal composition. The key figure, the famous Comanche chief Quanah Parker, pledges friendship with a white settler along with other significant historical events, including the railroad survey and the development of agriculture. Although the composition was approved by the members of the Section and the supervising architect of the building, there were several suggestions from Washington for changes during the course of the project. In August 1937 Inslee Hopper, assistant superintendent of the Section of Painting and Sculpture, wrote Bywaters that after reviewing the artist's "interesting and successful design," the committee suggested that "the two figures to the right of the center . . . who are picking vegetables presumably, should have their action somewhat clarified."[59] In December of the same year Rowan wrote Bywaters that "the able quality of painting found in this sketch is not lost upon us. The only suggestion which we have to offer is that in our opinion the central

figures with the teepee behind them do not quite take their place in the painting in relation to the rest of the material."[60] It is unclear whether the awkward composition of the mural is a direct result of or in disregard of these suggestions from the federal officials.

Occasionally Section commissions were obtained as a result of an honorable mention or runner-up status on an important competition. For example, in June 1938 Bywaters and Hogue were awarded mural commissions for the Houston Parcel Post Building "on the basis of competent designs submitted for a Dallas competition."[61] One hundred and forty-four artists from across the nation had submitted designs for the Dallas post office Terminal Annex. New Mexico artist Peter Hurd won the competition and the $7,200 commission for a series of murals. Thirty-one other appointments were awarded from this competition, including the three murals each by Bywaters and Hogue.

The two artists chose the history of the Houston Ship Channel as the subject for the mural series. Hogue depicted the actual building of the canal, and Bywaters portrayed contemporary workmen on the wharf. The artists worked for two years on the research and painting of the murals. Two large panels by Hogue pictured early riverboat traffic and the surveying, clearing, and dredging work at the channel around 1910. A smaller middle panel depicted a decorative map of the channel from Houston to the Gulf of Mexico. Bywaters presented the activities of the port. The left panel pictured the loading of an oil tanker by large cargo hoses attached to valves. The loading of cotton bales onto a freighter was the subject of the right panel. Between these two panels was a map by Bywaters that illustrated the Turning Basin and the location of the major wharfs. In the presentation for the composition Bywaters wrote Rowan, "I made many studies and sketches in color on the spot, taking a boat trip down the channel to the end of the main docks. Officials of one oil company permitted me to observe the loading of two tankers and I studied the loading of cotton at the huge Manchester wharf at the port. As far as I can determine all the properties and articles in the mural are authentic."[62] In portraying contemporary laborers, Bywaters wanted to depict purposeful productivity without heavy-handed symbolism. The murals each have strong form and good, clean graphics. The repetition of geometric shapes found in the machinery and ships reinforces the solidity of the composition. Bywaters used his customary palette of warm rusts and cool greys with accents of magenta. The result is a unity of rhythm and balance of design in Bywaters' three panels.

Loading Oil, *1939. Oil on canvas. Mural, Federal Building, Houston, Texas.*
Photograph by Mark Edward Smith.

At the completion of the Houston mural project, a contemporary report of
the installation stated, "Each artist received $1,300 for the execution of one
three-section panel, six feet high and eighteen feet long."⁶³ The murals were
painted in oil on canvas and then attached to the plaster walls of the building
with leading. The dedication ceremony for the murals was held July 6, 1941.

In the summer of 1939 Bywaters was one of sixty-four artists from nine
states who entered the competition for a large mural project of six panels for
the post office in Amarillo, Texas. Bywaters' interest in historic accuracy
prompted him to picture the Battle of Adobe Walls and other significant his-

Jerry Bywaters standing with full-scale drawing of one panel of his Houston mural cycle depicting the Houston Ship Channel's history, 1941. *The Jerry Bywaters Collection on Art of the Southwest, The Jake and Nancy Hamon Arts Library, Southern Methodist University, Dallas, Texas.*

toric events of the region. The panel of Amarillo and Washington, D.C., jurors chose the design of Julius Woeltz from New Orleans for the Amarillo project. Receiving $6,500 for the coveted commission, Woeltz depicted an idealized and stylized vision of Texas history – conquistadores and cowboys, Indians and oil wells, cattle and cotton.

Eleven artists who had entered the Amarillo competition were selected to complete smaller mural projects in towns throughout Texas and Oklahoma "on the basis of the competence and vitality of their design."[64] By this means,

Loading Cotton, 1939. *Oil on canvas. Mural, Federal Building, Houston, Texas. Photograph by Mark Edward Smith.*

Bywaters was commissioned for a mural in the Farmersville Post Office on July 15, 1940. He received seven hundred dollars in three installments. Bywaters wrote the local postmaster, "I was particularly pleased to be appointed to do a mural in Farmersville because I was born in Paris and most of my father's relatives live in Roxton. Naturally I feel I can do a good job in a part of Texas that is familiar to me."[65] Anxious to have a mural in his new building, the Farmersville postmaster gave Bywaters a list of subjects that "might be appro-

priate," including "Farm terraces, Farm dairying, Poultry raising, hogs, sheep, cotton, corn, wheat, Oats, onion industry, truck raising, stock farming."[66] The postmaster was emphatic on one point: "I certainly do not want any tractors in the scene." During the Dust Bowl era, when wind storms blew the topsoil off farmland, the tractor was a lamentable symbol of dangerous farming practices. Under the Agricultural Adjustment Act, the Roosevelt administration was implementing a variety of programs to educate farmers about soil conservation, water conservation, and land management, and it is probable that the Farmersville postmaster wanted the mural to reflect a progressive image.

Bywaters' preliminary sketch pleased the postmaster and the Section authorities. The design presented a panorama of the rolling landscape typical of southeastern Texas. Bywaters managed to include a variety of information about farming in the mural, including the cultivation of cotton, oats, onions, corn, and wheat on strip-cropping and terraces. There were also indications of dairy farming and truck farming as well as the raising of cattle and poultry – without a tractor in sight. The 6-by-10-foot mural is neither crowded nor awkward in composition, but surprisingly harmonious and unified. Bywaters' Farmersville mural, entitled *Soil Conservation in Collin County*, tells the story of the benefits of crop management and terracing without compromising the artistic integrity of the painting.

There are obvious differences in tone and motive between Bywaters' 1936 painting *Sharecropper* and his 1940 mural for the Farmersville post office. The images and messages of the two works are so conflicting that they appear to be mutual denunciations. The portrait of the sharecropper is an urgent admonition for assistance – the farmer's meager crop is being devoured by insects in front of him. Nature is out of control and the human being is helpless to change the imbalance. The colors in the painting are dry and lifeless, depicting the drought-stricken landscape. The portrayal of farming in Collin County, however, is a very different picture of bounteous crops and lush landscape. The farmer is in control of a world that is orderly and full of purposeful activity that produces adequate food through the application of scientific techniques. Is the difference in mood and message of the two works the result of pressure by the government to paint upbeat paintings? Is the Farmersville mural merely propaganda for New Deal agriculture policy? Referring to the mural, Bywaters simply replied, "I knew the Depression would not last forever; I wanted to create a lasting work of art."[67]

The last mural that Bywaters completed was perhaps his best. In July 1942

Lumber Manufacturing was installed in the Trinity Post Office. It was also one of the last commissions of the federal art program installed in the state of Texas. Bywaters received this commission as a runner-up in the competition for a mural in the Longview post office.[68] He was instructed to submit pencil sketches for his design before sending a color sketch for approval. He received this instruction from the Section administration: "The primary requisite is a simple and vital design. Experience has indicated that subject matter, based upon knowledge of the particular locality, frequently aids the artist in his desire to achieve vitality. But the Section, by this suggestion, does not wish in any way to curtail the artist's initiative and invention."[69] Bywaters chose to depict a scene of the East Texas town's main industry, logging. Pictured are men called "doggers" engaged in the first rough cut of logs. According to the Section's press release, the mural depicts

> the interior of a typical lumber manufacturing plant in East Texas, with a Head Rig unit in operation. Sitting under the protecting shed to the side of the giant band, or head saw is the Sawyer, his hand controls two levers . . . After quickly studying each approaching log to see what kinds of lumber it will best produce, the Sawyer signals by hand to the Setter . . . who sets the machinery controlling width of lumber to be cut. As the log is raised to the carriage, two men called "doggers," at each end of the carriage, clamp the log fast and it is then ready to be cut. After this first cutting, the rough lumber is then carried over endless conveyors to gang saws, edgers, trimmers, and finally to the planing mill for dressing.[70]

Beyond mere documentation, the mural portrays the strength, energy, and motion in the doggers' work. It is a bold composition, solidly constructed, with simplified forms and interesting rhythms. It is the work of an accomplished artist who is conscientious about the historic and technical accuracy of the subject, but above all concerned with the graphic quality of the product. In each of his murals Bywaters found the compositional and spatial solutions to overcome the awkward problems of viewing a painting hung above a doorway of the postmaster's office.

In December 1940 Bywaters had a one-man show at the Dallas Museum of Fine Arts of preliminary sketches and cartoons for his various mural projects. The exhibition also included Bywaters' completed murals for the Houston Parcel Post Building. Bywaters informed Edward Rowan about the exhibition and confided that "this sort of thing is interesting to the public and does not

Lumber Manufacturing, 1942. *Oil on canvas. Mural, Post Office, Trinity, Texas. Photograph by John Carlisle. Courtesy of the Texas Historical Commission.*

often present itself to the Dallas audience. Also I think it helps to explain the work of the Section of Fine Arts."[71]

Other Dallas artists participated in the Section's mural commissions for the duration of the program – from October 1934 through July 1943. Dallas artist Otis Dozier completed three New Deal murals with his typical humor and individual style. For the Giddings Post Office Dozier painted *Cowboys Receiving the Mail*, which depicts cowboys interrupted in their day's work by the lure of opening a brand new pair of mail-order boots. The painting goes beyond the anecdotal, however, with the artist's superb command of form and sense of design. Washington officials rejected Dozier's original plan to depict the gruesome subject of chicken processing, a local industry. Dozier then opted for a cowboy scene, which actually had little to do with the town of Giddings. For his Fredericksburg mural Dozier used the geometric construction of a corral to present the dramatic action of organizing and shipping cows to market.

Other Dallas artists completed commissions for the Section. Sculptor Allie Tennant completed a triptych of plaster relief entitled *Oil, Cattle and Wheat* for the post office in Electra, Texas. Tom Stell and Lloyd Goff produced excellent examples of mural art. A superb draftsman, Stell's major concern in painting was definition, organization, and solidarity of form. His mural for the Longview Post Office documents farm animals and machinery. Stell's strong light and cool colors remain vibrant today. Once a student of Tom Stell and a collaborator with muralist Paul Cadmus, Lloyd Goff developed his own

personal style, characterized by crowded compositions, clear light, and muscular figures. When Goff completed *Before the Fencing of Delta County* for the Cooper Post Office, local residents were so happy with the mural that they honored the artist with a formal reception. Another Dallas artist, Vernon Hunter, became director of the federal art projects in New Mexico.

The government-sponsored art programs played an important role in the financial and artistic survival of individual artists in Texas, especially the Dallas artists. In an article that Bywaters wrote for the *Southwest Review* at about the same time these murals were painted, he commented, "These Federal projects offer a small but steady income and encourage the regional artist to paint what he knows best – the life and history of his own community."[72] Bywaters and other Dallas regionalists believed the federal art projects did not place a stylistic straitjacket or aesthetic muzzle on their art. Artists saw the commissions as an opportunity to place a major work permanently in public spaces. Bywaters attributed the success of the federal art projects in Texas to the fact that the artists and the administration had the same primary concern for the integration of art into public life. A *Southwest Review* article by Anne Toomey entitled "Uncle Sam Art Patron" stated emphatically that the Section had had a "revolutionary" effect upon the "development of our art."[73]

For Bywaters the major contribution of the New Deal art project was the nationwide advancement of art and the decentralization of the art world. The golden age of American art could come for Bywaters only with the developing of "original art of the provinces . . . [rather] than provincial imitations of New York or European art."[74] For Bywaters the federal art projects were a clear expression of the promotion of regionalism. The government projects confirmed for Bywaters the continued progress in American art and art education. Bywaters anticipated an American school of painting. "It is a conclusive fact," he stated, "that Americans have never seriously produced or been actively interested in art as widely as today . . . we know that we have been present at the beginning of an era which expresses much of our way of life, our own way of thinking and our own American spirit."[75]

Other voices praised the direction of art in America and attempted to define regionalism. Throughout the decade of the 1930s ideas circulated about the nature of regionalism, and in 1938 a book entitled *American Regionalism* by Howard Odum and Harry Moore synthesized the prevailing thought: "By regionalism we mean a new American social economy and social determin-

ism."[76] The authors wrote, "Regionalism is organic, basic to the evolution of all culture." They described "a great national unity and integrated culture in which each region exists as a region solely as a component unit of the whole" (ibid., p. 43). Bywaters and the other Dallas artists would have agreed that regionalism is not tied exclusively to subject matter and it is not a secessionist attitude.

In 1939 Holger Cahill wrote, "Artists have definitely set themselves the task of saying something in terms of visual art about the environment and a social life which they are likely to know well. Naturally the first reaction will be to local subject matter, to themes linked with the life, the landscape, and the history of the locality . . . These will, in time, tend toward the formation of an attitude, toward a recognized trend in observation, sentiment, and even in technique. When these various factors are fused into an emotional unity, we have the beginning of a school."[77] Cahill recognized the Dallas artists as major exponents of the regionalist aesthetic. "One sees this sort of thing happening today in the Middle West, and even more in the Southwest especially Texas, where a group of artists has gone far beyond local narrative, or the sentimental-picturesque in landscape, toward the development of a regional point of view" (ibid.). In the same article Cahill quotes this emphatic statement of Donald Bear, director of the Denver Art Museum: "I think that certain names such as Alexandre Hogue, Jerry Bywaters, William Lester, Everett Spruce, Otis Dozier, Perry Nichols and of course others have defined the colony in terms of national as well as regional importance . . . these Texas artists whose work has interested a wide exhibition audience have not only caught the breadth of the country which they paint but have conveyed in terms of true social meaning something of the character of the people and their relation to the land. They have also made of an individual style, a vehicle which strengthens the meaning and gives clarity to their pictorial and social ideas. They have created Texas art" (ibid.).

THE REGIONAL MUSEUM

"Nobody is making any bones about it. Art in the 1942–43 season isn't going to be art as usual – it's going to be art with war." The *Dallas Morning News* made this pronouncement on October 11, 1942, as a global war demanded America's attention. The Dallas art community registered the effects of the war as young artists left to become soldiers.

The director of the Dallas Museum of Fine Arts, Richard Foster Howard, was reinstated as a captain in the U.S. Army. When How-

ard left Dallas, his assistant, Louise Britton McCraw, served as acting director of the museum and was temporarily named executive director. Bywaters, who was exempt from military duty because of his childhood injury, assumed a position as art director and head of the Museum School at a monthly salary of one hundred and fifty dollars. A year later, in September 1943 at a special meeting at the Adolphus Hotel, the Board of Trustees of the Dallas Art Association voted to name Jerry Bywaters as the director of the Dallas Museum of Fine Arts. Bywaters accepted the post with a one-year contract, or at the most a temporary position during the war, but he stayed for over twenty years.

During his first year as art director at the museum, Bywaters balanced a rigorous schedule of teaching art at SMU in the mornings, directing the museum in the afternoons, and writing articles and exhibition catalogues in the evenings.[1] Due to his museum administrative duties, Bywaters found little time and energy left to paint and it was awkward for him to show his art work publicly. As director of the Dallas Museum of Fine Arts, however, Bywaters had an opportunity to test the validity of his theories of regionalism. The museum became a working laboratory for Bywaters to prove and promote his theories.

As the war escalated in Europe and Asia, another war was brewing in American art. From 1936, when the Museum of Modern Art in New York presented an exhibition of surrealism, to 1941, with the arrival of Max Ernst, Andre Masson, and Andre Breton in New York, to 1942, when Peggy Guggenheim opened a gallery called "Art of This Century," the stylistic currents in American art began to shift and collide. The American Scene and social realism were eclipsed by geometric abstraction and surrealism. The decade of the 1940s was a decisive one for American art. At the beginning of the decade Thomas Hart Benton was still America's best-known painter, but by the end of World War II one of Benton's students, Jackson Pollock, had plunged American art into an entirely new phase. After the war university art schools began to expand with returning servicemen taking advantage of the G.I. Bill. Art galleries increasingly showed nonobjective work. By 1948 it was obvious that a new era of American art was beginning.

Jackson Pollock was discovered by Peggy Guggenheim the same year that Jerry Bywaters became director of the Dallas Museum of Fine Arts. As director, Bywaters found the state of art at war. During the first decade of his tenure, the museum's regional focus proved victorious, but during his next ten years there were significant battles on a number of fronts.

Upon accepting the position as art director at the museum, Bywaters announced to the museum board and news media that he would continue "to build the exhibition program for the year around local and regional material"[2] He expressed confidence that was supported in his efforts to promote "the already vital and versatile art activities of this region, thus giving the Dallas Museum a particular character among the museums of the country." The September 13, 1942, issue of the *Dallas Morning News* quoted Bywaters as saying, "It will be necessary to work with other museums and art agencies in the development of unexploited local and sectional art resources. To do this the museum will request the assistance of interested artists, laymen, and organized groups." Educating the public about art was a key interest of Bywaters, who asserted, "Certain educational services and opportunities are possible to supplement those now offered at the museum and nearby schools and universities." Bywaters expressed his ideas and ambitions for the museum with a kind of wartime determination and zeal that urged everyone to work together for a common good. "Although we are in a defense area, rather than a military area," Bywaters affirmed, "the museum should direct its facilities to aid special war and defense efforts both independently and according to the plans of governmental agencies."

During Bywaters' first year at the museum there were definite reminders that outside the serene confines of Fair Park the world was at war. Activities and attendance at the museum were reduced due to wartime restrictions on shipping and gasoline. Bywaters later recorded the war's effects on the museum: "Annual operating funds from the City and Park Board were reduced from $17,000 to $9,000; Art Association memberships dropped to 550 paid members; the State Fair of Texas was cancelled; funds for the summer W.P.A. Sinfonietta Sunday concerts were terminated; air conditioning was unusable since needed replacement parts were not available; and there were vague reports that the Art Museum might be closed, depending on whether 'an Art Museum can be considered as a vital industry in time of war.' "[3] In April 1943 Bywaters began planning an exhibition of art work by soldiers to open at the museum in September 1943. There was a special exhibition of war posters at the museum, and the Fifth Texas General Exhibition gave one-hundred-dollar war bonds as prizes to artists.

After serving one year as art director, Bywaters reported to the museum board that he had "reviewed immediate plans for the museum, including the addition of a membership secretary and receptionist to the staff."[4] He an-

nounced that changes in the exhibition space would include "two movable partitions [to] divide the large print gallery into smaller rooms and to provide exhibition space for artists not yet eligible for full solo shows." He also reported that "cataloging of the library books will be completed within three months and the motion picture programs are to be resumed" (ibid.). During that first year Bywaters also planned solo exhibitions of the works of Texas artists Artine Smith, William Cole, Lucille Jeffries, Donald Vogel, Victor Lallier, Barbara Maples, and Charles Bowling. Bywaters' commitment to exhibiting artists of the region and his positive steps toward the improvement of the museum received the approval of the museum board, which offered him the directorship.

Long before joining the museum staff, Bywaters had monitored the progress of the new museum and lobbied for more city funding. In 1937 he publicly admonished the museum's Board of Trustees that the "hand-waving speeches on what a living museum should be must be replaced by some hard work to arrive at what a living museum can be."[5] As director, Bywaters' mission was to create a "living museum." His abiding concern for the direction and programming of a modern museum was predicated upon his belief that the museum should be a living, dynamic thing – a place of activity, education, and a showcase of the work of living artists. John Chapman, a lifelong friend, wrote in 1942 that "Bywaters has brought the ideas tested by his own thought and painting, that art is of consequence only if people see it and understand it, and that art museums represent life; those of the regional days which insist that recognition and acclaim be given living painters and that art to be real must deal with things the artist knows."[6]

A living museum for Bywaters included an active art school. From its inception, Bywaters followed the development of art classes at the Dallas Museum of Fine Arts School.[7] In 1938, when the park board refused to fund equipment and staff for a museum art school, Bywaters stated emphatically that "no school should be started in the museum, either by the Art Association or any other group, unless the new school can receive the support from the city in the form of full rent, good equipment, and funds for the free children's classes."[8] After pointing to the friction between the museum and the park board, he urged "honest and disinterested thinking through by all parties concerned" (ibid.).

In the spring of 1938 an equitable solution to the problem was worked out. With an offer of free rent from the park board, the Dallas Art Institute moved

its offices and art classes from 2503 McKinney to the art-school wing of the museum.[9] By 1940 Maggie Jo Hogue, wife of Alexandre Hogue, was head of education at the museum, where she organized Saturday-morning art classes for about one hundred children of Dallas Art Association members.[10] According to Bywaters, "In 1941 the school wing of the Museum was vacated by the Art Institute, and the Trustees of the Association assumed the responsibility for the establishment of an art school to fill this community need."[11] A total of 206 students enrolled in the art school in 1943–1944, and by 1945 the Saturday children's classes in art were open to members of the Dallas Art Association and to the public. Bywaters hired Barbara Maples and Lucille Jeffries to teach art to children, Octavio Medellin to teach sculpture, and Edmund Bearden to teach painting to adults.

Before Bywaters took the position of director, the museum's permanent collection was small and limited in scope. In June 1939 Elizabeth Crocker had reported in the *Dallas Morning News* that the museum's collection contained 125 oils, 20 pastels and watercolors, around 100 original prints and drawings, 12 pieces of sculpture, and a "half-dozen other objects."[12] Most of the works were acquired from purchase prizes at the annual Allied Arts exhibitions. According to Crocker, the works of modern artists were "sadly lacking" from the collection. She asked, "Where are Benton, Wood, Curry, Burchfield, Pierce, Gropper, Sheets, Hartley, and a dozen others?" Crocker lamented that "all this adds up to a remarkably barren collection of art for the local museum." Crocker challenged Richard Foster Howard to improve the museum's holdings. "Hit-or-Miss acquisitions of museum pieces is out," she wrote, "and a well directed, planned course of action is in." Crocker predicted that "the next ten years should see the local museum in the forefront." Bywaters took up the challenge and set about increasing the number and improving the quality of the works in the museum's permanent collection. He faced, however, the problems of building the collection with no endowment and no city funds for the acquisition of art objects.

The early 1940s brought significant changes in the Dallas art community. Dallas artists received the recognition by the art world and attention by New York art galleries and museums nationwide for which they had fought so hard in the 1930s to attain. Otis Dozier, William Lester, Alexandre Hogue, and Everett Spruce found teaching jobs at prestigious institutions that provided them financial stability and a supportive atmosphere in which to produce art work. In 1939 Dozier joined the teaching staff of the Colorado Springs Fine

Arts Center under the direction of Boardman Robinson. In 1940 Spruce joined the art faculty at the University of Texas, and Lester followed in 1942 after teaching two years at the Dallas Museum of Fine Arts School. Hogue joined the faculty of the University of Tulsa and became head of the art department in 1945. Bywaters was thirty-seven years old when he became director of the Dallas Museum of Fine Arts as a younger generation of Dallas artists were vying for attention.

As professor of art at Southern Methodist University, Bywaters taught aspiring students who were anxious to make their own artistic statements. Dan Wingren entered Bywaters' painting class at SMU in 1942. "I knew him first as a teacher," Wingren wrote years later, "and I soon learned that his teaching went well beyond the classroom. He was a fine classroom teacher, though. He preached respect for materials and he gave practical advice on the construction of pictures. His students learned something of his own fastidious ordering of planes and connecting of rhythms, of the registering of colors into local, shape, and tint."[13] Barney Delabano, who also studied with Bywaters at SMU from 1947 to 1950, recalled that "it was a vital time to be in a university with a particularly lively group of teachers and students in the arts" (ibid., p. 41). Through Bywaters' influence, SMU hired Otis Dozier, Ed Bearden, and DeForrest Judd to teach art classes and Elizabeth Walmsley to teach art history. In his teaching Bywaters continued to emphasize the importance of painting one's own environment, or, in his words, artists "paint best what they know best."[14] His former students, however, maintain that he did not insist that they employ a particular or uniform stylistic vehicle. Wingren explained, "He taught the sense of quality as something independent of style or subject. He was quick to praise signs of individuality in his students and quick to recognize and interpret imagery and gestures which were authentic for the individual even though quite alien to his own tendencies."[15]

There was little evidence of the emergence of younger artists with new ideas at the Fifth Texas General Exhibition in the fall of 1943. This large juried exhibition, which toured from Houston to San Antonio and Dallas, was an accurate but conservative reflection of the art of the state. The jurors for the 1943 exhibition were the state's leading art figures: Everett Spruce, chairman of the art department at the University of Texas; Eleanor Onderdonk, curator of the Witte Museum in San Antonio; James Chillman, Jr., director of Houston's Museum of Fine Arts; and Jerry Bywaters, director of the Dallas Museum of Fine Arts.[16] Bywaters exhibited an oil painting, a print,

and a drawing in the exhibition, although no one – including the other judges, the reviewer of show, or Bywaters – acknowledged any conflict. Bywaters attempted to continue his career as an artist while advancing his interests in arts administration. In fact, Bywaters exhibited work at the Texas General exhibitions from 1942 through 1947. In 1945 he had a solo exhibition at the Civic Federation in Dallas, and his work appeared in two major group shows, "Artists West of the Mississippi" at the Colorado Springs Fine Arts Center and "Thirty-Second Annual Exhibition: Painters and Sculptors of the Southwest" at the Museum of New Mexico in Santa Fe. In 1946 Bywaters' work was included at the "Invitational Texas Exhibition" at none other than the Dallas Museum of Fine Arts.

Bywaters' artistic production diminished, however, after he became director of the museum. He continued to work in oil, watercolor, gouache, and lithography. In 1942 Bywaters' oil still life *Autumn Bouquet* was included in a show that Donald Vogel organized at the Dallas Little Theater.[17] In 1944 Southern Methodist University presented an exhibition of the works of Bertha Landers, Alexandre Hogue, and Jerry Bywaters. Included in that exhibition were six of Bywaters' paintings from trips to the Big Bend area of Texas and Colorado: *After the Rain*; *Chisos Mountains, Big Bend*; *Big Bend Ranch*; *Central City Theme*; *In the Big Bend*; and *In the Christmas Mountains*.

Works from this period reflected Bywaters' travels to New Mexico and Colorado. Family vacations each summer turned into sketching trips. He later recalled, "The towns of Central City, Cripple Creek, and Leadville were only three of a number of storehouses of the past scattered through these mountain peaks."[18] In such works as *Central City Theme* (1944), *Houses in Leadville* (1945), *Divide, Colorado* (1946), and *Old Buildings, Leadville* (1946), Bywaters found humor in the old houses that clung to the side of the mountain. He was interested in recording the mining, forestry, ranching, and industry of the region in *Mountain Patterns Sawmill* (1946) and *Ranch at Terryall* (1946). During a 1945 trip Bywaters painted *Stores at Cuervo*, which pictures the ghost town in the crisp mountain air and the clean light of the region.

Beyond occasional excursions outside Dallas, Bywaters had little time to paint. He was occupied with his duties as director of the museum, for which the total budget in the year 1943–1944 was less than $30,000. A very small staff presented fifty-two exhibitions that year, thirty-four of which were orga-

nized by the museum. Bywaters outlined an ambitious schedule of exhibitions for the year that included painting, sculpture, architecture, design, costume design, prints, advertising art, photography, pottery, and textiles, art pertaining to war and work by men in the armed services, and art by Dallas High School students. Exhibitions included "Applied Design," organized and toured by *Women's Day Magazine*; "Art from Dallas Collectors"; "Paintings by Otis Dozier"; and one-man shows of young Dallas artists Ben Danzers, Ben Culwell, and Fred Darge. An exhibition entitled "Indian Pictographs of Texas" presented accurate reproductions of ancient Indian wall paintings by Dallas painter Forrest Kirkland. Photography exhibitions included a group show from the Dallas Camera Club and works by Earl Moore and Edward Deis. Sales of $6,460 from the exhibitions were reported for the year. Bywaters produced a pamphlet on the history and programs of the museum and a brochure on early crafts in Texas.[19]

Bywaters accelerated the museum's public programming to include a series of eighteen lectures for college credit by Hugo Leipziger of the University of Texas on city planning. A visiting-artist program brought artists like Boardman Robinson and William Zorach to Dallas for a week of demonstrations, lectures, and exhibitions of their work. Bywaters invited Carl Zigrosser, curator of prints at the Philadelphia Museum of Art, to lecture and serve as juror for a print exhibition that became an annual event at the museum.

At the invitation of the American Federation of Art, Bywaters assembled an exhibition in 1943–1944 entitled "Texas Panorama." The exhibition not only included works by Everett Spruce, William Lester, Otis Dozier, Charles Bowling, and other well-known Texas regionalists but also newcomers to Texas such as Ward Lockwood, Loren Mozley, and Donald Vogel. Bywaters also included his own painting *In the Big Bend* in the exhibition. Bywaters wrote at the time, "Where it was impossible 20 years ago to scrape together a respectable exhibition of paintings from Texas, it is now difficult to limit such a show as the Texas Panorama to 27 artists without leaving out artists of importance."[20] The exhibition opened in Dallas and then traveled to Houston, San Francisco, Stockton, Santa Barbara, Bozeman, Great Falls, and St. Paul. Bywaters characterized the exhibition as "the first real introduction of artists in Texas to the nation."[21] It marked a decided change in the art of the maturing artists whose styles were evolving and the infusion of new ideas from younger artists who were reflecting the influence of a growing interest in abstraction. "Texas Panorama" received positive reviews, but, as art historian

Rick Stewart has accurately noted, the exhibition marked the decline of Texas regionalism.[22]

Bywaters wanted the exhibitions in his museum to represent the mainstream of American art. In September 1944 he traveled to New York to investigate the city's art galleries and assemble an exhibition of contemporary American art for the museum. He selected sixty works by such leading artists of the day as Peter Miller, Stuart Davis, George Grosz, Guy Pene Du Bois, Doris Lee, Raphael Soyer, Peter Hurd, and Milton Avery. The exhibition, which included Thomas Hart Benton's *Prodigal Son* and Reginald Marsh's *Grand Windsor Hotel*, opened at the museum in January 1945. Although there were a few abstract and expressionist works, regionalism and the American Scene dominated the exhibition. The art writer for the *Dallas Morning News* concluded from the show that "American art is heading over a long road toward a vigorous school of its own."[23] In 1945 the museum was host to another major group exhibition titled "Portrait of America," sponsored by Pepsi-Cola. These large group exhibitions presented a diversity of styles typical of the day, ranging from representational, to magic realism, to modified surrealism.[24]

Attendance at the museum increased dramatically during Bywaters' tenure as director; 80,000 people attended exhibitions at the museum in 1943–1944; 114,200 people attended from April 1944 to April 1945; and by 1947–1948 the yearly attendance was more than 200,000. Before Bywaters' tenure, 30,000 was the top attendance at the museum. Bywaters specialized in inventing ways to "demystify" the museum experience and to make an art exhibition inviting and unintimidating. When visitors walked through the museum's large glass doors, they saw a bulletin board covered with clippings and cartoons lampooning contemporary art, artists, and museums. Bywaters told a reporter, "That breaks the ice. So many people feel that they should be respectful. But one look at that board and they go into the galleries whistling and talking out loud. It dawns on them that this is their museum. Their tax money is paying for it."[25] Membership in the Dallas Art Association, which supported the museum, increased in 1945 to 691 people who contributed from five dollars to one hundred dollars. Annual operating funds from the City of Dallas and the park board also increased.

One accomplishment of which Bywaters was most proud was the establishment in 1945 of a special fund for acquisitions. The acquisitions committee of the Board of Trustees collected around $12,000 in its first year, of which

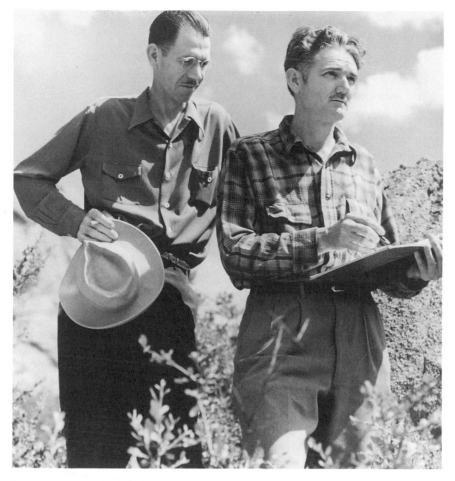

Jerry Bywaters and Otis Dozier sketching, 1945. *The Jerry Bywaters Collection on Art of the Southwest, The Jake and Nancy Hamon Arts Library, Southern Methodist University, Dallas, Texas. Photograph by Mitchell Wilder.*

one-third was spent "in the first step of a progressive accessions policy" (ibid.). Collecting focused on works by "American painters and sculptors since European old and contemporary masters were beyond the reach of the funds on hand."[26] The initial steps toward the development of a collection of American art were conservative and cautious. That first year after the establishment of the fund, the museum acquired a landscape by Otis Dozier and *Drouth Stricken Area* by Hogue. Two important portraits by Gilbert Stuart and a painting by Guy Pene Du Bois were obtained through special gifts. During that year the museum added twenty-eight works of art to its permanent col-

lection, and the *Dallas Morning News* reported, "The museum's prosperity has the look of permanence."[27]

The end of World War II stimulated a general sense of new beginnings. There was an emerging sense among Americans that the United States should prevail as a cultural leader as well as a military leader. The prospects for American art looked bright. As director of the Dallas Museum of Fine Arts, Bywaters wanted to make sure the art and artists of his region played a major role in this assumption of world leadership in the arts. At the age of forty, all his efforts were focused on that goal. Bywaters intended to make the Dallas Museum of Fine Arts one of the leading museums in the nation.

To reach that objective, he continued to make art accessible and understandable to the public. He kept abreast of new ideas in museum management and sought innovative solutions to problems of funding. Bywaters surveyed current trends in art museums "by means of questionnaires sent to more than 100 American regular art museums and galleries not including the few large metropolitan repository museums."[28] This research provided Bywaters with a large body of information to use in curating exhibitions and in managing the museum. The results of the survey also gave Bywaters material for an article in the *Southwest Review* entitled "Art Museums: Repositories or Creative Centers?"[29] This lengthy article, published in the summer of 1945, is so central to Bywaters' plans and strategy as director of the museum that it is worth examining in depth. Bywaters divided art museums into two basic categories, "the older types . . . dim, quiet storehouses of precious Old Masters" and "the new ones . . . beehives of experimental art activity" (ibid., p. 347). It is clear from the assumptions and thesis of Bywaters' article that he intended for the Dallas Museum of Fine Arts under his directorship to be a new and active museum. He wrote, "It is now a generally accepted premise that an art museum, whether old and large or new and small, must serve both art and people. It cannot successfully perform these two complementary functions by merely being a static repository for art; it must also be an intelligent interpreter and active sponsor of the arts for living people" (ibid., p. 348).

Ever the historian, Bywaters provided a brief chronology and analysis of the establishment of art museums in the United States. He pointed out that early museums reflected European influence in both their collections and architecture. He noted that as American art came of age, museum buildings grew away from the neoclassical traditions, and he found that after 1925 "the

museum was housed in a building with a new look, growing naturally from the nature of the business involved, which was 'art and living people' " (ibid., p. 350). Bywaters featured the Dallas Museum of Fine Arts building in the article as a representative of "a complete emancipation from European precedent." [30]

Bywaters used the *Southwest Review* article as an opportunity to express his philosophy of museum management and outline his ideas about exhibitions. "The annual program of exhibitions at the younger museum is one of its most important and productive activities," he wrote, "and here again the inventive and alert character of young museums shades their older counterparts" (ibid., p. 352). He asserted that the most essential part of a regional museum's exhibition schedule was "a series of annual competitive jury shows presenting the best of current art production in all mediums from city, state or region, with special recognition available in the form of adequate cash awards and purchase prizes" (ibid.). In addition to the competitive exhibitions, Bywaters advocated an exhibition schedule that included "at least two large and expensive exhibitions, planned to portray some trend in American art or a period in historical art ('Romanticism in America' or 'The Greek Tradition at Work')" (ibid.). And he stated that "rounding out a twelve-month schedule of between thirty and fifty exhibitions will be small but pertinent shows. The titles of some random examples might be: How a Painting is Made, Art Begins at Home, Design Today, Building in the Post-war Period, etc." (ibid.). Bywaters had many ideas for exhibitions. With a small staff and a limited budget, the museum produced an average of one new exhibition per week during Bywaters' tenure as director.

Art education was a key element in the museum's program for Bywaters. He wrote, "Next in importance to sponsorship and interpretation of the arts through collections and exhibitions is the more formal educational program for laymen (adults and children) and professionals. Since art has now become a 'legitimate' study in the curriculum of public schools and universities, young museums usually have direct and affiliated relations with the week-day studies of young people, often serving as an extension of the school systems and using mutual staff members" (ibid., pp. 352–353). In 1945 Bywaters hired his friend Otis Dozier to head the Museum School's teaching staff of six artists. Classes included landscape, still-life, portrait, and figure painting as well as sculpture and ceramics. There were life drawing classes with a nude model for adult students. Bywaters made arrangements with Southern Methodist

University to offer the museum's life drawing classes for college credit.[31] In addition to the Saturday art classes for children, an art appreciation program was offered in cooperation with the Dallas public schools. Bywaters believed that in addition to formal studio art classes and art history courses, the museum should offer a variety of programs – "many lectures, gallery tours, and demonstrations for all age groups."[32]

At the time, Bywaters' article on museums in the *Southwest Review* served as a kind of blueprint for the objectification and demonstration of his philosophy. Thirty-three years after its publication Bywaters characterized the article as "argumentative" and "impudent."[33] His thesis that young and small museums should serve both art and people to compete with larger, older museums was admittedly self-serving and self-protecting. Bywaters recalled, "The article aroused some sharp response of agreement and rebuttal, both regional and national, but it did focus attention of the Dallas Museum of Fine Arts and other young museums in their efforts to project a positive image against heavy odds" (ibid.). Bywaters' contemporaries generally agreed with the article. After reading the article, John Walker, chief curator of the National Gallery of Art, wrote Bywaters, "It seems to me to state so clearly the policy which museums should follow"[34]

In October 1946 the Dallas Museum of Fine Arts opened an exhibition entitled "Two Hundred Years of American Painting." Bywaters selected the works in this ambitious exhibition and wrote an essay for the catalogue. Works came from museum collections throughout the United States, including the Art Institute of Chicago, the Brooklyn Museum, the Metropolitan Museum of Art, the Whitney Museum of American Art, and others. The exhibition included fifty-five works dating from 1765 to 1946. The catalogue contained thirty-eight black and white reproductions and was intended as "an easily remembered outline and some brief comments on the main directions in American art."[35] Bywaters' preferences and prejudices were visible in his selection of works and throughout his essay, which surveyed the history of American art. He referred to impressionism as a "disturbance" and praised artists "interested in showing that art was related to everyday life" and paintings that reflected the artists' "social and political ideas as well as their preoccupation with daily life in city and rural areas" (ibid.). Bywaters presented his concept of works by regionalist artists: "The European apron strings of art were definitely severed and the main concern of painting was to study and interpret America. Once we were ashamed of our art and our background,

and we patronized Europe, but now there was a healthy desire to learn about ourselves and respect our own accomplishments." He characterized the modernist movements in America from 1920 to 1940 as a "Time for Experiments." In a concise outline he defined the major stylistic movements: "*Cubism* was a study of the structure of all things, animate and inanimate; *Dadaism* broke up objects and re-formed them grotesquely to make the point that we are doing a bad job of running the world; *Futurism* in painting attempted to depict objects in motion; *Abstraction* showed many sides of an object simultaneously; *Expressionism* was an automatic rendering of the essentials of an experience; *Surrealism* dealt with dreams, fantasy, and other phases of memory and psychology" Listing the names of several contemporary artists whose work was included in the exhibition, Bywaters made his prediction regarding the direction of American art: "Ralston Crawford, Robert Gwathmey, Otis Dozier, Morris Graves, . . . Philip Guston, Everett Spruce, and Jack Levine are some of the many who are consolidating the traditions of the past with the theories of today – pointing the direction of American art of tomorrow" (ibid.).

In the summer of 1947 the Dallas Museum of Fine Arts presented a large survey exhibition of painting and sculpture by artists of the Southwest. Sixty-four artists from New Mexico, Arizona, Colorado, Oklahoma, Arkansas, and Louisiana were represented in the show. Because the work of Texas artists was shown frequently at the Dallas museum, Bywaters decided to exclude Texas in this broad survey of the art of the region. Bywaters found a variety of artistic expression in the Southwest: "There are academicians, devotees of the American Scene, cubists, abstractionists, expressionists, surrealists, nonobjectivists – in fact all types of artists who can be classified; and some who defy classification."[36] Bywaters' catalogue essay, entitled "Southwestern Art Today: New Directions for Old Forms," was reprinted in the Autumn 1947 issue of *Southwest Review.*

The lengthy article explained his views on the stylistic and aesthetic changes that he was observing. "Contemporary art in the Southwest is no longer headed exactly in this direction or that," Bywaters stated, "but is decidedly at a crossroads" (ibid., p. 361). Unlike his usual decisive and clear writing style, the article was disjointed and ponderous, reflecting Bywaters' efforts to sort out the issues. There were old arguments to rehash and new problems to address.

The article documented the evolution of Bywaters' thought. He took a

wide brush to paint in the details of the historic progression of abstraction in the art of the Southwest. He first attacked the artists of Taos:

> Among these avant garde painters of the early thirties it became taboo to paint an Indian – that is unless he was abstracted and non-objectivized until little remained except some rain cloud symbols or a thunderbird. Likewise bluebonnets and Spanish moss . . . , Negro cabins and mules, overalls and working girls, and many other things were removed from the list of legitimate or significant properties from which art could be produced. From the objective, art turned inward to the subjective, to the individual ego, the psyche and its traumas. The artist came to believe only in a mission to re-create the world through invented symbols, or by sifting ideologic content through the fine sieve of his own delicate sensitivity" (ibid., p. 370)

Bywaters presented this view of the emergence and acceptance of abstraction in American art:

> . . . in most places during the thirties the New Art was ineffective (New York was the exception). The movement was not well organized, its strong individual artists were relatively few in number, and its critical support was limited. The fountainhead was far away in Europe. Perhaps the most important reason for the ineffectiveness of this movement was the great popularity of the painters of the American Scene (a popularity encouraged by the shrewdly contrived writings of Thomas Craven and by a rising tide of nationalism). Being foreign-inspired, and non-realistic, the various experimental and abstract movements did not wear well in America. And then preparations for war put the lid on nearly all art except patriotic and utilitarian forms. (ibid.)

For Bywaters the only legitimate use of nonobjective abstraction was camouflage. Bywaters continued,

> In the late thirties and early forties the New Art was receiving powerful and capable support from several unpredicted quarters. Pogroms in Europe drove to our shores many leaders of experimental art movements in Germany, Italy, and Spain, and unsettled conditions persuaded leading artists from England, Holland, France, Hungary, Russia and many other coun-

tries to make their way to America. Another outstanding factor was the rather complete although rarely acknowledged adoption of modern art by American advertising in package design, commercial photography, architecture, and other fields . . . Knowingly or not, American business, so scientifically innovative, so devoted to functionalism, and so willing to try anything that might pay off, is a perfect complement to the scientific and intellectual experimentation to be found in the modern art movements. So it was entirely logical for Americans to adopt the Bauhaus practices and even to employ many of the exiles from this famous German school; American advertising went all out for surrealistic psychic shock (eye appeal). America is a land of born mechanics, so it is natural that we should be interested in theories which have to do with speed, force, dynamics, and multiple action. Of course, the part we resented was calling these interests by such terms as futurism, cubism, expressionism, dadaism, constructivism, and abstractionism. (ibid., p. 371)

The article registered a turn in Bywaters' thinking. "Whatever may seem to be our opinion above, we are convinced that these developments are all to the good." Bywaters announced as though newly convinced, "Yes, we think modern art, the New Art, is here to stay; and we believe it will not be unbecoming or unsuited to American artists. Much of it, after all, consists of intellectual investigation or scientific research, and though we have not always distinguished ourselves in the first field, we have a natural aptitude for the second" (ibid.).

Bywaters acknowledged a major explosion in American art: "Indeed it is no secret that a national art battle is raging, with skirmishes going on in every museum and at most art gatherings, professional or lay. And, of course one *must* take sides, one way or another!" (ibid., p. 361). Taking sides was difficult for the director of a museum that was gaining recognition as a leading institution and for an artist who had experienced the approval of officialdom. Torn between the alternatives, Bywaters agonized, "If one is modern he avoids the humiliation of being branded old-hat; if one is traditional he eludes the accusation of being liberal and therefore communistic or subversive!" (ibid.). This comment was ironically prophetic because every attack launched at modern art in the next decade was based on the assumption that abstraction meant subversion and therefore communism. Both as an artist

and a museum director, Bywaters certainly felt the widening schism in American art and the public's inability to comprehend the changes.

The historical exhibitions which Bywaters brought to Dallas were popular and uncontroversial. In the autumn of 1947 the museum hosted an important exhibition of works selected from the permanent collection of the Metropolitan Museum of Art. The exhibition, "30 Masterpieces from the Met," attracted over 115,000 visitors during the State Fair to view works by Ghirlandio, Bellini, Titian, Tintoretto, Bosch, Rubens, Rembrandt, Goya, Bonheur, and others. Bywaters wrote, "It was a memorable show for those Texans who had not had the opportunity to see the works of such famous artists."[37] Bywaters also brought a famous painting by Rosa Bonheur to the museum especially for the 1947 State Fair. Jerry Jane Smith Henderson, who served as the museum secretary at the time, dropped brightly colored leaflets from the top of the ferris wheel announcing, "See the *Horse Fair* at the State Fair."[38]

The large competitive group exhibitions at the museum registered the groundswells of stylistic changes in contemporary Texas art. As modernism crept into the Texas art scene, the general reaction was unfavorable. In 1947 the social-realist painter George Biddle evaluated the Texas General Exhibition and informed the *Dallas Morning News:* "We felt that all too many of the dozen or so abstract or non-objective paintings in the Texas General lack not only meaning but technique. In fact a good many of the other paintings also fail to appeal to the senses or to the intellect, or to either, at least for us."[39] Perhaps Biddle disapproved of Ward Lockwood's cubistic *Prison Rodeo*, or DeForrest Judd's abstract *Monday*, or Robert Preusser's nonobjective *Color Infusion*, all of which were in that exhibition. (The same news article mentioned a "Modern Artists" exhibition in the Theatre '47 lounge-lobby area. There was little opportunity in Dallas for young artists to exhibit contemporary abstraction, and works on exhibit in this makeshift space were characterized as experimental. The article mentioned the work of Dan Wingren, Ben Culwell, and John Rosenfield III, all of whom were students of Bywaters at SMU.)

Under Bywaters' direction the Dallas Museum of Fine Arts began to present large, important exhibitions of works by leading contemporary artists. Although modern art was not always well received by the public, Bywaters believed that the young artists of Dallas were best served by introducing them to the current trends in art. The museum hosted an exhibition of paintings by Hans Hofmann, and in the summer of 1948 an exhibition traveled to Dal-

las from the Chicago Art Institute entitled "Abstract and Surrealist American Art." Art writer Patricia Peck Swank speculated before the exhibition opened that "some of the museum's patrons will trumpet with rage about degeneracy in American art. Others will admit to complete bewilderment. But they will come and study the paintings intently – controversial exhibitions always draw them."[40] Swank also pointed out that Bywaters was being accused of "giving too much space to 'modern art.' " In rebuttal Bywaters produced a list of all the museum's exhibitions from the time he became director in 1943. Swank concluded that of these exhibitions "barely a fourth represented extreme trends in painting. Another fourth was strictly classical. The remainder could only be termed middle-of-the-road" (ibid.).

Bywaters assembled two important exhibitions to take advantage of the large crowds for the 1948 State Fair exhibit. He presented the first exhibition in the United States focused on the works of two giants of contemporary Mexican art – David Alfaro Siqueiros and Rufino Tamayo. And to balance that exhibition of modern art with a historic survey, Bywaters curated the exhibition "Famous American Paintings," which brought Grant Wood's *American Gothic* and Benton's *Persephone* to Dallas for the first time as well as works by Copley, Homer, Eakins, Duveneck, Harnett, Remington, Albright, Burchfield, and Curry. The survey focused on realism, which Bywaters viewed as a natural stylistic progression in and hallmark of American art.

The following year's State Fair exhibit registered a record-breaking attendance for one day of 22,000 visitors for the exhibition "Leonardo da Vinci and His Times," which was from the Jacob M. Heimann collection. That same year the museum also presented a selection of twenty-four works by modernists Braque, Chagall, de Chirico, Dali, Derain, Kokoschka, Picasso, Tanguy, and others whose work was exhibited for the first time in the region. In the midst of changing artistic currents, it was Bywaters' intention to present the most contemporary art of the highest quality to the public.

In the early 1950s there were growing signs that the museum was coming of age and both the museum and the director were receiving national recognition. Bywaters' own art work was mentioned in Oliver Larkin's major survey of the history of American art, *Art and Life in America*. In 1950 Bywaters was elected to membership in the Association of Art Museum Directors, and in 1953 he was acclaimed by *Atlantic Monthly* as one of the best museum directors in the nation.

Amid the growing prosperity of the early 1950s, Bywaters commissioned his

friend O'Neil Ford to design a new, larger house for his family near Southern Methodist University. The house overlooked "a small, picturesque lake" at the head of Turtle Creek, which meanders through the fashionable Highland Park area of Dallas. The *Dallas Morning News* reported that "its artistic location and simplicity of design are what you might expect of a museum director's home." [41] The flat-roofed, red brick structure at 3625 Amherst was very modern and daring for 1950. Only high narrow windows faced the suburban street, but large walls of glass opened to the lake view. Along with waxed concrete floors in the bedrooms and a brick floor in the kitchen there were redwood-paneled walls, cabinets, and bookshelves. Navajo Indian rugs were scattered on the floors, and a collection of Indian art and artifacts was displayed on special shelves. A mobile by Otis Dozier hung near the fireplace, and a portrait of Mary Bywaters by Ed Bearden hung near her grand piano. Simplicity and economy of space were obvious in Ford's design. The house was a symbol of modernity and quality appropriate for the home of a director of a major art museum.

Prosperity brought an increase in museum membership, and in 1950 the museum's budget increased to $37,295. The constantly troublesome air conditioning was finally repaired, and more money was available for larger and more elaborate exhibitions and additions to the permanent collection. The 1950 State Fair exhibition was an extravaganza of over two thousand works of pre-Columbian art in stone, gold, jade, ceramic, and textile. Purchases from that exhibition formed the nucleus of the museum's present collection of Mesoamerican art. The 1950 State Fair also featured Emanuel Leutze's famous painting *Washington Crossing the Delaware*, an unprecedented loan from the Metropolitan Museum of Art. Bywaters recalls, "It was 'show business,' but good business in introducing the Art Museum to many people who might otherwise never have come inside such a building." [42]

Exhibitions for the year included "500 years of Egyptian Art" and "Hudson River School of Painting" as well as an exhibition of two "natural," or self-taught, painters, H. O. Kelly and Clara Williamson. The museum's permanent collection increased substantially through gifts and the acquisition fund. The estate of Joel T. Howard left thirty-six works to the museum by American artists Duveneck, Dewing, Inness, Twatchman, and Hassam. At the instigation of trustee Stanley Marcus, Mr. and Mrs. Bernard Reis gave *Cathedral* by Jackson Pollock to the museum. The Garden Club commissioned and donated a work by Alexander Calder. A large drawing by Andrew Wyeth was the

gift of oilman E. L. DeGolyer, and a series of paintings by Tom Lea on the history of cattle was commissioned by *Life* and given to the museum. A Thomas Moran landscape was purchased by the Munger Fund. Dallas Art Association funds bought works by Eugene Speicher, Andrew Dasburg, Charles Hawthorne, and others. Museum trustees adopted a formal policy to focus the collection "in the contemporary American and Latin American fields, with continued dominance in the regional area and some buying in the early American and modern European market as opportunities occurred" (ibid., p. 30). In order to present art and artists outside the scope of the collection, Bywaters continued to organize special exhibitions and to book touring exhibitions from other museums.

In 1950 the Metropolitan Museum of Art named the Dallas Museum of Fine Arts as one of the five regional centers to receive and to judge entries for a large survey exhibition of contemporary American art. Regional centers received 6,248 paintings and selected 761 examples, from which the national jury accepted 307 works for an exhibition that filled fourteen galleries of the Metropolitan. Bywaters chaired the Southwest jury that screened work from Texas, New Mexico, Oklahoma, Arkansas, and Louisiana. Eleven Texas artists were included in the exhibition. As evidenced by this significant exhibition, the Texas regionalist artists were no longer rebellious outsiders but part of the ranks of established artists welcomed by major art institutions.

Bywaters used every means possible to introduce the Dallas audience to the history of art and the concepts of modern art. He took advantage of a new educational medium and initiated a television program in the summer of 1950. A weekly program on WFAA-TV was planned by John Rosenfield, art critic for the *Dallas Morning News*, and hosted by his wife, Claire Rosenfield. The half-hour program "Is This Art?" on Sunday afternoons presented visiting art celebrities and toured exhibitions at the museum. The program included demonstrations of the actual processes of painting, sculpture, and ceramics by various artists. Tours of the museum with special discussions of the major works in the collection were also telecast. Television cameras roamed the museum, surveying such works as Thomas Hart Benton's lithographs and abstract paintings by Arthur Dove, Joseph Stella, John Marin, Willem de Kooning, Mark Rothko, and others. As interest in the program grew, the Dallas Junior League funded a second year and assisted in the conception and presentation of the program. An immediate success, the program aided in increasing the museum membership to a new high of 1,172.

In 1951 Mitchell Wilder, director of the Colorado Springs Fine Arts Center, published an article in *Atlantic Monthly* which rated the quality of art museums and art activities in the Southwest. He ranked the Dallas Museum of Fine Arts first for its service to the public: "Bywaters and the Dallas Museum are pacing the Southwest with an art school, a children's education program, and an exhibition schedule singularly rich in regional interest and aesthetically well balanced."[43] Wilder praised Bywaters for an innovative approach, citing "two galleries for the permanent display of useful arts and design – a testing ground as well as exhibition, where the citizen may sit in the latest gadget designed to keep him off the floor, read beside the newest lamps, and decide at no personal cost what the modern home is coming to." Wilder reported that Bywaters had described the museum as "a little regional outfit trying to behave like a metropolitan organization" (ibid.).

The Dallas Museum of Fine Arts, however, was no longer a small institution. In 1952 annual attendance increased to 140,000 and there were 570 students enrolled in the Museum School; by 1954 annual attendance had grown to 221,497. As president of the Dallas Art Association, Stanley Marcus and the Board of Trustees initiated an elaborate plan for the future of the museum, which included detailed program goals for exhibitions, acquisitions, activities, publications, special services, educational activities, membership, building expansion, promotion, and public relations.

The museum's commitment to artists of the region during this period was evident in the acquisition of works by Otis Dozier, Vernon Hunter, William Lester, Everett Spruce, Dan Wingren, Charles Umlauf, and DeForrest Judd. The museum also acquired works by Joseph Albers and other contemporary artists working in the United States, but its major commitment was to Mexican art. Bywaters traveled to Mexico and purchased works by Diego Rivera, Jose Orozco, David Siqueiros, Rufino Tamayo, Alfredo Zalce, Carlos Merida, Castro Pacheco, Jean Charlot, Carlos Romero, Miguel Covarrubias, and Juan O'Gorman. The museum commissioned a major mural titled *El Hombre* by Rufino Tamayo.[44] Concentrating on Texas, American, and Latin American art, the museum assumed an international focus.

In the late spring of 1952 German-born artist George Grosz visited Dallas at the invitation of Leon Harris, one of the founders of a leading department store in Dallas. Grosz produced a number of watercolors and a few oil paintings expressing the dynamic nature of the bustling city of Dallas. Works such as *Dallas Broadway* vibrate with the flash of neon signs of a busy street. His

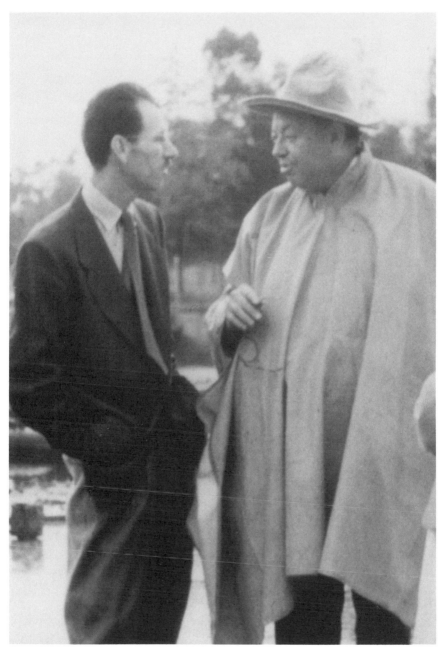

Jerry Bywaters with Diego Rivera at the "Cárcamo del Río Lerma" in Mexico City, 1951. *The Jerry Bywaters Collection on Art of the Southwest, The Jake and Nancy Hamon Arts Library, Southern Methodist University, Dallas, Texas.*

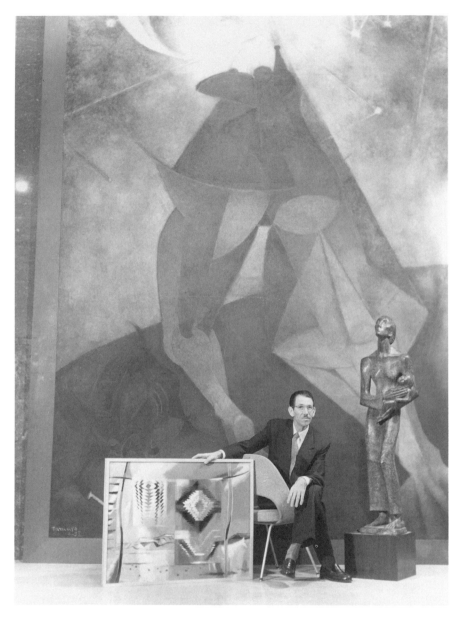

Jerry Bywaters with mural *El Hombre* by Rufino Tamayo, sculpture *Mother and Child* by Carl Umlauf, and painting *Navajo Blanket* by Otis Dozier, 1953. *The Jerry Bywaters Collection on Art of the Southwest, The Jake and Nancy Hamon Arts Library, Southern Methodist University, Dallas, Texas.*

interpretations of the city were shown at the Dallas Museum of Fine Arts in an exhibition titled "Impressions of Dallas."

In 1952 the State Fair began to offer a one-thousand-dollar purchase prize for its annual Texas Painting and Sculpture exhibition, which traveled to other Texas museums. Dallas artist Dan Wingren won the prize with his painting *The Explorer*, which was stylistically a descendant of cubism. Jurors for the exhibition were Dorothy Miller of the Museum of Modern Art, John I. H. Baur of the Whitney Museum of American Art, and H. Harvard Arnason from the Walker Art Center.[45] That same year Bywaters and two other museum directors, James Chillman of the Museum of Fine Arts of Houston and Daniel Defenbacher of the Fort Worth Art Association, assembled an exhibition titled "Texas Contemporary Art" for the Knoedler Galleries in New York.

The Knoedler exhibition served not only to highlight the work of Texas artists but also to place them in the mainstream of American art. According to a review in the *Christian Science Monitor*, "The same proclivities in Texas . . . are to be found in any or all of the other 47 states. For there is no longer a provincial, or rural, area of art. Cosmopolitan trends have spread far and wide."[46] The exhibition served to define a new regionalism. The reviewer saw the stylistic changes as a movement away from ruralism to cosmopolitanism, observing that Texas artists had abandoned painting directly from nature: "There is so much tampering with tangible and visible facts that they lose obvious identity with familiar natural phenomena and the native scene" (ibid.). The artists cited for their work were newcomers, sculptor Charles Umlauf and painter Kelly Fearing, both of the University of Texas, John Biggers of Texas Southern University, and John Erickson of Texas Christian University. Dozier's work was categorized as sophisticated. Works by Spruce and Lester in the exhibition reflected the movement toward abstraction in their individual styles.

Despite the fact that the core group of regional artists were dispersed throughout Texas, Oklahoma and Colorado, Bywaters pursued every avenue to bring art by Southwest artists to the public's attention. He worked with SMU Press to produce a portfolio of reproductions of original lithographs titled *Twelve from Texas*. The portfolios were limited in number to 525, of which 450 were for sale. Representative works by Charles Bowling, Don Brown, Otis Dozier, E. G. Eisenlohr, Alexandre Hogue, DeForrest Judd, William Lester, Merritt Mauzey, E. M. Schiwetz, Coreen Mary Spellman,

Everett Spruce, and Thomas Stell were included in the portfolio. "SMU Press will issue a related series of portfolios of prints by regional artists," Bywaters wrote in the foreword. "The series will represent the works of leading artists both in Texas and the rest of the southwest region, and these artists will be reproduced in all print media from engravings to aquatints, from lithographs to serigraphs."[47] His essay sounded the familiar notes of the regionalist aesthetic.

In February 1952 the famous surrealist painter Salvador Dali toured the United States and delivered a lecture in Dallas at Bywaters' invitation. He expounded his new theories of "nuclear mysticism" to a stunned audience at McFarlin Auditorium on the SMU campus. Jerry and Mary Bywaters escorted Dali and his wife Gala on a tour of Dallas. Bywaters recalled that Dali obstinately refused to speak English for the duration of the visit until he noticed a portrait of Wanda Ford by Tom Stell hanging in Bywaters' house. According to Bywaters, Dali exclaimed, "Who is it that can paint as well as Dali?"[48] This expression of appreciation of the work of a Texas artist by a world-renowned art figure was proof positive for Bywaters and others that art from their region was important.

As the Dallas Art Association marked its fiftieth anniversary in 1953, prospects were never brighter for the future of art in Texas. That November, *Look* pictured Bywaters posing in front of the mural *El Hombre* by Rufino Tamayo, holding Otis Dozier's *Navajo Blanket* with a sculpture titled *Mother and Child* by Charles Umlauf at his side. The caption announced, "In Dallas, the focus is on the Southwest."[49] Other museums featured were the Art Institute of Chicago and the California Palace of the Legion of Honor. The article surveyed the leading figures and trends in American art. According to the article, the magazine had invited some of the "leading art impresarios" to be photographed with "the most important paintings and sculptures they will exhibit within the next few months" (ibid., p. 89). Bywaters was pictured along with such New York art dealers as Grace Borgenicht presenting Lee Gatch's *Lancaster Version*; Betty Parson with *No. 14* by Ad Reinhardt; Curt Valentin with Marino Marini's *The Juggler*; and Edith Halpert with *Medium Still Life* by Stuart Davis. It is evident from the comparison of art works that Bywaters and other leaders in the art world were in general agreement about the stylistic direction of American art in 1953. Bywaters, however, preferred to promote the modernism of his region.

Bywaters' interest in the art of the Southwest climaxed in the blockbuster

exhibition "The Fabulous West." Record-breaking State Fair crowds viewed not only works by Indian artists but also Indian artists demonstrating their crafts. Navajo sandpainters, silversmiths, weavers, and dancers from Arizona pitched tents outside the museum and remained on call to perform publicly. Works by Charles Russell and Frederic Remington were also exhibited. The exhibition was extremely popular; on one day alone, October 9, 1954, over 30,000 visitors saw the show.[50] Bywaters intended the exhibition to present a substantive comparison of native American art with the abstraction of contemporary art. Bywaters recalled, "The abstract or 'modern' qualities of the Indian arts, from pictographs to blanket designs, were compared with other early cultures as well as with the contemporary sculpture of Hans Arp or the paintings of Joan Miro" (ibid., p. 33). Bywaters found similarities between cattle brands and barbed wire and the sculpture of Alexander Calder and David Smith, and the exhibition highlighted the abstract qualities of all. As journalist William Johnson wrote in *Life*, "When Texans saw the symbolic designs of Navajo rugs in close juxtaposition to the paintings of such artists as Mondrian, Picasso, and Klee, they were apt to conclude the moderns are not so strange and foreign after all."[51]

There were signs that Texas art and artists were finally emerging as leaders in American art. In the *Life* article, titled "Texas Breaks the Spell of the Bluebonnet," Johnson observed that "Texas is emerging into the wider world of non-bluebonnet art, and in Texas fashion is enjoying the experience with abnormal gusto" (ibid., p. 26). Bywaters was certainly optimistic about the future of his museum and art in Texas. The state's booming economy promoted art sales, and new museums of art opened in San Antonio and Fort Worth. Exhibitions and programs at the Dallas Museum of Fine Arts were more successful than ever. Bywaters ranked with the leading museum directors in the nation and received a citation for service to the arts from Houston's Museum of Fine Arts and from San Antonio's Witte Museum. It seemed regional artists had won the war for recognition and national attention. Stylistically, Texas artists were working in a new abstraction based on realism and rooted in the region. Bywaters was confident that the art of his region would not be overlooked in the next decade by the eastern art establishment.

RED, WHITE, AND BLUE ART

AT THE DALLAS MUSEUM

On March 15, 1955, the Public Affairs Luncheon Club, a polite and political group of affluent Dallas ladies, presented a resolution to the Dallas Art Association and issued a statement to the press declaring that the Dallas Museum of Fine Arts was "overemphasizing all phases of futuristic, modernistic, and non-objective painting and statuary." The group leveled another, more

serious charge: the museum was allegedly "promoting the work of artists who have known Communist affiliations to the neglect of . . . many orthodox artists, some of them Texans, whose patriotism . . . has never been questioned." The public resolution demanded that the museum officials "correct their policy of sponsoring the work of Communists."[1]

This curious incident would be easy to write off today as merely a comical episode, but Bywaters viewed the accusations seriously. The anticommunist alarm that the luncheon club sounded was ringing across the United States. Amid a climate of reaction and intolerance, any criticism or deviation from "the American way" was viewed as subversive and motivated either directly or indirectly by the Soviets. The use of congressional investigatory committees in the cause of anticommunism was pioneered by East Texas congressman Martin Dies, the first chairman of the House Committee on Un-American Activities from 1938 to 1944, and later duplicated in the Senate by Senator Joseph R. McCarthy. Across the nation an atmosphere of suspicion was officially fostered. The image of the Soviet threat was forged by the U.S. government and the news media. FBI director J. Edgar Hoover was quoted as saying that the Communist influence had infiltrated "newspapers, magazines, books, radio, . . . churches, schools, colleges, and even fraternal orders"[2] A *Dallas Morning News* editorial characterized the uneasy peace of the Cold War: "Things are looking up for the dove of peace, it would seem. Let us hope it is not Picasso's notorious symbol, a decoy if there ever was one. Let's make certain, first, that it is the real McCoy."[3] The editorial warned, "Now is the time for America to be on guard. Now is the hour when all the warnings of recent years against the world-wide Communist conspiracy take on a newer and deeper meaning."

The American public was thoroughly warned about the Communist threat, but was generally unsure of how to deal with the problem. Accusations and flag-waving were symptoms of public reaction to the Cold War. Americans were standing on guard, but their specific target was uncertain.

Historian Don Carlton has argued in *Red Scare!* that conservative Texans of this period were especially disturbed about the drift of politics and economics of postwar America. "Instead of contending with a multitude of domestic and international postwar developments as individual and separate issues and events," Carlton found that "many Texans and Americans accepted a simple explanation to deal with everything."[4] The members of the Public Affairs Luncheon Club, in an effort to fire at the Communist

enemy, aimed at modern art, which they found inscrutable and therefore subversive.

From 1955 to about 1959, Bywaters and the Dallas Museum of Fine Arts faced a puzzling sequence of politically motivated events and accusations. Symptomatic of the McCarthy era, vigilant superpatriots suspected that abstract art was subversive and accused the museum of exhibiting art works by "Reds" or "pinko" artists. The right-wing luncheon club was joined by a discordant chorus of American Legionnaires and avocational painters who were displeased with the progressive tenor of the museum's exhibitions. An exhibition entitled "Sport in Art," organized and toured nationally by the American Federation of Art, received a sustained assault of criticism and harassment from the museum's critics. City support for the museum was threatened, but Bywaters and the museum's Board of Trustees clung to its standards of freedom of expression and professionalism.

The issues involved in the case are so complicated that thirty years later Bywaters struggled to describe the nature of the attacks on the museum. "It's like trying to make a piece of sculpture out of smoke," he explained as he gestured. "It isn't there, it isn't there, you can't pin it down."[5] In retrospect, the Communist controversy at the Dallas Museum of Fine Arts in the mid-1950s and the cancellation of the international tour of "Sport in Art" provides a case study of the complex and difficult dialogue between postwar politics and the evolution of modern art in America. At issue was not only aesthetics, but also the changing social role of the artist. The case at the Dallas Museum of Fine Arts must be examined in the light of changing political impositions on art. As the capital of the avant-garde shifted from Paris to New York and American culture went through a period of reconstruction buttressed by changes in the world economy, both the art market and the art product were transformed. The protracted controversy at the Dallas museum was not centered on any single event or crisis, but rather was fueled by chronic harassment, innuendo, unsubstantiated accusations, fear, and intolerance.

In 1953 Bywaters requested that the museum board form a standing committee on art and politics. He explained, "I had seen the things happening in San Francisco, Refregier murals; Los Angeles, the sculpture on the police station; New York, the Met sculpture show which Wheeler Williams' bunch said was 'endangering the American way of life'; Hollywood, blacklisting movie writers, actors, etc.; Washington, the infamous 'recalled' State Department exhibit; etc." (ibid.). Bywaters kept a scrapbook of clippings about

the various art scandals around the country. Despite his desire to take precautions against such attacks in Dallas, at that time the Board of Trustees did not see the need to establish a political policy or guidelines.

In March 1955, when the controversy in Dallas began, the museum's galleries were filled with sculptured jewelry by Salvador Dali and early American folk art. Attendance at the museum was up, and Bywaters anticipated a busy spring planning new exhibitions. He had just returned from the American Association of Museums convention in Washington and had been elected honorary member of the Dallas chapter of the American Institute of Architects for his efforts to promote the study and appreciation of architecture. Neither Bywaters nor the museum board could ever have anticipated or imagined the intensity and duration of criticism from outside agitators that the museum would face. As the Dallas controversy unfolded, the local press thrived on the scandal, and the national press debated the issues. Ultimately the specific events in Dallas had national and international ramifications.

Certainly no one predicted that the Public Affairs Luncheon Club would cast the first stone. Many of its members were also members of the museum, and their children attended art classes at the Museum School. The club met once a week and "concentrated on bringing conservative speakers to town."[6] During the mid-1950s these luncheon speakers included George Wallace, William F. Buckley, Jr., Ronald Reagan, and Barry Goldwater. Organized in 1932 as the Democratic Women's Luncheon Club and later merged with the Non-Partisan Legislative Forum in 1944, the Public Affairs Luncheon Club existed "to encourage women to take a thoughtful, informed, and active interest in the affairs and functions of government."[7]

The club was sponsored by wealthy Dallas oil man Harold Lafayette Hunt, and his wife served on the club's Board of Directors. H. L. Hunt was a key figure in the museum controversy, not so much as an active participant but as a backer of various organizations and publications that coalesced against the museum. A strong supporter of Joseph McCarthy, Hunt founded in 1951 and headed a tax-exempt organization, ostensibly nonpartisan and nonpolitical, called Facts Forum, which produced radio and television programs and a magazine called *Facts Forum News*. By 1955 Facts Forum programs were appearing on 315 radio affiliates and 58 television outlets. Hunt also sponsored a newsletter called the *American National Research Report*, which "named Communists" and "fronts" and described their activities in detail – a com-

mon weapon of vigilant citizens. Hunt hired former FBI agent Dan Smoot as commentator of a superpatriotic radio show called "Life Line." Smoot later founded his own conservative newsletter, which became the voice of the extremist fringe in Dallas. Hunt, Smoot, and their associates viewed foreign aid, fluoridated water, income tax, and mental health programs as Communist plots. As the controversy surrounding the museum unfolded, Hunt's propaganda organs trumpeted alarm.

The public accusations by the Public Affairs Luncheon Club that the Dallas Museum of Fine Arts was exhibiting works by Communists was the first assault in a clumsy tactical battle against an uncertain enemy. The women based their charges on the information disseminated by Facts Forum and the ideas of Representative George A. Dondero, a Michigan Republican who in 1949 announced to the House that modern art originated as a weapon of the Russian Revolution for the destruction of the Czarist government. Dondero found modern art a rich source for hidden conspiracies: "Communist art, aided and abetted by misguided Americans, is stabbing our glorious American art in the back with murderous intent."[8] The congressman demanded a full-scale investigation by the House Committee on Un-American Activities on the subject of Communist domination of art in the United States.

The aim of Dondero's March 17, 1952, speech in the House of Representatives, titled "Communist Conspiracy in Art Threatens American Museums," was to expose Red infiltration, his favorite topic. He vowed to show that museums from coast to coast were agents for communist aggression. A New York arts group, Artists Equity, was a principal target of the speech, and by implication any artist who had ever been a member of Artists Equity was under suspicion. Central to his argument was his mission to "expose Red infiltration and control in certain artists' organizations" and to declare abstractionism in modern art as dangerous.[9] Dondero theorized that abstractionism was a vehicle of Communism and, therefore, that museums which showed abstract art were Communist fronts. The Public Affairs Luncheon Club took Dondero's admonition to heart when he urged, "No immunity should be granted to the red art termites. The loyal American artists in our cultural centers of New York, Chicago, Los Angeles, San Francisco, and others, are determined to protect our cultural birthright from this horde of art saboteurs who would first destroy in order to control" (ibid., p. 7).

Based on Dondero's recommendations and lists of suspect artists, the excited club members checked the museum's catalogues and listed "the most

objectionable" artists: "Joseph Hirsch, Chaim Gross, George Grosz, Jo Davidson, Picasso, Rivera, and Max Webber [*sic*]."[10] The club then published a pamphlet titled "Is There a Communist Conspiracy in the World of Art?" and distributed it to club members and to the members of the museum board. The publication answered the rhetorical question with a resounding affirmation that "Communist art . . . has infiltrated our cultural front in America."[11] Quoting liberally from two different Dondero speeches, the pamphlet announced that abstraction was a means of subversion. Using an often-quoted phrase of Dondero's analysis of stylistic trends in art, the pamphlet concluded, "These isms can be tagged specifically . . . as instruments of destruction: Cubism aims to destroy by designed disorder; Futurism by the machine myth; Dadism [*sic*] by ridicule; Expressionism by aping the primitive and the insane; Abstractionism by the creation of brainstorms; Surrealism by the denial of reason" (ibid.).

The day after the luncheon club leveled its charges at the Dallas Museum of Fine Arts, Stanley Marcus, president of Neiman-Marcus and president of the Dallas Art Association, consulted with Bywaters to marshal a response. Before leaving for a fashion-buying expedition in Europe, Marcus appointed a committee of trustees to study the charges.[12] The committee of J. T. Suggs, Mrs. Alex Camp, and Robert M. Olmsted found no basis for complaints: "Some people like one kind of art and some people like the other."[13] They decided the issue was purely "a matter of taste, and neither communism or patriotism is involved." The investigation committee issued a prompt public response, denying charges that the museum was "being used for the presentation of the art and concepts of Communists" and asserting that "no tax or City funds have ever been used to acquire any of the Museum's works of art. The collections have been accumulated by the Dallas Art Association with privately donated funds or through gifts" (ibid.).

"That was on a Friday afternoon," Marcus wrote in his autobiography. "On Saturday I paid calls on the publishers of the two daily papers at their homes and asked if they believed in the principle of the freedom of the press. Naturally they replied affirmatively. I followed up by saying, 'If you believe in freedom of the press, then you must certainly accord similar rights of freedom of expression to writers, actors, and artists.'"[14] Marcus told them of the efforts being made by a group of superpatriots to impinge on freedom of expression at the museum. According to Marcus, the editors promised to back the museum "on both the editorial and news pages." Marcus recalled, "The Dallas

papers did stand by the museum's right of free expression for the duration of the problem. Their news stories, of course, reflected the attacks from the opposition, but at no time did the papers pull out their editorial support."[15]

In an effort to quickly defuse any controversy, the museum board announced to the press, "We believe the people of Dallas are intelligent enough to decide this matter for themselves, on the basis of the evidence. Therefore, we have requested the Director of the museum to hang in a prominent place in the Museum the three paintings by the artists whom the Museum's critics have identified as Communist or Communist affiliated, so that the Citizens of Dallas can inspect them and decide for themselves whether the pictures are calculated to present the concepts of Communism."[16] Bywaters hung three paintings near the museum entrance for easy viewing: a bust portrait of a man by Diego Rivera, a scene of workmen washing up by Joseph Hirsch, and a painting of a nude arranging her hair by George Grosz. Bywaters posted a sign that read, "These paintings are by artists listed by the Public Affairs Luncheon Club resolution as presenting concepts of communism." Also displayed were a few abstract paintings with a sign stating, "Abstract art is not communist art" (ibid.).

Attendance at the museum that Saturday was larger than usual, and Bywaters reported that the museum added "some 20–25 new members" due to the controversy.[17] Dallas newspapers publicized the story. On March 20 the Joseph Hirsch painting on loan to the museum from the National Academy of Design of New York was reproduced in the *Dallas Morning News*, and the next day's *Times Herald* pictured the museum secretary, Jerry Jane Smith, with a pensive posture standing next to the Diego Rivera portrait with the caption "Communistic?"

During the week of March 20, newspapers across Texas, including the *Fort Worth Star Telegram*, the *Houston Press*, the *Texarkana Gazette*, and the *Galveston News*, covered the controversy. According to an article in the March 21, 1955, issue of the *Texas Observer*, Bywaters claimed that the club members were "attacking one thing they dislike – contemporary art – and linking with it another thing they dislike – communism."[18] Bywaters believed that if the misunderstanding about the nature and sources of abstraction in art were understood, the controversy would soon dissipate. An article in the *Dallas Morning News* also addressed the issue of aesthetics and stressed the interesting fact that "Dondero makes his plea for realism on these grounds: 'Art

which does not portray our beautiful country in plain simple terms that everyone can understand breeds dissatisfaction.'"[19] The article ironically pointed out that Alexander Mikhailovitch Gerasimov, president of the Soviet Academy of Arts, had expressed similar ideas about realism: "We work for our people and our art must be understood by our people. That is why we believe in realistic art." Despite Bywaters' numerous arguments that abstraction was anathema to Soviet Russia, the museum's critics were not convinced.

It was clear, however, from a March 21 letter from Colonel John W. Mayo, commander of Dallas Metropolitan Post 581 of the American Legion, that the controversial issue was not based solely on aesthetics. The war veteran was incensed by Stanley Marcus's comment that the controversy stirred by the luncheon club was "tommyrot." Mayo's letter to the museum trustees asked urgently whether "Communist party membership or Communist-front affiliation . . . [would] have no bearing upon decisions to purchase, accept, or exhibit an artist's work?"[20] Mayo demanded that the investigating committee of the museum board "study the documentation available on those affiliations and then state whether or not the museum will continue to sponsor showings of the work of these artists." Mayo pleaded that "consideration be given to the affiliation of these artists with an international conspiracy that already has enslaved half the world." The war veteran obtained newspaper space to make public his position.

J. T. Suggs was uneasy as chairman of the museum board's committee to investigate the accusations that the museum exhibited works by Communists. A staunch conservative, and vice-president of the Texas and Pacific Railway, Suggs had served as the museum's legal counsel and trustee since 1947. He announced to the board by memo that "some months ago I visited Mr. Dondero in Washington and discussed this subject with him at some length."[21] Suggs provided the committee with copies of Dondero's March 17, 1952, speech to the House on the subversion of modern art. Suggs also obtained a list of Communist and Communist-front organizations from the U.S. attorney general as he considered it the committee's duty to amass as much information as possible about the nature and extent of Communist infiltration of art institutions.[22] Under the guidance of Suggs, the museum board at the April 4 meeting responded to Mayo's letter by affirming their Americanism and vowing not to exhibit the works of known Communists. The board issued a public statement affirming that "it is not our policy knowingly to acquire or

exhibit work of a person known by us now to be a Communist or of Communist front affiliation."[23] The aesthetic issue of realism versus abstraction was not addressed in the board's statement.

The statement was intended to be conciliatory, to prove the board's patriotism, and to avoid confrontation. However, their indecisiveness left them vulnerable. The enraged patriots reasoned that if the museum did not know its artists were "Commies," then they would prove it. Instead of reassuring the museum's accusers, the statement prompted immediate reaction. At an April 11 meeting at the Adolphus Hotel the Public Affairs Luncheon Club issued a resolution urging the museum to "consider seriously the documentary evidence that artists with Communist affiliations have been honored in the exhibitions of the museum of Fine Arts."[24] The sources of this documentary evidence were various reports of the House Committee on Un-American Activities. The club's resolution also requested that "the Trustees of the Dallas Museum of Fine Arts . . . withhold exhibition privileges for artists who have proven affiliations with Communist or Communist Front Organizations."[25]

The strongest reaction was registered by H. L. Hunt's conservative newsletter, the *American National Research Record*. The publication characterized the museum's position this way: "The substance . . . was that the Board rejected documented proof of extensive Communist front records compiled from various Congressional reports and hearings."[26] The editorial continued, "What the Dallas Art Museum Board or committee has done is to insist that they will not be moved except by official documentation . . . This leaves the Dallas Public Affairs Luncheon Club, American Legion Post #581, and other supporting organizations no choice but to force the issue and give the Dallas Art Museum Board just what it wants – an official investigation into the whole controversy. An essentially insincere, not-so-clever brush-off is obviously not going to end the matter." Like Dondero, the editorial also called for "a full scale Congressional investigation into the whole question of Communist infiltration in the arts."

Throughout that spring, Bywaters fielded the accusations of suspicious clubwomen, irate Legionnaires, enraged bluebonnet painters, and militant Minute Women that the museum was regularly exhibiting works by known Communist artists. On several occasions women marched into Bywaters' office and demanded to see the Communist art. Each time Bywaters graciously offered to conduct a private tour of the museum for them, but they declined for fear of being indoctrinated by Communist propaganda.[27] At a time in

Texas when the New Deal was simply equated with communism, Bywaters suffered for his close association with the federal art projects of the 1930s. And the fact that he had written an article about Diego Rivera in the 1920s and met the professed Communist in Mexico City in 1951 were not marks in Bywaters' favor with Dallas conservatives. Bywaters' duties as director did not diminish during this time; he had exhibitions to plan, an art school to run, and administrative responsibilities to fulfill. Years later he remembered, "We just dealt with it as best we could . . . But I must say we had to use up a lot of energy just answering questions."[28] His secretary, Jerry Jane Smith, recalled that Bywaters never lost his sense of humor and always remained calm and courteous in the face of crisis. The business of the museum continued without interruption.

At an April 4 meeting the museum board decided that it would be unwise to make Bywaters a spokesman because it was too easy to target a single individual. Because museum policy was at issue, the board shouldered the responsibility, and Bywaters abided by their wishes. The gesture did not, however, stop the personal attacks on Bywaters. As director of the museum, he was a public figure. He received unsigned and undated hate mail. One letter, clipped to a copy of one of Dondero's speeches, admonished, "Inform yourself Mr. Bywaters and do not allow yourself to be a dupe for communist subversion by not knowing the truth."[29] Another letter, addressed "Dear Comrade," urged Bywaters to go to Russia, where "there is a real need for your type" There were also anonymous notes that listed the names of the museum's most strident enemies. Curiously, during one heated public debate Florence Rodgers, chair of the Public Affairs Luncheon Club, announced to all that "there is no fight between us and the distinguished director of the museum, Mr. Jerry Bywaters."[30] Bywaters' long association with the *Dallas Morning News* saved him somewhat from direct attacks during the long assault on the museum.

On April 5, 1955, both the *Dallas Times Herald* and *Dallas Morning News* reported at length the trustees' statement of policy. A small wave of hysteria rippled through the editorial pages. The Dallas newspapers were filled with letters to the editors warning people to be alert to Communist infiltration, voicing patriotism and denouncing modernism, while others pleaded for freedom of expression and an end to paranoia. For many, the issue was censorship versus freedom of speech, but many inflamed patriots wanted Communists out of their city museum even if that meant censorship. As one letter

to the editor of the *Dallas Morning News* said, "I happen to love America far more than I love art."[31]

The museum board's statement was viewed by many as timid and placative. John Chapman, longtime friend of Bywaters and former board member, wrote an article titled "Aesthetic Judgements and Art Museums" in the summer 1955 issue of *Southwest Review*, pleading for a single standard in the judgment of art works: the aesthetic standard."[32] A *Texas Observer* article, "The Sad Tale of the Timid Trustees," recounted the events from March 15 and discussed issues at stake regarding freedom of expression.[33] The controversy received national attention when *Time* quipped, "The Public Affairs Luncheon Club racked up a thumping victory in their campaign to censor the Dallas Museum of Fine Arts . . ."[34]

The art world was shocked by the museum board's action. An *Art News* editorial, "Shame in Dallas," condemned the action of the trustees: "There are moral problems involved, ladies and gentlemen, trustees of the Dallas Museum. Moral problems, you should be reminded, which are scrupulously regarded in most civilizations except of course in Communist totalitarian states. The conclusions of civilized man over these problems are that we judge the work of art and not its author unless he intrudes himself, or ideas extraneous to art, upon that work."[35]

On July 1 Marcus attended the first board meeting after his return from Italy and the last in his elected term as president. He read aloud the *Art News* editorial and informed trustees that he vehemently disagreed with their April 4 action. At the next meeting J. T. Suggs was elected president, and he recited an acceptance speech that pledged an era free of controversy for the museum. The first order of business, however, was decidedly controversial. A former trustee and art dealer demanded the return of a portrait by Diego Rivera which he had donated to the museum in 1952. The work, which had never been exhibited by the museum, was deemed controversial by the museum's critics. The board opted to postpone any decision about returning the work and turned to the problems of future exhibitions.

Anxious about potential controversy, Suggs proposed "a careful look at those 'Family of Man' pictures before we show them at the Fair."[36] Bywaters had booked "The Family of Man" exhibition, a gigantic show of 503 photographs, for the month of October during the State Fair. The exhibition, selected by the famous photographer Edward Steichen, had opened in New York to rave reviews and had traveled to Washington and Minneapolis. The

exhibition was scheduled to travel from Dallas to Cleveland and abroad. Suggs anticipated problems because many works were credited to Russian photographers. Despite Suggs's misgivings about a few images in the exhibition, "The Family of Man" brought very large crowds to the museum with a record number of catalogue sales.

That summer the Dallas newspapers were filled with another heated art controversy. Metal sculptor Harry Bertoia was commissioned by architect George Dahl to produce a contemporary work for the new Dallas Public Library. From the moment the untitled work arrived in Dallas and was assembled in the lobby of the library there was a public outcry; it was too modern, too abstract, too costly. Bertoia's 24-by-10-foot sculpture was constructed of hundreds of small pieces of steel, brass, copper, and nickel welded together into a screen. Bywaters was asked his opinion of the work for the press. "It is a careful and skillful creation by an expert," he affirmed. "This decorative grid has an inventive quality that is intriguing and supplements the architecture and makes original use of the techniques for which our machine age has become famous."[37]

Most public statements were not so kind to Bertoia's art work. It was deemed "a pile of junk" by the mayor of Dallas.[38] A firestorm of letters to newspapers followed, debating the aesthetic qualities and the $8,500 price tag of the metal sculpture. For art critic Rual Askew the scandal evolved from the kind of reasoning which says "that what is unfamiliar is suspect, that what is not 'liked' by some is unacceptable to all."[39] The library board's answer to the controversy was to seek a private donor for the sculpture. In a surprising move the architect for the new library bought the work and had it removed from the library and installed in his home. The *Dallas Morning News* announced, "Now, Dallas taxpayers will not have to pay for it – or look at it."[40] Two weeks later a committee of four concerned citizens, Mrs. Edward Marcus, Mrs. Alex Camp, Mrs. George W. Works, Jr., and Waldo Stewart went to the Dallas City Council with a proposal to buy the sculpture and donate it to the library. This idea was approved, and the metal mural was reinstalled in the library for the formal opening in September.

These various art controversies throughout the fall of 1955 were aggravated by a thoroughly inaccurate and insipid article in the *American Legion Magazine* entitled "Art for Whose Sake?" by Esther Julia Pels and subtitled "Some Modernists Are Peddling More than Pictures."[41] The article was an unscrupulous exposé of modern art by the wife of Karl Boarslay, editor of the *Ameri-*

can National Research Record. Without benefit of any knowledge of art, Esther Pels compared the emergence of modern art to the Hans Christian Andersen story of the emperor's new clothes. "This may sound very funny," she wrote, "but the sickening story of decadence, perversion, and revolutionary purpose behind the introduction of modern art to America is far from humorous. So called 'modern art' had its origin in socially sick and decadent European art circles before the First World War. From them sprung [sic] Cubism, Dad[a]ism, Futurism, Symbolism, Expressionism, etc. In the social ferment that was to produce communism, fascism, and nazism, there arose artists who plotted to use art as a means of power over the masses." Pels continued her own version of art history: "Since its inception, 'modern art' has been revolutionary, in the deliberate turning of the human mind from what is true, good, and beautiful to the contemplation and worship of ugliness, disordered visions of madness, 'social protest', and the use of esoteric and occult symbols for reality" (ibid., p. 54). Pels equated abstraction with perversion and subversion. It is ironic that the art-blind Pels called for clear-sighted vision to expose the hoax of modern art.

In another line of attack Pels emphasized that modern art "was not an American art movement" based on the number of "foreign names" such as Jewish, French, German, and Italian names of the leading modern artists. She also evoked Dondero's favorite themes and listed artists associated with UNESCO and Artists Equity, which she believed to be Communist-front organizations. The crux of her argument was that modern art is ugly and distorted, and therefore degenerate and meaningless. She believed that modern art was Communist-inspired and Communist-fostered and that it aimed to break down human dignity and religious reverence. She maintained that modern artists are predominantly Communists and Communist-sympathizers.

Pels specifically cited the Dallas Museum of Fine Arts as a leading proponent of Communist-inspired art. After connecting artist Joseph Hirsch with "a record of communist front affiliations," Pels pointed out that a Hirsch painting occupied "a place of honor in the Dallas Museum of Fine Arts, along with the work of others with notorious records of red front affiliations." Pels suggested that the museum had ignored the protests of honest citizens who objected to the exhibition of Communist art in a public institution. The article was later reprinted verbatim in *Facts Forum News*.[42]

The unhappy members of the Public Affairs Luncheon Club took Pels's

article as gospel. Throughout the fall and winter of 1955, the museum's problems were kept alive in club meetings, speeches, and letters to newspaper editors. Women's clubs urged members to cancel museum memberships and not to send their children to art classes at the museum. There were threats to picket the museum and Neiman-Marcus as well because of Stanley Marcus's association with the museum.[43]

The skirmishes continued when "Sculpture in Silver" opened at the museum on December 11, 1955. The exhibition, circulated by the American Federation of Art, presented small works in silver by artists from ancient Egyptian times to the present day. Long before the exhibition opened, agitators demanded that a piece titled *Head* by William Zorach be removed, but Bywaters and the museum trustees ignored the demands.[44]

Following the "Sculpture in Silver" exhibition, the museum opened another touring American Federation of Art exhibition called "In Memoriam." The exhibition included works by John Steuart Curry, Arthur Dove, Arshile Gorky, Marsden Hartley, Bernard Karfiol, Walt Kuhn, John Marin, Reginald Marsh, Kenneth Hayes Miller, Niles Spencer, John Sloan, and Yasuo Kuniyoshi. Conservative vigilantes publicly charged that six of the twelve artists represented in the exhibition had Communist-front records. Astonished at the protest, Bywaters answered the charges this way: "The 'In Memoriam' show is devoted to artists who have died within the last twelve years. The Communist activities of Sloan and Kuniyoshi are dubious, inasmuch as both are dead."[45]

At the lengthy museum board meeting of December 7, 1955, members discussed the current problems and the future of the museum. They were tired of constant harassment and were weary of efforts to defend their position. As Al Meadows queried, "I wonder if it would be necessary to call a Board meeting every time there is a new exhibition" (ibid.). Members expressed their desire to change their April 4 statement. Gerald Mann, a new board member and former attorney general of Texas, pursued this change of thinking and insisted that the museum form a policy which would keep it out of the political arena. Jerome Crossman and Leon Harris endorsed Mann's stand. Harris made a motion and the board approved a policy statement that the museum would "exhibit and acquire works of art only on the basis of their merit as works of art."[46] The museum board informed Mayo of the new policy to exhibit and acquire art works only on the basis of artistic merit. Later the museum announced publicly that it would not ban any pictures from an

upcoming Sport in Art show and that henceforth decisions would be made solely on artistic grounds. The museum's public statement added the wish "to dissipate this nonsense that any single group is the custodian of the patriotism of all of us."[47] Although the museum board never backed down from this position, the controversy continued.

Immediately after that announcement, the Dallas Art Association trustees received a letter from Mayo in the name of the Dallas County Patriotic Council, a newly formed group of sixteen societies.[48] The council was comprised of such organizations as Pro-America, Daughters of the American Revolution, Daughters of 1812, the Woman's Chamber of Commerce, the Dallas Veterans of Foreign Wars, the American Legion, the Inwood Lions, the Matheon Club, and the Southern Memorial Association. Local art clubs like the Frank Reaugh Club, the Klepper Club, the Federation of Dallas Artists, the Bassett Club, and the Oak Cliff Fine Arts Society also joined the council. The council demanded that the museum restate its original policy not to buy or show works by known Communists. The council also requested deletion of works by four artists from the upcoming "Sport in Art" exhibition and demanded the removal of Zorach's silver head from the "Sculpture in Silver" exhibition. The Dallas Morning News recorded the events with an article announcing "Museum Art Again Attacked as 'Red.'"[49]

On January 27, 1956, the museum board meeting was concerned exclusively with the accusation that four of the eighty-five artists represented in the "Sport in Art" exhibition had Communist affiliations. A touring show organized by a pillar of conservative art, the American Federations of Art, "Sport in Art" was scheduled for exhibition in Dallas from March 25 through April 20, 1956. More than one hundred handsome works of art demonstrating a variety of styles and dealing with the subject of sport had been drawn from numerous public and private collections for the tour. The exhibition was composed of works by such European masters as Daumier and Goya and such American greats as Homer, Eakins, and Tait. Modern artists represented in the exhibition included Paul Cadmus, Elaine de Kooning, Peter Hurd, and Fletcher Martin. The exhibition opened at the Museum of Fine Arts in Boston in November of 1955, traveled to the Corcoran Gallery of Art in Washington, D.C., and the Speed Art Museum in Louisville. Traveling from Dallas, the show was scheduled to open in art museums in Denver, Los Angeles, and San Francisco. "Sport in Art" was to end its tour in Australia as a crowning element of the 1956 Olympic Games. Planned as a proud and fitting rep-

resentation of the resources of American art, the exhibition proved to be the Rubicon for the Dallas Museum of Fine Arts.

The Dallas Patriotic Council demanded that the following works of art be removed from the exhibition: *National Pastime*, a drawing by Ben Shahn; *Skaters*, a drawing by Yasuo Kuniyoshi; *Fisherman*, a watercolor by William Zorach; and *The Park, Winter*, an oil on canvas by Leon Kroll.[50] Each of the four artists had major reputations in the art world, but the council judged the art not on an aesthetic basis but rather on a political one. Those four artists were targeted by the Patriot Council as enemies of the United States. There were distinct overtones of anti-Semitism and racism in the charges that the four artists were Communists. Despite the council's rhetoric, the objections to these art works were not based on style or subject. Bywaters and the museum board broadcast information that Zorach was apolitical and had voted conventionally in Republican Maine most of his life. Shahn, a liberal, had survived an FBI investigation and had been issued a passport to lecture abroad. Kroll had designed and executed a mosaic in a government war memorial for which security clearance was required. Kuniyoshi was the first president of Artists Equity and had fought possible Communist subversion in that organization. He had served as a broadcaster to Japan for the U.S. government during World War II. But the museum's counter to the charges that the artists were Communists left little impression; the mere fact that the artists were mentioned in the file of the Committee on Un-American Activities was enough to convince members of the Patriotic Council that they were indeed Communists.

Records of that January meeting of the museum board state that "the matter was fully discussed, with some feeling it would be unwise to take up the specific defense of these four artists or any others since that was not the museum's function. Many felt it most important that the Board not place itself in the position of being judge and jury for these men, who had not been on trial nor convicted; nor act as a board of censorship . . ." (ibid.). The board voted to reaffirm its December 7 statement, which contained the policy of exhibiting works of art solely on an aesthetic basis.

Suggs, however, was troubled by the museum's controversial position: "To some people it is of supreme importance to display art, perhaps as a measure or gesture of artistic freedom. To some of us, it is more important that we not promote and further the interests of the individual who has aligned himself with a cause that would destroy all freedoms, regardless of the merit of his art

work. To us this is a matter of judgement as to how we can best preserve our system of liberty, and it has nothing to do with artistic quality" (ibid.). He admitted his viewpoint was in the minority on the board.

Discussion then centered on the curatorial authority of the director of the museum. Hamon made a motion that "the selection of exhibitions be made at the discretion of the Director according to policy established by the Board," and a motion carried for "a vote of confidence from the Board for the Director" (ibid.). Bywaters' position as director of the museum was secure. His actions in the face of controversy were commendable. With a board united in a policy decision, Bywaters continued his interest in showing the best historic and contemporary art to Dallas audiences.

After reaffirming the curatorial authority of the director of the museum, the board sent a special delivery letter by Western Union to Colonel Mayo, restating its policy "to exhibit and acquire works of art only on the basis of their merit as works of art; and to exercise their best judgement to protect the integrity of the Museum as a museum of art and as a municipal institution."[51] In answer to the Dallas County Patriotic Council's demands and after much deliberation, the museum's letter stated, "It is against the best interests of the museum to delete those pictures mentioned in your letter." The trustees' strongest rejection statement was as follows: "One of the basic principles of American Justice is that a person is presumed innocent until proved guilty, . . . the fundamental issue at stake is that of freedom and liberty – not just for the Dallas Museum of Fine Arts, but eventually for our school system, our free press, our library, our orchestra, and the many other institutions of our society. We believe that democracy cannot survive if subjected to book-burning, thought control, condemnation without trial, proclamation of guilt by association – the very techniques of the Communists and Fascist regimes."

That news prompted the January 28, 1956, issue of the *Dallas Morning News* to announce that "Museum Says Reds Can Stay." The inflammatory title for art critic Rual Askew's article was changed from the morning edition to "Museum Bans Politics Rule" for the city, or afternoon, edition. The identical articles stated the museum's policy not to withdraw any pictures from current or projected exhibitions.[52]

Members of the Dallas County Patriotic Council deplored the board's decision to exhibit art based on aesthetics and surmised that it would "permit the work of Red artists to be shown in the museum of our city."[53] They called a meeting at the Highland Park Town Hall on January 31, 1956. "The Reds

are moving in upon us," warned Colonel Alvin Mansfield Owsley, a former U.S. minister to Ireland and Denmark and a former commander of the American Legion. One hundred and fifty inflamed council members cheered Owsley's words: "The works of the Red hand and the black heart hating America do not deserve to be exhibited to our citizenship." Standing in front of U.S. and Texas flags, he ended his speech triumphantly, "Let those who would paint a Red picture supplant it with the Red, White and Blue. White for purity, blue for fidelity as blue as our Texas bluebonnets."[54]

Another speech, by William Ware, also of the American Legion, charged that "the members of the board of trustees have been very cleverly maneuvered into the position of serving as a Communist Front for the protection of pro-Communist artists."[55] He also raised great concern among the group by saying that "our tax money is going into the pockets of artists devoted to the destruction of our way of life." Ware saw the museum's new position as a "reversal" of the April 5 statement. In a resolution the Dallas County Patriotic Council appealed to the park board, which controlled the museum's budget, to "exercise the authority vested in them by the citizens of this city to deny exhibition privileges of a public tax-maintained institution to persons with records of affiliation with subversive activities of Communist and Communist front organizations."[56]

Mayo took his grievance to the newspapers. "The reason I resent showing the works of a Communist-front artist in a tax-supported museum," he wrote, "is that our country is at war with Communism."[57] It was generally agreed among members of the Dallas County Patriot Council that censorship was a fair price to pay to save America from communism. The tax issue became their banner. Handbills signed by a Jacquelyn R. Bynum were circulated throughout Dallas and posted on the automobiles of museum visitors; the handbills read: ". . . your tax money is going through the Park Board to the museum for the aid, comfort, and prestige of your enemies . . . Don't you think it's time to cut off Park Board funds from the Dallas Museum of Fine(?) Arts?"[58]

The *Dallas Morning News* asked Gerald Mann to make a statement in rebuttal to Mayo's article. Mann defended the museum's policy as one that "is in substance the policy followed by the Boston Museum, the Metropolitan in New York, the National Gallery in Washington and all the leading museums of the world except those located in Soviet Russia and its satellites."[59] He added that "the pictures you see at the Dallas Museum, whether in a

traveling exhibit or purchased by the museum, do not cost the tax payers of Dallas a single cent." The City of Dallas, through the park board, supplied the museum with an annual operating fund of $63,365 for the year 1955. Again and again museum representatives explained that not one cent of tax money went to purchase any works of art. The Patriotic Council's appeal to the park board to cut off operating funds for the museum was a dangerous threat to the survival of the museum. When approached by the media, park board president Ray Hubbard said succinctly, "We think the Art museum is running fine . . . We back up the Art Museum."[60] Dallas mayor R. L. Thornton attempted unsuccessfully to defuse the issue before a showdown at a park board meeting.[61]

For two weeks the controversy raged in the Dallas newspapers with headlines like "Art Museum Critics Vow All-Out Fight" and "Trustees Answer Art Museum Critics."[62] There was extensive coverage of the political records and art careers of the four suspected artists.[63] During this time the museum board received a letter from Patriotic Council member Florence Rodgers stating that "the specific issue is whether the paintings of an artist who is a Communist or who is a known supporter of Communists or Communist party activities and who is supported by official Communist publications should be exhibited in a museum supported by Dallas taxpayers, thereby in turn giving support to the Communist Party itself and the Russian Communist government."[64] In a formal statement to the press, which the *Times Herald* reprinted in full, Rodgers asked, "Let every fair-minded reader understand that the question to be answered is this: Shall art by Reds be exhibited at taxpayers' expense in our museum?"[65]

On February 23 members of the Dallas County Patriotic Council appeared before the park board with their grievance. There were planned speeches by John Owsley, B. F. McLain, John Mayo, William Ware, and Florence Rodgers. The issue remained the censoring of four works in the "Sport in Art" exhibition, and the group promised "to take its case to the City Council and 'the people,' if the paintings are not banned."[66] The park board listened to the Patriotic Council's complaints but upheld the Dallas Art Association's decision to exhibit the entire "Sports in Art" show. Although the park board's action was not the final answer to the council's demands, it was a definite step toward defusing the problem.[67]

The day of the park board meeting Bywaters was quoted as stating that "the House Un-American Activities Committee was charged with investigating

'hate groups' as well as those suspected of Communist affiliation. I'm afraid the council falls in this category."[68] A wave of articles in sympathy and support of the museum followed. John Rosenfield wrote a lengthy editorial outlining the dangers of censorship as specifically applied to the Dallas controversy. He quoted liberally from President Eisenhower's remarks at the twenty-fifth anniversary celebration of the Museum of Modern Art.[69] Eisenhower had made a clear statement in support of aesthetic freedom: "Freedom of the arts is a basic freedom, one of the pillars of liberty in our land."[70] Eisenhower stated not only that artists must have freedom of expression but also that "people must have unimpaired opportunity to see, to understand, and to profit from our artists' work." He called for "healthy controversy and progress in art" and reminded everyone "how different it is in tyranny. When artists are made the slaves and tools of the state; when artists become chief propagandists of a cause, progress is arrested and creation and genius are destroyed." The museum board reprinted the president's statement and circulated it. The statement substantiated their decisions, and they felt that the words of the most revered Republican would carry a great deal of weight with their most ardent critics. The Dallas Junior Chamber of Commerce adopted a resolution commending the actions of the Board of Trustees of the Dallas Art Association "on their exhibition policy in theory and in practice which will aid the growth and stature of our Museum in the cultural life of our city."[71]

As the opening of the "Sport in Art" exhibition approached, public debate and controversy continued. Stanley Marcus later recalled that a powerful banker, Fred Florence, president of Republic National Bank, had been alerted by Owsley and tried to apply pressure on both the museum and Neiman-Marcus not to show the works of Shahn, Kuniyoshi, Zorach, and Kroll. Marcus described the encounter this way: "Mr. Florence summoned me to his office and told me that he had reports that the exhibition Neiman Marcus was co-sponsoring with the Museum contained some radical works of art. He said, 'You and the store, as well as the Museum, are going to be in trouble if you don't meet these complaints by withdrawing them from the exhibition.' I told him since we had not organized the exhibition, it was impossible for us to withdraw them"[72]

The museum board mobilized with a campaign of its own. Three trustees, Jerome Crossman, Gerald Mann, and Waldo Stewart, authored a carefully considered and effective letter regarding the issue of censorship at the mu-

seum and sent it to two thousand community leaders. Trustees met with the mayor and City Council to explain the museum's stand. Their efforts were met with empathy and support. The entire Rotary Club gave a standing ovation to museum trustee Eugene McElvaney, who spoke at the club's March 1 luncheon meeting. Vice-president of First National Bank, McElvaney told the Rotarians that he objected to the "brand of patriotism associated solely with an obsessive fear of Communism." He stated, "Certain patriot groups, almost in desertion of the fundamental defenses of our freedoms from all forms of ideology encroachment, devote their major energies toward banning or censoring – and imagine they are fulfilling their highest devotion to home and country."[73] Bywaters credited McElvaney with "changing the negative opinion of some of the public."[74]

The next week Patriotic Council leader William Ware received a cool reception from the East Dallas Rotary Club when he explained that the council was "not fighting the board of trustees of the art museum, rather we seek to warn them of certain dangers."[75] Ware compared the council to the "group of patriots who took their stand at Lexington, Massachusetts . . . We are uncompromising in our demand that Communist artists not be honored in our tax-supported Museum. With God's help, we will win because we are right." There was a tone of desperation to Ware's speech.

The week before the opening of the "Sport in Art" exhibition, the Patriotic Council ran an elaborate advertisement in the *Times Herald* asking readers to clip a ballot and choose between the following alternatives: "We do not (do) want Communists and pro-Communists exhibited or honored in our municipal museum." The Patriotic Council's urgent plea concluded: "Does any reasonable person need further proof that the Communist party is behind these four artists of the 'Sport in Art' Show? Do you want your tax money (City taxes) used to honor these Communist Artists in our museum? The Dallas County Patriotic Council protests the use of public facilities for exhibiting or honoring Communists or pro-communists. We urge you to express your opinion as a citizen of Dallas while there is still time!"[76] *The Dan Smoot Report* hurled the most venomous insults at the Dallas Museum of Fine Arts. The article began with this statement: "For ten years now, the citizens of Dallas – like all other Americans – have been subjected to the most intensive and massive educational drive in the history of the world – a drive designed, almost exclusively, to teach them that communism is the number-one threat to their way of life."[77] The article recounted the entire Dallas controversy and

stated emphatically that the museum's exhibitions had "become top-heavy with communist art – to the exclusion of works by American artists who are not communists"

Bywaters saved the various articles, letters, and resolutions that the museum received during this ordeal.[78] He was the first to recognize that the leaders of the Dallas County Patriotic Council were disgruntled artists – a loose affiliation of Sunday painters, dilettantes, dabblers, and semi-professionals. "It was just the effluvia," Bywaters later explained, "I would say, of anger and thwarting that came from specialized groups of artists, mostly amateur artists, who didn't like modern art."[79] For Bywaters, the museum staff, and trustees the complaints of local artists "seemed especially ungrateful" because of the museum's efforts "to promote competitive exhibits and invitational shows for artists of the region."[80]

Reveau Bassett, the leader of the disgruntled artists and the most venomous in his attacks against the museum, was a successful painter of landscapes and ducks whose work had appeared in many of the museum's exhibitions. Bassett had not only influenced small clubs of amateur artists but also gained notoriety on the luncheon-club lecture circuit. A Dondero disciple, Bassett peppered his remarks with spicy language, and often said that the sight of a modern painting by a "Red" made him feel as though he had eaten a salad and then found it had been made by "an infectious chef."[81] He announced to the Pro-America Club at Highland Park Town Hall that the art world had been taken over by Communist organizations. Using his own definition of art as beauty and sanity, Bassett pointed disparagingly to works by expressionists, cubists, and futurists as examples of "anti-beauty" and "anti-art." He repeatedly targeted the Dallas art museum for supporting "commie artists," citing the Tamayo mural as "strange."[82] He complained that "the good American artists don't have a chance" and that the juries for competitive exhibitions at the museum were fixed. Pointing to a reproduction of a work by abstract artist Irene Rice Pereira, Bassett exclaimed that "it looks something like a fried egg in moonlight" and announced to his audience that Pereira "belongs to 20 to 24 Communist front organizations."

Bassett had quite a following, and in November 1956 he became president of a newly chartered Dallas chapter of the American Artists Professional League. In an effort to promote American art, the organization was founded in New York on a platform calling for all official government portraits to be painted by "American artists with American colors" and a "fair jury system"

for all exhibitions and competitions.[83] Opposed to government subsidies for art, the league launched a legislative program "to defeat certain bills before Congress that seek to establish a Federal Department of the Arts."[84] Bassett urged American artists to "hold fast to conservative principles of painting and to oppose sensationalists, revolutionists and innovators of decadent isms" (ibid.).

Other traditional artists in Dallas were also unhappy with the actions of the Dallas museum. "For years they have filled the Museum with modernistic paintings ignoring Dallas artists," complained B. G. Edes, president of the Federation of Dallas Artists; he added that "exhibitions at the museum are closed affairs, the same people have won prizes for 15 years."[85] According to Mrs. L. H. Hertz of the Delta Art Club, "Different art clubs haven't been able to exhibit art out there in a long time. I know of local professional artists who can't show, and their works are good" (ibid.). The Reaugh Club and the Klepper Club backed the charges, and Mrs. T. G. Harkey of the Aunspaugh Art Club made the argument clear: "We have not been given a room where we could exhibit our art. After all, we are taxpayers" (ibid.). This loose affiliation of artists supported the Public Affairs Luncheon Club's initial resolution and joined the Dallas County Patriotic Council because they believed the museum had done them some great injustice by not exhibiting their art work. The vocal Inez Hummelbaugh of the Reaugh Club asserted, "There are 600 artists in these art clubs. None of these artists has had any support from the Museum at any time – we back the resolution."[86]

The Dallas Women's Chamber of Commerce, also a member of the Patriot Council, stepped in to resolve the friction between the avocational artists and the art museum by issuing a resolution urging that "at no time shall space in the Museum of Fine Arts be used for the display or showing of the works of known propagandists who have been active in organizations listed as 'subversive and communistic' by duly constituted investigating committees."[87] These women also believed that the museum galleries were "limited to only a small group, whose works comprise the extreme modernistic in all phases of art" As a solution to the controversy, they proposed that the museum hang "the fine permanent collection" and that "at no time shall less than 20 per cent of the collection be kept hanging and that through rotation all pictures in this collection be made available to the visiting public during the course of a year." Their resolution also called for the museum "to make a special gallery space available for local artists" (ibid.).

Such a plan was discussed and accepted by the museum board as a viable means to win back the support of local art groups. The board's decision to open exhibition space to local amateur art groups, however, placed Bywaters in an untenable position. In his tireless efforts to promote the art of the region, quality and professionalism were his major concerns. The work of avocational artists was excluded from the Dallas Museum of Fine Arts, as from every other art museum across the nation that aspired to high artistic and professional standards. In February 1956 the museum officially inaugurated a series of exhibitions of works by the local art clubs. It was reported that "the museum's plan to show work this season by qualified Dallas artist groups on an experimental basis was formulated at a November meeting with representatives of interested groups. It was decided that exhibits would be displayed for 10-day periods and juried by a jury of the group's own selection"[88] Gallery A of the museum was designated as the art clubs' turf; the clubs were in charge of assembling, judging, and maintaining the standards of the shows. Bywaters did not have curatorial control of the work to be exhibited in Gallery A, and the museum staff was obliged to hang the local art clubs' exhibitions.

An exhibition of thirty-six works by the members of the Aunspaugh Club inaugurated the series of shows by local art groups. On that occasion art critic Eugene Lewis of the *Times Herald* wrote, "These . . . shows will give the public an idea of what the various art clubs around Dallas are up to currently. From a cursory examination we would say that they are mainly up to painting fruits and flowers."[89] Following the Aunspaugh Club show the Bassett Club opened an exhibition on February 26 that inspired this favorable criticism: "If the horizon of its creative outlook . . . is limited to undeviating representationalism, the case is stated with commendable craftsmanship."[90] *Dallas Morning News* art critic Rual Askew pointed out that "ironically the Bassett Club is high on the list of signatories to the Dallas Patriotic Council which has been charging Red influence in certain Museum exhibitions." Askew added this satirical comment: "Evidently this is all in good clean fun as the Bassett Club willingly shows its wares in the self-same galleries" (ibid.).

The Federation of Dallas Artists, yet another member of the Dallas County Patriotic Council, opened its show on March 11. Askew assessed the work as "the noncommittal fare that is both the bane and life of avocational painting."[91] Askew panned the Klepper Art Club show: "The japonica, magnolia and other floral exercises, snow scenes, copied calendars, assorted still lifes

and the like are different from their predecessors only in their fewness (there are only 33 canvases this time). The smattering of professional competence jumps out of the total mediocrity unavoidably."[92] Another reviewer, commenting on the Klepper show, lamented, "At the museum Sunday the staff will change the signs in Gallery A, but the names, subject matter and quality will remain largely the same."[93]

The Reaugh Club opened a show on April 6 of twenty-four oils, two watercolors, one pastel, one mosaic, and one sculpted head. One of the exhibiting artists was Inez Hummelbaugh, wife of W. C. Hummelbaugh, vice-president of the Dallas County Patriotic Council. Askew leveled this realistic criticism of the exhibition: "The quality of work runs the gamut of Sunday or hobby painting, from cautiously competent to stereotyped. Generally speaking it is the type of painting that fills a need of therapeutic self-expression for the painter, and which is perfectly valid. It is also work which has little creative appeal for the serious viewer."[94]

The Gallery A experiment proved to be a concession to local politics that seriously damaged the museum's credibility. The loss of curatorial control constituted a major defeat for Bywaters. During this time Bywaters tried to distance the museum as much as possible from the clubs made up of Sunday painters, amateurs, and enemies of the museum. Despite his efforts to maintain a high level of professionalism, however, amateur artists hung mediocre works on the walls of the Dallas Museum of Fine Arts. Bywaters knew that the greatest challenge to the museum centered on curatorial control and standards of artistic excellence.

After almost a year of controversy the events in Dallas were still being debated regionally and nationally. On March 12, 1956, *Time* published an update on "the running battle between the Dallas Museum of Fine Arts and a band of vociferous Texas patriots . . ."[95] The Sunday art page of the *New York Times* published an article supportive of the museum's position: "The courageous stand of the Dallas Art Association is of benefit not only to the Texas museum but also for every creative person in the land."[96] A week later three trustees of the Dallas Art Association voiced their impatience and frustration with the controversy by writing to the arts editor of the *New York Times*: "It is important once and for all time to dissipate this nonsense that any single group in our community is the custodian of the patriotism of the rest of us. We reject and resent the imputation that we are less patriotic than others and

that because we hold to a different opinion of museum operation that we and our director are 'dupes.' "[97]

At the time Bywaters was heartened by support from artists and museum administrators in Texas and throughout the nation. He received a telegram from the faculty of the art department at the University of Texas in Austin as well as letters of support and encouragement from Eleanor Onderdonk, Charles Umlauf, William Lester, and Charles Bowling. The Texas Institute of Letters adopted a resolution to commend the museum for its courageous stand.[98] And the *Texas Observer* published a seething editorial about the Patriot Council's actions.[99]

On Sunday March 25, 1956, the "Sport in Art" exhibition opened at the Dallas Museum of Fine Arts. The atmosphere was unusually tense that afternoon. Before the opening reception, Mayor Thornton telephoned the potential troublemakers and got assurances that the public event would not be disrupted by picketing or protests of any kind. The five museum galleries housing the "Sport in Art" show were packed by members of the Dallas Art Association and the park board. Members of the Dallas County Patriotic Council mingled with the crowd and, according to newspaper reports, were outspoken in their disagreements with the show.[100] There was a constant crowd hovering around the four "suspect" paintings. A worn copy of a *Daily Worker* editorial praising the Dallas museum was quietly passed around. One man was overheard saying in the gallery, "The more you try to find the subject in the paintings, the fuzzier you get in the head, and this is the way the Communists want you to feel, for when you are feeling fuzzy in the head, you are ready for infiltration."[101] Extra armed guards were summoned for the occasion. An eight-page locally printed leaflet attacking the four paintings by Shahn, Kuniyoshi, Kroll, and Zorach was found on the windshield of every car in the museum parking lot, but the infamous exhibition hung unmolested on the public walls of the Dallas Museum of Fine Arts.

It was a curious event indeed. Also opening that day at the opposite end of the museum corridor in Gallery A was the Klepper Art Club exhibition. Members of the Klepper Club served tea and tried to draw museum visitors into their show. Rual Askew reported, "The Janus-like irony that joins these events on the same calendar date also renders them opponents, unfairly but inevitably matched in the arena of aesthetics. How such a Gulliver of a show could inspire such pinpricks of petulance is a major civic embarrassment."[102]

Askew continued his evaluation of the "Sport in Art" opening with this interesting commentary: "Considering the heat generated and the headlines manufactured, there is a grave danger that the show itself will be a ludicrous anticlimax. Sports as a theme is as innocuous and noncontroversial as you can get and doesn't raise as much blood pressure as bluebonnets. There isn't a thing in it, least of all the works of the 'objectionable' artists, that smells of dirt and shovel let alone hammer and sickle."

Attending the opening was Charolette Devree, journalist and wife of Howard Devree, art critic for the *New York Times*.[103] She was in Dallas specifically to write a story for *Art News* on the protracted controversy. She interviewed Bywaters and studied his collection of newspaper clippings. Devree tried to make sense of the events by listing key figures and presenting a chronology of events. On July 28 Bywaters received a draft of Devree's article with the instructions not to show it "to another single soul, or let on around town that you've seen it."[104] Bywaters followed the advice. Bywaters pored over the article, made corrections, fine-tuned the details, cleared up misconceptions, and tempered overstatements. He returned the draft to Devree by airmail two days later and wrote, "You did an amazingly fine job of sorting out all you absorbed while here. By now, though, I'll bet you are tired to death of the whole thing – and, as you can imagine, we're not too blasted fresh on it!"[105] Bywaters was careful to present as accurate a picture as possible. His letter to Devree explained, "I hope you will considerately understand why I have given such attention to details in your article. If it is published, accuracy of detail will have little meaning for the national reader – but, for the local audience there must be accuracy in fact and fairness (because we will be the ones to try to defend it and/or explain it)" After several rewritings, *Art News* published the Devree article in September 1956.

There was even more positive press about the controversy. Six months after the publication of Esther Pels's erroneous article there was a rebuttal in a respected art magazine. The editors of *Arts Magazine* wrote, "We should like to dismiss this latest fusillade from the unknown Miss Pels by saying 'hogwash' (or perhaps something stronger) but fist violence and the threat it constitutes to creative thought and activity are so strong that they demand reply."[106] The editorial discounted and disproved each of Pels's feeble arguments: "Miss Pels is really saying that anything imaginative, anything unfamiliar, or simply anything she does not like, is dangerous." The editors were particularly disturbed by her insinuation that the Museum of Modern Art's

founders – people like John D. Rockefeller, Lille P. Bliss, and Mrs. Cornelius J. Sullivan – were Communists.

The most extensive and authoritative counter to the Pels article was written by René d'Harnoncourt, director of the Museum of Modern Art. He charged, "To attack modern art, which is in itself a manifestation of individual freedom of expression, as part of the Communist conspiracy is to misunderstand the nature of the Communist conspiracy."[107] D'Harnoncourt argued that the social realism of official Russian art presented only happy enthusiastic workers, and he quoted the official Soviet view of modern art as expressed by *Pravda*, the official newspaper of the Communist party: "It cannot be tolerated that side by side with Social Realism we still have concurrent representation by the worshippers of bourgeois decadent art who regard as their spiritual teachers Picasso and Matisse, cubists and artists of the formalist school" (ibid., p. 14). D'Harnoncourt summarized his argument in this way: "Objective observation of the history of recent years reveals the fact that where ever tyranny has taken hold of a people and a government modern art has been suppressed, but when tyranny is replaced by democratic freedoms, and artists are free to create and people free to use their own judgement, modern art once again emerges. Communism, like all other political systems based on tyranny, condemns art forms that cannot be used as weapons for its own ends. It is for this reason that the Communists hate and fear modern art" (ibid., p. 17).

By the end of the summer of 1956 the museum controversy occupied less space in the newspapers. The "Sport in Art" exhibition closed in Dallas and traveled on to Denver without incident. The Dallas superpatriots had exerted no real influence except harassment. Legionnaire Ware threatened a citywide petition, demanded a referendum, appealed again to the City Council, but in none of these efforts was he successful in his demands that the museum establish a policy to ban the works of suspected artists. The Public Affairs Luncheon Club felt frustrated that their grievances were not being heard in Dallas, so they took one final step to have "Sport in Art" canceled or censored. The ladies announced to the press that "the club appealed to the Un-American Activities Committee of the House, the International Security Committee of the Senate and the Department of State to take immediate action either to eliminate the works of Ben Shahn, Leon Kroll, Yasuo Kuniyoshi and William Zorach from the exhibit or refuse United States sponsorship of the exhibit."[108]

Sponsored by Time, Inc., and *Sports Illustrated* in collaboration with the American Federation of Art, "Sport in Art" was to travel in November 1956 to Australia for the Olympic Games under the auspices of the U.S. Information Agency. In May of that year the tour of the exhibition was canceled. The *New York Times* reported, "The United States Information Agency has canceled plans to send overseas a modern art exhibit that once incurred 'subversive' charges."[109] The article directly linked the controversy in Dallas to the U.S. government's decision: "Before the Dallas showing . . . plans were considered so final that USIA officials told the exhibit sponsors to mention the Australian trip in their programs." The official reason for the cancellation was "over-all budgetary considerations." According to the *New York Times* report, the USIA spokesman refused to comment when asked whether the Dallas episode had played any part in the decision to cancel the tour.

Editorials in such newspapers as the *New York Times* and the *Des Moines Register* denounced the decision and related it directly to the Dallas controversy: "One reason for this change of plans is that a Texas organization . . . charged that four of the artists represented had once been members of Communist-front groups."[110] The American Civil Liberties Union viewed the cancellation of the tour as casting "a heavy shadow over . . . the First Amendment guarantee of freedom of expression."[111] In an editorial titled "Dondero, Dallas, and Defeatism," *Arts Magazine* blamed the Dallas controversy for the cancellation of the exhibition.[112] In the following issue were letters to the editor from Senators J. W. Fulbright and Hubert H. Humphrey, both of whom were disturbed by the action of the USIA.[113]

A brilliant article by Ben Shahn titled "Nonconformity" put the entire controversy into perspective. His essay was addressed to those who fear and misunderstand freedom of individualism and artistic expression. Shahn wrote, "The artist is likely to be looked upon with some uneasiness by the more conservative members of society."[114] He pointed out that in such a climate of conformity all art is suspect and conformity is actually a retreat from controversy. His argument was augmented by an understanding of art history and included such cogent examples as a Russian artist named Nikritin who did not employ Soviet Realism and was accused of decadent Western formalism for a painting of a sports event. Shahn referred to pressure groups seeking conformity in American art as a result of the fallacious assertions of Congressman Dondero. "The most recent of the civic crusades" Shahn pointed out,

"was directed against a very large exhibition of sports themes" Referring to the Dallas controversy, Shahn asserted, "So great was the Texas commotion . . . that the exhibition was not sent on to Australia" (ibid., p. 41).

The cancellation of the "Sport in Art" exhibition marked a defeat for the Dallas Museum of Fine Arts. Throughout the controversy the museum could point with pride that the sponsorship of the exhibition by the U.S. Information Agency was proof that the art works were not controversial. Also challenged was Bywaters' belief that a good work of art should be exhibited regardless of the artist's politics. There was also a larger defeat in the acquiescence to the pressure groups to cancel the exhibition.

Dondero and his supporters, of course, were pleased with the cancellation of "Sport in Art." In a June 14, 1956, speech he included a detailed rundown of the events in Dallas as he saw them: "Alert and well-informed citizens of Dallas . . . joined forces in the Dallas County Patriotic Council to protest the showing of an exhibition called Sport in Art."[115] He praised the efforts of the Patriotic Council, denounced the actions of the Dallas Museum of Fine Arts, and asserted that "the action by the United States Information Agency in withdrawing its sponsorship of this exhibition was a blow to the Communist conspiracy as the violent antagonistic reaction in the Communist and Communist-influenced press proved."[116]

In reaction to the threat of scandal the U.S. Information Agency not only canceled the tour of "Sport in Art" but also changed U.S. policy regarding touring exhibitions. Before the Dallas controversy the USIA had asked the American Federation of Arts to plan an exhibition of one hundred works by contemporary American artists to tour Europe. The exhibition was canceled at the last minute because ten of the artists were considered "social hazards."[117] The upshot of the decision was that the U.S. government adopted a policy of not sponsoring any international touring shows of works of contemporary artists. Paintings after 1917 were to be excluded for fear of exhibiting the work of artists who were Communist sympathizers.

There were other ramifications of the Dallas affair. When rumors spread from Dallas to Houston that William Zorach was on the Dallas County Patriotic Council's list of suspected Communists, a major art commission was canceled. The Bank of the Southwest in Houston had contracted Zorach to complete a commission for a four-part metal relief sculpture. After more than two years' work on the project, which was to cost $124,755, and after numer-

ous approvals, the commission was unexpectedly canceled. L. R. Bryan, Jr., vice-chairman of the bank's Board of Directors, told the Associated Press that "the panels were turned down because the bank changed its name from the Second National Bank of Houston to the Bank of the Southwest." He also claimed that "the work was too modern for the new aluminum and granite structure that was to be dedicated next month."[118] *Life* assessed the Zorach sculpture as "a victim of a struggle that has plagued art in Texas during the past year."[119] The article pointed out that although bank officials deemed the Zorach allegorical figures as too modern, they had also commissioned a mural by Rufino Tamayo, an abstract painting that they praised as "a fine portrayal of inter-American friendship" (ibid.). The unfortunate cancellation of the Zorach commission was settled out of court for $56,515.

One other curious result of the controversy was a blow to the ultraconservatives in Dallas. In a rare punitive action the executive committee of the American Legion in Texas voted to remove the charter of Metropolitan Post 581 of Dallas, although this action was not attributed completely to the art scandal. A spokesman for the state association explained that the post was "doing everything within their power to embarrass, disrupt, and destroy the American Legion in Texas."[120] The efforts of the Patriotic Council were severely weakened without that Dallas chapter of the American Legion.

In November 1956, the same month that the newly reelected Eisenhower and Nixon appeared on the cover of *Time*, the Dallas Museum of Fine Arts presented "Mr. President," an exhibition of thirty-three portraits of U.S. presidents by such American artists as Charles Wilson Peale, Gilbert Stuart, George Healy, and others.[121] Bywaters strategically planned for the exhibition from the National Portrait Gallery to open in Dallas during the State Fair and the presidential election. In a political move of his own, Bywaters sent catalogues of the "Mr. President" show to President Eisenhower, Adlai Stevenson, Harry S. Truman, and J. W. Fulbright, who in return sent warm letters of gratitude and support for the efforts of the museum. With the opening of this exhibition, there was no doubt that the Dallas Museum of Fine Arts was showing red, white, and blue art.

That fall the focus of controversy shifted from the Dallas Museum of Fine Arts to the Dallas Public Library. At the downtown library two works by Picasso were removed from an exhibition of textiles by Max Ernst, Alexander Calder, Fernand Leger, and other contemporary artists.[122] The *Dallas Times*

Herald reported, "Library Director James D. Meeks ordered removal of the controversial artists' work from a library display a week ago after a deluge of protests. The Dallas Public Library Board of Trustees backed him up, calling the display 'a mistake.' "[123] The *Times Herald* also reported that the library board would delete "all controversial art" from future exhibitions at the library, a rule that would not apply to books because, according to Boude Storey, president of the board, "Books are a different field entirely." The library controversy quickly became a national issue. NBC's "Today" show sent reporters and a camera crew to Dallas to cover the story for its December 1, 1956, broadcast.

Bywaters and Maurice Purnell, the new president of the museum board, watched the Picasso controversy closely. The manner in which the library board acted could have had an impact on the museum. Similar issues were at stake. In a November 18, 1956, talk on WFAA radio, Dick West, editorial writer for the *Dallas Morning News*, focused on the Dallas Public Library controversy and condemned the inclusion of works by Communist artists in tax-supported institutions.

The library scandal, however, marked a clear change in the momentum of the superpatriotic protests. Citizens of Dallas were tired of all the controversy surrounding the Bertoia sculpture, the "Sport in Art" exhibition, and the Picasso tapestries. *Dallas Morning News* entertainment editor John Rosenfield was disgusted: "Museum heads and even art associations don't think it matters whether good art is painted by Communists or comes from Communism or even propaganda purposes . . . They regard the issue, not at all burning, as 'juvenile and immature.' "[124] In a subsequent article he implied that museum board members were bored with the issues: "The upshot [of the controversy] was that certain reluctant benefactors of the museum used this as an excuse to discontinue contributions to the museum and put their money into fishing trips."[125]

As the smoke of battle cleared, Bywaters' reputation was not by any means tarnished by the events of 1956. He emerged as a hero for having withstood an insidious assault. His actions were commended by a resolution at the thirty-eighth Annual Meeting of the American Association of Art Museum Directors, thus signifying the respect of the art world. *American Artist* congratulated Bywaters as "a progressive director who has worked hard at building a first-rate institution."[126] The most important commendation was voiced

by Francis Henry Taylor, director of the Metropolitan Museum of Art, who announced at the opening of the Fort Worth Art Museum, "Without the extraordinary qualities of Jerry and Mary Bywaters of Dallas this artistic movement, which 20 years ago was looked upon as quaint and provincial, would not have assumed the place of national importance and leadership that is everywhere acknowledged for it today." [127]

A SYMPATHETIC EYE

In June 1956 Bywaters took his camera to the second floor of the Dallas City Hall to take the last photographs of the murals he and Alexandre Hogue had painted more than twenty years before. In a wave of modernization the City Hall was being remodeled. The New Deal murals depicting the history of Dallas were considered old-fashioned and were scheduled to be plastered over.[1] Around this same time the federal art project murals by Bywaters and Hogue were removed from the walls of the Houston Parcel Post

Building. Bywaters' paintings of dock workers, which embodied such hope during the Depression, were viewed in the Cold War era of the mid-1950s with suspicion. Bywaters accepted these changes and resigned himself to the idea that his art, grounded in the region, was no longer in vogue.

He turned his attention away from his own art and concentrated his efforts as an art teacher and museum administrator. The demands of directing an active art museum and school did not permit Bywaters time to paint. In addition, he found it awkward to try to exhibit his work or in any way advance his career as a painter. During the second decade of Bywaters' tenure as director of the Dallas Museum of Fine Arts, he faced more controversy. In addition to the accusations of disgruntled artists and patriotic zealots, the museum was criticized by wealthy art patrons for focusing too closely on regional art. Despite the fact that the museum had a growing national reputation for its leadership in museum education and for its significant exhibitions, the issue of regionalism smoldered throughout Bywaters' term as director.

Despite the distractions of controversy, Bywaters left a remarkable record of achievement in his administration of the Dallas Museum of Fine Arts. His duties as director of a small but energetic staff included not only planning and implementing exhibitions and writing catalogues, but also managing the museum's personnel, publicity, fund raising, and membership development. Bywaters also made recommendations to the museum board about purchasing art works for the collection, and his duties included the maintenance, conservation, and exhibition of the permanent collection. He also directed the Museum Art School and the museum's other educational programs. During his tenure, there were major improvements to the museum edifice, including air conditioning the auditorium and enlarging the stage to accommodate dance and musical performances. Bywaters pushed for improvements in the art school wing, and the museum's rental gallery was a growing success.

The late 1950s and the early 1960s was an era of growth at the Dallas Museum of Fine Arts. Bywaters worked with a series of influential boards and dynamic board presidents. Attorney Maurice Purnell served from 1956 to 1958, and business leader Frederick Mayer served from 1959 to 1960. Corporate memberships increased significantly and museum staff benefits were enhanced. Margaret McDermott served as board president from 1961 to 1962. She had been involved with the museum from 1948 when she worked as the museum's publicist. In 1954 she married Eugene McDermott, one of the

founders of Texas Instruments, and they shared an interest in art and the advancement of Dallas as a cultural center. She campaigned to expand museum programs, and an extensive model for future planning was developed during her presidency. Architect O'Neil Ford was chosen by trustees to design the new wing to enlarge and greatly enhance the museum facility. The people of Dallas approved a bond issue of $400,000 for its construction.

This expansion was based on the museum's reputation for excellent exhibitions. Bywaters was known for assembling large, ambitious shows and for bringing top-quality touring exhibitions to Dallas. Bywaters scheduled a large retrospective of 160 paintings and prints by social realist Reginald Marsh that was assembled by the Whitney Museum of American Art and circulated by the American Federation of Art. The Karolik Collection of Colonial American Art from the Boston Museum and an exhibition of modern art originating from the Baltimore Museum traveled to Dallas. Bywaters contracted leading figures in the art world to participate in regional competitions. Francis Henry Taylor, former director of the Metropolitan Museum, judged the Eighteenth Annual Texas Painting and Sculpture Exhibition in 1956. The presence of such nationally known figures was part of Bywaters' strategy to keep the museum an integral part of the national network of art museums.

Bywaters and the museum staff organized about forty special exhibitions a year, ranging in scope from a survey of Southwest painting and sculpture to an industrial arts show. Most of the changing exhibitions were small and focused on a particular educational point. The exhibition "Paintings by Toulouse-Lautrec" was sponsored at the museum by Neiman-Marcus in conjunction with the store's 1957 Fortnight, an elaborate marketing device to promote French products. The collection of Lautrec's work was accompanied by an extensive program of lectures, fashion shows, and special events focused on French art. In the spring of 1958 the Dallas Museum of Fine Arts presented its largest and most extensive exhibition to date. "Religious Art of the Western World" occupied the entire twelve galleries of the museum with dramatically lighted installations of more than 500 altars, crosses, mosaics, menorahs, manuscripts, tapestries, and works of stained glass. "Over a period of many months," Bywaters recalled, "the staff traveled and borrowed from museums and artisans in this country and Europe, examples of the arts used in the service of all faiths."[2]

The next year Bywaters curated the comprehensive survey "Mexican Art: Pre-Columbian to Modern Times." The museum's exhibition schedule also

included "Sculpture by Aristide Maillol," "American Prints Today," and "Four American Expressionists." In 1960 the museum staff assembled a collection of 132 art works for "Famous Families in American Art," beginning with works from every artist member of the famous Peale family and ending with the Wyeth dynasty. The painting *That Gentleman* by Andrew Wyeth was acquired from that exhibition by the museum for $58,000. The purchase was extremely important to the museum and to Bywaters because it set a record for the highest price ever paid by a museum at that time for a painting by a living American artist.

The 1961 State Fair provided yet another opportunity for a major exhibition produced by Bywaters; "Directions in Twentieth-Century American Painting" presented a broad survey of works by important American artists from Winslow Homer to Jackson Pollock. That year the exhibition schedule included works by significant modernists with a solo exhibition of the art of John Marin and the exhibition "Twentieth-Century Drawings from the Museum of Modern Art."

A leading figure in the museum community, Bywaters was very active during this period. He served on the Board of Directors of the Print Council of America. He delivered lectures entitled "A Museum Director's Third Eye" and "Contemporary Trends in Art" at the annual Fine Arts Festival at Southwest Texas State University in San Marcos. He served as juror for the Seventh Midwestern Biennial at the Joslyn Art Museum in Omaha, Nebraska. And he found time to complete the first handbook on the museum's collections, exhibits, and activities. Even his vacations were opportunities to learn more about other museums. As he and his family traveled through Europe in the summer of 1959, Bywaters wrote articles about the trip and museum-hopping for the *Dallas Morning News.*

After a year of preparation, in 1962 the museum presented "Arts of Man," an exhibition that today would be called a "blockbuster." Acclaimed by critics as "the most significant accomplishment in the museum's sixty-year history," the exhibition consisted of 877 art objects covering a time span from 3000 B.C. to the present day (ibid., p. 40). Museum trustees raised $50,000 to produce this mammoth exhibition, which was gathered from over one hundred public and private collections throughout the world. The exhibition was accompanied by a major catalogue; Bywaters wrote the introduction, and curator John Lunsford wrote the text. The staff was busied with a lengthy lecture series, numerous school tours, and special gallery tours for employ-

ees of corporations such as Texas Instruments and Sears. Over a three-month period the exhibition attracted 126,713 visitors to the museum. Several major purchases for the museum's permanent collection were made from that exhibition.

Bywaters was a master at locating funding sources for special exhibitions. "Gallery Garden," for example, was sponsored by the Dallas Garden Club and the Dallas Woman's Club. Galleries were filled with floral arrangements that complemented the paintings and sculptures of flowers by Dufy, Chagall, Gauguin, O'Keeffe, Redon, Matisse, Laurencin, Renoir, and contemporary Texas artists like Chapman Kelly, Dan Wingren, and Jim Love.

In 1963 Bywaters traveled to New Mexico and Arizona in search of material for the exhibition "Indian Art of the Americas," and he planned the first retrospective of the work of abstractionist Ben Nicholson. This ecumenical and eclectic approach to programming grew directly from Bywaters' philosophy that a museum is a vital place. "An art museum . . . must serve both art and people" was Bywaters' credo. A museum, he believed, "cannot successfully perform these two complementary functions by merely being a static repository for art; it must also be an intelligent interpreter and active sponsor of the arts for living people."[3] By the same token, the work of living American artists was of great importance to Bywaters. That interest was reflected in his abiding concern for the art and artists of the region. An article in *American Artist* characterized Bywaters this way: "Artist in his own right, he knows well the situation of American painters and is a leader in the fight for their recognition."[4]

Bywaters believed that in order to promote the best interests of contemporary artists, their antecedents must be recognized. To that end Bywaters curated "A Century of Art and Life in Texas," which was a pioneering effort to survey the history of art in Texas. The small but significant exhibition opened at the Dallas Museum of Fine Arts in April 1961. For Bywaters the purpose of the exhibition and catalogue was to "highlight humanistic and historical events as well as artistic and cultural developments in this territory."[5] The chronological survey included works from Forrest Kirkland's watercolor reproductions of Indian pictographs to sculpture by Elisabet Ney and paintings by Robert Onderdonk, Louise Weust, Richard Petri, Frank Reaugh, Alexandre Hogue, Thomas Stell, Otis Dozier, and others. Also included in the exhibition were works by two of Bywaters' discoveries, naive artists Clara Williamson and H. O. Kelly, who painted memory pictures of their early

experiences in rural Texas. Because of the exhibition's historical context, Bywaters placed two of his own works in the exhibition, *On the Ranch* and *Texas Courthouse*. "A Century of Art and Life in Texas" focused on the landscape, people, and special character of the region as portrayed by the state's leading artists.

During this period Bywaters also curated three solo retrospective exhibitions of works by Otis Dozier, Andrew Dasburg, and Everett Spruce. It was important to Bywaters that the art of these leading regionalists be presented in a professional and comprehensive manner. In 1956 Bywaters not only wrote an exhibition catalogue but also completed a monograph on Otis Dozier, the first of a series of handsomely produced books on Texas artists sponsored by the Blaffer Gallery.[6]

The museum's retrospective exhibition of 120 works by Andrew Dasburg was held in March and April of 1957. Bywaters had long admired Dasburg's cubism-based compositions and regional subjects. "Dasburg has an enviable reputation with all who have ever known him," Bywaters wrote in the catalogue. "He is an artist's artist as well as a painter who has had great influence in many directions . . ."[7] A European immigrant, Dasburg studied at the Art Students' League and traveled in 1916 to New Mexico. From then on he traveled each spring from Woodstock, New York, to New Mexico to paint the landscape and the people. In 1930 he became a permanent resident of the Taos art community. A catalogue essay by Dasburg described his association with other Taos artists and the development of his art. Ward Lockwood, Loren Mozley, Mabel Dodge Luhan, Kenneth Adams, and Lewis Garrison also wrote testimonials on Dasburg's contributions to contemporary art for the catalogue.

Accompanying the Spruce retrospective in December 1958 was a monograph on the artist. *Everett Spruce: A Portfolio of Eight Paintings* was published by the University of Texas Press with an introduction by Lloyd Goodrich, associate director of the Whitney Museum of American Art, and an essay titled "Everett Spruce: An Appreciation" by Bywaters. "Spruce's paintings demonstrate the best qualities to be found in contemporary American painting," Bywaters wrote, outlining his criteria for greatness: "Extensive technical resources expressing vital personal experiences, deeply felt; a continuing search and exploration to better realize these experiences; a devotion to a region in which the artist lives with evident satisfaction; rich and complex expression in paint but with motivation clear and the execution strong."[8]

The reputations of Dozier, Dasburg, and Spruce were certainly not limited to the region. Each of these artists enjoyed large, national reputations. *American Painting Today*, edited by artist Nathaniel Pousette-Dart, was a veritable who's who of art in 1956, and the works of Dasburg, Dozier, and Spruce were included in the list of important artists.[9] The book focused on contemporary American art and included many well-established artists such as Rufino Tamayo, Arshile Gorkey, Georgia O'Keeffe, Yasuo Kuniyoshi, Howard Cook, Mark Tobey, Ivan Albright, John Marin, and Stuart Davis as well as such new names as James Brooks, Jackson Pollock, Jack Tworkov, Georgio Cavallon, and Robert Motherwell. Also included in the exhibition as leading national figures were Texas artists Michael Frary, Bror Utter, and William Lester.

Publications such as *American Painting Today* confirmed Bywaters' belief that the artists of Texas were engaged in a nationwide movement of modern art. Bywaters' mission to promote art of the region did not ignore artists of the younger generation. Bywaters was invited by *Art in America* to submit an article entitled "New Talent in the USA" for a special issue. The magazine divided the country into regions and asked authorities to identify "artists whose talents show promise of greater recognition ahead."[10] The article was devoted to the work of younger or lesser-known American artists. The young artists recognized from New York included sculptor Constantino Nivola and painters Kenzo Okada and George Mueller. Other sections of the country boasted artists such as Steven Trefondides of New England, Frank Sapousek of Nebraska, and Roger Kuntz of California. The purview of Bywaters' report was the lower Midwest. He chose artists McKie Trotter, John O'Neil, and Dan Wingren as the leading young artists of the region.

At the time Trotter was an associate professor of art at Texas Christian University in Fort Worth. He was not an unknown. His work was handled by Knoedler Gallery in New York, and his paintings had appeared in an exhibition at the Guggenheim Museum and in a solo exhibition at the Fort Worth Art Museum in 1954. Bywaters described Trotter's abstract style: "In all of the paintings by McKie Trotter there is an astute blending of rugged masses, well organized to set a theme, with greyed but exciting color and versatile textures pulling the whole into a vibrating personal sort of pictorial reality . . ." Bywaters added that Trotter's work is "firmly determined by the artist at the beginning" (ibid.). Bywaters' subtle argument was directed to artists who approach the canvas without a preconceived notion of composition or subject.

John O'Neil, another artist featured in Bywaters' article, was director of the

School of Art at the University of Oklahoma and had works in the permanent collections of the Joslyn Museum, Denver Art Museum, Dallas Museum of Fine Arts, Seattle Art Museum, and others. After considerable European travel and study, O'Neil had developed a painting style derivative of Picasso's abstraction and patterning of figures, which Bywaters called "a sort of visual humanism" (ibid.).

Bywaters also highlighted the work of Dan Wingren. After studying at SMU and a stint in the U.S. Army, Wingren received a master of fine arts degree from the University of Iowa and began teaching at the University of Texas. Wingren's early work was influenced by Tamayo's themes and organization of forms. Bywaters praised his former student: "Of all the young artists I know in the Southwest, Wingren seems to have the most cogent creative fountain which he taps for inspirational refreshment" (ibid.).

This special issue of *Art in America*, focused on new American talent across the nation, is particularly revealing in the context of the discussion of the regional artists. It is interesting to note that in 1956 the vision and appreciation of leading art administrators across the nation did not recognize one New York action painter or any of the circle of abstraction expressionists as the future direction of American art. Stylistically the works represented as the avant-garde are all based in the abstraction of reality. According to the editors, "Most of the painters [and] the newer sculptors eschew realism and conventional forms in favor of that profound visual revolution to which we give the collective title 'modern' art" (ibid., p. 13). What looked modern in 1956 with a variety of personal styles can be generally described as biomorphic shapes, abstraction based on human form, cubist space, interest in spatial relationships, and rich color in a wide chromatic range. Accident and chance did not play a major role in the works of young American artists chosen for the survey. Artists were concerned with careful organization of color and planes in an objective presentation of a recognizable subject.

Bywaters neither perceived nor believed that artists in Texas were somehow working outside the active currents of modernism. On a trip to New York in 1959 to locate works for an exhibition, Bywaters wrote about the art scene for the *Dallas Morning News*. He reported on the success of James Brooks, a former student at the Dallas Art Institute and Southern Methodist University who was associated with the abstract expressionists. Bywaters observed, "In New York, certainly, time waited for neither man nor artist as the action painters were found to be quickening their technical performances; and the

school of New York was looking more than ever like the school of Texas or California or Paris or vice versa – as if distance had become obliterated and communication instantaneous."[11] The New York art scene provided no standard for Bywaters. He complained about the lack of representation of Texas artists in New York galleries: "At least ten Texas painters could have been scattered around in various exhibits with salutary results. But, of course, this is a 'regional' observation and is therefore out of place." This observation makes it clear that Bywaters was aware that his viewpoint was not popular.

No doubt regionalism was out of vogue. Art critic Barbara Rose cemented the thoughts of a generation in her 1967 critical history of American art, *American Art Since 1900*, which characterized the American Scene movement of the 1930s as a detour in American art's march toward modernism and abstraction. Rose viewed the regionalists as retrogrades: "Regionalists by and large wished to escape the art of their time, just as they wished to turn their backs on contemporary reality in order to preserve the atmosphere and life styles of times gone by."[12] Regionalist art and artists were old hat. As Rose stated emphatically, "The WPA programs produced almost no art of any consequence that has survived" (ibid., p. 127). A generation of art students believed her pronouncement.

Bywaters did not recognize his understanding of the American regional renaissance in Rose's analysis. The shift of the center of gravity of the art world away from the heartland of America and back to New York was disturbing to Bywaters. What most concerned him, however, was that his efforts to promote regionalism were misunderstood and unappreciated. Old discussions of regionalism versus provincialism were resurrected. Arguments resurfaced that Bywaters and others thought were settled once and for all with the success of the American Scene movement of the 1930s. Bywaters renewed his efforts in his continuous struggle to gain recognition for artists living outside the mainstreams of modern art. His career in the arts was based on the premise that art is accessible regardless of location and that living artists who had chosen not to live in New York could have successful careers and make significant contributions.

"We felt we must encourage and support the talent of people in the area in the arts whether artists, teachers, scholars, or experimenters," Bywaters affirmed.[13] He proudly pointed to his accomplishments: "In that sense we were regional. Regionalism has never been an insular thing to me. It has always been the relationship of the artist to his environment – and that environment

may be in his head. We've got to have a balance between supporting things familiar to us as well as bringing in things from throughout the world to pollinate what is here."

In a letter Bywaters wrote twenty years later to a former director of the Whitney Museum of American Art, he said, "I felt a very strong obligation to provide essential services to artists in every way possible. Over the years this earned me an unfair reputation of being too interested in "regional art" – but I was promoting our artists because I knew no one else would."[14] Bywaters was certainly not antimodern or antagonistic to the contemporary movement of abstract expressionism. The abiding interest in promoting the art of his region simply took precedence.

Regarding a large exhibition that included works by contemporary abstract expressionists, Bywaters correctly characterized the movement: "The versatile movement of abstraction now embraces a majority of current painting styles whether the subtitle be such as action painting or abstract expressionism . . . Pollock and Toby have evolved styles employing active linear patterns to symbolize subjects."[15] Bywaters identified the basis of contemporary abstractions of many of the leading American artists: "Realistic subject is only an indefinite point of departure and psychological meanings are sought." Bywaters recognized that action painting was about surface decoration. Because abstract expressionism did not demonstrate the social content, realism, and technical ability that Bywaters felt were requisite for artistic expression, he asserted that the movement lacked substance. On another occasion Bywaters wrote, "The emphasis has been on technical experimentation and psychological probings . . . As exciting as such lusty searchings are, both in color and technical bravura, most contemporary paintings seem to lack a 'maturing process and spiritual depth'. . . ."[16] In a letter to the editor of *Life* Bywaters expressed his misgivings about the swift currents of modern art: "The 'human element' has continued to be one of the weakest parts about contemporary painting. It has been a little bit discouraging to have too many shows of contemporary painting which continue to look more and more alike. Perhaps the time for reinvestigation has arrived."[17]

The regionalism issue became the basis for controversy surrounding the focus and purpose of the Dallas Museum of Fine Arts. Bywaters found himself in an impossible position when he was accused of showing too much regional art and not enough contemporary American art at the museum. He tried to maintain a balance between his commitment to regional artists and

his insistence on quality in a wide range of contemporary and historic art experiences for the public.

In 1956 the Dallas Society for Contemporary Arts was founded by sculptor Heri Bartsch and a small group of artists, architects, theater directors, photographers, and critics to meet "a growing need for a society that concerned itself only with contemporary art." [18] The Courtyard Theatre was turned into an art gallery. The founders of the society intended eventually to have a permanent building and a permanent collection of contemporary art. A year later the society was joined by Betty Marcus and her husband Edward Marcus and other art patrons who also wanted a museum to concentrate exclusively on contemporary art. Their stated purpose was to focus on "stimulating appreciation of contemporary art and developing a center which would be a citadel of contemporary art." [19] The newly formed Dallas Museum for Contemporary Arts moved into a 1,600-square-foot space at 5966 North West Highway in Preston Center, a new upscale shopping center in a rapidly growing and affluent area of Dallas. Edward Marcus, executive vice-president of Neiman-Marcus and younger brother of Stanley Marcus, was named president of the board of the Dallas Museum for Contemporary Arts. The museum opened with one full-time paid secretary and a budget of $28,000 underwritten by about thirty-five supporters. No museum professionals were consulted in the project. [20]

Art critic Rual Askew expected healthy competition and cordial cooperation between the Dallas Museum for Contemporary Arts and the Dallas Museum of Fine Arts. [21] Edward Marcus described the purpose of the new museum: ". . . to stimulate and encourage in Dallas the fullest possible expression of and appreciation of contemporary art in all of its forms and manifestations. It is the belief of several hundred people in the community that a museum dedicated to contemporary art is a crying need . . . Our second purpose is to develop a permanent museum which will be the citadel for contemporary art in Dallas, serving as an exponent of and vehicle for community-wide education in the highest concepts of the art of our own day." [22] Marcus believed that the older, larger museum fulfilled the need to educate a broad audience about all periods of art and that a new smaller museum was needed to focus on contemporary art.

Although Bywaters believed he was presenting the best in contemporary art, he approached the group to try to convince them to work with the Dallas Museum of Fine Arts. "There was both room for them to have an office in

the museum, and there was the gallery that could be allocated to them," Bywaters explained. "But they still felt that they had to operate in a separate way and as a separate entity in order to get the publicity that they wanted and to be able to express their ideas about what contemporary museums should be, and what modern art was. . . ."[23] The issue was curatorial control.

In a letter from Marcus to Bywaters dated January 3, 1958, Marcus justified the existence of the Dallas Museum for Contemporary Arts on the grounds that "Dallas has grown to a size that justifies the existence of a museum that can concentrate its attention on contemporary art."[24] Years later Bywaters recorded his reaction to the competing museum: "I naturally felt like that could be done within the framework of the museum . . . because we were showing a lot of modern art and so forth. But the point here . . . was, I'm afraid, a little bit of elitism. There was a group of collectors who were some of the leaders of art in town in name, and they had a group, a study group, and they wanted to project themselves really more and to form a collection which would not have any interference from anybody else, like a board of trustees, or staff members, any thing like that. What they really wanted to be, each one wanted to be a curator at a museum, and this was one way of doing it. . . . They had the money too."[25] Wealth, power, and will were key elements in the support of the Dallas Museum for Contemporary Arts. In Bywaters' eyes the project embodied the mistaken Dallas dictum that culture can be bought and imported.

The relations between the two institutions were cordial but competitive. As Bywaters recalled, "We were vying with each other for available funds" (ibid., p. 114). Many of the board members of the Dallas Museum for Contemporary Arts had once served on the board of the Dallas Art Association. Bywaters remembered, "We'd try to cooperate with them if they needed a particular work sometime, or if they needed to use the library . . . but there was no way that we could endorse what they were doing without just saying that you're weakening our effort to the extent that you're dividing up the funds severely" (ibid.).

Around one thousand people attended the opening reception of the museum's inaugural exhibition at Preston Center. The first exhibition, "Abstract by Choice," traced the stylistic development from realism to abstraction in the art of Stuart Davis, Lyonel Feininger, Max Weber, Marsden Hartley, and others who were not unknown to the Dallas Museum of Fine Arts. Exhibitions at the Museum for Contemporary Arts were curated by board members.

In 1958 Betty Blake assembled "Contemporary Realism," and "Isms" was curated by Betty Lingo. Dora Stecker assembled "Action Painting," which presented works by Gottlieb, Pollock, Tworkov, Kline, and others. The museum produced a catalogue with essays by Thomas Hess and Harold Rosenberg, editors of *Art News*. In 1959 Betty Blake presented "Laughter in Paintings," and Juanita Bromberg selected a show called "Poetic Vision."[26]

In 1958 the Dallas Museum for Contemporary Arts hired a professional museum director, Douglas MacAgy.[27] He was well educated, a writer, and an arts administrator who had served as curator of the San Francisco Museum of Art, director of the California School of Fine Arts, and consultant to the director of the Museum of Modern Art. He left his post in New York as director of research at Wildenstein and Company to come to Dallas. Two years before, art patrons John and Dominique de Menil had hired Jermayne MacAgy to direct a new contemporary arts institution in Houston. The MacAgy husband-and-wife team of contemporary art experts, representing the elite eastern art establishment, ushered in a new era in Texas museums.

After Douglas MacAgy was hired as its director, the Dallas Museum for Contemporary Arts moved into a building at 3415 Cedar Springs that had been acquired by five museum trustees. In October 1959 "Signposts of Twentieth-Century Art" opened in the new quarters. Under MacAgy's able direction, the museum produced innovative exhibitions and a children's program. A permanent collection was begun with gifts of works by European modernists Gauguin, Matisse, and Redon and by American artists Joseph Stella and Gerald Murphy.

The new museum presented a variety of innovative exhibitions that defined contemporary art in broad terms. "Art That Broke the Looking-Glass" opened in November 1961 with works by Veronese, Picasso, Durer, Currier and Ives, David McManaway, Joseph Cornell, and Kurt Schitters.[28] The exhibition titled "1961" presented paintings by such artists as James Rosenquist, Roy Fridge, Joe Glasco, Robert Motherwell, Claes Oldenburg, and Robert Rauschenberg. The exhibition lived up to the museum's intentions of presenting the most avant-garde art to Dallas, but ironically this was the last exhibition of the Dallas Museum for Contemporary Arts.

When the museum opened "1961," the Dallas Museum of Fine Arts opened an exhibition of twentieth-century drawings from the Museum of Modern Art. The two museums were showing similar works and competing for limited funds and a limited audience. A comparison of the two exhibitions

reveals that both institutions were presenting shows of equal or parallel aesthetic value. In 1959 both museums had presented exhibitions of contemporary Mexican art. While the Dallas Museum of Fine Arts hosted a traveling show from the Whitney Museum of American Art of works by four American expressionists, Doris Caesar, Abraham Rattner, Chaim Gross, and Karl Knaths, the Dallas Museum for Contemporary Arts sponsored a show called "Made in Texas by Texans," which presented works by Otis Dozier, Michael Frary, Octavio Medellin, Ben Culwell, Dan Wingren, and several other Texas artists who had had solo exhibitions at the Dallas Museum of Fine Arts.[29] The Museum for Contemporary Arts produced an exhibition called "Regional – Ford," which lauded Bywaters' longtime friend and colleague, O'Neil Ford. The Museum for Contemporary Arts presented "Impressionism and Their Forebears from Barbizon" at the same time the Museum of Fine Arts was showing "Directions in Twentieth-Century American Painting," a large show of fifty-three American artists. Included in the exhibition were works by Winslow Homer, Thomas Eakins, Georgia O'Keeffe, and Loren McIver as well as contemporary artists Jackson Pollock, Willem de Kooning, Mark Toby, Irene Rice Pereira, and Ben Shahn. In reality the two institutions were presenting similar exhibitions, and, as Bywaters had predicted, the new museum was simply duplicating the efforts of the Dallas Museum of Fine Arts.

Several factors prompted the eventual merger of the two art museums. In 1961 Dallas voters passed a bond issue to double the exhibition space of the Dallas Museum of Fine Arts, and the Dallas Museum for Contemporary Arts faced the loss of its rent-free space on June 1, 1963. Attendance at the new museum's exhibitions was decreasing, and MacAgy indicated that he was returning to the East. After some discussion about housing the Dallas Museum for Contemporary Arts in the new art building at Southern Methodist University, trustees on both museum boards questioned "the advisability and practicality of trying to support two museums."[30]

The Dallas press debated the proposition to merge the two museums. Art critic Rual Askew observed, "The merger ploy is now an open secret widely shared with special committees of both museums doing their work quietly weeks before last Tuesday's election. Whether the ultimate decision to merge is favorable or no, now is the time to probe every aspect of a matter not to be taken frivolously by anyone in a position of influence."[31] In the same article Askew discussed the politics of the merger: "It seems apparent that some of

the backers of Dallas Museum for Contemporary Art[s] should like to relieve themselves of their equity and maintenance involvements, either for purely business reasons or for simply having tired of what may have been a fashionable plaything from the start." Askew's criticism of the situation may have expressed Bywaters' thoughts on the merger. After working for thirty years to professionalize and legitimize the art of the region, it must have been difficult for Bywaters to watch dilettantes dabble in the museum business. Bywaters' populist approach to art education differed greatly from the elitist efforts of Edward Marcus to import culture. Bywaters, however, remained diplomatically tight-lipped.

Askew also expressed the concerns of many who thought the contemporary museum was needed as a separate institution: "Wasn't DMCA invented in the first place to accelerate a special interest to provide a more freewheeling directorship free of municipal restraints, to engender healthy competition down the line . . . ?"[32] Thus, according to Askew, "any merger would have to guarantee sustained drive for the contemporary specialties and interests plus a full time professional directorship geared to national and international perspectives as much as local and regional." Bywaters believed he had never varied from a course of presenting the best available contemporary art to the Dallas public.

Board members of the Dallas Museum for Contemporary Arts met on February 19, 1962, to consider the merger of the two museums but voted against the proposal. In the face of the museum's dire economic position, the board members also vowed to participate in a drive to raise membership to adequately support the new museum. This action postponed the merger of the two museums, and the uncertainty continued. After almost a year of indecision and numerous meetings by committees from both boards, the matter of a merger was dropped.[33] In March 1962 Margaret McDermott and Betty Blake, presidents of DMFA and DMCA, respectively, issued a public statement that the joint committee had recommended that "the question of merger be no longer pursued."[34] The discussion may have ended, but the problems remained. The Dallas Museum for Contemporary Arts planned to move to smaller quarters and change directors. Art critic Askew, after reviewing the issues, had this comment: "What still remains unresolved, apparently, is what image DMCA has in mind for itself and for its public. What is it? Where is it trying to go? These are the same basic matters that have brought the still-young project to its present crossroads of intent and which have

plagued it since it evolved from the loose-knit, fired up society it was in the beginning to the precious private pursuit it has appeared of late."[35]

One year later the discussion of merging the two museums was rejuvenated. The Museum for Contemporary Arts was facing eviction, and the Museum of Fine Arts needed to make plans for the new expansion. As the *Dallas Morning News* reported, "Though time is of the essence at DMFA, it is imperative at DMCA."[36] At issue was gallery space for the permanent collection of the Museum for Contemporary Arts and a separate fund for the purchase of contemporary art. The details of the merger were worked out in a series of conferences by both boards. At separate meetings of the respective boards on April 19, 1963, the merger was consummated.[37] The boards, membership, and resources of the two museums were combined under the name the Dallas Museum of Fine Arts. The former museum's permanent collection, valued at nearly $1 million, was by contract deeded to a new Foundation for the Arts to maintain the collection as a separate trust. Anne Bromberg was named president of the foundation, and a special acquisitions fund was established for contemporary art.

Under the agreement of the merger, the collection of contemporary art would be exhibited in the new wing of the Dallas Museum of Fine Arts. Dallas Art Association president C. A. Tatum would remain as president of the museum, and the president of the former museum was named executive vice-president of the Dallas Museum of Fine Arts. The problem of merging the two staffs was also discussed. Written into the merger was a policy that "works of art shall be judged and exhibited solely upon their artistic merits. Neither political interference nor any other form of censorship will be permitted."[38]

Before the merger at the March 1963 board meeting, Bywaters presented to the trustees an extensive program for the future growth of the Dallas Museum of Fine Arts. This plan covered all aspects of the museum's possible development: "The new building would double present space and require additional operating funds and enlargement of the staff, ideas for exhibitions and acquisitions and many possibilities for new community projects, including several branch museums in other parts of the city."[39] The plan outlined his goals for the museum and restated his philosophy of art education, which demanded that the best works available from all periods and styles of art be offered to the public.

Included in the plan was Bywaters' suggestion that a new director be

sought to take over these more demanding responsibilities. Officially By-
waters requested that he be relieved of his position as director so he could
concentrate on other work for the museum, including research and publica-
tions as well as "spending some time on planning expanding relations be-
tween the Museum school and other schools and colleges" (ibid.). The local
press reported, "Bywaters, in an action unrelated to the merger plan, has re-
quested of the DAA [Dallas Art Association] board that – among a number of
other suggestions in a series of recommendations – he be relieved of admin-
istrative duties to devote full time to curatorial research, development of the
museum school, and closer liaison between the museum and the Fine Arts
Center at SMU and with other area schools. The expansion of the DMFA
program, would in [the] Bywaters recommendations, bring a new director to
the museum."[40] One can only speculate that Bywaters' position as director
was in jeopardy. The factions that had formed the Museum for Contempo-
rary Arts did not agree with Bywaters' approach to museum programs. As the
two museums merged, Bywaters saw the end of his leadership.

The terms of merger included the hiring of a new director of the Dallas
Museum of Fine Arts. A joint letter of both museum boards, dated May 10,
1963, outlined the merger of the two museums: "The first and most important
challenge facing the new merger is the selection of a new director who will
bring to Dallas recognized leadership in the field of art, from ancient to
'Pop.'"[41] After the merger of the two boards, Bywaters did not have the sup-
port to remain director. According to the *Dallas Morning News*, "The DAA
executive committee accepted DMFA director Jerry Bywaters' recommen-
dation that the museum seek a new director and that he remain on the staff
as director of the museum school and handle curatorial work. No time was
set when a new director would take over."[42] The new Board of Trustees, how-
ever, could not deny the large contributions that Bywaters had made as direc-
tor of the Dallas Museum of Fine Arts. He had served for twenty years and
brought the museum national attention. His expertise was needed in the fu-
ture developments of the museum.

In April 1964 Merrill Rueppel, assistant director of the City Art Museum
of St. Louis, was named the next director of the Dallas Museum of Fine Arts.
On July 1 Bywaters turned over his desk to the new director and assumed the
position of director of research for publication and educational planning. By-
waters told the press, "I will be in charge of research, which sounds vague
enough I suppose, but I have several projects that have been waiting until I

had time. There will be a continuation and expansion of the kind of things I have been working on – books, monographs of artists and the like."[43] He told reporters that he was thinking of establishing a research collection at the museum which would serve as an information center on the arts of the Southwest – a dream that would not be fully realized for another twenty years. Bywaters continued, "I now want to enter into other areas of activity that will enable me to interpret the experiences in the arts I have had over the past two decades." He intended to expand the museum's educational activities and to serve as a kind of liaison between Southern Methodist University and the Dallas Museum of Fine Arts. His curatorial duties focused specifically on the art of the Southwest.

As a gesture of gratitude the museum board honored his semiretirement with a foreign travel fund to be used as he wished. One year later SMU officials announced that Bywaters would become chairman of its Fine Arts Division and a key figure in the planning of a new Owens Fine Arts Center at the university. In a newspaper interview Bywaters assessed his accomplishments at the Dallas Museum of Fine Arts: "I feel pretty darn good that I can serve painters. They need a sympathetic ear – and a sympathetic eye."[44] And, looking forward to his new position at SMU, he added, "Speaking like an artist, one should always sign a canvas and leave it for what it is and turn to a new canvas. That is what I am doing."

A REGIONALIST REDISCOVERED

At the age of sixty-three Bywaters completed a remarkable self-portrait in pencil using a pose similar to his 1935 self-portrait in oil. The 1969 drawing is not a sketch but a finished work that is the product of an experienced artist. Bywaters presented himself in a direct, self-assured manner. The work exhibits a realism that goes beyond the depiction of wrinkles and greying hair; the self-portrait reveals a clear sense of identity and self-appreciation. The eyes are determined but softened by a sense of humility. The

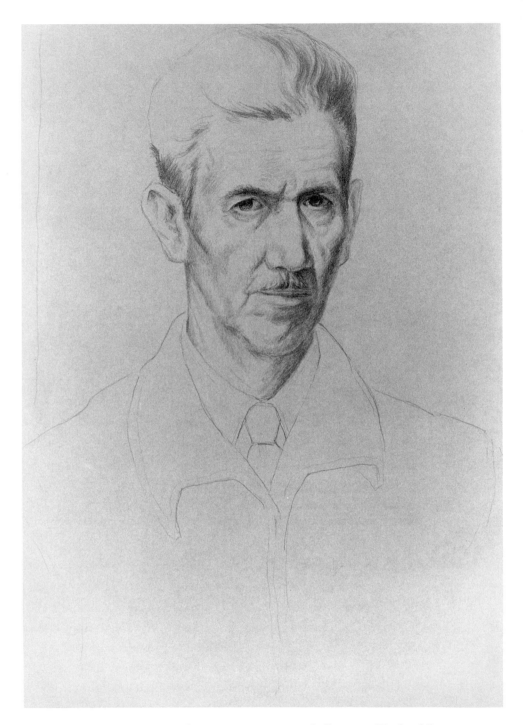

Self-Portrait, *1969. Pencil on paper. 23 × 17 in. Collection of Richard Bywaters,*
Dallas, Texas. Photograph by Reinhard Ziegler.

mouth and chin are firm but kind. The self-portrait is carefully rendered, and the face emerges from the paper with convincing three-dimensionality while the details of the bust are left unfinished. In an interview in 1975 Bywaters discussed self-portraiture: "The artist is trying to find out who he is. So, he looks at himself, directly head-on and tries to see what he is and what he wants to be."[1] The 1969 self-portrait certainly deals with self-examination.

Like the other self-portraits that Bywaters completed throughout his life, this work corresponds to a turning point in his career. After serving twenty years as director of the Dallas Museum of Fine Arts, Bywaters was named chairman of the art department at Southern Methodist University and director of the university's Pollock Galleries. His painting activity had diminished to only one or two pieces per year from 1955 to 1964, and his art work had not been exhibited publicly since 1951. Away from the demands of the museum, Bywaters' university schedule allowed time for painting and the opportunity to resume his career as an artist. The self-portrait was a starting point for Bywaters to renew his commitment to painting.

During the years when he had neither time nor energy to paint, Bywaters developed his capacity to organize compositions in his mind and essentially created mental paintings. "I cultivated the habit of painting 'visually' any interesting idea or subject which struck my fancy," Bywaters explained. "I think most artists do this anyway, but for me it had special meaning because my graphic perception remained alive; and this not only gave me solace but it helped remind me that as an administrator I was still working with art and should never forget it!"[2] Bywaters perfected this mental exercise to the point that when he finally sat down to paint after a decade of inactivity, he found his painting ability facile and his compositions fully developed. According to Bywaters, "The ideas and forms which remain with you over long periods are the real essentials or essences from which art may be made" (ibid.).

Bywaters found the pictorial means to extract the essential form and character of the Southwest landscape. He resumed his interest in familiar themes and subjects. He began with studies of the mountains of New Mexico and the flat Texas fields. He painted *Near Abiquiu* (1968), an expansive view of gentle hills and immense clouds in watercolor. On a trip to New Mexico he painted *Near Santa Fe*, a dark pastel, and later completed a small watercolor of the same composition called *Taos Mountains*, which presents a monumental scene of a dark, craggy mountain across a vast plain against a stormy sky. In 1978 Bywaters applied the lessons he learned from those two works to an

oil titled *The Taos Mountain.* The work is a romantic portrait of a mountain that rises like a dark giant from the plains. Bywaters adroitly handled the difficult media of watercolor and pastel. His 1970 watercolor *Willows and Fields* pictures the North Texas landscape with an understanding of the light, color, and atmosphere of the region.

Writing about his work from this period, Bywaters explained that each piece was "a summary of all separate and individual types of the generic subject in an attempt to secure that always hoped for quality of universality" (ibid.). Finding the universal in the particular was essential to Bywaters' art. A 1970 oil entitled *Symbols of a Landscape* dealt specifically with that aesthetic concern. Stylistically the painting is the most abstract work that Bywaters ever completed. The elements of the landscape remain identifiable as mesas, clouds, and horizon, but the shapes are flattened, geometric and simplified. The painting approximates Dozier's ability to pare down forms to essential elements.

During this period Bywaters also renewed his interest in painting architectural subjects. He saw human structures as a natural extension of the landscape. The special character of houses served as a kind of portrait of the region. Bywaters found abstract qualities in the geometric manmade forms in contrast with the organic shapes of the surrounding landscape. He returned to the theme in 1974 with the oil painting *Adobe House in Taos* and in 1975 with the watercolor *Houses in the Big Bend.* Both works were revisions of familiar themes. In 1938 Bywaters had completed a pastel sketch of an adobe house that embodied the light and form of the region; as though to retrace his steps, Bywaters returned to the subject using oil. The composition of the two works is the same, but the later work is simplified, succinct; there are no unnecessary details to distract from the essential form, light, and color of the subject. A watercolor done in 1975 of a row of houses in the Big Bend area of Texas is a copy of a 1942 painting, *Houses in West Texas, Big Bend.* Bywaters also completed a lithograph in 1943 of the same composition. His continued interest in the subject points to the fact that, for him, this work was an emphatic statement about the dynamic form of the region. The stair-stepped row of houses echoes the form of the mesas behind them. The harmonious geometry of manmade structures and natural formations expresses a deep appreciation of the region.

Bywaters' interest in the landscape dominated his work. He continued to make regular trips to New Mexico, where he found the dramatic landscape

as appealing as ever. A small pastel titled *Dusk at Taos* (1970) is an enduring and elegant image that combines solid form with rich color. *Toward Abiquiu* (1978) shows Bywaters' ability to depict in oil a great expanse of space as the view of the landscape encompasses the vast plains and the blue mountains in the distance.

The painting that sums up Bywaters' special vision of the land is *Autumn Cotton Fields* (1970). This oil painting of a cotton field after the harvest presents Bywaters' sure sense of the color of the earth of Central Texas farmland, his knowledge of the dim light of a cool autumn day, and his understanding of dry-land farming. The work is similar in composition to *Snow in the Furrows*, a watercolor of 1947. Unlike the earlier work, however, Bywaters used a much more fluid and facile painting technique in the oil painting. Loose, cursive brushstrokes suggest the stubble of brown cotton stocks and the scattering of white cotton fibers. The painting reveals the artist's careful sense of balance in a well-organized composition. The plowed furrows fan out from a distant vanishing point, and the landscape is composed of interlocking geometric shapes.

Autumn Cotton Fields presents Bywaters' conception of abstraction in art. As Marla Redelsperger correctly observed, "Abstraction is not something he invents, but something he sees."[3] Bywaters saw abstraction in the natural forms and contours of the landscape. Abstraction for Bywaters is that underlying structure of the color, line, shape, scale, and texture of the region. Abstraction is not something outside or apart from the natural order of things. The landscape, architecture, and people are all integrated into a complete, comprehensive, understandable, and rational expression. "More and more I see the abstractions that are innate in nature," Bywaters said in a 1975 interview. ". . . I see more order to nature and more geometry and more sequence and more abstraction. Eventually, I want to do a whole series of studies – they may be ink drawings with a big thick brush, or they may be in watercolor, or they may be big heavy-handed oils – of nothing but plowed furrows because there's infinite variety there."[4] For Bywaters, the straight furrows of a cotton field after the harvest are a potent symbol of the land and the people of the land.

Although Bywaters continued to paint through the early 1980s, he never returned to his former status of full-time artist. From 1965 on, the main thrust of his career was his continuing effort to promote and serve regional artists. In addition to his teaching and administrative duties at Southern Methodist

University, Bywaters was active and visible in the art world. His expertise as administrator, curator, and historian was used at a high level. He participated in the planning of SMU's Owens Fine Arts Center, which included classrooms, studios, theaters, offices, and the Pollock Galleries. He served as juror for "The Art of Extra High Voltage," a national contemporary art exhibition sponsored by the Allis-Chalmers Corporation. Bywaters wrote the introduction to Pauline Pinckney's *Painting in Texas: The Nineteenth Century*, a pioneering effort to chronicle the history of art and artists in Texas. He organized for the Pollock Galleries a small but significant exhibition titled "The American Woman as Artist, 1820–1965." The catalogue and exhibition of twenty-eight works were groundbreaking in the recognition of women artists. Bywaters wrote, "As the exhibit demonstrates, women in America have made vital and versatile contributions to the arts as they have all other social and professional activities."[5]

In 1971 Bywaters assembled another milestone exhibition, "Texas Painting and Sculpture: Twentieth Century." Working with Martha Utterback, curator at the Witte Memorial Museum in San Antonio, Bywaters selected works to survey six decades of art in Texas. Eighty-seven artists were represented – from Robert Onderdonk, born in 1852, to Bill Wiman, born in 1940. Included were works by Frank Reaugh, Reveau Bassett, Alexandre Hogue, Charles Umlauf, Donald Weismann, Dorothy Hood, Dan Wingren, David McManaway, Mel Casas, and others. After opening at the Pollock Galleries at SMU, the exhibition traveled to the San Antonio Museum of Art at Hemisfair Plaza, the University Art Museum at the University of Texas, the Amon Carter Museum, and the Texas Tech Museum. The exhibition's catalogue not only reproduced each art work in the exhibition but also presented a brief history of art institutions throughout the state. Bywaters wrote the forward and an essay on the history of art in Dallas. Martha Utterback of San Antonio, James Chillman of Houston, Loren Mozley of Austin, and Sam Cantey II of Fort Worth each contributed essays to the catalogue with histories of the art institutions in their respective cities. The exhibition represented a major achievement for Bywaters in the presentation of Texas art past and present.

Bywaters' untiring efforts to promote the art of living artists were rewarded as he saw a gradual change in attitudes toward regionalism. In four decades the level of recognition of Bywaters' personal and professional efforts to promote the art of his region went from drought in the 1950s to a trickle in the 1960s to a flood in the 1970s and 1980s. By the mid 1970s a new generation

had begun to appreciate the aesthetic and formal qualities of the art of the American Scene movement. What they discovered and admired in the paintings of Jerry Bywaters, Everett Spruce, Otis Dozier, and other regionalists were content and social conscience.

In the fall of 1974 the Dallas Museum of Fine Arts presented "A Salute to the Doziers of Dallas," an exhibition of the extensive sketchbooks of Otis Dozier and the handcrafted jewelry of Velma Dozier. The exhibition was organized through the efforts of Bywaters, along with Barney Delabano, associate curator and longtime member of the museum staff, and Esther Houseman, who had been with the museum since 1957 and was one of the original founders along with Velma Dozier of the Craft Guild of Dallas. The exhibition included 140 sketchbooks filled with over 9,000 drawings by Otis Dozier. Bywaters wrote in the catalogue essay, "Dozier's sketchbooks of this period [the 1940s] are among the most interesting interpretations of mountain landscapes in American art, without sequel in either early or contemporary records. Their creative qualities and technical varieties are well worth some detailed accounting."[6]

In the interest of providing information for future "detailed accounting," Bywaters was appointed in 1974 by the Smithsonian Institution as director of Archives of American Art, Texas Project. A natural extension of Bywaters' interest in promoting and preserving the art of the region, the Texas Project consisted of gathering original research material on art and artists of Texas and adjoining states. From a small office on the SMU campus Bywaters and several graduate students, including Francine Carraro and Marla Redelsperger, began the task of gathering, organizing, and preserving photographs, letters, sketchbooks, notebooks, and other materials donated to the project. Oral history interviews were conducted with artists and transcribed. There was a sense of importance and urgency to the mission, which would provide information about Southwest art, artists, and art institutions for future scholars.

In 1978, on the occasion of the seventy-fifth anniversary of the founding of the Dallas Art Association and the Dallas Museum of Fine Arts, Bywaters organized an exhibition titled "Seventy-five Years of Art in Dallas." Bywaters' catalogue essay chronicled the history of the museum, and the exhibition presented photographs of key figures and events as well as works from the permanent collection which measured the growth and strength of the museum.

The exhibition that prompted renewed interest in the art of the region,

City Suburb at Dusk, 1978. *Oil on canvas. 18 × 24 in. Collection of Gerald Patterson Bywaters, Dallas, Texas.*

however, was the 1976 retrospective exhibition of Bywaters' paintings that opened at the University Galleries at Southern Methodist University and traveled to Laguna Gloria Art Museum in Austin. The exhibition presented fifty-five works from a forty-year period. The man who had long been identified as a promoter of other artists was recognized for his own artistic abilities. Janet Kutner, art critic for the *Dallas Morning News,* wrote, "Certainly Bywaters' services to Southwest regional art have been devoted, consistent, and energetic during the years. But his paintings stand on their own merit and deserve notice."[7]

The retrospective opened a flood tide of interest in the art of Bywaters and his contemporaries. With a bit of caution Bywaters told Lorraine Haacke, art critic for the *Dallas Times Herald,* "We were not disturbed by the fact that we were dubbed 'regionalists.'"[8] There was no need, however, for Bywaters to be self-conscious about the term "regionalist" because it had new meaning. Bywaters and other regional artists were being rediscovered by younger artists

of the region. Sculptor James Surls was teaching in the SMU art department at the time and drawing on the region as the source for his art. David Bates was a graduate student in painting and a student of Dan Wingren at SMU at the time of the Bywaters retrospective. Both Surls and Bates credit Bywaters as their mentor in the appreciation of the region. Bywaters was aware of the interest generated by his work: "I think the region is an extremely good place. I've been interested in hearing some of the younger group (Surls, Wade, and others) today talking and they are echoing word for word what we were saying in the '30's . . . The results of their efforts may seem different but they are similar in that they are working with their own environment because they want to be here. They've traveled and they could live elsewhere" (ibid.).

A number of important conferences, exhibitions, and publications followed in the wake of interest in regionalism after the Bywaters retrospective.[9] Rice University sponsored a national conference on regional art of the 1930s. Speakers at the conference included cultural historian Warren Susman and art historian Karal Ann Marling, who delivered a paper titled "Public Patronage of the Visual Arts: The Depression Decade." That talk was the basis for her history of government-supported post office murals. The Rice conference included an exhibition of photographs of post office murals in Texas; featured were the 1941 murals by Bywaters and Hogue which had originally hung in the Houston Parcel Post Building. The murals had been recently discovered rolled up in the basement of the government building.

This new interest in regional artists can be attributed to the temper of the times. After the oil embargo in the fall of 1973, the price of oil doubled, and Texans witnessed some significant changes in the social, economic, and political fabric of the state. As the population of the state became more urbanized, there was a general nostalgia for rural Texas. Most native Texans could recall a time when the state had a distinctive character, when the local restaurant was not a franchise and the general store was not in a shopping mall. Journalist Nicholas Lemann noted that "Texans and non-Texans thought they saw the state becoming homogenized, losing its distinctiveness."[10] True or not, people certainly perceived that Texas was changing, and in the moment when loss of identity was threatening, the art of Bywaters and his colleagues of the 1930s was rediscovered. Paintings of such diverse cultural icons as gussied-up cowgirls, devastating dirt storms, ostentatious courthouses, and humble farmhouses provided indisputable evidence of the unique character of Texas.

Museum curators across the state discovered the special qualities of art by Texans. In 1979 Becky Duval Reese at the Archer M. Huntington Art Gallery at the University of Texas at Austin organized "Made in Texas" to highlight the art of contemporary Texas artists, many of whom were exploring regional subjects and issues in their art. In 1982 the Corpus Christi Art Museum organized an exhibition titled "Texas Observed: 1932–1942," which toured the drawings, paintings, and prints of Jerry Bywaters and photographs by Russell Lee throughout the state in the South Texas Artmobile. A 1983 Texas A&M University Press publication titled *Pecos to Rio Grande: Interpretations of Far West Texas by Eighteen Artists* included four works by Bywaters that embodied the character of the Big Bend region of Texas. In the same year Huntington Art Gallery presented "Texas Images and Visions," an extensive survey of the history of art in Texas and the first serious appraisal of the art of the Texas regionalists of the 1930s.[11] Bywaters was represented in that exhibition by two of his finest works, *Century Plant, Big Bend* and *Oil Field Girls*. Out of that exhibition *Oil Field Girls* was acquired by writer James Michener for the collection of American art at the University of Texas at Austin. The exhibition, curated by William Goetzmann and Becky Duval Reese, served to provide a kind of mirror for Texans to see their identity reflected in the work of artists who had observed the region for 150 years.

The next exhibition that had significant impact on the critical assessment of regional art focused specifically on the work of Dallas artists of the 1930s. "Lone Star Regionalism: The Dallas Nine and Their Circle" was organized by Rick Stewart at the Dallas Museum of Fine Arts in 1985. It was a triumphant moment for Bywaters, Hogue, Dozier, Bowling, and other members of the Dallas Nine, who, in their eighties, gathered to reminisce and received the adulation of thousands of visitors to the exhibition. Their art was recognized as an important, original, and powerful vein of American art. "The Dallas artists were regional but not provincial," as one magazine reporter affirmed.[12]

The "Lone Star Regionalism" exhibition was followed in 1986, the year of the Texas Sesquicentennial, by a major exhibition at Houston's Museum of Fine Arts. Curated by Susie Kalil, "The Texas Landscape 1900–1986" presented 153 works by historic and contemporary Texas artists who portrayed the region with various styles and approaches. The survey ranged in media from painting, sculpture, watercolor, pastel, and photography to assemblage

and environmental earthworks. In an exhibition dubbed "as sweeping as Texas," one of the most popular and critically acclaimed works was Bywaters' *Oil Field Girls*.[13]

Today Bywaters' untiring efforts to promote the art of the region live on in the Jerry Bywaters Collection on Art of the Southwest at Southern Methodist University. The collection began with Bywaters' initial gift in 1981 of approximately 5,000 color slides to SMU's Meadows School of the Arts. The slides were used for many years in Bywaters' popular lecture course titled "Art and Artists of the Southwest." Bywaters also gave SMU his extensive collection of papers on art and artists of the Southwest. In 1988 the McDermott Foundation presented a gift of $400,000 for special collections of the art library in the name of Jerry Bywaters to the Meadows School of the Arts at Southern Methodist University. The Bywaters Collection is currently housed in the Jake and Nancy Hamon Fine Arts Library, which is adjacent to the Meadows School of the Arts. Current director Sam Ratcliffe estimates that the collection contains 100,000 items including photographs, slides, newspaper clippings, exhibition catalogues, correspondence, taped interviews with artists of the Southwest, and files on individual artists. The director of the Meadows Museum was quoted as saying that "in naming the special collections area for Jerry Bywaters, Mrs. McDermott has not only paid tribute to one of Texas's most respected artists and a longtime friend, but assured that the spirit of the Texas regionalists lives on."[14] The mission to provide scholars and historians the primary research material for further investigation into the art of the region was of utmost importance to Bywaters.

Documentation is essential to preserve the work of local artists within the larger history of American art. Bywaters' lifelong commitment to the work of living artists of the Southwest was predicated upon the belief that local artists are taken for granted and soon forgotten by local audiences. Bywaters would certainly agree with cultural historian A. C. Greene, who described Dallas as a city that has historically disdained homegrown artists and ideas. According to Greene, "Dallas seems not to understand culture in the local sense of social experimentation, tradition, custom, and opinion, and overlooks the fact that culture, like history, is created regardless of intent"[15] Bywaters was very aware of the city's self-consciousness and reluctance to accept the local artists as prophets. He once said that if he were to write a history of art in Texas, he would title it "In Search of Culture," referring to the general belief

among Dallasites that culture is something to be found and purchased elsewhere, preferably Europe.[16] Through Bywaters' various capacities as artist, art critic, art educator, museum director, and exhibition curator, he fought for the recognition of the efforts of artists of the region and sought to identify the culture of the region.

By the same token, he was aware of the constant pendulum swing of what is in and out of vogue, but he never succumbed to the capriciousness of taste. Bywaters' greatness lay in his adamant devotion to quality not only in his curatorial decisions but most particularly in his own art. Until his death in 1989 he was dedicated to an art based on his own unique vision of a particular part of America. Bywaters' art is stalwart and earthy. His paintings such as *On the Ranch, Century Plant, Big Bend, Oil Field Girls,* and *Autumn Cotton Fields* remain fresh and continue to have a ring of truth to them. The paintings speak eloquently about Texas and Texans.

He developed a realistic style of painting and a self-styled expressionism. His art expressed what he understood to be true about the land and the people. Sometimes with humor, but never with nostalgia, he painted Texas without the props of cliché. He saw the region clearly and painted no Hollywood cowboys, no quaint anecdotes, no reminiscing about some lost garden. He dispensed with the old myths and the painting of bluebonnets. Bywaters held no delusions that Texas was a misty meadow of azure blue. He knew, like every true Texan, that the land is hard and the weather unrelenting. Bywaters' art described the hard times – farmers defeated by insects and wind and the loss of innocence in the oil fields. His work was in touch with common people. He developed a sympathetic eye in an age of social concerns, but his art was not about despair. His landscapes express boundlessness and amplify the dynamics of natural forces. There is a sense of monumentality and expansiveness in his work. Bywaters found the vastness of the landscape a symbol of optimism – a land of no limits where even a boy from Paris, Texas, can make it big in the world of art. As eminent cultural historian and leader of the myth and symbol school, Henry Nash Smith told Bywaters, his longtime friend, on the occasion of his eightieth birthday, "You and the other members of 'the Dallas nine' had something to say that seems to me untouched by . . . time"[17]

notes

1. Growing Up Texan

1. "Little Boy Seriously Hurt," *Paris News*, September 10, 1913, Jerry Bywaters Collection on the Art of the Southwest, Research Library, Jake and Nancy Hamon Fine Arts Library, Southern Methodist University (hereafter cited as Bywaters Collection). Other biographical information is from interviews with Jerry Bywaters. See also Marla Redelsperger, "Jerry Bywaters: Regional Artist of the Southwest," master's thesis, Southern Methodist University, 1976.

2. Lamar County Marriage Records; U.S. Census for Lamar County, 1880, 1900, 1910.

3. Jerry Bywaters, interview with author, Dallas, April 7, 1987.

4. Honey Grove newspaper clipping, Bywaters Collection.

5. *Crimson Colt*, Freshman Number, 1926, p. 14.

6. Jerry Bywaters, "Oral History Interviews," interview with Gerald Saxon, Dallas, May 9, 1985, p. 17.

7. *A Retrospective Exhibition: Jerry Bywaters*, University Galleries, Owens Fine Arts Center, Southern Methodist University, Dallas, 1976, p. 31.

8. Porter A. Bywaters, Jr., "The Organization and Management of the Bywaters Dry Goods Company," bachelor's thesis in business administration, University of Texas, May 10, 1925, Vertical File, Barker Texas History Center, University of Texas at Austin.

2. On Becoming an Artist

1. "Frank Reaugh," Vertical File, Barker Texas History Center, University of Texas at Austin.

2. Helen Raley, "Texas Wild Flower Art Exhibit," *Holland's Magazine*, July 1927, pp. 5, 49.

3. Rountree's name is often spelled Roundtree and Rowntree.

4. "Beauties of China Shown by Rowntree," *Dallas Morning News*, March 20, 1927, sec. 5, p. 1; Idalea Andrews Hunt, "Dallas Colors Borne Aloft Proudly at Fair by Showing of Local Artists," *Dallas Morning News*, October 23, 1927.

5. *Dallas Morning News*, May 8, 1927, sec. 5, p. 8.

6. *A Retrospective Exhibition*, p. 9.

7. "Scenes from Spain and France Painted Sympathetically on Exhibition in Highland Park," *Dallas Morning News*, April 22, 1928; *Dallas Morning News*, March 4, 1928, p. 4.

8. *Dallas Times Herald*, January 29, 1928.

9. "Art School Leases Space," *Dallas Morning News*, January 3, 1926, sec. 6, p. 6.

10. "Greatest Art of America Due from Southwest and South, Vonnoh Foretells," *Dallas Morning News*, March 25, 1938, Society, p. 1.

11. *Dallas Morning News*, January 22, 1928, Society, p. 1. Porter Bywaters, Jr., married Margaret Alwood of Ennis.

12. "Mexican Folkways," *Dallas Morning News*, September 11, 1927, sec. 3, p. 3.

13. *Mexican Folkways* 4, no. 2 (1928), and 5, no. 4 (1929).

14. *A Retrospective Exhibition*, p. 10.

15. Jerry Bywaters, "Discussion of Mural Painting," interview with Marla Redelsperger, Dallas, October 3, 1975.

16. Jerry Bywaters, "Art Trend in Mexico Wakes Keen Interest," *Dallas Morning News*, June 3, 1928, p. 14.

17. Jerry Bywaters, "Diego Rivera and Mexican Popular Art," *Southwest Review* 13, no. 4 (July 1928).

18. William Gerdts, *American Impressionism*, p. 201.

19. See *American Masters: Art Students League* (New York: American Federation of Arts, 1967–1968). Jerry Bywaters is listed among the students who attended the league.

20. David W. Scott, *John Sloan*, p. 158.

21. Jerry Bywaters to Porter Ashburn Bywaters, August 26, 1928, Bywaters Collection.

3. A Hotbed for Indigenous Art

1. Frances B. Fisk, *A History of Texas Artists and Sculptors* (Abilene, Texas: Frances B. Fisk, 1928), n.p.

2. "Gerald Bywaters First Artist in Theatre Showing," *Dallas Morning News*, October 25, 1931, sec. 4, p. 5.

3. David R. Williams, "An Indigenous Architecture," *Southwest Review* 14, no. 1 (Autumn 1928): 60–74. See also David Wilson, "O'Neil Ford," *Arts and Architecture*, Winter 1981, p. 61; Mary Lance, *Lynn Ford: Texas Artist and Craftsman*.

4. "Trio of Dallas Painters Will Seek Color in Summer Camps in Beauty Spots of Southwest," *Dallas Morning News*, June 3, 1928, Society, p. 1.

5. Everett Spruce, interview with author, Austin, January 23, 1976.

6. James Chillman, "The Hogue Exhibit," *Southwest Review* 14 (Spring 1929): 380.

7. Jerry Bywaters, "Five Dallas Artists," *Southwest Review* 14 (Spring 1929): 379.

8. Alexandre Hogue, "A New Gallery for Taos," *Southwest Review* 15 (Autumn 1929): 126.

9. Henry Nash Smith, "A Note on the Southwest," *Southwest Review* 14 (Spring 1929): 272.

10. Matthew Baigel, "Introduction," *Nature's Forms/Nature's Forces: The Art of Alexandre Hogue* by Lea Rosson DeLong (Norman: University of Oklahoma Press, 1984), p. 2.

11. Otis Dozier, interview with author, Dallas, March 20, 1976.

12. Jerry Bywaters, "Robert Vonnoh, N.A.," *Southwest Review* 14 (Spring 1929): 378.

13. Jerry Bywaters, "Autobiographical Sketch with Slides," interview with Marla Redelsperger, June 18, 1975.

14. Henry Nash Smith, "Culture," *Southwest Review*, January 1928, p. 253.

15. David Williams, "An Indigenous Architecture," *Southwest Review* 14 (Spring 1929): 74.

16. David W. Guion, "Is the Southwest Musical?" *Southwest Review* 14 (Spring 1929): 350.

17. Marion Murry, "Art of the Southwest," *Southwest Review*, July 1926, p. 291.

18. Alexandre Hogue, "Rockwell Kent Exhibition," *Southwest Review* 15 (Autumn 1929): 128.

19. Jerry Bywaters, "A Dallas Gallery," *Southwest Review* 15 (Autumn 1929): 130.

20. Jerry Bywaters, "Buried Rubies That Have Claimed Lives," *Dallas Morning News*, September 8, 1929, p. 4.

21. Jerry Bywaters, "Sketching in Mexico City," *Holland's, the Magazine of the South*, March 1930, p. 28.

22. "Allied Arts Exhibition," *Dallas Morning News*, April 14, 1929, p. 7.

23. "Art Culture with Direction," *Dallas Morning News*, October 27, 1929, p. 4.

24. "New Gallery Directors, Art Association Usher in New Era," *Dallas Morning News*, August 4, 1929, p. 6.

25. "Algerian City Will Be Scene for Arts Ball," *Dallas Morning News*, February 2, 1930, Society, p. 3.

26. *Dallas Morning News*, January 6, 1929.

27. Muriel Quest McCarthy, *David R. Williams: Pioneer Architect*, pp. 36–37.

28. Maureen Osborn, "Dallas Gallery Goes Modern," *Dallas Morning News*, December 1, 1929, p. 7.

29. John Ankeney, "Exhibition of French Modern Art in Dallas," *Dallas Morning News*, December 15, 1929, p. 5.

30. Maureen Osborn, "Modernism Wins Out Locally as Jury Bestows the Ribbons," *Dallas Morning News*, April 20, 1930, p. 10.

31. Maureen Osborn, "6 Exhibits in One Week," *Dallas Morning News*, March 2, 1930, p. 10.

32. Maureen Osborn, "Young Dallas Artists," *Dallas Morning News*, April 13, 1930, p. 10.

33. "Women's Club Art Activities Will Start Wednesday," *Dallas Morning News*, October 19, 1930, Society, p. 4.

34. Jerry Bywaters, "The Fall Openings," *Southwest Review* 16, no. 1 (Autumn 1930): 137.

4. The Fight for Acceptance

1. Jerry Bywaters, "The Artist Aroused," *Southwest Review* 17, no. 4 (Summer 1932): 490.

2. "Fourth Annual Allied Show Overshadows Past Exhibits," *Dallas Morning News*, April 12, 1931. Jurors for the show included Oscar Jacobson, Oklahoma Univer-

sity; James Chillman, Museum of Fine Arts, Houston; and Goldwin Goldsmith, University of Texas.

3. Maureen Osborn, "3 Exhibits Open Sunday at Local Galleries," *Dallas Morning News*, March 31, 1931, p. 9.

4. "Former Paris Boy Becomes Widely Known as Artist and Illustrator," *Paris News*, July 26, 1931.

5. Henry Nash Smith, "New Dallas Gallery," *Southwest Review* 16 (January 1931).

6. Maureen Osborn, "Modernism Only an Influence in This Real Day," *Dallas Morning News*, November 1, 1931, p. 5.

7. "Art Institute Will Operate in 'The Barn,'" *Dallas Morning News*, September 14, 1930, p. 5.

8. Frederic McFadden, "New Deal at Art Institute," *Dallas Morning News*, August 28, 1932.

9. Kay Jefferson, untitled clipping, *Dallas Times Herald*, n.d., Bywaters Collection.

10. Quoted in McCarthy, *David R. Williams*, pp. x–xi.

11. Jerry Bywaters, interview with author, Dallas, October 29, 1983.

12. See *Dallas Morning News*, September 25, 1932, p. 1, and October 9, 1932, p. 4.

13. Maureen Osborn, "Exhibits at Local Galleries Include Many Forms of Art," *Dallas Morning News*, November 8, 1931, p. 4.

14. Everett Spruce, interview with author, Austin, May 31, 1976.

15. Maureen Osborn, "Owned-in-Dallas Exhibition," *Dallas Morning News*, November 15, 1931, p. 5.

16. "Dallas Artists Plan Unique Carnival," *Dallas Morning News*, June 19, 1932. The league continued the art carnival as an annual event for ten years.

17. Maureen Osborn, "Artists Go Arty and Dear Public Goes to See Them," *Dallas Morning News*, June 24, 1932, p. 6.

18. "Dallas Edited Art Journal Contemporary Arts of the South and Southwest Makes Appearance," *Dallas Morning News*, November 6, 1933, p. 5.

19. *Southwestern Art* 1, no. 1 (August 1932), n.p. The name of the publication was changed in the next issue to *Contemporary Art of the South and Southwest*. The dates of publication are November/December 1932, January/February 1933, and March/April/May 1933. See Sarah Chokla, "Book-Printing in Texas," *Southwest Review* 21, no. 3 (April 1936). Chokla praised the short-lived magazine "in whose pages fine printing was extolled and (the editors prayed) exemplified. The intelligence and compositional flair of Jerry Bywaters, coupled with the patience, tolerance, and good mechanical equipment of the Boyd Printing Company of Dallas, wrought excellent results in the format of this interesting periodical" (p. 325).

20. Tom Stell, "TFAA Exhibit," *Contemporary Art of the South and Southwest*, November/December 1932, p. 6.

21. Vernon Hunter, "The Artist and the Region," *Southwest Art*, August 1932, p. 2.

22. Jerry Bywaters, "Comments," *Contemporary Art of the South and Southwest*, January/February 1933, p. 9.

23. Frederic McFadden, "Clubs Plan New Deal in Art Lectures," *Dallas Morning News*, October 30, 1932, p. 7.

24. "Young Texans, All Under 30, Show in Dallas," *Art Digest*, March 15, 1932, p. 8.

25. Maureen Osborn, "Study of Contrasts Present in New Dallas Art Exhibits," *Dallas Morning News*, February 7, 1932, p. 9.

26. Maureen Osborn, *Dallas Morning News*, April 10, 1932.

27. "Freshness and Assurance Mark Dallas Show," *Art Digest*, May 1, 1932, p. 16.

28. Mary Marshall, "The Allied Arts Show," *Southwest Review* 17, no. 3 (Spring 1932): 360.

29. "Art Notes," *Dallas Morning News*, October 1, 1932, p. 7.

30. Maureen Osborn, "Dallasite Wins Prix de Rome, Putting Home Town on Atlas," *Dallas Morning News*, May 8, 1932, p. 9.

31. *Dallas Morning News*, July 10, 1932, p. 7.

32. Jerry Bywaters, "Taos Losing Much of Its Atmosphere with Rebuilding of Plaza Side; Emil Bisttram, Mural Artist, Joins Colony," *Dallas Morning News*, September 18, 1932, sec. 3, p. 9.

33. Jerry Bywaters, "The Artist Aroused," *Southwest Review* 17, no. 4 (Summer 1932): 490.

34. Frederic McFadden, "Scope Versus Quality in Fair Gallery," *Dallas Morning News*, October 9, 1932, p. 4.

5. The Texas Scene Is the American Scene

1. "A Season's Citation: Four Musketeers of Dallas Art," *Dallas Morning News*, May 21, 1933, p. 7.

2. "Dallas Annual," *Art Digest*, April 1, 1933, p. 11.

3. Jerry Bywaters, "Texas Artists at the Fair," *Dallas Morning News*, October 11, 1933.

4. Frederic McFadden, "Victory for the Rebellion," *Dallas Morning News*, March 19, 1933, sec. 3, p. 7.

5. Jerry Bywaters, "More about Southwestern Architecture," *Southwest Review* 18, no. 3 (Spring 1933): 241.

6. *Dallas Morning News*, March 19, 1933.

7. *Dallas Times Herald*, March 26, 1933.

8. Frederic McFadden, "Youth Serves Itself: Are Dallas' Older Artists Neglected?" *Dallas Morning News*, April 30, 1933, sec. 3, p. 7.

9. *Dallas Morning News*, March 19, 1933.

10. John Rogers, *Dallas Times Herald*, March 19, 1933.

11. John Ankeney, *Dallas Times Herald*, March 26, 1933.

12. Harry Carnohan, *Dallas Journal*, April 11, 1933.

13. Jerry Bywaters, "St. Jerome and St. Frances," *Dallas Morning News*, February 4, 1934, p. 12.

14. Everett Spruce, interview with author, Austin, January 23, 1976.

15. John Sloan, *New York Scene*, p. xxii.

16. Scott, *John Sloan*, pp. 194–195.

17. "All American Exhibit to Open," *Dallas Morning News*, January 1, 1933, p. 11.

18. Harry Carnohan, "Cabbage Fair This Week in Local Bohemia," *Dallas Morn-

ing News, June 25, 1933, p. 5. See also *Dallas Morning News*, June 18, 1933, for information about the Second Annual Alice Street Carnival. There was a fifty-cent registration fee for artists for booth space. The theme was the Southwest, and both the public and artists were urged to attend in costumes. Evening entertainment included a forty-niners' dance and burlesque show.

19. Jerry Bywaters, "World's Fair Art Represents at Least the Fine Taste of Collecting During So-Called 'Century of Progress,'" *Dallas Morning News*, August 13, 1933, sec. 3, p. 7.

20. Jerry Bywaters, The Moderns: Contemporary Art as Fully Revealed at Chicago Exhibition," *Dallas Morning News*, August 18, 1933.

21. Jerry Bywaters, "The Benton Mural: Tremendous Decoration for Indiana State Building," *Dallas Morning News*, August 20, 1933, sec. 3, p. 11.

22. Jerry Bywaters, "A Natural Painter," *Dallas Morning News*, August 27, 1933, sec. 3, p. 12.

23. Jerry Bywaters, "A Painter Changes," *Dallas Morning News*, September 10, 1933, sec. 3, p. 12.

24. Jerry Bywaters, "Art and Much Craft," *Dallas Morning News*, September 17, 1933, sec. 3, p. 6.

25. Jerry Bywaters, "Open Season on Art," *Dallas Morning News*, September 3, 1933, p. 10.

26. Jerry Bywaters, "Art's Theory of Relativity," *Dallas Morning News*, November 5, 1933, p. 8.

27. Jerry Bywaters, "Klepper's 'Scapes and Some Regrets on a Newer Manner," *Dallas Morning News*, November 17, 1933.

28. Jerry Bywaters, "America's Rembrandt," *Dallas Morning News*, October 4, 1933, sec. 1, p. 10.

29. Jerry Bywaters, "The Art Exhibit at the State Fair," *Dallas Morning News*, October 8, 1933, sec. 3, p. 6.

30. Jerry Bywaters, "Whitney Loan Exhibit," *Dallas Morning News*, November 12, 1933, sec. 3, p. 10.

31. John William Rogers, "Dallas Artists Comment on Whitney Loan Collection on View at Dallas Museum," *Dallas Times Herald*, December 10, 1933, sec. 3, p. 8.

32. *Dallas Morning News*, November 12, 1933.

33. R. L. Duffus, *The American Renaissance* (New York: Alfred A. Knopf, 1928), pp. 317–318.

34. Edward Alden Jewell, "American Painting," *Creative Art* 9, no. 5 (November 1931): 366–367.

35. Matthew Baigell, *The American Scene: American Painting of the 1930's*, p. 38.

36. Henry McBride, "The Palette Knife," *Creative Art*, November 1931, p. 357.

37. *Painting and Sculpture from Sixteen American Cities*, Museum of Modern Art, New York, 1933, n.p.

38. Jerry Bywaters, "Dallas Among 16 Cities for Art Exhibition," *Dallas Morning News*, December 7, 1933.

39. Jerry Bywaters, "Making a National Art," *Dallas Morning News*, December 10, 1933, p. 8.

40. *Dallas Morning News*, December 7, 1933.

41. Baigell, *The American Scene*, p. 46.

42. Robert B. Harshe, "The Museum and the American Art Renaissance," *Creative Art*, November 1931, p. 381.

6. A New Deal for Art

1. "Texas Creative Artists Will Be Employed at Wages for Craftsmen," *Dallas Times Herald*, December 13, 1933; see also "Artists Plan Decoration," *Dallas Times Herald*, December 13, 1933; "Artists to Redecorate Municipal Buildings as Government Pays Wage," *Dallas Morning News*, December 13, 1933; "Emergency Use of Arts," *Dallas Morning News*, December 14, 1933.

2. Earlier that year in May of 1933, American social realist artist George Biddle wrote President Roosevelt and urged him to initiate a governmental program of art patronage to employ artists. As a former classmate of FDR at Groton, Biddle became a close advisor to the president and his recommendations were taken seriously.

3. For information on New Deal art projects, see Karal Ann Marling, *Wall-to-Wall America: A Cultural History of Post-Office Murals in the Great Depression*; William F. McDonald, *Federal Relief Administration and the Arts*; and Richard McKinzie, *The New Deal for Artists*.

4. Records of the Public Building Service, Record Group No. 121, Files on the Federal Art Projects, Inventory Entry 133, Case Files Concerning Embellishment of Federal Buildings, 1934–1943, National Archives and Records Service, Washington, D.C.

5. "Walls and Wages for Artists," *Dallas Morning News*, December 17, 1933, sec. 3, p. 12.

6. John Ankeney, "Ankeney Explains Plan of Government Public Works of Art Project; Chance for Texas Artists," *Dallas Times Herald* [January 14, 1934], Bywaters Collection.

7. Jerry Bywaters, "With Corn in Chicken Coop the Feathers Begin to Fly," *Dallas Morning News*, December 31, 1933, Society, p. 5.

8. Jerry Bywaters, "On the Public's Wall," *Dallas Morning News*, January 7, 1934, sec. 3, p. 10.

9. *Dallas Morning News*, December 31, 1933.

10. *Dallas Times Herald*, January 14, 1934.

11. *Dallas Morning News*, January 7, 1934.

12. *Dallas Times Herald*, January 14, 1934.

13. See Marling, *Wall-to-Wall America*.

14. Everett Spruce served as curator at the Dallas Public Art Gallery, and Charles Bowling worked for the Dallas Power and Light Company. Neither of these two artists applied for PWAP commissions.

15. *Dallas Morning News*, January 18, 1934, sec. 1, p. 5.

16. "Mural Sketches to Be Exhibited at Art Institute," *Dallas Morning News*, January 30, 1934, sec. 1, p. 5.

17. "New Courses Included in 1934–35 Curriculum of Local Art Institute," *Dallas Morning News*, August 19, 1934.

18. Bywaters, "Autobiographical Sketch with Slides," June 25, 1975.

19. "Historical Murals Doomed," *Dallas Morning News*, June 27, 1956. The panels were destroyed in the remodeling of the Dallas City Hall in 1956; all that remains are photographs taken when the murals were completed. In fact, most of the early PWAP art works have been destroyed or lost, and, therefore, much visual evidence is lacking.

20. Bywaters, "Autobiographical Sketch with Slides," October 3, 1975.

21. Elisabeth Crocker, "Benton Praise for City Hall Mural Recalled," *Dallas Morning News*, February 9, 1940.

22. "Bywaters' Murals for Paris Library Are Completed," *Paris News*, September 23, 1934.

23. *Dallas Morning News*, March 11, 1934, sec. 2, p. 1.

24. See O'Connor, *Art for the Millions*, p. 21.

25. Jerry Bywaters, "El Paso Panels Show History of Mining Art," *Dallas Morning News*, July 15, 1934.

26. *Dallas Morning News*, August 15, 1937.

27. From 1933 until 1943 the federal government supported and subsidized an unprecedented art program that originated as relief projects for the unemployed artists of the Depression and developed into a series of programs that brought a vast number of original works of art to government buildings across the nation. Although all the art programs of this period are commonly referred to as "WPA art," only two such programs existed: the Federal Art Project/Works Progress Administration program and the WPA Art Program. The FAP/WPA program, which operated from August 1935 to September 1939, was under the supervision of the WPA and was strictly relief-oriented. The WPA Art Program, also called the Art Program/Works Projects Administration Federal Works Agency program, operated from September 1939 to March 1942.

Other federal art programs were administered by the Treasury Department. These included the Public Works of Art Project (PWAP), which operated from December 1933 to June 1934; the Section of Painting and Sculpture (October 1934 to October 1938); the Section of Fine Arts (October 1938 to June 1939); and the Treasury Relief Art Project (July 1935 to June 1939). From July 1939 to June 1943 the Treasury Relief Art Project continued as the Section of Fine Arts, Federal Works Agency. The federally funded art programs in Texas were all administered by the Treasury Department. The participation of Bywaters and his contemporaries in the federal art programs will also be discussed in Chapter 8.

7. The Texas Renaissance

1. Jerry Bywaters, "No Imitation Matisses in Lounging Robes, But Painters in Overalls Produce Art of Today," *Dallas Morning News*, January 6, 1935, sec. 3, p. 10.

2. Esse Forrester O'Brien, *Art and Artists of Texas*.

3. "U.S. Scene," *Time*, December 24, 1934, p. 24.

4. This is a recurring idea in Bywaters' writings and statements. See Jerry Bywaters, "Art Comes Back Home," *Southwest Review* 23, no. 1 (October 1937): 79–83; and

Jerry Bywaters, "Answers to Questions," interview with author, Dallas, November 21, 1987.

5. "Art in America," *Art Digest*, February 1, 1934, p. 17.

6. Virgil Barker, "The Search for Americanism," *American Magazine of Art*, February 27, 1934, pp. 51–52.

7. Baigell, *The American Scene*, p. 55.

8. Carey McWilliams, "Localism in American Criticism," *Southwest Review* 15, no. 4 (July 1934): 428.

9. Jerry Bywaters, "Paintings of Spruce," *Dallas Morning News*, March 25, 1934, sec. 3, p. 12.

10. Jerry Bywaters, "As the New Curator Finds the Museum," *Dallas Morning News*, November 25, 1934, sec. 3, p. 12.

11. Jerry Bywaters, "The Year in the Art World," *Dallas Morning News*, December 23, 1934, sec. 3, p. 10.

12. Jerry Bywaters, "Notable Private Print Collector Has Dallas Home," *Dallas Morning News*, October 21, 1934, sec. 3, p. 10.

13. *Dallas Morning News*, November 25, 1934. The Dallas Artists League included Beryl Tilson, Alice Spruce, Maud Work, Esther Webb, Vivian Stanley, Jessie Aline White, Verde Ligon, Laura Ann Taylor, Harry Lawrence, Otis Dozier, Betty Straiton, Everett Spruce, Jerry Bywaters, Alexandre Hogue, William Lester, Lloyd Rollins, Ruth Glasgow, Helen Brooks, Harry Carnohan, Velma Davis, Anna Pearl Huffhines, B. Launders, Ruth Fuqua, Nina Peeples, Perry Nichols, Marie Croft, Ann Orr, Calvin Holmes, and Lucy Ann McLantern.

14. Jerry Bywaters, "Orozco and Rivera in First Exhibit at Dallas Museum," *Dallas Morning News*, November 11, 1934, sec. 3, p. 10.

15. John W. Rogers, *Dallas Times Herald*, November 11, 1934.

16. Jerry Bywaters, "Museum's Lithographs, First Rollins Show," *Dallas Morning News*, December 9, 1934, sec. 3, p. 16.

17. Harry Carnohan, *Dallas Journal*, November 22, 1934.

18. *Dallas Morning News*, February 17, 1935, sec. 3, p. 12.

19. Jerry Bywaters, "Gertrude Stein Clearest on Most Complex Subject," *Dallas Morning News*, March 24, 1935.

20. Redelsperger, "Jerry Bywaters," pp. 54–55.

21. Bywaters, "Not Good Intentions but Finest Achievements Marks Allied Exhibit," *Dallas Morning News*, March 24, 1935, sec. 3, p. 14.

22. John W. Rogers, untitled clipping, *Dallas Times Herald*, n.d., Bywaters Collection.

23. Alexandre Hogue, "Jerry Bywaters' Gargantua," *Dallas Morning News*, March 24, 1935.

24. Harry Carnohan, *Dallas Times Herald*, Bywaters Collection.

25. *Dallas Morning News*, March 24, 1935.

26. Jerry Bywaters, "Dallas Allied Arts Show," *Southwest Review* 20, no. 3 (April 1935): 320.

27. Bywaters, "As the New Curator Finds the Museum," *Dallas Morning News*, November 25, 1934, sec. 3, p. 12.

28. Jerry Bywaters, "Esthetics Emerge after Ban of 100 Years," *Dallas Morning News*, June 23, 1935, sec. 3, p. 9.

29. Jerry Bywaters, "New Relations for Esthetics and Business," *Dallas Morning News*, June 30, 1935, sec. 3, p. 13.

30. *Dallas Morning News*, November 8, 1936. Craven spoke at the Dallas Woman's Club on December 3, 1936, and Grant Wood lectured there in December, 1937.

31. Jerry Bywaters, "Craven Again Probes Modern Art Tendency," *Dallas Morning News*, May 20, 1934, sec. 3, p. 8.

32. *Dallas Morning News*, January 6, 1935.

33. Jerry Bywaters, "Thomas Benton Back in Texas in Full Glory," *Dallas Morning News*, December 30, 1934, sec. 3, p. 10.

34. Jerry Bywaters, "Last Buzzes of Buzz Week in Dallas," *Dallas Morning News*, January 20, 1935, sec. 3, p. 10.

35. *Dallas Morning News*, January 6, 1935.

36. Jerry Bywaters, "The New Texas Painters," *Southwest Review* 21, no. 3 (April 1936): 332.

37. Jerry Bywaters, "Contemporary American Artists," *Southwest Review* 23, no. 3 (April 1938): 301–302.

38. Bywaters, "The New Texas Painters," p. 336.

39. See Kenneth B. Ragsdale, *The Year America Discovered Texas: Centennial '36*, pp. 176–207.

40. Jerry Bywaters to Thomas Hart Benton, September 19, 1935, Bywaters Collection. See also Rick Stewart, *Lone Star Regionalism* (Austin: Texas Monthly Press, 1985), pp. 54–59.

41. Quoted in Ragsdale, *The Year America Discovered Texas*, p. 184. Bywaters' statements are from a February 23, 1978, interview.

42. Thomas Hart Benton to Jerry Bywaters, n.d., Bywaters Collection.

43. Jerry Bywaters, "New Director Keys Work of Living Museum," *Dallas Morning News*, April 26, 1936, sec. 2, p. 8.

44. Jerry Bywaters, "Centennial Art Exhibit by Galleries" *Dallas Morning News*, June 14, 1936, sec. 2, p. 9.

45. Jerry Bywaters, "Centennial Art Exhibit by Galleries" *Dallas Morning News*, June 28, 1936 sec. 2, p. 4.

46. Jerry Bywaters, "Negro Art Works Being Displayed at Fair Exhibit," *Dallas Morning News*, June 28, 1936.

47. Alexandre Hogue to Emil Bisttram, February 29, 1936, Alexandre Hogue Papers, Archives of American Art, Smithsonian Institution, Washington, D.C. Quoted in Stewart, *Lone Star Regionalism*, p. 59.

48. Ibid., p. 55.

49. Peyton Boswell, "Some Comments on the News of Art," *Art Digest*, June 1, 1936, p. 7.

50. Foster Howard, "Art of Texas Presents an Epitome of Aesthetics of Modern Age," *Art Digest*, June 1, 1936, p. 14.

51. Alexandre Hogue, "Progressive Texas," *Art Digest*, June 1, 1936, p. 18.

52. Jerry Bywaters, "Against Narrowness," *Art Digest*, June 1, 1936, p. 19.

53. John William Rogers, "Opportunity," *Art Digest*, June 1, 1936, p. 23.

54. "The Print Display," *Art Digest*, June 1, 1936, p. 32.

55. The Farm Security Administration, which operated from 1935 to 1942, was established for the purpose of photodocumenting the devastation of the Depression and drought on the American farmer as well as convincing the public to support federal aid for farmers. Directed by Roy Stryker, the FSA hired professional photographers Walker Evans, Dorothea Lange, Russell Lee, and others to develop a body of photographic work known as "The File," which served as social documentation of the plight of the rural poor.

56. Richard Foster Howard, "Foreword," *13 Dallas Artists*, Lawrence Art Galleries, Dallas 1936, n.p. See also *Dallas Morning News*, August 2, 1936, sec. 2, p. 8.

57. "Dallas Winner," *Art Digest*, February 15, 1937, p. 21.

58. Bywaters, "The New Texas Painters," p. 342.

59. "Southwest Painter," *Time*, December 17, 1956, p. 82.

8. Bywaters Paints America

1. "Dallas Winner," *Art Digest*, February 15, 1937, p. 21.

2. Jerry Bywaters, "The New Texas Painters," *Art and Artists of Today* 1, no. 4 (November/December 1937): 7.

3. Elizabeth Crocker, "Home Region as Source of All Art," *Dallas Morning News*, June 12, 1938. Bywaters' influence was pervasive. An article in the May 14, 1939, issue of the *Dallas Morning News* describing an exhibition entitled Negro Art mentioned a "picture of a house and garden in the true primitive style by Olinder Reynolds, whose inspiration was none other than her artist-employer, Jerry Bywaters."

4. Jerry Bywaters, "American Art Section at Museum," *Dallas Morning News*, June 20, 1937.

5. See "200 Art Pieces Shown in SMU Exhibition," *Dallas Morning News*, May 22, 1938; *Dallas Morning News*, August 4, 1940.

6. Jerry Bywaters, "New Dallas Museum Preparing Its Most Significant Exhibit," *Dallas Morning News*, January 3, 1937, sec. 3, p. 5.

7. Bywaters, "Art Comes Back Home," p. 80.

8. Jerry Bywaters, "American Artists Group Eyes Dallas Paintings for Inclusion in Series of Reproductions," *Dallas Morning News*, June 6, 1937, sec. 3, p. 14.

9. See *American Prints 1900–1950*, Yale University Art Gallery, New Haven 1983.

10. *Dallas Morning News*, June 6, 1937, sec. 3, p. 14.

11. Jerry Bywaters, "A Note on the Lone Star Printmakers," *Southwest Review* 26, no. 1 (Autumn 1940): 63.

12. David Farmer, "The Printmakers Guild," paper presented at the National Print Conference, Austin, 1987.

13. Bywaters, "A Note on the Lone Star Printmakers," p. 63. Bywaters viewed the illustration of books as another means to bring understandable and accessible art to the public. In 1936 the Lawrence Art Galleries of Dallas had a special exhibition of Bywaters' book illustrations. The fine graphic quality of the illustrations attested to

Bywaters' belief that they were an important aspect of his printmaking ability. During this period Bywaters illustrated several books by Texas authors, including *With Milam and Fannin* by Herman Ehrenberg; *Tell Us about Texas* and *Wagon Yard* by August Wisdom Johnson; *Tales of the Mustang* by J. Frank Dobie; *The Devil in Texas* by Frank Goodwyn; *Early Times in Texas* by John C. Duval; *Naturalists of the Frontier* by Samuel Wood Geiser; and *Big Spring: The Casual Biography of a Prairie Town* by Shine Philips.

14. *Dallas Morning News*, November 13, 1938.

15. Carl Zigrosser, "Prints in Texas," *Southwest Review* 26, no. 1 (Autumn 1940): 55.

16. Ibid., p. 54. Bywaters had also produced the lithograph *Old Victorian House* in 1933.

17. Carl Zigrosser to Jerry Bywaters, March 3, 1941, Correspondence File, Bywaters Collection.

18. *A Retrospective Exhibition*, p. 18. Bywaters also completed a watercolor in 1934 of the Denton County Courthouse and a painting of the Dallas County Courthouse. The 1938 lithograph *Texas Courthouse* was produced in an edition of fifty.

19. Stewart, *Lone Star Regionalism*, p. 94.

20. Elizabeth Crocker, "Lone Star Printmakers Release Second Folio," *Dallas Morning News*, October 15, 1939, sec. 3, p. 15.

21. Bywaters, "Autobiographical Sketch with Slides," June 25, 1975.

22. Frances Folsom, "Exhibition of Art Works by Jerry Bywaters Opening," *Dallas Morning News*, October 31, 1937.

23. Elizabeth Crocker, "Bywaters Exhibition at Hockaday," *Dallas Morning News*, November 2, 1938. Included in the exhibition were the watercolors *Ranch House near Alpine*, *Stores in Shafter*, *Mine at Study Butte*, *Captain Dilly's House*, and *Texas Courthouse*; the prints *Ranch Hand and Pony*, *Election Day in Balmorhea*, *North Texas Railroad Station*, *Gargantua*, *Old Clown*, *Boneyard*, *Opera at Popular Prices*, *Mexican and Maguey*, and *Mexican Mother*; and the oils *In the Chair Car*, *Lucy*, and *Texas Subdivision*. The *Dallas Journal* also listed works in the Hockaday show. Bywaters designed, set the type for, and printed the catalogue for the exhibition. *Chisos Mountains* won a prize in the 1939 Allied Arts show.

24. Elizabeth Crocker, "Museum Performs for Fair," *Dallas Morning News*, October 9, 1938, sec. 2, p. 4.

25. *A Retrospective Exhibition*, p. 28.

26. *Texas Images and Visions*, Archer M. Huntington Art Gallery, University of Texas at Austin, 1983, p. 102.

27. Oliver W. Larkin, *Art and Life in America*, p. 414.

28. *Where the Mountains Meet the Plains* was also produced in lithograph in 1940. Bywaters' painting can also be compared with *Where the Desert Meets the Mountain* (ca. 1922) by New Mexico artist Walter Ufer.

29. *A Retrospective Exhibition*, p. 24.

30. Elizabeth Crocker, "Great Spanish Works Shown for the Fair," *Dallas Morning News*, October 8, 1939, sec. 3, p. 4.

31. *Art News*, October 28, 1939, p. 18.

32. *A Retrospective Exhibition*, p. 39.

33. Bywaters, "Autobiographical Sketches with Slides," June 25, 1975.

34. Kathryn Mayfield, "Allied Arts Show Appeals with Quality," *Dallas Morning News*, March 29, 1942, sec. 4, p. 8.

35. A *Retrospective Exhibition*, p. 28.

36. *Dallas Morning News*, March 29, 1942.

37. A *Retrospective Exhibition*, p. 28.

38. *Dallas Morning News*, April 4, 1943.

39. Redelsperger, "Jerry Bywaters," p. 60.

40. A *Retrospective Exhibition*, p. 17.

41. The 1939 oil *Elizabeth* was also titled *Portrait of a Coed* (and *Portrait of Elizabeth Williams Rucker*).

42. *Dallas Morning News*, March 2, 1939.

43. Elizabeth Crocker, "Year's Art Viewed in Retrospective," *Dallas Morning News*, June 11, 1939, sec. 2, p. 3. The Tenth Annual Allied Arts Exhibition was juried by artist Boardman Robinson, who chose 78 works out of 228 entries. The competition was stiff, but Bywaters' portrait *Elizabeth* was one of the outstanding works. Bywaters called the exhibition "the greatest encouragement and the best proving ground for the development of local artists" in his article "Judges Are Different but Artists the Same," *Dallas Morning News*, March 12, 1939, sec. 2, p. 3.

44. Louise Long, "Grand Old Man of Trinity Will Be Honored by Alumni," *Dallas Morning News*, September 1, 1940, sec. 4, p. 4.

45. *Dallas Times Herald*, December 8, 1940, Bywaters Collection.

46. *Dallas Morning News*, April 13, 1941. *Oil Rig Workers* is also called *Roughnecks*.

47. *Dallas Morning News*, April 7, 1940.

48. Bywaters got the idea of the composition from a Neiman-Marcus newspaper advertisement. Friends of Mary Bywaters posed as models for the painting.

49. *Dallas Times Herald*, December 8, 1940.

50. *Dallas Morning News*, April 21, 1949. The exhibition was one of a series of solo exhibitions by Dallas artists William Lester, Bertha Landers, Olin Travis, Adelle Herring, Roland Beers, Charles Bowling, Merritt Mauzey, Adele Burnet, Fred Darge, Florence McClung, and Stella LaMond.

51. Louise Long, "Bywaters Paintings in Exhibit," *Dallas Morning News*, December 6, 1940, sec. 3, p. 5. *Miss Priss* is also called *Little Jerry*.

52. *Dallas Morning News*, April 13, 1941.

53. *Dallas Morning News*, August 15, 1937.

54. Ibid. Not all mural commissions, however, were public. Bywaters received a private commission in 1937 from John William Rogers. Bywaters completed four small murals based on the points of the compass for Rogers' entrance hall. Rogers also commissioned Perry Nichols to design light fixtures, Lynn Ford to carve lintels over windows and doors, and Everett Spruce to paint an Arkansas landscape to be hung in the living room.

55. Federal Art Projects File, Amarillo Mural Contest, Vertical File, Bywaters Collection.

56. See Stewart, *Lone Star Regionalism*; Jerry Bywaters, "Murals for Post Office and 1938 Allied Arts Exhibition," *Dallas Morning News*, January 30, 1938, sec. 3, p. 12.

57. Edward Rowan, Superintendent, Section of Painting and Sculpture, to Jerry Bywaters, July 22, 1937, Bywaters Collection.

58. Jerry Bywaters to Edward Rowan, July 29, 1951, Bywaters Collection.

59. Inslee A. Hopper, Assistant Superintendent, Section of Painting and Sculpture, to Jerry Bywaters, August 31, 1937, Bywaters Collection.

60. Edward Rowan to Jerry Bywaters, December 8, 1937, Bywaters Collection.

61. The murals are now in the Houston Federal Building at 515 Rusk; they were lost until 1976, when they were found rolled up in the basement of the post office building and moved by the General Services Administration. For information about the commission, see "Contract between USA and Jerry Bywaters, Artist," Federal Art Projects File, Houston Mural, Vertical File, Bywaters Collection.

62. Jerry Bywaters to Edward Rowan, July 29, 1951, Bywaters Collection.

63. Louise Gossett, "History of Houston Ship Channel Is Depicted in Post Office Murals by Hogue and Bywaters," *Dallas Morning News*, July 6, 1941.

64. Edward Rowan to Jerry Bywaters, September 12, 1939, Bywaters Collection.

65. Jerry Bywaters to Marvin B. Smith, Postmaster, Farmersville, September 20, 1939, Bywaters Collection.

66. Marvin B. Smith to Jerry Bywaters, n.d., Bywaters Collection.

67. Jerry Bywaters, "Some Biographical Information," interview with the author, Dallas, October 2, 1986.

68. Edward Rowan to Jerry Bywaters, June 16, 1941, Bywaters Collection.

69. Edward Rowan to Jerry Bywaters, July 7, 1941, Bywaters Collection.

70. See "Contract between USA and Jerry Bywaters, Artist," Vertical File, Bywaters Collection.

71. Jerry Bywaters to Edward Rowan, July 10, 1940, Bywaters Collection.

72. Bywaters, "Art Comes Back Home," p. 80.

73. Anne Toomey, "Uncle Sam Art Patron," *Southwest Review* 24, no. 1 (October 1938): 59.

74. Bywaters, "Art Comes Back Home," p. 80.

75. Jerry Bywaters, "Toward an American Art," *Southwest Review* 25, no. 2 (January 1940): 142.

76. Howard Odum and Harry Moore, *American Regionalism: A Cultural-Historical Approach to National Integration*, p. 18.

77. Holger Cahill, "American Art Today," *Parnassus*, May 1939, p. 14.

9. The Regional Museum

1. In order for Bywaters to assume the position as director of the Dallas Museum of Fine Arts, the Dallas Art Association's Executive Committee had to make arrangements with President Umphry Lee of Southern Methodist University. Bywaters was allowed to continue to teach one class at the university and retain faculty status with a charge to develop greater cooperation between the university and the museum. Mary Bywaters resigned as recording secretary for the museum's Board of Trustees but remained on the board and served on two committees.

2. "Museum's New Direction Is Innovation," *Dallas Morning News*, September 13, 1942, contained the announcement of the appointment of Jerry Bywaters as art direc-

tor and supervisor of the education department of the Dallas Museum of Fine Arts. The announcement also noted that Louise Britton McCraw would "attend the executive duties." A graduate of Randolph-Macon College, McCraw had served as assistant director of the museum before taking over as acting director when Howard left the museum. After one year as executive director working with Bywaters, she resigned.

3. *Seventy-Five Years of Art in Dallas*, Dallas Museum of Fine Arts, 1978, p. 22.

4. Patricia Peck, "Bywaters New Director for Art Museum," *Dallas Morning News*, September 9, 1943, sec. 1, p. 10.

5. Jerry Bywaters, "Manifest Destiny of Art Gallery," *Dallas Morning News*, September 12, 1937, sec. 2, p. 6.

6. John Chapman, "Jerry Bywaters, Interpreter of the Southwest," typescript, 1942, Bywaters Collection.

7. Jerry Bywaters, "Make Haste Slowly on Museum Art School," *Dallas Morning News*, January 23, 1938, sec. 3, p. 14.

8. Jerry Bywaters, "From Brushes of Children Come Truths," *Dallas Morning News*, February 27, 1938, sec. 3, p. 14.

9. Elizabeth Crocker, "Educational Work at Museum Assuming Role of Importance," *Dallas Morning News*, January 14, 1940, sec. 2, p. 4.

10. Patricia Peck, "Art Students to Open New Term Saturday," *Dallas Morning News*, January 28, 1945, sec. 4, p. 2.

11. *Seventy-Five Years of Art in Dallas*, p. 21.

12. Elizabeth Crocker, "Need of City Museum for Future Seasons," *Dallas Morning News*, June 18, 1939, sec. 2, p. 3.

13. *A Retrospective Exhibition*, p. 39.

14. Bywaters, "Toward an American Art," p. 130.

15. *A Retrospective Exhibition*, p. 39.

16. Patricia Peck, "Fort Worth Artist Winner Texas General's Top Prize," *Dallas Morning News*, October 24, 1943.

17. This may be the same painting as *Autumn Still-Life*.

18. *A Retrospective Exhibition*, p. 34.

19. See *Seventy-Five Years of Art in Dallas*; and Vertical File, museum archives, Dallas Museum of Art.

20. Jerry Bywaters, "Texas Panorama," *Magazine of Art*, December 1944, p. 308.

21. *Seventy-Five Years of Art in Dallas*, p. 24.

22. Stewart, *Lone Star Regionalism*, p. 123.

23. Patricia Peck, "Liberal Sample of Activity in American Art," *Dallas Morning News*, January 14, 1945, sec. 4, p. 2.

24. Peggy Louise Jones, "Major Exhibit Will Open at Dallas Museum," *Dallas Morning News*, September 30, 1945, sec. 4, p. 7.

25. Patricia Peck, "More People More Pictures in Fair Park," *Dallas Morning News*, April 22, 1945, sec. 4, p. 3.

26. *Seventy-Five Years of Art in Dallas*, p. 24.

27. *Dallas Morning News*, April 22, 1945.

28. Peggy Louise Jones, "Museum Seen as Creative Center of Art," *Dallas Morning News*, September 2, 1945, sec. 4, p. 3.

29. Jerry Bywaters, "Art Museums: Repositories or Creative Centers?" *Southwest Review* 30, no. 4 (Summer 1945): 347–353.

30. Ibid., p. 351. Despite the praise that Bywaters lavished on the 1936 building, he does not mention that the museum's air conditioning never functioned correctly and in the hottest summer months visitors complained bitterly about the heat. The museum administration repeatedly requested money from the city to repair the air conditioning system.

31. Peggy Louise Jones, "Great Strides to Developing Dallas School," *Dallas Morning News*, October 14, 1945, sec. 4, p. 11. Under Bywaters' direction SMU and the Dallas Museum of Fine Arts worked in concert as a creative center.

32. Bywaters, "Art Museums: Repositories or Creative Centers?" p. 353.

33. *Seventy-Five Years of Art in Dallas*, p. 27.

34. John Walker, Chief Curator, National Gallery of Art, to Jerry Bywaters, October 10, 1945, Bywaters Collection.

35. *Two Hundred Years of American Painting*, n.p.

36. Jerry Bywaters, "Southwest Art Today, New Directions for Old Forms," *Southwest Review* 32, no. 4 (August 1947): 362. This article reprints Bywaters' catalogue essay in *Six Southwestern States*, Dallas Museum of Fine Arts, 1947.

37. *Seventy-Five Years of Art in Dallas*, p. 27.

38. Jerry Jane Smith Henderson, "The Communist Controversy," interview with author, Dallas, July 26, 1988.

39. Peggy Louise Jones, "Modern Art Evaluated by George Biddle," *Dallas Morning News*, December 7, 1947, sec. 6, p. 6.

40. Patricia Peck Swank, "Art for Everyone," *DAC News*, August 1948, p. 7.

41. Dorothy Hyde, "Museum Director's Home Distinctive," *Dallas Morning News*, March 5, 1950.

42. *Seventy-Five Years of Art in Dallas*, p. 31.

43. Mitchell Wilder, "Art in the Southwest," *Atlantic Monthly*, March 1951, p. 72.

44. In 1953 Rufino Tamayo was commissioned to paint a mural for the museum with funds from the Neiman-Marcus Exposition Fund. Painted in the artist's studio in Mexico City, the 18-by-10-foot mural was shipped by an oversized rail car that was temporarily lost in the Mexican mountains on the way to Dallas. The work was received in time to be installed for the 1953 State Fair exhibition.

45. *Seventy-Five Years of Art in Dallas*.

46. Dorothy Adlow, "Contemporary Art from Texas in New York," *Christian Science Monitor*, July 12, 1952.

47. Jerry Bywaters, Foreword, *Twelve from Texas: Portfolio of Lithographs* (Dallas: Southern Methodist University Press, 1952), n.p.

48. Jerry Bywaters, "A Look at Texas Murals during the Depression" interview with Cynthia Duke Brock, Dallas, April 3, 1985; and interview with author, Dallas, November 27, 1987.

49. "Art Preview for U.S.A.," *Look*, November 17, 1953, p. 90.

50. *Seventy-Five Years of Art in Dallas*, pp. 32–33. Crowds at The Fabulous West numbered 131,715 in a two-week period.

51. William Johnson, "Texas Breaks the Spell of Bluebonnets," *Life*, November 29, 1954, p. 30.

10. Red, White, and Blue Art at the Dallas Museum

1. "Resolution on the Promotion of the Work of Communist Artists," Public Affairs Luncheon Club of Dallas, March 16, 1955, Dallas Museum of Fine Arts Controversy File, Vertical File, Bywaters Collection. Press coverage of the resolution included "Women's Group Protests Policy of Art Presentation at Museum," *Dallas Morning News*, March 15, 1955; "Dallas Museum Heads Deny 'Communistic' Art Displayed," *Dallas Times Herald*, March 15, 1955; "Museum to Study Charges," *Dallas Times Herald*, March 16, 1955.

2. Charolette Devree, "The U.S. Government Vetoes Living Art," *Art News*, September 1956, p. 35.

3. *Dallas Morning News*, August 14, 1955.

4. Don Carlton, *Red Scare: Right Wing Hysteria, Fifties Fanaticism and Their Legacy in Texas* (Austin: Texas Monthly Press, 1985), p. 100.

5. Jerry Bywaters, "Oral History Interviews," interview with Gerald Saxon, June 21, 1985, Dallas, p. 110.

6. Lawrence Wright, *In the New World: Growing Up with America 1960–1984* (New York: Alfred A. Knopf, 1988), p. 18.

7. "The Public Affairs Luncheon Club of Dallas, 1954–55 Year Book," n.p., Bywaters Collection.

8. Devree, "The U.S. Government Vetoes Living Art," p. 34.

9. George A. Dondero, "Communist Conspiracy in Art Threatens American Museums," *Congressional Record*, March 17, 1952, p. 1.

10. "Resolution on the Promotion of the Work of Communist Artists," Dallas Museum of Fine Arts Controversy File, Vertical File, Bywaters Collection

11. "Is There a Communist Conspiracy in the World of Art?" handbill, Public Affairs Luncheon Club of Dallas, 1955, Dallas Museum of Fine Arts Controversy File, Vertical File, Bywaters Collection.

12. Stanley Marcus, *Minding the Store: A Memoir*, p. 153. The Dallas Art Association's Board of Trustees for 1955–1956 included Mrs. George N. Aldredge, Mrs. Robert A. Beyers, Mrs. L. A. Bickel, Mr. Roland Bond, Mrs. Alex Camp, Dr. John Chapman, Mr. Jerome Crossman, Mrs. H. Ben Decherd, Jr., Mr. E. L. DeGolyer, Mrs. Albert D'Errico, Mr. E. G. Eisenlohr, Mrs. Fred Florence, Mr. Jack Frost, Miss Cleo George, Mrs. Tom Gooch, Mr. Leon A. Harris, Jr., Mr. Karl Hoblitzelle, Mrs. Edwin B. Hopkins, Mrs. E. H. Hulsey, Mr. Jack F. Hyman, Mrs. John Leddy Jones, Mr. Phillips Brooks Keller, Jr., Mrs. Dale Heard Lambert, Mrs. W. M. Lingo, Mr. H. Neil Mallon, Mr. Gerald Mann, Mrs. Edward Marcus, Mr. Stanley Marcus, Mr. Eugene McDermott, Mr. Eugene McElvaney, Mr. Algur H. Meadows, Mr. John D. Murchison, Mr. Robert M. Olmsted, Mrs. John A. Pace, Mr. Summerfield G. Roberts, Mrs. Alex Spence, Mr. Waldo E. Stewart, Mr. J. T. Suggs, Mr. C. A. Tatum, Jr., Miss Allie Tennant, Mr. J. Lon Tinkle, Mrs. Leslie Waggener, Mrs. Alex Weisberg, and Mrs. George W. Works, Jr. See *Seventy-Five Years of Art in Dallas*, pp. 57–63.

13. Dallas Museum of Fine Arts Controversy File, Vertical File, Bywaters Collection.

14. Marcus, *Minding the Store*, pp. 155–156.

15. Stanley Marcus to the author, July 8, 1991.

16. "Larger Sunday Crowd Visits Dallas Museum," *Dallas Morning News*, March 21, 1955.

17. "Debate over Art Stirs Curiosity," *Dallas Times Herald*, March 20, 1955.

18. "Dallas Museum Is Criticized for 'Pink' Art," *Texas Observer*, March 21, 1955.

19. "Art & Artists: Red Versus Real?" *Dallas Morning News*, March 27, 1955.

20. Colonel John W. Mayo, Dallas Metropolitan Post 581, American Legion, to Dallas Art Association, March 21, 1955, Bywaters Collection.

21. J. T. Suggs to Board of Trustees, Dallas Art Association, April 1, 1955, Bywaters Collection.

22. Suggs acquired a list of twenty-eight additional "subversive" artists from Dondero and circulated it to the museum board by a memo dated June 6, 1955. Suggs continued to research artists with Communist affiliations.

23. "Public Statement," Dallas Art Association, April 4, 1955, Dallas Museum of Fine Arts Controversy File, Vertical File, Bywaters Collection.

24. *Dallas Times Herald*, April 11, 1955; *Dallas Morning News*, April 12, 1955.

25. "Resolution," Public Affairs Luncheon Club of Dallas, April 11, 1955, Dallas Museum of Fine Arts Controversy File, Vertical File, Bywaters Collection.

26. Editorial, *American National Research Record*, April 30, 1955.

27. Bywaters, "Answers to Questions," November 21, 1987.

28. Bywaters, "Oral History Interviews," June 21, 1985, p. 108.

29. Dallas Museum of Fine Arts Controversy File, Vertical File, Bywaters Collection.

30. *Dallas Morning News*, June 29, 1958.

31. Dallas Museum of Fine Arts Controversy File, Vertical File, Bywaters Collection.

32. John Chapman, "Aesthetic Judgements and Art Museums," *Southwest Review* 40, no. 3 (Summer 1955), pp. 262–266.

33. "The Sad Tale of the Timid Trustees," *Texas Observer*, November 9, 1955.

34. "Closed Doors," *Time*, May 2, 1955, p. 80.

35. Alfred Frankfurter, "Shame in Dallas," *Art News* 54, no. 4 (Summer 1955).

36. Dallas Museum of Fine Arts Controversy File, Vertical File, Bywaters Collection.

37. *Dallas Times Herald*, June 27, 1955.

38. *Dallas Times Herald*, June 28, 1955.

39. Rual Askew, "That Bertoia 'Affair' Just Won't Go Away," *Dallas Morning News*, July 10, 1955.

40. *Dallas Morning News*, July 9, 1955.

41. Esther Julia Pels, "Art for Whose Sake?" *American Legion Magazine*, October 1955.

42. *Facts Forum News*, February 1956. The magazine invited rebuttals to Pels's article. In a letter to the editor, Bywaters referred to Pels's attack on modern art: "Since the institution which I serve as director is interested in all kinds of 'good' art (whether traditional or 'modern') we see no point in taking sides against ourselves." Bywaters suggested that representatives from the Museum of Modern Art, the Guggenheim, *Art News*, or *Arts Magazine* be given an opportunity to reply to the Pels article.

43. Marcus, *Minding the Store*, p. 155.

44. *American National Review*, December 5, 1955.

45. Dallas Museum of Fine Arts Controversy File, Vertical File, Bywaters Collection.

46. The museum board's policy statement was based on "Statement of Artistic Freedom," American Federation of Art, October 22, 1954. The AFA stated: ". . . artistic expression must be judged solely on its merits as a work of art and not by the political or social views of the artist . . ."

47. "Resolution," Dallas Art Association, January 1956, Vertical File, Bywaters Collection.

48. Colonel John W. Mayo to Dallas Art Association, January 12, 1956, Bywaters Collection.

49. Rual Askew, "Museum Art Again Attacked as 'Red,'" *Dallas Morning News*, January 21, 1956.

50. Dallas Museum of Fine Arts Controversy File, Vertical File, Bywaters Collection.

51. Dallas Art Association to Colonel John W. Mayo, January 27, 1956, Bywaters Collection.

52. Rual Askew, "Museum Bans Politics Rule," *Dallas Morning News*, January 28, 1956; Rual Askew, "Museum Says Reds Can Stay," *Dallas Morning News*, January 28, 1956. See also Harvey Bogen, "More Action on Art Row Slated Here," *Dallas Morning News*, February 1, 1956; "City Will Be Asked to Ban Reds' Art," *Dallas Times Herald*, February 1, 1956; "Dallas Art Museum Won't Ban Works on Political Basis," *Dallas Morning News*, January 28, 1956.

53. "More Action on Art Row Slated Here," *Dallas Morning News*, February 1, 1956.

54. "Owsley's Speech to Patriotic Council," January 31, 1956, typescript, Dallas Museum of Fine Arts Controversy File, Vertical File, Bywaters Collection. See also Devree, "The U.S. Government Vetoes Living Art," p. 55; and "More Action on Art Row Slated Here," *Dallas Morning News*, February 1, 1956.

55. "More Action on Art Row Slated Here," *Dallas Morning News*, February 1, 1956.

56. "Resolution," Dallas County Patriotic Council, January 31, 1956, Dallas Museum of Fine Arts Controversy File, Vertical File, Bywaters Collection.

57. John Mayo, "Show No Red Art, Says Taxpayer," *Dallas Morning News*, February 3, 1956.

58. Dallas Museum of Fine Arts Controversy File, Vertical File, Bywaters Collection.

59. Gerald B. Mann, "Essential Issue Is Our Freedom," *Dallas Morning News*, February 4, 1956.

60. "Park Chief Backs Museum Art Stand," *Dallas Times Herald*, February 1, 1956; "Mayor Seeking End to Art Controversy," *Dallas Morning News*, February 21, 1956.

61. Eugene Lewis, "The Museum Fuss and Some Facts," *Dallas Times Herald*, February 6, 1956; "New Developments Crop Up in Art Row," *Dallas Morning News*, February 7, 1956.

62. Eugene Lewis, "Art Museum Critics Vow All-Out Fight," *Dallas Times Herald*, February 9, 1956; Eugene Lewis, "Trustees Answer Art Museum Critics," *Dallas Times Herald*, February 10, 1956.

63. Rual Askew, "Art and Artists: Who's Who among Suspect Artists," February 5, 1956; Lewis, "The Museum Fuss, and Some Facts," *Dallas Times Herald*, February 6, 1956; Lewis, "Art Museum Critics Vow All-Out Fight," *Dallas Times Herald*, February 9, 1956; Lewis, "Trustees Answer Art Museum Critics," *Dallas Times Herald*, February 10, 1956.

64. Florence Rodgers to the Dallas Art Association, February 10, 1956, Bywaters Collection.

65. "Patriot Group Gives Answer in Art Dispute," *Dallas Times Herald*, February 14, 1956.

66. "Second Round Set Wednesday in Art Dispute," *Dallas Times Herald*, February 22, 1956.

67. "Park Board Expected to Back Art Group," *Dallas Times Herald*, February 28, 1956.

68. Bob Fenley, "Art Director Labels Council as 'Hate Group,'" *Dallas Times Herald*, February 23, 1956.

69. John Rosenfield, "Censorship in Art Might Be the Start," *Dallas Morning News*, February 22, 1956.

70. "Eisenhower Statement on the Occasion of the 25th Anniversary of the Museum of Modern Art," Dallas Museum of Fine Arts Controversy File, Vertical File, Bywaters Collection.

71. "Resolution," Dallas Junior Chamber of Commerce, February 16, 1956, Dallas Museum of Fine Arts Controversy File, Vertical File, Bywaters Collection.

72. Stanley Marcus to the author, July 8, 1991.

73. Helen Bullock, "Banker Opposes 'Patriotic' Fear," *Dallas Morning News*, March 1, 1956.

74. *Seventy-Five Years of Art in Dallas*, p. 35.

75. "Speech: Delivered by William Ware," March 6, 1956, typescript, Dallas Museum of Fine Arts Controversy File, Vertical File, Bywaters Collection; "New Charges Made in Art Controversy," *Dallas Morning News*, March 6, 1956.

76. "Let the Voters Decide," *Dallas Times Herald*, March 14, 1956.

77. "Art for Propaganda," *Dan Smoot Report*, March 16, 1956.

78. Bywaters presented this information to the Board of Trustees at the March 16, 1956, meeting.

79. Bywaters, "Oral History Interviews," June 21, 1985, p. 110.

80. *Seventy-Five Years of Art in Dallas*, p. 33.

81. Devree, "The U.S. Government Vetoes Living Art," p. 54.

82. Dallas Museum of Fine Arts Controversy File, Vertical File, Bywaters Collection.

83. "Bassett Lists Services, Benefits of League," *Dallas Times Herald*, November 7, 1956.

84. "Bassett Heads New Dallas Chapter of Artists League," *Dallas Times Herald*, November 2, 1956.

85. *Dallas Times Herald*, March 17, 1955.

86. *Dallas Morning News*, March 17, 1955.

87. "Women's Chamber Seeks to Resolve Art Controversy," *Dallas Times Herald*, May 22, 1955.

88. Rual Askew, "Paintings in First Club Show," *Dallas Morning News*, February 12, 1956.

89. Eugene Lewis, "Museum Opens First of Art Club Shows," *Dallas Times Herald*, February 12, 1956. Following the Aunspaugh were exhibitions by the Bassett Club (February 26–March 7), the Federation of Dallas Artists (March 11–21), the Klepper Club (March 25–April 4), and the Reaugh Art Club (April 8–18).

90. Rual Askew, "Technical Assurance Dominates," *Dallas Morning News*, February 26, 1956.

91. Rual Askew, "One More Exhibit by Clubs," *Dallas Morning News*, March 11, 1956.

92. Rual Askew, "Art and Artists: Points of View Clearly Drawn," *Dallas Morning News*, March 25, 1956.

93. "Klepper Club," *Dallas Times Herald*, March 25, 1956.

94. *Dallas Morning News*, April 6, 1956.

95. "Dallas Armistice," *Time*, March 12, 1956, p. 70.

96. Aline B. Saarinen, "Art Storm Breaks on Dallas," *New York Times*, February 12, 1956.

97. "Dallas Trustees Take a Stand," *New York Times*, February 19, 1956.

98. Dallas Museum of Fine Arts Controversy File, Vertical File, Bywaters Collection.

99. "'Red Art' Onslaught Hot," *Texas Observer*, February 12, 1956.

100. Alice Murphy, "Art Show Viewed Despite Opposition," *Dallas Times Herald*, March 26, 1956.

101. Devree, "The U.S. Government Vetoes Living Art," p. 56.

102. Rual Askew, "Art and Artists: Points of View Clearly Drawn," *Dallas Morning News*, March 25, 1956.

103. *Dallas Morning News*, March 26, 1956.

104. Charolette Devree to Jerry Bywaters [July 28, 1956], Bywaters Collection.

105. Jerry Bywaters to Charolette Devree, July 30, 1956, Bywaters Collection.

106. Jonathan Marshall, "Spectrum: An Answer to Miss Pels," *Arts* 30, no. 6 (March 1956): 13.

107. Rene D'Harnoncourt, "Modern Art and Freedom," *Facts Forum News*, June 1956, p. 13.

108. Ruby Clayton McKee, "Public Affairs Luncheon Club Backs Interposition Proposals," *Dallas Morning News*, February 28, 1956.

109. Anthony Lewis, "U.S. Bars Art Tour after 'Red' Charge," *New York Times*, May 26, 1956.

110. "Art in the Heart of Texas," *New York Times*, May 27, 1956.

111. ACLU newsletter, Dallas Museum of Fine Arts Controversy File, Vertical File, Bywaters Collection.

112. "Dondero, Dallas, and Defeatism," *Arts Magazine*, July 1956, p. 9.

113. "U.S.I.A. and Art," *Arts Magazine*, August 1956, p. 5.

114. Ben Shahn, "Nonconformity," *Atlantic Monthly*, September 1957, p. 36.

115. Dondero, "Communism under the Guise of Cultural Freedom – Strangling American Art," *Congressional Record*, June 14, 1956, p. 5.

116. Dondero, "UNESCO – Communism and Modern Art," *Congressional Record*, July 20, 1956, p. 1.

117. Devree, "The U.S. Government Vetoes Living Art," p. 56.

118. "Sculptor Is Paid for Unused Work: Zorach Accepts with 'Broken Heart' $56,515 for Texas Bank for Three Panels," *New York Times*, May 21, 1956.

119. "A Cast Lady Cast Off," *Life*, July 23, 1956, p. 93.

120. "Texas Legion Votes to Take Post's Charter" [*Dallas Times Herald*, August 4, 1956]; "Dallas Legion Chief Blasts Punitive Move" [*Dallas Times Herald*, August 5, 1956], Dallas Museum of Fine Arts Controversy File, Vertical File, Bywaters Collection.

121. *Time*, November 12, 1956.

122. *Dallas Morning News*, November 28, 1956.

123. Bob Fenley, "Board Bans Controversial Library Art," *Dallas Times Herald*, November 22, 1956.

124. John Rosenfield, "Art Silliness and Republicans," *Dallas Morning News*, August 2, 1956.

125. John Rosenfield, "If Anybody Objects Just Yank It Down," *Dallas Morning News*, November 30, 1956.

126. Jacob Getlar Smith, "Deep Is the Art of Texas," *American Artist*, September 1956, p. 25.

127. A *Retrospective Exhibition*, p. 42.

I I. A Sympathetic Eye

1. "Historical Murals Doomed," *Dallas Morning News*, June 27, 1956, sec. 3, p. 1.

2. *Seventy-Five Years of Art in Dallas*, p. 37.

3. Don Freeman, "Bywaters Drawls Art," *Dallas Morning News*, June 29, 1958.

4. Smith, "Deep Is the Art of Texas," pp. 25–26.

5. A *Century of Art and Life in Texas*, Dallas Museum of Fine Arts, 1961, n.p.

6. *Southwest Review*'s publication of Bywaters' article on Otis Dozier coincided with Dozier's retrospective exhibition. See Jerry Bywaters, "Otis Dozier, Growth and Maturity of a Texas Artist," *Southwest Review* 62, no. 1 (Winter 1957): 33–40.

7. Jerry Bywaters, *Andrew Dasburg*, p. 3. Bywaters' catalogue essay for the Dasburg exhibition was rewritten and published in hardback under the auspices of the American Federation of Art in 1959. The Dasburg exhibition was toured throughout the nation.

8. Jerry Bywaters, "Everett Spruce: An Appreciation," in *Everett Spruce: A Portfolio of Eight Paintings*, Blaffer Series of Southwestern Art (Austin: University of Texas Press, 1958), n.p.

9. Nathaniel Pousette-Dart, *American Painting Today*. It is interesting to note that the book's introduction on modernism does not mention American artists but focuses entirely on the School of Paris.

10. Jerry Bywaters, "New Talent in the USA," *Art in America*, February 1955, p. 12.

11. Jerry Bywaters, "Problems of Space over All Continents," *Dallas Morning News*, June 12, 1959.

12. Barbara Rose, *American Art Since 1900: A Critical History* (New York: Praeger, 1967), p. 119.

13. Janet Kutner, "Bywaters Sets Retirement," *Dallas Morning News*, June 13, 1971.

14. Jerry Bywaters to Lloyd Goodrich, October 31, 1975. The letter gives concise autobiographical information and a statement of Bywaters' assessment of his own accomplishments.

15. Jerry Bywaters, "Foreword," *Directions in Twentieth-Century American Painting*, Dallas Museum of Fine Arts, 1961, n.p.

16. Bywaters, *Otis Dozier*, n.p.

17. Jerry Bywaters, "Letter to the Editor," *Life*, September 1956.

18. Dallas Museum for Contemporary Arts File, Vertical File, Bywaters Collection.

19. Edward Marcus, "Defenders Now Have Own Base," newspaper clipping [November 17, 1957], Bywaters Collection.

20. "Edward Marcus New Art Society President," *Dallas Morning News*, April 1, 1957.

21. Rual Askew, "Growth of Society Non-Stop," *Dallas Morning News* [February 17, 1957], Bywaters Collection.

22. Marcus, "Defenders Now Have Own Base."

23. Bywaters, "Oral History Interviews," June 21, 1985, p. 115.

24. Edward Marcus to Jerry Bywaters, January 3, 1958, Bywaters Collection.

25. Bywaters, "Oral History Interviews," June 21, 1985, pp. 113–114.

26. Eugene Lewis, "The Great 'Action Painting' Debate to Be Joined Here," *Dallas Times Herald*, March 2, 1958.

27. Rual Askew, "MacAgy Is Museum Head," *Dallas Morning News*, August 7, 1959.

28. "Art That Broke the Looking Glass," Dallas Museum for Contemporary Arts, 1961, Dallas Museum of Fine Arts File, Vertical File, Bywaters Collection.

29. Joe Minick, "The Texans; Men of Art," *Dallas Times Herald*, May 17, 1959. The large Made in Texas exhibition was presented in two sections – at the Dallas Museum for Contemporary Arts and at the Sheraton Dallas.

30. Dallas Museum of Fine Arts File, Vertical File, Bywaters Collection.

31. Rual Askew, "Major Issue at Hand," *Dallas Morning News*, January 28, 1962.

32. Rual Askew, "Let's Stick to Facts," *Dallas Morning News*, February 10, 1962. A Dallas Art Association memo stated that "definite proposals and conditions of such a merger are now being formulated by a committee representing both museums." See Dallas Museum of Fine Arts File, Vertical File, Bywaters Collection.

33. Rual Askew, "No Merger of Museums," *Dallas Morning News*, March 1, 1962.

34. Rual Askew, "Back to Work: In Clearer Air," *Dallas Morning News*, March 4, 1962.

35. Rual Askew, "DMCA Returns to Crossroads," *Dallas Morning News*, July 22, 1962.

36. Bob Porter, "Art: Merger of Museums Moves to a Climax," *Dallas Times Herald*, April 20, 1963. See also Bob Porter, "Merger of Museums Is Being Restudied"

[*Dallas Times Herald*, April 11, 1963]; Porter, "Art Museums' Union Expected" [*Dallas Times Herald*, April 14, 1963]; William A. Payne, "Terms of 'Maybe' Art Merger," *Dallas Morning News*, April 18, 1963; "Museums Approve Merger," *Dallas Morning News*, Bywaters Collection.

37. Bob Porter, "Merger Voted by Museums," *Dallas Times Herald*, April 20, 1963; Bob Porter, "Art Merger of Museum Moves to a Climax," *Dallas Times Herald*, April 20, 1963. The Board of Trustees voted 24 to 5 in favor of the merger.

38. "Terms of Agreement," Dallas Museum of Fine Arts File, Vertical File, Bywaters Collection.

39. Memorandum, Dallas Museum of Fine Arts File, Vertical File, Bywaters Collection.

40. Rual Askew, "Bywaters Wants to Give Up Directorship to Do More for DMFA," *Dallas Morning News*, March 16, 1963.

41. Charles Mayer to Board of Trustees, Dallas Museum of Fine Arts, May 10, 1963. Also see "Terms of Agreement." Dallas Museum of Fine Arts File, Vertical File, Bywaters Collection.

42. Dallas Museum of Fine Arts File, Vertical File, Bywaters Collection.

43. Bob Porter, "Art: Fine Arts' Jerry Bywaters Takes on New Challenges," *Dallas Times Herald*. Dallas Museum of Fine Arts File, Vertical File, Bywaters Collection.

44. Bob Porter, "The Bywaters Are Honored," *Dallas Times Herald*, June 18, 1966.

12. A Regionalist Rediscovered

1. Bywaters, "Autobiographical Sketch with Slides," June 18, 1975.

2. *A Retrospective Exhibition*, p. 37.

3. Redelsperger, "Jerry Bywaters," p. 60.

4. Bywaters, "Autobiographical Sketch with Slides," June 25, 1975.

5. Jerry Bywaters, "Foreword," in *The American Woman as Artist, 1820–1965*, Pollock Galleries, Owens Fine Arts Center, Southern Methodist University, 1966, n.p.

6. Jerry Bywaters, "The Artist and His Sketchbooks," *A Salute to the Doziers of Dallas*, Dallas Museum of Fine Arts, 1974, n.p.

7. Janet Kutner, "Bywaters Paints Regional Art," *Dallas Morning News*, March 16, 1976.

8. Lorraine Haacke, "A Retrospective Jerry Bywaters" *Dallas Times Herald*, February 22, 1976.

9. In 1976 Marla Redelsperger, a graduate student in art history at SMU, completed a master's thesis titled "Jerry Bywaters: Artist of the Southwest," and Francine Carraro wrote her thesis on the art of Otis Dozier, William Lester, and Everett Spruce.

10. Nicholas Lemann, "Power and Wealth," *Texas Humanist*, January/February 1985, p. 13.

11. *Texas Images and Visions*, Archer M. Huntington Art Gallery, University of Texas at Austin, 1983.

12. Michael Berryhill, "Lone Star Regionalism," *Dallas Fort Worth Home and Garden*, February 1985, p. 34.

13. Janet Kutner, "An Exhibition as Sweeping as Texas," *Dallas Morning News*, August 21, 1986.

14. "McDermott Foundation Gives $400,000 to SMU Arts Library," News Release, Southern Methodist University, August 23, 1988, Bywaters Collection.

15. Carol Luker, "Historian Greene Analyzes Contribution of Dallas Nine," *Dallas Downtown News*, February 18–24, 1985.

16. Bywaters, "Answers to Questions," November 21, 1987.

17. Henry Nash Smith to Jerry Bywaters, May 17, 1986, Bywaters Collection.

bibliography

Major Collections of Jerry Bywaters Papers

Jerry Bywaters Collection on Art of the Southwest, Research Library, Jake and
 Nancy Hamon Fine Arts Library, Southern Methodist University, Dallas, Texas.
 This collection houses Bywaters'personal papers, including sketchbooks, teaching
 notes, and records of his art work, and his correspondence with artists, art critics,
 museum administrators, and art historians. The collection houses a selection of
 Bywaters' original prints, works on paper, mural sketches, and drawings. Also in-
 cluded is Bywaters' collection of newspaper clippings, bulletins, brochures, and
 more than 400 art books and exhibition catalogues, many from his personal col-
 lection. Oral history interviews on tape and transcriptions of interviews with By-
 waters and some of his contemporaries are in the collection (see interview section
 in this bibliography). The collection also houses extensive chronological files on
 the Dallas Museum Association and the Dallas Museum of Art from 1903 to the
 present. The collection includes more than 700 files on American artists and
 more than 9,000 photographs and slides of art works related to the study of Ameri-
 can art and the art of the Southwest.
Dallas Museum of Art, Library, Dallas, Texas. The collection includes exhibi-
 tion catalogues, correspondence, minutes from trustee meetings, and newspaper
 clippings.

Interviews
(Arranged Chronologically)

"Interview with Jerry Bywaters." Taped and transcribed interview with Jerry Bywaters
 by Sylvia Loomis, Dallas, June 9, 1965. Archives of American Art, Smithsonian
 Institution, Washington, D.C.
"The Artist's Eye." Taped interview with Jerry Bywaters by Susan Wendel, Dallas,
 March 1973.
"Autobiographical Sketch with Slides of Selected Works." Taped interviews with
 Jerry Bywaters by Marla Redelsperger, Dallas, June 18, 1975, June 25, 1975, and
 October 3, 1975.
"Texas Murals." Taped interview with Jerry Bywaters by Kinsey Marshall, Dallas,
 February 13, 1976.
Taped interviews with Jerry Bywaters by the author, Dallas: "The Dallas Art Scene,"
 April 19, 1976; "On Becoming an Artist in the Early 1930s," October 29, 1983;
 "Some Biographical Information," October 2, 1986; "On Being an Art Critic,"
 February 23, 1987; "Answers to Questions," April 7, 1987; "Answers to Questions,"
 November 21, 1987; "Bywaters Family History," June 22, 1988.

"An Interview with Jerry Bywaters." Taped interview by Mary Lance, Dallas, January 14, 1982.
"Concerning the Texas Centennial Exposition of 1936." Taped and transcribed interview with Jerry Bywaters by Sarah Hunter, Dallas, January 13, 1984. Dallas Historical Society.
"A Look at Texas Murals during the Depression." Taped and transcribed interview with Jerry Bywaters by Cynthia Duke Brock, Dallas, April 3, 1985.
"Oral History Interviews." Taped and transcribed interviews with Jerry Bywaters by Gerald D. Saxon, Dallas, May 9 and 16, June 13 and 21, 1985.
"The Communist Controversy." Interview with Jerry Jane Smith Henderson by the author, Dallas, July 26, 1988.

Selected Articles and Reviews by Jerry Bywaters
(Arranged chronologically)

"Irresistible, A Freshman Drammer of Love and Hatred and Three Acts." *Crimson Colt* [Southern Methodist University], Freshman Number, 1926.
"Like Thoreau, Philosopher of Texas Lives 'By Side of the Road, Watching World Go By.'" *Dallas Morning News*, March 14, 1926.
"Life of College Annual Editor Not Bed of Roses: Work Furnishes Thrills That Can't Be Found in Flight to Pole." *Dallas Times Herald*, June 6, 1926.
"Have You Had Your Irony Today?" *Semi-Weekly Campus* [Southern Methodist University], November 7, 1926.
"Gay Gotham Welcomes Dallas Lad." *Dallas Morning News*, July 24, 1927.
"Trials of an Amateur Sailor." *Dallas Morning News*, August 14, 1927.
"Seeing Sunny Spain Is Hard on the Feet." *Dallas Morning News*, November 13, 1927, p. 5.
"Bullfights Are Fine If You Like Them." *Dallas Morning News*, February 16, 1927.
"Art Trend in Mexico Wakes Keen Interest." *Dallas Morning News*, June 3, 1928, p. 14.
"Diego Rivera and Mexican Popular Art." *Southwest Review* 13, no. 4 (July 1928): 475–480.
"Five Dallas Artists." *Southwest Review* 14 (Spring 1929): 379.
"Robert Vonnoh, N.A." *Southwest Review* 14 (Spring 1929): 378–379.
"Fair Park Art Exhibit." *Southwest Review* 15, no. 1 (Autumn 1929): 127.
"A Dallas Gallery." *Southwest Review* 15, no. 1 (Autumn 1929): 129–130.
"Buried Rubies That Have Claimed Lives." *Dallas Morning News*, September 8, 1929, Feature, p. 4.
"On Withholding Part." *Southwest Review*, Winter 1929, pp. 264–265.
"Sketching in Mexico City." *Holland's, the Magazine of the South*, March 1930, p. 28.
"The Fall Openings." *Southwest Review* 16, no. 1 (Autumn 1930): 137–138.
"The Artist Aroused." *Southwest Review* 17, no. 4 (Summer 1932): 490.
"Taos Losing Much of Its Atmosphere with Rebuilding of Plaza Side: Emil Bistram,

Mural Artist, Joins Colony." *Dallas Morning News*, September 18, 1932, sec. 3, p. 9.

"More about Southwest Architecture." *Southwest Review* 18, no. 3 (Spring 1933): 234–264.

"World's Fair Art Represents at Least Fine Taste of Collecting During So-Called 'Century of Progress.'" *Dallas Morning News*, August 13, 1933, sec. 3, p. 7.

"Works Which Caused Art World to Change Thinking and Doing in Majority at Fair." *Dallas Morning News*, August 15, 1933, sec. 1, p. 7.

"The Moderns: Contemporary Art as Fully Revealed at Chicago Exhibition." *Dallas Morning News*, August 18, 1933.

"The Benton Mural: Tremendous Decoration for Indiana State Building." *Dallas Morning News*, August 20, 1933, sec. 3, p. 11.

"A Natural Painter." *Dallas Morning News*, August 27, 1933, sec. 3, p. 12.

"Open Season on Art." *Dallas Morning News*, September 3, 1933, sec. 3, p. 10.

"A Painter Changes." *Dallas Morning News*, September 10, 1933, sec. 3, p. 12.

"Art and Much Craft." *Dallas Morning News*, September 17, 1933, sec. 3, p. 6.

"Painting and Poland Chinas." *Dallas Morning News*, September 24, 1933, sec. 3, p. 6.

"League Plans First Meeting Next Thursday." *Dallas Morning News*, October 1, 1933, sec. 3, p. 3.

"America's Rembrandt." *Dallas Morning News*, October 5, 1933, sec. 1, p. 10.

"The Art Exhibit at the State Fair." *Dallas Morning News*, October 8, 1933, sec. 3, p. 6.

"Texas Artists at the Fair." *Dallas Morning News*, October 11, 1933.

"Headhunters in American Art." *Dallas Morning News*, October 15, 1933, sec. 3, p. 8.

"Human Being of the Palette, Douthett Wilson." *Dallas Morning News*, October 22, 1933, sec. 3, p. 10.

"Watercolors at Dallas Museum Texas Room." *Dallas Morning News*, October 20, 1933, sec. 3, p. 8.

"Cliff Lounge Exhibit." *Dallas Morning News*, November 1, 1933, sec. 1, p. 7.

"Art's Theory of Relativity, the Muses and Their Historians: A Critical Agenda." *Dallas Morning News*, November 5, 1933, sec. 3, p. 8.

"Whitney Loan Exhibit." *Dallas Morning News*, November 12, 1933, sec. 3, p. 10.

"Klepper's 'Scapes and Some Regrets on a Newer Manner." *Dallas Morning News*, November 17, 1933.

"Mystery of Man of French Art." *Dallas Morning News*, November 19, 1933, sec. 3, p. 8.

"Art of America at Museum." *Dallas Morning News*, November 26, 1933, sec. 3, p. 7.

"Thumb-Box Art and the Marked Holiday Reminder That Paintings Can Be Sold." *Dallas Morning News*, December 3, 1933, sec. 3, p. 6.

"Dallas Among 16 Cities for Art Exhibition." *Dallas Morning News*, December 7, 1933, sec. 1, p. 8.

"Making a National Art." *Dallas Morning News*, December 10, 1933, sec. 3, p. 8.

"Walls and Wages for Artists." *Dallas Morning News*, December 17, 1933, sec. 3, p. 12.

"Dallas Art at End of Calendar." *Dallas Morning News*, December 24, 1933, sec. 1, p. 4.

"Art of CWA Gets Criticism." *Dallas Morning News*, December 22, 1933, sec. 1, p. 6.

"With Corn in Chicken Coop the Feathers Begin to Fly." *Dallas Morning News*, December 31, 1933, Society, p. 5.

"On the Public's Wall." *Dallas Morning News*, January 7, 1934, sec. 3, p. 10.

"College Art Group Offers Its Examples." *Dallas Morning News*, February 2, 1934, sec. 1, p. 8.

"'St. Jerome' and 'St. Frances.'" *Dallas Morning News*, February 4, 1934, sec. 3, p. 12.

"Martin's Exhibit." *Dallas Morning News*, March 1, 1934, sec. 3, p. 12.

"Amateur Week of Dallas Art." *Dallas Morning News*, March 18, 1934, sec. 3, p. 16.

"Paintings of Spruce." *Dallas Morning News*, March 25, 1934, sec. 3, p. 12.

"Art from Our Neighbor City." *Dallas Morning News*, April 15, 1934, sec. 3, p. 8.

"Goya as Guide to 20th Century." *Dallas Morning News*, April 22, 1934, sec. 3, p. 11.

"SMU Art Show on View." *Dallas Morning News*, June 3, 1934, sec. 3, p. 10.

"El Paso Panels Show History of Mining Art." *Dallas Morning News*, July 15, 1934, sec. 3, p. 7.

"Fifty Prints for Fair." *Dallas Morning News*, July 29, 1934, sec. 3, p. 10.

"Art as Something to Be Learned in Anybody's Career." *Dallas Morning News*, August 12, 1934, sec. 3, p. 9.

"The Two Georges." *Dallas Morning News*, August 19, 1934, sec. 3, p. 9.

"Mrs. O'Brien's Roster." *Dallas Morning News*, September 2, 1934, sec. 3, p. 10.

"Bywaters' Murals for Paris Library Are Completed." *Paris News*, September 23, 1934.

"Seasonal Plans Indefinite for Art Activities." *Dallas Morning News*, September 23, 1934, sec. 3, p. 10.

"The Director of State Fair Show." *Dallas Morning News*, September 30, 1934, sec. 3, p. 10.

"Fair Exhibit Preview." *Dallas Morning News*, October 4, 1934, sec. 1, p. 4.

"Fairs Fine Best." *Dallas Morning News*, October 7, 1934, sec. 4, p. 3.

"Notable Private Print Collection Has Dallas Home." *Dallas Morning News*, October 21, 1934, sec. 3, p. 10.

"Rest of the Country, Surrealism Versus the Soil." *Dallas Morning News*, October 28, 1934, sec. 3, p. 10.

"Highland Park Show." *Dallas Morning News*, November 4, 1934, sec. 3, p. 10.

"The Child as Artist." *Dallas Morning News*, November 18, 1934, sec. 3, p. 10.

"Highland Park Gallery." *Dallas Morning News*, December 2, 1934, sec. 3, p. 14.

"Museum's Lithographs." *Dallas Morning News*, December 9, 1934, sec. 3, p. 16.

"Watercolors by Craig Seen in Local Show." *Dallas Morning News*, December 16, 1934, sec. 3, p. 10.

"No Imitation Matisses in Lounging Robes, but Painters in Overalls Produce Art of Today." *Dallas Morning News*, January 6, 1935, sec. 3, p. 10.

"Lockwood and Others at Highland Park." *Dallas Morning News*, January 13, 1935, sec. 3, p. 10.

"Last of Buzz Week in Dallas Art." *Dallas Morning News*, January 20, 1935, sec. 3, p. 10.

"Still lifes and Flowers Get Broad Treatment at Museum." *Dallas Morning News*, January 27, 1935, sec. 3, p. 8.

"New Exhibit Indicates That Opportunities Exceed Demand for Revealing Local Talent." *Dallas Morning News*, February 10, 1935, sec. 3, p. 12.

"Impressionism as Practiced by Inventors." *Dallas Morning News*, February 17, 1935, sec. 3, p. 12.

"Three Shows at Museum." *Dallas Morning News*, March 3, 1935, sec. 3, p. 16.

"Ralph Rowntree." *Dallas Morning News*, March 17, 1935, sec. 3, p. 14.

"Not Good Intentions but Finest Achievement Marks Allied Exhibit." *Dallas Morning News*, March 24, 1935, sec. 3, p. 14.

"Gertrude Stein Clearest on Most Complex Subject." *Dallas Morning News*, March 20, 1935.

"Modern French Works Drawing Attention Here." *Dallas Morning News*, March 31, 1935, sec. 3, p. 12.

"Dallas Allied Arts Show." *Southwest Review* 20, no. 3 (April 1935): 319–320.

"Government's Taste. Artists for New U.S. Buildings." *Dallas Morning News*, April 7, 1935.

"Serious Art from Serious Students Seen." *Dallas Morning News*, May 5, 1935, sec. 3, p. 14.

"Summer Show at the Museum." *Dallas Morning News*, June 9, 1935.

"Otis Dozier's Work Arrives at New Values." *Dallas Morning News*, June 16, 1935, sec. 3, p. 13.

"Esthetics Emerge after Ban of Hundred Years." *Dallas Morning News*, June 23, 1935, sec. 3, p. 9.

"New Relations for Esthetics and Business." *Dallas Morning News*, June 30, 1935, sec. 3, p. 13.

"Art Becoming Integral Part of Activity." *Dallas Morning News*, July 5, 1935, sec. 3, p. 9.

"Art Becoming of Importance to Craftsmen." *Dallas Morning News*, July 14, 1935, sec. 3, p. 7.

"Washington Medicis." *Dallas Morning News*, August 18, 1935, sec. 3, p. 16.

"$250,000 for Duccio." *Dallas Morning News*, August 25, 1935, sec. 3, p. 12.

"First Exhibition of Year." *Dallas Morning News*, September 1, 1935, sec. 4, p. 3.

"There're Others Besides Hitler in the Alumni." *Dallas Morning News*, September 8, 1935, sec. 2, p. 12.

"Museum Show Opens Sunday to Start Year." *Dallas Morning News*, September 15, 1935, sec. 3, p. 16.

"30 Dallasites in Exhibition at New School." *Dallas Morning News*, September 29, 1935.

"Dallas Eastward Trend Reflected by Architecture." *Dallas Morning News*, October 1, 1935, sec. 4, p. 4.

"Nason Prints Added to Show at Museum." *Dallas Morning News*, October 6, 1935, sec. 3, p. 14.

"Frank Reaugh Is Still Master of Own Field." *Dallas Morning News*, October 20, 1935, sec. 3, p. 14.

"American Printmakers at Museum." *Dallas Morning News*, October 27, 1935, sec. 3, p. 14.

"Dallas Artist, Aid to Rivera, Returns Home." *Dallas Morning News*, November 24, 1935, sec. 4, p. 4.

"4 Home-Town Boys." *Dallas Morning News*, December 29, 1935, sec. 3, p. 10.

"Artist Looks at Self." *Dallas Morning News*, January 5, 1936, sec. 3, p. 12.

"New Director Arrives Here at Bog Moment." *Dallas Morning News*, January 12, 1936, sec. 3, p. 12.

"Four Dallas Mural Painters in Light of Changing Times." *Dallas Morning News*, January 19, 1936, sec. 3, p. 10.

"Prints Remain Popular When Need Passes." *Dallas Morning News*, February 16, 1936, sec. 2, p. 8.

"Red Paintings Go on View at Museum Today." *Dallas Morning News*, March 8, 1936, sec. 2, p. 8.

"Considering the Uselessness of Clubwomen and Art Cause." *Dallas Morning News*, March 15, 1936, sec. 3, p. 10.

"Art Exhibition for Centennial Takes Its Role." *Dallas Morning News*, March 22, 1936, sec. 3, p. 8.

"Local Art Association Ends Year as Bright Future Seen." *Dallas Morning News*, March 29, 1936, sec. 2, p. 4.

"The New Texas Painters." *Southwest Review* 21, no. 3 (April 1936): 330–342.

"Old Name of 'Lady Painter' Won't Do for Dallas Artists." *Dallas Morning News*, April 5, 1936, sec. 3, p. 14.

"Generalized Nude Subjects in Public Row." *Dallas Morning News*, April 12, 1936, sec. 2, p. 8.

"New Director Keys Work of Living Museum." *Dallas Morning News*, April 26, 1936, sec. 2, p. 8.

"Centennial Forces Dallas' Hand Culturally." *Dallas Morning News*, May 3, 1936, sec. 3, p. 14.

"650 Valuable Art Items in Fair Museum." *Dallas Morning News*, May 31, 1936, sec. 3, p. 4.

"Against Narrowness." *Art Digest*, June 1, 1936, pp. 19–20.

"Initial Four through Palace of Fine Arts in Fair Civic Center." *Dallas Morning News*, June 7, 1936, sec. 13, p. 4.

"Centennial Art Exhibit by Galleries." *Dallas Morning News*, June 14, 1936, sec. 2, p. 9.

"Centennial Art Exhibit by Galleries." *Dallas Morning News*, June 21, 1936, sec. 2, p. 4.

"Centennial Art Exhibit by Galleries." *Dallas Morning News*, June 28, 1936, sec. 2, p. 4.

"Centennial Art Show by Galleries." *Dallas Morning News*, July 5, 1936, sec. 2, p. 4.

"Master Pieces of the Little Shown in Print, Watercolor, Lithograph Museum Rooms." *Dallas Morning News*, July 6, 1936, sec. 3, p. 6.

"Southwestern and Remington Rooms Visited." *Dallas Morning News*, July 12, 1936, sec. 3, p. 10.

"Museum's Texas Rooms Not Just Soft-Soap." *Dallas Morning News*, July 19, 1936.

"Museum Show Does Well by Its Sculpture." *Dallas Morning News*, August 2, 1936, sec. 2, p. 8.

"13 Dallasites, Making Merry with Cultism." *Dallas Morning News*, August 9, 1936, sec. 2, p. 11.

"Dallas Museum of Fine Arts Looks Forward." *Dallas Morning News*, August 23, 1936, sec. 2, p. 6.

"Texas History Reaches Arts Via Literature." *Dallas Morning News*, August 30, 1936, sec. 2, p. 4.

"Some Cheering for the Year in Local Art." *Dallas Morning News*, December 20, 1936, sec. 2, p. 7.

"New Dallas Museum Preparing for Most Significant Exhibit." *Dallas Morning News*, January 3, 1937, sec. 3, p. 5.

"Spruce Show Was Gotham's Idea Not His." *Dallas Morning News*, January 17, 1937, sec. 2, p. 5.

"Midwestern Art Exhibit Opens Feb. 7." *Dallas Morning News*, January 24, 1937, sec. 3, p. 12.

"Art Arrives at Rare Era of Progress." *Dallas Morning News*, January 31, 1937, sec. 3, p. 12.

"Dallas Artists Taking Honors and Commissions with Such Regularity It Must Mean Something." *Dallas Morning News*, February 14, 1937, sec. 2, p. 5.

"Controversial Show from Chicago." *Dallas Morning News*, March 28, 1937, sec. 3, p. 12.

"Exciting Chicago Collection on View at Dallas Museum." *Dallas Morning News*, April 4, 1937, sec. 3, p. 14.

"American Artists Group Eyes Dallas Paintings for Inclusion in Series of Reproductions." *Dallas Morning News*, June 6, 1937, sec. 3, p. 14.

"Art of the Americas for Exposition Period." *Dallas Morning News*, June 13, 1937, sec. 2, p. 7.

"American Section at Museum." *Dallas Morning News*, June 20, 1937, sec. 3, p. 1.

"American Art and Mr. Hopper." *Dallas Morning News*, June 27, 1937, sec. 2, p. 8.

"Edward Bruce and He-man Art: Ward Lockwood and Taos." *Dallas Morning News*, July 11, 1937, sec. 3, p. 10.

"Vernon Hunter, Painter of the Panhandle." *Dallas Morning News*, July 18, 1937, sec. 3, p. 9.

"Modern Art's Trends Shown in Fair Display." *Dallas Morning News*, August 1, 1937, sec. 3, p. 11.

"Ex-House Painter Wins Art Fame." *Dallas Morning News*, August 8, 1937, sec. 3, p. 15.

"Museum to Display Handiwork of Uncle Sam's Own Artists." *Dallas Morning News*, August 15, 1937, sec. 2, p. 6.

"Boondoggling Federal Daubers Laugh Last as Work Is Shown." *Dallas Morning News*, August 22, 1937, sec. 3, p. 12.

"War and Art; Loyalists True in Spain." *Dallas Morning News*, September 5, 1937, sec. 2, p. 6.

"Manifest Destiny of Art Gallery." *Dallas Morning News*, September 12, 1937, sec. 2, p. 6.

"Art Comes Back Home." *Southwest Review* 23, no. 1 (October 1937): 79–83.

"Dozier Works Dominate Exhibition." *Dallas Morning News*, October 3, 1937, sec. 3, p. 14.

"Art Comes Home from Sea." *Dallas Morning News*, October 10, 1937, sec. 3, p. 6.

"Arts' Center of Gravity Shifts West and Peeves Press." *Dallas Morning News*, October 17, 1937, sec. 3, p. 14.

"The New Texas Painters." *Art and Artists of Today* 1, no. 4 (November–December 1937): 7.

"The Artists in America." *Southwest Review* 23, no. 2 (January 1938): 167–173.

"Make Haste Slowly on Museum Art School." *Dallas Morning News*, January 30, 1938, sec. 1, p. 3.

"Murals for the Post Office and 1938 Allied Arts Exhibit." *Dallas Morning News*, January 23, 1938, sec. 3, p. 14.

"Agitation and Fuss over Museum Send Throngs to Inspect Place." *Dallas Morning News*, February 6, 1938, sec. 2, p. 9.

"Contemporary American Artists." *Southwest Review* 23, no. 3 (April 1938): 297–306.

"Don Brown Regional Cosmopolite." *Dallas Morning News*, April 24, 1938, sec. 2, p. 8.

"Art Carnival Now Moves to Museum Center." *Dallas Morning News*, May 1, 1938, sec. 2, p. 6.

"Power of the Printed Line Surpasses Power of the Printed Word." *Dallas Morning News*, May 8, 1938, sec. 2, p. 6.

"Dallas Museum Shapes Policy of Permanency." *Dallas Morning News*, May 29, 1938, sec. 2, p. 5.

"Taos Art Colony, Not Resort." *Dallas Morning News*, September 4, 1938, sec. 2, p. 4.

"New Mexico Makes Most of WPA." *Dallas Morning News*, September 11, 1938, sec. 2, p. 4.

"That Controversial Matter of Murals and Architects." *Dallas Morning News*, January 16, 1939, sec. 1, p. 4.

"Judges Are Different but Artists Are Same." *Dallas Morning News*, March 12, 1939, sec. 2, p. 3.

"Toward an American Art." *Southwest Review* 25, no. 2 (January 1940): 128–142.

"A Note on the Lone Star Printmakers." *Southwest Review* 26, no. 1 (Autumn 1940): 63–64.

"Artist Studied Our Landscape Firsthand." *Dallas Morning News*, November 9, 1941, p. 26.

"Texas Panorama." *Magazine of Art*, December 1944, pp. 306–309.

"Art Museums: Repositories or Creative Centers?" *Southwest Review* 30, no. 4 (Summer 1945): 347–353.

"Otis Dozier, Painter of Desert and Mountain." *American Artist*, May 1947, pp. 20–25.

"Southwest Art Today, New Directions for Old Forms." *Southwest Review* 32, no. 4 (Autumn 1947): 361–372.

"New Talent in the USA." *Art in America*, February 1955, p. 12.

"Museum Director's Choice: Old Texas Fort by Modern Texas Artist." *Life*, June 6, 1955, p. 73.

"Otis Dozier, Growth and Maturity of a Texas Artist." *Southwest Review* 42, no. 1 (Winter 1957): 33–40.

"Problems of Space over All Continents." *Dallas Morning News*, June 12, 1959, sec. 4, p. 6.

"France Still Hub for New, Old Creators." *Dallas Morning News*, June 19, 1959.

"Avant-Garde Is Rampant in Paris Spring Art Show." *Dallas Morning News*, June 20, 1959.

"Visit to Studio in Paris Finds Young Texas Pupils." *Dallas Morning News*, June 21, 1959.

"Backward Steps Trace Art Studies in Europe." *Dallas Morning News*, July 12, 1959.

"Greatest Western Art Abounds in Florence." *Dallas Morning News*, July 23, 1959.

"Big German Display Centers at Kassel." *Dallas Morning News*, September 7, 1959.

"Holland Can Provide Own Top Collections." *Dallas Morning News*, September 17, 1959.

"Art-filled Home." *Dallas Times Herald*, April 28, 1963.

"Big D: Unique Ability Unites Commerce with Culture." *Art Gallery*, May 1963, pp. 10–11.

Selected Catalogues and Portfolios

American Masters: Art Students' League. Art Students' League of New York. New York, 1967–1968. Exhibition circulated by the American Federation of Arts.

The American Woman as Artist, 1820–1965. Pollock Galleries, Owen Arts Center, Southern Methodist University. Dallas, 1966. January 23–February 1. Foreword by Jerry Bywaters.

Americans 1942. Museum of Modern Art. New York, 1942. Edited by Dorothy Miller.

Andrew Dasburg. Dallas Museum of Fine Arts. Dallas, 1957. March 3–April 21. Introduction by Jerry Bywaters. Notes by Andrew Dasburg.

Andrew Dasburg. American Federation of Arts. New York, 1959. Text by Jerry Bywaters. Notes by Andrew Dasburg.

The Art That Broke the Looking-Glass. Dallas Museum for Contemporary Art. Dallas, 1961. November 15–December 31. Essay by Douglas MacAgy.

A Century of Art and Life in Texas. Dallas Museum of Fine Arts. Dallas, 1961. April 9–May 7. Foreword and essay by Jerry Bywaters.

Contemporary Art. Golden Gate International Exposition. San Francisco, 1939.

The Crafts of Worship. Dallas Museum of Fine Arts. Dallas, 1964. March 15–April 12.

Directions in Twentieth-Century American Painting. Dallas Museum of Fine Arts. Dallas, 1961. October 7–November 12.

Eighteenth Annual Exhibition of Texas Painting and Sculpture. Dallas Museum of Fine Arts. Dallas, 1956.

Eleventh Annual Texas Exhibition of Painting and Sculpture. Dallas Museum of Fine Arts. Dallas, 1949–1950.

Everett Spruce. American Federation of Arts. New York, 1959. Introduction by John Palmer Leeper.

Everett Spruce: A Portfolio of Eight Paintings. Blaffer Series of Southwestern Art. University of Texas Press. Austin, 1958. Foreword by Lloyd Goodrich. Essay by Jerry Bywaters.

Gallery Garden. Dallas Museum of Fine Arts. Dallas, 1963. February 23–March 24.

H. O. Kelly, Retrospective Exhibition. Dallas Museum of Fine Arts. Dallas, 1960. October 8–November 13. Foreword by Jerry Bywaters.

John Sloan in Santa Fe. Smithsonian Institution Traveling Exhibition Service. Washington, D.C., 1981.

Lone Star Regionalism: The Dallas Nine and Their Circle. Dallas Museum of Fine Arts. Dallas, 1985. February 1–March 17. Essay by Rick Stewart.

New Horizons in American Art. Museum of Modern Art. New York, 1936. Introduction by Holger Cahill.

Otis Dozier. Dallas Museum of Fine Arts. Dallas, 1956. Text by Jerry Bywaters.

Painting and Sculpture from 16 American Cities. Museum of Modern Art. New York, 1933.

A Retrospective Exhibition: Jerry Bywaters. University Galleries, Owen Fine Arts Center, Southern Methodist University. Dallas, 1976. February 22–March 28. Introduction by Lloyd Goodrich. Notes by Jerry Bywaters.

A Salute to the Doziers of Dallas. Dallas Museum of Fine Arts. Dallas, 1974. September 20–October 27. Foreword by Harry S. Parker III. Essay by Jerry Bywaters.

Seventeenth Annual Exhibition of Texas Painting and Sculpture. Dallas Museum of Fine Arts. Dallas, 1955. Foreword by Lloyd Goodrich.

Seventy-Five Years of Art in Dallas. Dallas Museum of Fine Arts. Dallas, 1978. January 24–February 28. Essay by Jerry Bywaters.

Six Southwestern States. Dallas Museum of Fine Arts. Dallas, 1947. June 15–September 14. Text by Jerry Bywaters.

Southwestern Art: A Sampling of Contemporary Painting and Sculpture. Dallas Museum of Fine Arts. Dallas, 1960. April 10–May 22. Foreword by Jerry Bywaters.

A Survey of Texas Painting. Dallas Museum of Fine Arts. Dallas, 1957. Foreword by Jerry Bywaters. Introduction by Jerry Harwell.

The Texas Centennial Exposition. Dallas Museum of Fine Arts. Dallas, 1936.

Texas Images and Visions. Archer M. Huntington Art Gallery, University of Texas at Austin. Austin, 1983. February 25–April 10. Essay by William H. Goetzmann. Catalogue by Becky Duval Reese.

The Texas Landscape, 1900–1986. Museum of Fine Arts. Houston, 1986. May 17–September 7. Essay by Susie Kalil.

Texas Painting and Sculpture: The Twentieth Century. Pollock Galleries, Owens Fine

Arts Center, Southern Methodist University. Dallas, 1971. January 17–March 7. Foreword by Martha Utterback and Jerry Bywaters.

Texas Panorama. Dallas Museum of Fine Arts. Dallas, 1944–1945. Text by Jerry Bywaters.

Texas State Fair Exhibition of Spanish Art, Texas Paintings, and Frank Reaugh. Dallas Museum of Fine Arts. Dallas, 1939.

13 Dallas Artists. Lawrence Art Galleries. Dallas, 1936. Foreword by Richard Foster Howard.

Twelfth Annual Exhibition of Texas Painting and Sculpture. Dallas Museum of Fine Arts. Dallas, 1950–1951.

Twelve from Texas: Portfolio of Lithographs. Southern Methodist University Press. Dallas, 1952. Foreword by Jerry Bywaters.

Twentieth Annual Dallas Allied Arts Exhibition. Dallas Museum of Fine Arts. Dallas, 1949.

Two Hundred Years of American Painting. Assembled for the State Fair of Texas. Dallas Museum of Fine Arts. Dallas, 1946. October 5–November 4. Text by Jerry Bywaters.

William Lester. Dallas Museum of Fine Arts. Dallas, 1947.

Books, Articles, and Other Sources

"All America Represented in New York's First National Show." *Art Digest,* June 1, 1936, pp. 34–35.

"Art of Americas: A Texas Event." *Art News,* September 18, 1937, p. 15.

"Art of Texas Presents an Epitome of Aesthetics of Modern Age." *Art Digest,* June 1, 1936, pp. 14, 15, 20.

"Art Preview for U.S.A." *Look,* November 17, 1953, pp. 88–93.

Berryhill, Michael. "Lone Star Regionalism." *Fort Worth Home and Garden,* February 1985, pp. 32–36.

Boswell, Peyton. "Some Comments on the News of Art." *Art Digest,* June 1, 1936, p. 7.

Cahill, Holger. "American Art Today," *Parnassus,* May 1939, pp. 14–15.

Carraro, Francine. "Jerry Bywaters: Canvasing Icons of the Texas Landscape." *Texas Humanist,* January/February 1985, pp. 38–40.

———. "Painters of the Southwest Landscape: Otis Dozier, William Lester, Everett Spruce." Master's thesis, Southern Methodist University, 1976.

———. "A Regionalist Rediscovered: A Biography of Jerry Bywaters." Ph.D. diss., University of Texas at Austin, 1989.

Chapman, John. "Aesthetic Judgements and Art Museums." *Southwest Review,* Summer 1955, pp. 262–266.

Chokla, Sarah. "Book-Printing in Texas." *Southwest Review* 21, no. 3 (April 1936): 319–328.

"Collection Begun as Two Classes Donated Paintings." *Southern Methodist University News-Digest,* June 15, 1940.

"Dallas Annual." *Art Digest*, April 1, 1933, p. 11.

"Dallas Armistice." *Time*, March 12, 1956.

"Dallas Museum Criticized for 'Pink' Art." *Texas Observer*, March 21, 1955.

"Dallas Winners." *Art Digest*, February 15, 1937, p. 21.

Davis, Timothy Mark. "Cultivating the Machine in the Garden: Landscape as Text and Subtext in *The Humble Way*." Master's thesis, University of Texas at Austin, 1987.

DeLong, Lea Rosson. *Nature's Forms/Nature's Forces: The Art of Alexandre Hogue*. Norman: University of Oklahoma Press, 1984.

Devree, Charolette. "The U.S. Government Vetoes Living Art." *Art News*, September 1956, pp. 34–35 and 54–56.

D'Harnoncourt, Rene. "Modern Art and Freedom." *Facts Forum News*, June 1956, pp. 12–17.

"Dondero, Dallas, and Defeatism." *Arts Magazine*, July 1956, p. 9.

Dondero, George A. "Communist Conspiracy in Art Threatens American Museums." *Congressional Record*, March 17, 1952.

———. "UNESCO – Communism and Modern Art." *Congressional Record*, June 20, 1956.

"Exhibition Reveals Southwest's Contribution to 'American Scene,'" *Art Digest*, June 1, 1936, pp. 16–17.

Frankfurter, Alfred. "Shame in Dallas." *Art News* 54, no. 4 (Summer 1955).

"Freshness and Assurance Mark Dallas Show." *Art Digest*, May 1, 1932, p. 16.

George, Mary Carolyn Hollers. *O'Neil Ford, Architect*. College Station: Texas A & M University Press, 1992.

Gerdts, William. *American Impressionism*. New York: Abbeville Press, 1984.

Goodrich, Lloyd. *Three Centuries of American Art*. New York: Frederick A. Praeger, 1966.

Hankins, Barbara Lynn. "New Deal Art: The Art That Time Forgot." Master's thesis, University of Dallas, 1982.

Hogue, Alexandre. "Progressive Texas." *Art Digest*, June 1, 1936, pp. 17–18.

Hunter, Vernon. "The Artist and the Region." *Southwestern Arts*, August 1932, pp. 1, 2, 8.

Hutson, Ethel. "The South in Art Today." *Southwestern Arts*, August 1932, p. 7.

Johnson, William. "Texas Breaks the Spell of the Bluebonnet." *Life*, November 29, 1954, pp. 26–28, 30.

Klitgaard, Kaj. *Through the American Landscape*. Chapel Hill: University of North Carolina Press, 1941.

Lance, Mary. *Lynn Ford: Texas Artist and Craftsman*. San Antonio: Trinity University Press, 1978.

Lansford, Alonzo. "Lone Star Annual – No Bluebonnets." *Art Digest*, November 15, 1949, p. 9.

Larkin, Oliver W. *Art and Life in America*. New York: Holt, Rinehart, and Winston, 1949.

"Lone Star Artists." *Time*, June 30, 1952, pp. 62, 69.

McCarthy, Muriel Quest. *David R. Williams: Pioneer Architect*. Dallas: Southern

Methodist University, 1982.

McDonald, William F. *Federal Relief Administration and the Arts.* Columbus: Ohio State University Press, 1969.

McKinzie, Richard D. *The New Deal for Artists.* Princeton: Princeton University Press, 1973.

Marcus, Stanley. *Minding the Store: A Memoir.* Boston: Little, Brown & Co., 1974.

Marling, Karal Ann. *Wall-to-Wall America: A Cultural History of Post-Office Murals in the Great Depression.* Minneapolis: University of Minnesota Press, 1982.

Marshall, Mary. "The Allied Arts Show." *Southwest Review* 17, no. 3 (Spring 1932): 359–365.

Murry, Marion. "Art of the Southwest." *Southwest Review,* July 1926.

O'Brien, Esse Forrester. *Art and Artists of Texas.* Dallas: Tardy Publishing, 1935.

O'Connor, Francis (ed.). *Art for the Millions: Essays from the 1930s by Artists and Administrators of the WPA Federal Art Project.* Greenwich, Connecticut: New York Graphic Society, 1973.

———. (ed.). *The New Deal Art Projects; An Anthology of Memoirs.* Washington: Smithsonian Institution, 1972.

Odum, Howard, and Harry Moore. *American Regionalism: A Cultural-Historical Approach to National Integration.* 1938. Reprint. New York: Holt Rinehart & Winston, 1966.

Pels, Esther Julia. "Art for Whose Sake?" *American Legion Magazine,* October 1955, pp. 16–17 and 54–58.

Pinckney, Pauline A. *Painting in Texas: The Nineteenth Century.* Introduction by Jerry Bywaters. Austin: University of Texas Press, 1967.

Pousette-Dart, Nathaniel (ed.). *American Painting Today.* New York: Hastings House, 1956.

Ragsdale, Kenneth B. *The Year America Discovered Texas: Centennial '36.* College Station: Texas A&M University Press, 1987.

Raley, Helen. "Texas Wild Flower Art Exhibit." *Holland's Magazine,* July 1927, p. 5.

Randle, Mallory B. "Murals and Sculpture of the Public Works of Art Project and the Treasury Section in the Southwest," Master's thesis, University of Texas, 1967.

———. "Texas Muralists of the PWAP." *Southwestern Art* 1, no. 1 (Spring 1966): 51–69.

Redelsperger, Marla. "Jerry Bywaters: Regional Artist of the Southwest." Master's thesis, Southern Methodist University, 1976.

"Red Art Onslaught Hot." *Texas Observer,* February 12, 1956.

Scott, David W. *John Sloan.* New York: Watson-Guptell, 1975.

Shahn, Ben. "Nonconformity." *Atlantic Monthly,* September 1957, pp. 36–41.

Sloan, John. *New York Scene: From the Diaries, Notes, and Correspondence 1906–1913.* Edited by Bruce St. John. Introduction and Notes by Helen Farr Sloan. New York: Harper and Row, 1965.

Smith, Henry Nash. "A Note on the Southwest." *Southwest Review* 14 (Spring 1929): 267–277.

Smith, Jacob Getlar. "Deep in the Art of Texas." *American Artists,* September 1965, pp. 21–26.

index